Africa The Art of a Continent

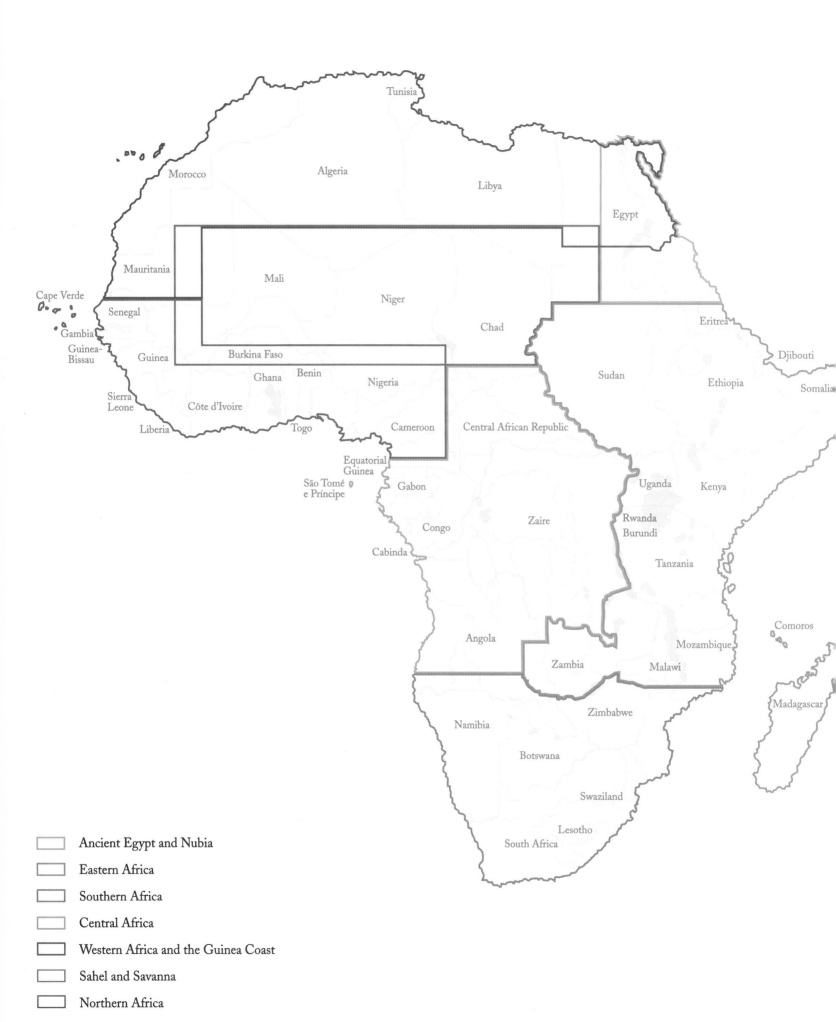

Tunisia

Morocco

Algeria

Libya

Egypt

Mauritania

Mali

Niger

Chad

Eritrea

Cape Verde

Senegal

Djibouti

Gambia

Guinea-
Bissau

Guinea

Burkina Faso

Sudan

Ethiopia

Somalia

Ghana

Benin

Nigeria

Sierra
Leone

Côte d'Ivoire

Liberia

Togo

Cameroon

Central African Republic

Uganda

Kenya

Equatorial
Guinea

São Tomé
e Príncipe

Gabon

Rwanda
Burundi

Congo

Zaire

Tanzania

Cabinda

Comoros

Angola

Mozambique

Zambia

Malawi

Zimbabwe

Madagascar

Namibia

Botswana

Swaziland

Lesotho

South Africa

Ancient Egypt and Nubia

Eastern Africa

Southern Africa

Central Africa

Western Africa and the Guinea Coast

Sahel and Savanna

Northern Africa

# Africa

## The Art
## of a Continent

100 Works of Power and Beauty

GUGGENHEIM MUSEUM

Africa: The Art of a Continent
Curated by Tom Phillips

Royal Academy of Arts, London
October 4, 1995–January 21, 1996

Martin-Gropius-Bau, Berlin
March 1–May 1, 1996

Solomon R. Guggenheim Museum, New York
June 7–September 29, 1996

This exhibition was organized by the
Royal Academy of Arts, London,
in association with the
Solomon R. Guggenheim Museum.

This exhibition and its related
programming are made possible by
generous grants from
Time Warner and Warner Bros.

Major continuing support and
international air transportation
are provided by Lufthansa.

Significant funding has been
provided by Hugo Boss as part of
its long-term partnership with the
Guggenheim Museum.

Additional funding has been
provided by American Express
Company and also by UNESCO,
in celebration of its fiftieth anniversary.

This catalogue is funded in part through the
generosity of The Rockefeller Foundation.

Honorary Patrons of the Exhibition

Secretary-General and Mrs. Boutros Boutros-Ghali,
    United Nations, chairs

His Excellency J. J. Rawlings,
    President of the Republic of Ghana

His Excellency Abdou Diouf,
    President of the Republic of Senegal

His Excellency Yoweri Kaguta Museveni,
    President of the Republic of Uganda

His Excellency Dr. Sam Nujoma,
    President of the Republic of Namibia

His Excellency Antonio Mascarenhas Monteiro,
    President of the Republic of Cape Verde

His Excellency Alpha Oumar Konaré,
    President of the Republic of Mali

Mr. Nelson Mandela,
    President of the Republic of South Africa

His Excellency Dr. Bakili Muluzi,
    President of the Republic of Malawi

His Excellency Albert Zafy,
    President of the Republic of Madagascar

His Excellency Henri Konan Bedi,
    President of the Republic of Côte d'Ivoire

Director-General Frederico Mayor, UNESCO

# Contents

# Lenders to the Exhibition

*Austria*
Kunsthistorisches Museum, Vienna
Museum für Völkerkunde, Vienna

*Belgium*
Etnografisch Museum, Antwerp
Felix Collection
Pierre Loos Collection
J. W. and M. Mestach
Museum voor Midden-Africa, Tervuren
Lucien van de Velde, Antwerp

*Canada*
Frum Collection, Ontario

*Côte d'Ivoire*
Musée National de la Côte d'Ivoire,
　Abidjan

*France*
Musée de l'Homme, Paris
Musée du Louvre, Paris
Musée National des Arts d'Afrique et
　d'Océanie, Paris

*Germany*
Bareiss Family Collection
Fred Jahn Gallery
Fritz Koenig Collection
Linden-Museum, Stuttgart
Museum für Völkerkunde, Hamburg
Museum für Völkerkunde, Leipzig
Staatliches Museum für Völkerkunde,
　Munich
Württembergisches Landesmuseum,
　Stuttgart

*Italy*
Tesoro della Basilica di San Marco, Venice

*Morocco*
Bert Flint
Musée Dar al-Batha, Fez
Musée d'Archéologie, Rabat
Musée Dar Si Said, Marrakesh
Musée Majorelle d'Art Islamique,
　Marrakesh

*Namibia*
State Museum of Namibia, Windhoek

*The Netherlands*
Afrika Museum, Berg en Dal
National Museum of Ethnology, Leiden
Royal Tropical Institute/Tropenmuseum,
　Amsterdam

*Nigeria*
The National Commission for Museums
　and Monuments

*South Africa*
Bowmint Collection
East London Museum
Johannesburg Art Gallery
Local History Museum, Durban
McGregor Museum, Kimberley
The National Cultural History Museum,
　Pretoria
Rock Art Research Unit, Archaeology
　Department, University of the
　Witwatersrand, Johannesburg
Groote Schuur Collection, Cape Town
South African Museum, Cape Town
Standard Bank Collection of African Art
　Housed at the University of the
　Witwatersrand, Johannesburg
University Art Galleries, University of the
　Witwatersrand, Johannesburg

*Sudan*
Sudan National Museum, Khartoum

*Switzerland*
W. and U. Horstmann Collection
Musée Barbier-Mueller, Geneva
George Ortiz Collection

*Tunisia*
Musée de Carthage
Musée National du Bardo, Le Bardo

*United Kingdom*
The Visitors of The Ashmolean Museum,
　Oxford
Ian Auld Collection
The British Library, Oriental and India
　Office Collections
The Trustees of the British Museum,
　London
Cambridge University Museum of
　Archaeology and Anthropology
Commonwealth Institute, London
Kevin and Anna Conru
The Provost and Fellows of Eton College,
　The Myers Museum
The Syndics of the Fitzwilliam Museum,
　Cambridge
Herman Collection
Horniman Public Museum and Public Park
　Trust, London
Mimi Lipton
Lords of the Admiralty
Jonathan Lowen Collection
Manchester City Art Galleries
The Board of Trustees of the National
　Museums and Galleries on Merseyside
　(Liverpool Museum)
Pitt Rivers Museum, University of Oxford
Royal Albert Memorial Museum and Art
　Gallery, Exeter City Museums

# Sponsors' Statement

Time Warner and Warner Bros. are proud to be the cosponsors of *Africa: The Art of a Continent* at the Solomon R. Guggenheim Museum. Along with helping spotlight the power and richness of a uniquely magnificent cultural heritage, this show will be a landmark in fostering a deeper appreciation for the profound artistic achievements of generations of African artists.

As cosponsors of this important exhibition, we welcome the opportunity to reiterate our commitment to education and the arts. We are a company whose strength and purpose are intimately tied to the vitality and energy of the creative community, to the global dialogue of ideas and information, and to the promotion of human understanding and diversity.

We congratulate the Solomon R. Guggenheim Museum both for its role in bringing this extraordinary gathering of Africa's artistic treasures to the United States and for its leadership in the crucially important work of cultural enrichment and enlightenment.

Gerald M. Levin
*Chairman & CEO*
*Time Warner Inc.*

Richard D. Parsons
*President*
*Time Warner Inc.*

Robert A. Daly
*Chairman & CEO*
*Warner Bros. & Warner Music Group*

Terry Semel
*Chairman & Co-CEO*
*Warner Bros. & Warner Music Group*

# Introduction

Cornel West

This monumental exhibition is unprecedented in the history of the art world. Never before has there been gathered such a rich and vast array of African art objects and artifacts from such a broad timespan. And rarely has any exhibition embraced the artistic treasures of the whole of Africa, from Egypt to Ife to Great Zimbabwe.

This historic public showing of beautiful and complex African gems takes place at an upbeat moment in African art criticism and a downbeat time of African political life. With fascinating new breakthroughs in archaeological and anthropological investigations into African empires and societies, we are able to appreciate better the complex diversity and incredible creativity of past and present African artists. Yet the pernicious legacy of European imperialism coupled with the myopic and corrupt leadership of many African elites has left much of the continent politically devastated and economically impoverished. Gone are the old intellectual frameworks predicated on crude white supremacy and subtle Eurocentrism. The once popular categories of "barbarism," "primitivism," and "exoticism" have been cast by the academic wayside. The homogeneous definitions and monolithic formulations of "African art" have been shattered. The Whiggish historiographical paradigms of cultural "evolution" and political "modernization" have been discredited. Instead, we are in search of new ways of keeping track of the fully fledged humanity of Africans by seriously examining their doings, makings, and sufferings under circumstances not of their own choosing. By taking their humanity for granted, we are in danger of being neither apologists for European colonialism nor romantic celebrants of African achievements. Rather we take Africans seriously by taking African history seriously—an ambitious endeavor still in its embryonic stage in the West. This important exhibition is a crucial step in such a world-historical endeavor. To take African history seriously requires a careful and cautious scrutiny of the distinct and sometimes disparate contexts of particular African traditions, rituals, kinship networks, patronage relations, and disciplines of craftsmanship. This kind of historicist inquiry—with its stress on the complex interplay of the local with the regional, continental, and global forces at work—enables us to highlight the specific ways in which African artists, critics, patrons, and communities create, sustain, and deploy art objects.

An intellectually challenging and morally humane approach of this order—be it to metalwork, rock art, male masked performance, female pottery sculpture, body decoration, or architecture—rests on a deep knowledge and sophisticated analysis of the particular histories of specific African peoples. Intellectual ferment in the art world in regard to African artworks may contribute to overcoming the invisible status of African life in late-twentieth-century international relations. The tragic plight and predicament of most present-day Africans remains forgotten on the world scene. And the old ugly stereotypes of African persons as exotic and transgressive objects—as hypersexual and criminal abstractions in the white imagination—are still pervasive in much of the postmodern West.

Art never simply reflects reality. Rather it forces us to engage our past and present so that we see the fragility and contingency of our prevailing views of reality. In this way, art can and does change the world. This unparalleled exhibition at the end of a barbaric century confirms the tenacious human will to survive and thrive—with artistic beauty and worldly engagement—in history, then and now.

# Preface and Acknowledgments

Thomas Krens

It is a privilege for the Guggenheim Museum to celebrate the extraordinary contribution of the African continent to the world's visual culture.

This monumental exhibition marks a departure from our usual programming. It is only our third show to focus on art outside the context of Europe and America (the others were a 1968 exhibition at the Solomon R. Guggenheim Museum called *Mastercraftsmen of Ancient Peru*, and a 1994 presentation at the Guggenheim Museum SoHo, *Scream Against the Sky: Japanese Art after 1945*), and also includes many works from centuries earlier than our own. Indeed, the oldest object exhibited is a stone hand axe some one-million-six-hundred-thousand years old, the earliest of all known human artifacts.

When word first reached us that Tom Phillips and Norman Rosenthal at the Royal Academy of Arts in London had taken up the ambitious subject of art from the entire continent of Africa, we felt immediately that a theme of this importance demanded a venue in the United States. The incalculable and long-acknowledged debt of some of this century's leading Modernist artists to African aesthetic traditions has made Africa a subject of special regard for those interested in modern art. Major collectors of modern art—Peggy Guggenheim among them—have often been collectors of African art, too. One of the first exhibitions in New York to present the arts of Africa for their aesthetic significance was organized in 1935 at the Museum of Modern Art by James Johnson Sweeney, who later became director of the Guggenheim.

Following America's growing interest in international themes as the new century approaches, the Guggenheim has itself developed a special emphasis in international programming. An exhibition on the artistic traditions of a continent that has so enriched our national culture seemed for us an entirely logical development.

This show is the first major art exhibition ever to present Africa as an entity unbroken by the Sahara. Revolutionary as this may be from the point of view of museum practice, the approach is fully justified by reference to African history, as Ekpo Eyo's essay in this volume makes clear. This continental focus makes it possible to unite in the show works that museums traditionally exhibit in separate departments (including African, Ancient Egyptian, Islamic, and Classical), as well as to display remarkable objects like early stone tools and rock engravings that are more often classified as historical artifacts than as works of art.

The Guggenheim showing of the exhibition includes a smaller number of objects overall than were displayed in London because of space limitations in our Frank Lloyd Wright building. We have, however, arranged for a number of supplemental and replacement loans from public and private collections on this continent. We are particularly grateful for the generosity of these lenders, who have helped us showcase the unique strengths of American collections of African art.

In this new publication we have made a selection of one hundred works, including some that are being shown only at the Guggenheim. Joining the essays by Cornel West, Henry Louis Gates, Jr., and Kwame Anthony Appiah, originally published in the Royal Academy's catalogue, are articles by other distinguished scholars that we have commissioned for this publication, which focus on other themes that are particularly relevant to our American audience. The Royal Academy's indispensable publication, *Africa: The Art of a Continent*, distributed internationally by Prestel Verlag, will continue to serve as the scholarly record of the exhibition.

The theme of the show is almost indescribably rich and varied. We hope this volume will give our visitors a proper sampling of some of the extraordinary works of art that have been produced in the African continent.

This exhibition and its accompanying catalogue were realized with the generous collaboration of many individuals and institutions. Foremost, we would like to express our gratitude to Tom Phillips, whose original vision created this unprecedented exhibition of African art. In addition, we would like to thank those members of the Royal Academy's staff who made this show possible, including Norman Rosenthal, Piers Rodgers, Simonetta Fraquelli, Annette Bradshaw, Emeline Max, James Robinson, Mary Anne Stevens, and Diana Brocklebank.

For their scholarly contributions to the show and catalogue, thanks are extended to Petrine Archer Straw and to the distinguished committee assembled by the Royal Academy: John Mack, Rowland Abiodun, Codjovi Joseph Adande, Claude Daniel Ardouin, Sir David Attenborough, Viviana Baeke, Omar Bwana, Vivian Davies, Ekpo Eyo, Yaro T. Gella, Lorenz Homberger, Frank Herreman, Hans-Joachim Koloss, Germain Loumpet, Francine N'Diaye, John Picton, Jean Polet, Doran H. Ross, Christopher Roy,

Mohammed Saleh, Thurstan Shaw and John Wembah-Rashid.

We are deeply grateful to the Advisory Committee that helped adapt the exhibition for its New York venue: Michael Kan (chair), Roy Sieber, Ekpo Eyo, Frank Herreman, Edna Russman, Dominique Malaquais, and Peter Mark.

A project of this magnitude could not have occurred without the cooperation of the private collectors and institutions worldwide who have lent so generously to the show. A special expression of gratitude is extended to those lenders who have contributed from their collections special loans to the exhibition's New York venue.

The many staff members of the Solomon R. Guggenheim Museum who have coordinated the various aspects of the exhibition and the Guggenheim catalogue deserve much praise: Jay A. Levenson, who oversaw the project for the Museum; the exhibition coordinating team, consisting of Manon Slome, Romy Phillips, and Regina Woods; Carol Stringari, Suzanne Quigley, Marion Kahan, Hubbard Toombs, Judith Cox, Amy Husten, Marilyn JS Goodman, and Isolde Brielmaier; Rosemarie Garipoli, George McNeely, Scott Gutterman, Christine Ferrara, Ultan Guilfoyle, and Diane Dewey.

Special thanks is due to the design team, who worked with great spirit and dedication to transform the Guggenheim spaces for this exhibition: Adegboyega Adefope and W. Rod Faulds, assisted by Peter Read, Peter Costa, and Jocelyn Groom. For all aspects of graphic design we are grateful to Catarina Tsang and Patrick Seymour.

We are also deeply indebted, for their unfalteringly professional expertise and guidance in the realization of this project, to Cornel West, Henry Louis Gates, Jr., Kwame Anthony Appiah, Paul A. Giddins, Philip L. Ravenhill, John Mack, John Picton, Vivian Davies, Grace Stanislaus, Kinshasha Holman Conwill, Howard Dodson, William Lynch, and Jewell Jackson McCabe.

This catalogue was produced by the Guggenheim's Publications Department. We are sincerely grateful to Anthony Calnek, Elizabeth Levy, and to Edward Weisberger. It was designed with grace by Patrick Seymour. We would also like to extend thanks the scholars who prepared new entries and essays for this volume, to Roy Sieber for his guidance, and, in particular, to Dominique Malaquais, who shaped its present content and form. Our thanks are also extended to Helen Shannon and Letty Bonnell, who prepared the scholarly texts for the objects in the exhibition.

Finally we would like to extend thanks to the many other individuals who have so amiably given their time and knowledge to the project: Dorothea Arnold, Alberta Arthurs, Jeanne Moutoussamy-Ashe, Grace Blake, Tatiana Carayannis, Consul-General Luk Darras, Ezio Bassani, Brent Benjamin, Charles Bennenson, Morris Bierbrier, Doreen Bolger, J. Carter Brown, Mary Schmidt Campbell, Commissioner Schuyler Chapin, Jeremy Coote, Egidio Cossa, Dorothy Davis-Joseph, Emile Deletaille, Djibril Diallo, Manthia Diawara, Ambassador and Mrs. Nabil Elaraby, Jeanne Evans, Kate Ezra, Richard Fazzini, Florence Friedman, Ambassador Ibrahim Gambari, Christaud Geary, Ambassador H. Donald Gelber, Frank Ferrari, Wayne Fredericks, Rita Freed, Zaha Hadid, William Hayden, Fred Jahn, Christos Joachimedes, Gerhard Köhler, Tunji Lardner, Michael Maegraith, Roger Mandle, Danielle Amato Milligan, William Johnston, Otto Letze, Roger Mandle, Jean Michel Massing, Graham Modlin, Manfred Noetzel, Peter Norton, James E. Payne, Edmund Pillsbury, Julian Raby, Andrew Radolf, Ambassador Joseph Verner Reed, Ellen Reeder, Liz Robbins, Eric Robertson, Tamara Robinson, J. Michael Rogers, James Romano, Pierre Rosenberg, Samuel Sachs, John Scanlon, Enid Schildkrout, Allon Schoener, Daniel Shapiro, Willaim Siegmann, David Silverman, M. Shreve Simpson, Ian Slome, Sheldon Solow, Christina Stelzing, Keith Taylor, Carol Thompson, Roberta Yancy, Tomás Ybarra-Frausto, Susan Vogel, Mourad Wahba, Christopher White, Dietrich Wildung, the late Sylvia Williams, Karim Wissa, Dennison Young Jr., and Christiane Ziegler.

# Why Africa? Why Art?

Kwame Anthony Appiah

Tenabea nyinaa nse.
*(All dwelling places are not alike.)*
—Asante proverb

I learned about art growing up in my hometown, Kumasi, the capital of Asante, an old kingdom at the heart of the new republic of Ghana. There were paintings and drawings on our walls; there were sculptures and pots, in wood and ivory and earthenware and brass; and there were art books in the bookcases. But above all, my mother collected Asante goldweights: small figures or geometrical shapes, cast in brass from wax originals, that had been used for weighing gold dust when it was (as it was well into this century) our currency. The figurative goldweights are wonderfully expressive; they depict people and animals, plants and tools, weapons and domestic utensils, often in arrangements that will remind an Asante who looks at them of a familiar proverb.

Quite often, for example, you will find a weight that represents two crocodiles with a shared stomach, which will evoke the proverb: *Funtumfunafu ne Denkyemfunafu baanu yafunu ye yafunkoro; nanso woredidi a na woreko no, na firi atwimenemude ntira*. It means, roughly: stomachs mixed up, crocodiles' stomachs mixed up, they both have one stomach but when they eat they fight because of the sweetness of the swallowing. The idea of the proverb—which expresses one of the dilemmas of family life—is that while the acquisitions of each family member benefit the whole family (there is only one stomach), the pleasure of enjoyment is an individual thing (the food has to get into the stomach through one of the mouths).

Even the abstract geometrical weights, with their surfaces decorated with patterns, often use the *adinkra* symbols, which are found as well on Akan stools and funeral cloths, each of which has a name—Gye Nyame, for example—and a meaning—in this case, the power of God. But quite often, also, you will find that one of these elegant weights, so obviously crafted with great skill and care, has a lump of unworked metal stuffed into a crevice, in a way that completely destroys its aesthetic unity, or sometimes a well-made figure has a limb crudely hacked off. These amputations and excrescences are there because, after all, a weight is a weight; if it does not weigh the right amount, it cannot serve its function. If a goldweight, however finely crafted, has the wrong mass, then something needs to be added or chopped off to bring it to its proper size.

There is, thus, an extremely elaborate cultural code expressed in these miniature sculptures, and—with the patina that comes from age and human handling, and the exquisite detail produced in the

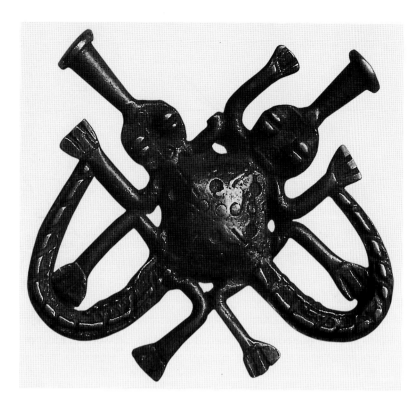

**Goldweight.** Asante, 18th–19th century. Private collection.

lost-wax process that made them—many of them have an obvious aesthetic appeal. It does not take long to recognize that the goldweights of Asante differ from those of other Akan societies: Fante or Baule, say. Nor is it hard to recognize stylistic change over the centuries. There are histories of taste written in these objects, if only we could read them. Goldweights, in sum, have many of the features that we expect of works of art. In Ashanti itself, they were appreciated for their appeal to the eye or for the proverbial traditions they engaged. But in the end, as I say, they were weights, and their job was to tell you the value of the gold dust in the weighing pan.

The best of the Asante goldweights are among the splendors of African creativity. But they were not the product of a culture that valued these objects *as art*. Their decorative elegance was something prized and aimed for, of course, but it was an ornament, an embellishment, on an object that served a utilitarian function. It is clear that some people—chiefs among them, but also the richest commoners—made particularly fine collections of weights, and that, in using them in trade, they advertised their wealth at the same time, by displaying the superior craftsmanship of their possessions. Perhaps once, when the weights were still being used, people knew the names of those who made them best, but no one now knows the names of the great casters of goldweights from the past. Still, to insist upon my point, in appreciating and collecting these weights as art we are doing something new with them, something that their makers, and the men and women who paid them, did not do.

The goldweight tradition is also very particular. The use of figurative and abstract weights, made in brass by the lost-wax process, is not widespread in western Africa, let alone Africa more generally. Outside the Akan region of Ghana and Côte d'Ivoire, there are, so far as I am aware, no traditions that have produced objects that could be mistaken for Akan goldweights. Akan goldweights are African, because the Akan cultures are in western Africa, but these traditions are local, and while they reflect the complex cultural and economic exchanges—between, say, Asante and the Islamic traders of the Sahel, or Baule culture and the European trade of the coast (and thus reflect currents of life wider than those of the societies in which they were made)—it would be a mistake to see them as capturing the essence of the vast gamut of African creativity.

Anyone who has looked at collections of masks from western and central Africa will tell you that you can soon learn to recognize roughly where most of them come from. The traditions of each society in masking, even those that have influenced and been influenced by neighboring traditions, are still quite recognizably distinct, as are the roles masks play in the different forms of performance where they have their fullest life. The point here is the same: Africa's creative traditions are various and particular. You will no more capture the essence of Africa's arts in a single tradition than you can grasp the meaning of European art by examining Tuscan painting of the fifteenth century. And what goes for art, goes, even more, for life. Africa's forms of life are too diverse to capture in a single ideal type. An understanding of our goldweights requires that you know something not of African but of Akan life; the generalities about African life are, by and large, human generalities.

So we might as well face up to the obvious problem: neither *Africa* nor *art*—the two animating principles of this exhibition—played a role *as ideas* in the creation of the objects in this spectacular show.

### Africa

Take, first, "Africa." Through the long ages of human cultural life in the continent, and, more particularly, in the half-dozen or so millennia since the construction of the first great architectural monuments of the Nile Valley, most people in the continent have lived in societies that defined both self and other by ties of blood or power. It would never have occurred to most of the Africans in this long history to think that they belonged to a larger human group defined by a shared relationship to the African continent; a hundred years ago, it would not have occurred to anyone in my hometown. Only recently has the idea of Africa come to figure importantly in the thinking of many Africans, and those that took up this idea got it, by and large, from European culture.

The Europeans who colonized Africa thought of sub-Saharan Africa as a single place, in large part because they thought of it as the home of a single—Negro—race. (That is why, when we speak of Africans, black people come to mind, despite the fact that lighter-skinned northern Africans—Arabs, Berbers, Moors—are unequivocally inhabitants of continental Africa.) In the European imagination, the cultures and societies of sub-Saharan Africa formed a single continuum, reflecting an underlying racial unity, which expressed itself in the "savage rhythms" of African music, the "sensuality" of African dance, the "primitive vigor" of sculpture, and masks from what was called the "Dark Continent."

As intellectuals in Africa came to think of themselves, for the first time, as members of a Negro race—and as Africans—they drew not only on this general Western framework, but also on the ideas of African American intellectuals—Alexander Crummell, E. W. Blyden, W. E. B. Du Bois—who had been taught to understand themselves as Negroes in the context of the New World system of racial domination, the framework left by slavery. In the New World, where so many dark-skinned people had been brought together from Africa and deprived of the specific cultural knowledge and traditions of their ancestors, the common experience of the Middle Passage and of enslavement bonded together people whose ancestors had lived very diverse styles of life, hundreds, sometimes thousands, of kilometers apart. In the New World—in Brazil, for example, or Cuba or the United States—people of diverse African ancestries, bound together in each place by a shared language, might end up experiencing themselves as a unity.

But in Africa itself, the great diversity of societies and cultural forms was not homogenized by the slave trade. Over the last millennium, as Islam spread across northern Africa and into western Africa, and down the eastern African littoral; over the last few centuries, as Christianity came (with its multiple inflections) in the footsteps of European trade and colonization; over the last century, as colonial empires bound African societies increasingly tightly into the new global economic system and into the modern order of nation-states; and over the last decades, as the global spread of radio and television and the record and film industries has reached its tentacles into villages and towns all over Africa; there have, of course, been enormous forces bringing the experiences of African societies closer together. But despite all these forces, the central cultural fact of African life, in my judgement, remains not the sameness of Africa's cultures, but their enormous diversity. Since many of the objects in this exhibition antedate some or all of these energies of incorporation, their origins are more diverse yet.

This should not be surprising. We are speaking of a continent, of hundreds of millions of people. But the fact is that the legacy of the old European way of thinking, in which what unites Africa is that it is the home of the Negro, makes it natural for us, here in the West, to expect there to be a shared African essence, and that tradition makes us equally likely to expect that this essence will show itself in the unity of African art. In this older way of thinking, after all, all the arts everywhere expressed the common genius of a people. (This is one reason why so many of the objects collected by Europeans in Africa in the last two centuries are labeled not with the name of a maker, but with the name of a "tribe," an ethnic group whose shared conceptions these masks or bronzes or shrine figures were thought to express.) But, as you will see as you travel through the works on display here, it would take an eye completely insensitive to the particular to reduce this magnificent miscellany to the expression of the spirit of a singular, coherent, African nature.

What unites these objects as African, in short, is not a shared nature, not the shared character of the cultures from which they came, but our ideas of Africa, ideas that have now come to be important for many Africans, and thus are now African ideas too.

## Art

It is time now to explore, for a moment, the second side of the difficulty I have been adumbrating: the fact that what unites these objects as art is our concept as well. There is no old word in most of the thousand or so languages still spoken in Africa that well translates the word "art." This too is not surprising once you think about it; there is, after all, no word in seventeenth-century English (or, no doubt, in seventeenth-century Cantonese or Sanskrit) that carries exactly that burden of meaning either. The ways of thinking of "art" with which we live now in the West (and the many places in the world where people have taken up this Western idea) began to take something like their modern shape in the European Enlightenment. And it is no longer helpful to try and explain what art has come to be for us by offering a definition; in an age in which, as John Wisdom liked to say, "every day, in every way, we are getting meta and meta," the art world has denizens whose work is to challenge every definition of art, to push us beyond every boundary, to stand outside and move beyond every attempt to fix art's meaning. Any definition of art now is a provocation, and it is likely to meet the response: "Here, I have made (or found) this thing that does not meet your definition and I dare you to say it is not art."

Still, we have received ideas about art and about artists, and my point is that most of these ideas were not part of the cultural baggage of the people who made the objects in this exhibition. For example, since the nineteenth century especially, we have had an important distinction between the fine and the decorative arts, and we have come increasingly to think of fine art as "art for art's sake." We have come, that is, increasingly to see art as something we must assess by criteria that are intrinsic to the arts, by what we call aesthetic standards. We know art can serve a political or a moral or even a commercial purpose, but to see something as art is to evaluate it in ways that go beyond asking whether it serves these "extrinsic" purposes. Many of the objects in this exhibition, on the other hand, had primary functions that were, by our standards, nonaesthetic, and would have been assessed, first and foremost, by their ability to achieve those ends. Something about our attitude to art is captured by the incomprehension we would feel for someone who looked at a painting and said: "It's profoundly evocative, but what is it for?"

## A Response

If African art was not made by people who thought of themselves as Africans; if it was not made as art; if it reflects, collectively, no unitary African aesthetic vision; can we not still profit from this assemblage of remarkable objects?

What, after all, does it matter that this pair of concepts—*Africa, art*—was not used by those who made these objects? They are still African; they are still works of art. Maybe what unites them as African is our decision to see them together, as the products of a single continent. Maybe it is we, and not their makers, who have chosen to treat these diverse objects as art. But it is also *our* show—it has been constructed for us now, in the Western world. It might be anything from mildly amusing to rigorously instructive to speculate what the creators of the objects celebrated here would make of our assemblage. (Consider: some of these works had religious meanings for their makers, were conceived of as bearers of invisible powers; some, on the other hand, were in use in everyday life.) But *our* first task, as responsible exhibitiongoers, is to decide what *we* will do with these things, how *we* are to think of them.

In presenting these objects as art objects, the curators of this exhibition invite you to look at them in a certain way, to evaluate them in the manner we call "aesthetic." This means, as you know, that you are invited to look at their form, their craftsmanship, the ideas they evoke, to attend to them in the way we have learned to attend in art museums. (It is hard to say more exactly what is involved here—at least in a brief compass—but most adults who go regularly to exhibitions of painting and sculpture will have practiced a certain kind of attention and found it worthwhile; if they have not, it is hard to see why they should keep going.) So what is important is not whether or not they are art or were art for their makers. What matters is that we are invited to treat them as art, and that the curators assure us that engaging our aesthetic attention will be rewarding.

We can also accept that they were selected on a continental basis that guarantees nothing about what they will share, nothing about how these objects will respond to each other. Provided you do not expect to discover in these creations a reflection of an underlying African artistic unity, an engagement with the whole exhibition will be more than the sum of the unrelated experiences of each separate object, or each separate group of objects from a common culture. How these individual experiences add up will depend, of course, as much as anything else, on the viewer, which is as it should be. But there are questions that might guide a reading of this show—it is part of the pleasure we can anticipate from it that there are so many—and, in closing, I would like to suggest a few of mine.

Let me start with a datum: this exhibition decisively establishes that anyone with half an eye can honor the artistry of Africa, a continent whose creativity has been denigrated by some and sentimentalized by others, but rarely taken seriously. I have been arguing that to take these African artworks seriously does not require us to take them as their makers took them. (If that were so, we should, no doubt, be limited to religious evaluations of Western European art of the High Middle Ages.) And one other way to take them seriously would be to reflect through them on how the enormous temporal and spatial range of human creativity exemplified in this exhibition has been adapted in our culture over the last few centuries to an interpretation of Africa as the home of people incapable of civilization.

What does it teach us about the past of Western culture, that it has had such great difficulty learning to respect many of the artworks in this exhibition, because they are African? Many of these objects come from European collections, and were assembled as curiosities or as puzzles or as scientific data; they were undoubtedly appreciated—loved even—by many of the individuals who gathered them. But they have rarely lived at the heart of our aesthetic consciousness; and when they have, it has often been with astonishing condescension, as when Ladislas Szesci told readers of Nancy Cunard's *Negro* (a work published in 1934 in celebration of black creativity): "The Negroes have been able to create works of art because of their innate purity and primitiveness. They can be as a prism, without any intentional preoccupation, and succeed in rendering their vision with certitude and without any imposition of exterior motive." It is part of the history of *our* culture—something that bears reflection as we travel among these African artifacts— that half a century ago, this was an obvious way of speaking up for African art.

What (more hopefully, perhaps) does it tell us about our cultural present that we have now, for the first time, brought together so many, so marvelous African artifacts not as ethnographic data, not as mere curiosities, but for the particular form of respectful attention we accord to art? How, in short, may we interpret our exhibition itself as part of the history of our Western culture: a moment in the complex encounter of Europe and its descendant cultures with Africa and its? This is a question that everyone who visits this exhibition is equipped to reflect on; all of us can dredge up a common sense that we have picked up about Africa, and we can test that common sense against these uncommon objects.

These, then, are some questions that I bring to this show. But, like each of you, I will bring many others, some of them peculiar to my own history, some more widely shared.

These artifacts will speak to you, and what they say will be shaped by what you are as well as by what they are. But that they speak to you—as the goldweights of Asante spoke to my English-born mother—should be a potent reminder of the humanity you share with the men and women that made them. *As* they speak to you, they will draw you into an exploration of the worlds of those who made them (this is always one of our central responses to art). What you will discover in that exploration is not one Africa, but many, a rich diversity reflected in—but by no means exhausted by—the parade of wonders in this extraordinary exhibition.

# Putting Northern Africa Back into Africa

Ekpo Eyo

*For while it is true that the Sahara has long placed a barrier between northern Africa and the rest of the continent, and that the great rain forests, further south, have sometimes done the same in relation to central-southern Africa, it is also true that all these regions belong together, and that what is particular to each of them is general to them all in their foundation and emergence.*
—Basil Davidson

The title of this essay may appear to be uncalled for, but in fact it is not. Scholars have for a long time asserted that historically and culturally the northwestern African countries of Morocco, Algeria, and Tunisia, collectively known as the Maghreb, are part of the "Mediterranean Cultural Zone." They also maintain that because the cultures of ancient Egypt were similar to the Mesopotamian culture zone of the so-called "Fertile Crescent," Egypt must therefore be regarded as part of the "Near East." By these artificial groupings, scholars appear to have succeeded in "lifting" northern Africa out of Africa with complete disregard for the existence of the geographically well-defined boundaries of the African continent.

The idea that northwestern Africa and Egypt are not part of Africa has gained such wide acceptance that when the Royal Academy of Arts in London contemplated mounting the exhibition *Africa: The Art of a Continent*, it had first to justify the inclusion of the arts of northwestern Africa and Egypt in an exhibition dedicated to the continent as a whole. That it decided to do so was for me a triumph for truth and common sense. This is an unprecedented exhibition and, hopefully, one that will foster the necessary changes in the way that people look at the African continent, its history, and its arts.

### Africa as the Homeland of Humankind

To understand why it is erroneous to separate northern Africa from the rest of the continent, we have to go back to the beginnings of time. Scientists have determined that the earth was originally one large landmass, with Africa in the middle. Later, tectonic changes in the crust of the earth caused the landmass to break and drift apart, forming the separate continents of the world. The geographical boundaries of these continents have largely remained unchanged since about fifty million years ago, except for some cracks here and there. The best known of these cracks is the Great Rift Valley system, which begins in Syria and runs through the Red Sea to Ethiopia and farther into Kenya, Uganda, Tanzania, and Malawi. In eastern Africa, the Rift Valley is known as the Olduvai Gorge and Omo Valley, and it is here that archaeologists have unearthed the remains of the earliest forms of human beings.

Before proper human forms evolved, there were prehuman antecedents. One of these, the *australopithecus* or the "southern ape," discovered first in South Africa and subsequently in other parts of eastern Africa, is dated to two million years ago. It had developed

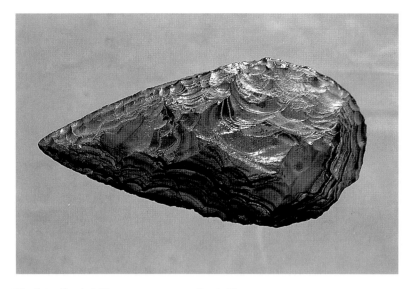

**Hand Ax.** South Africa, ca. 600,000 B.C. Banded ironstone, 23 x 11.4 cm. McGregor Museum, Kimberley, South Africa, MMK 6538.

human dentition and bipedalism, walking erect rather than on all fours like the apes. Although *australopithecus* was, by and large, an ape with a small brain capacity, an astonishing recent find of a particular species, *australopithecus afarensis*, found in Ethiopia and nicknamed "Lucy," has been dated to circa three million one hundred thousand B.C. The recovered skeleton of Lucy shows that, like modern-day humans, she walked erect although she had a small brain capacity.

Living alongside the *australopithecus* was another species of prehuman known as *Homo habilis*, who had a larger brain capacity and hands that were shaped in a way that allowed him to fashion a genre of crude but useful stone tools known as the Oldowan, which he used in breaking open bones to extract their marrow. In addition to this ability to make tools, *Homo habilis* was also bipedal, with the erect posture of modern humans. He was given the status of human because he was able to make the Oldowan tool to a set and regular pattern. Fossils of this early human have been found and dated to about one-and-one-half million years ago. It is important to note that both fossils of these earliest forms of the human, *australopithecus* and *Homo habilis*, have been found only in Africa and nowhere else. Such evidence indicates that the long process of evolution toward human status began in the African continent.

By about one million or more years ago, *Homo habilis* was replaced by another human type, *Homo erectus*, with an even bigger brain capacity and bigger bone structure, including overdeveloped eyebrows. *Homo erectus* made a better and general stone implement, the hand ax, a bifacial tool shaped on both sides, which he used to dig up wild, edible roots and tubers. Also from a large flake of stone, he made the cleaver, a tool with a transverse cutting edge that he used in felling trees. The hand ax and the cleaver were made with great deliberation; they were mostly symmetrical along their main axes, and the process of making such tools required great concentration and manual dexterity. Some were so well finished that they look like ceremonial pieces. It is therefore believed that this might well represent the beginning of human artistic creativity. The term most commonly used to refer to such tools and to processes whereby they were created is "the Acheulian industry."

Evidence of the Acheulian industry has been found in all parts of Africa south of the Sahara. Such evidence has been found also in

Africa north of the Sahara, in Casablanca and Rabat in Morocco, and in Ternifine near Oran on the Algerian plateau. The presence of Acheulian assemblages in all parts of Africa, north and south of the Sahara, underscores the unity of this continent at this early stage. The route by which Acheulian peoples reached northern Africa must have been through what has since become the Sahara desert. From northern Africa, they spread into Europe, where their industry has been found in France, England, and Germany, and other sites in Europe. This spread into Europe constitutes only their western movement, for there was also an eastern movement, perhaps along the Nile Valley into Asia, where important sites have been recorded in China and Java. Once more, this scenario portrays the cultural unity, not only of the African continent but also of the entire Old World with Africa as its innovative technological leader.

Within the last fifty thousand and forty thousand years, there emerged yet another human type in Europe and in northern Africa known as the Neanderthal man (*Homo sapiens neanderthalensis*), or, in Africa south of the Sahara, as the Rhodesian man (*Homo sapiens rhodesiensis*). Although the Neanderthal and the Rhodesian man were related in body structure, with even larger brain capacities than their predecessors and large prognathous jawbones, they represented two distinctive climatic regions of the world, the temperate and the tropical. The different climatic zones were also reflected in their tool kits. *Homo sapiens neanderthalensis* preferred light stoneworking tools, whereas *Homo sapiens rhodesiensis* continued to make the Acheulian type, which he supplemented with some light tools meant for working wood, particularly in the forested areas of western and central Africa. This, then, was the beginning of specialization in cultural development of the Old World, as dictated by environmental requirements. Although there were some differences between tool production in temperate northern Africa and tropical Africa, these differences did not result in northern Africa's being "lifted" out of Africa, for cultural links remained between northern Africa and sub-Saharan Africa.

By thirty-five thousand years ago, *Homo sapiens neanderthalensis* and *Homo sapiens rhodesiensis* had vanished entirely from the scene and were replaced by modern man, *Homo sapiens sapiens*. Archaeologists have found evidence, however, that *Homo sapiens sapiens* did coexist with these vanishing species for a long time, before their complete disappearance. *Homo sapiens sapiens* have been found at several sites from the mouth of the Klasies River at the tip of southern Africa to Diredawa in Ethiopia. Two *Homo sapiens sapiens* fossils found at two Palestinian caves, Skhul and Qafzeh, appear to represent the movement of *Homo sapiens sapiens* out of Africa. The Qafzeh fossil has been firmly dated to 100,000 B.C. However, it was probably not until 10,000 B.C. that there began a rapid increase in human diversity, giving rise to the various existing African human groups. Among these were the San of southern Africa; a group in the Congo basin with small stature,

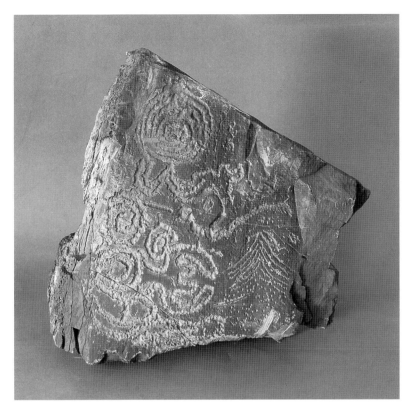

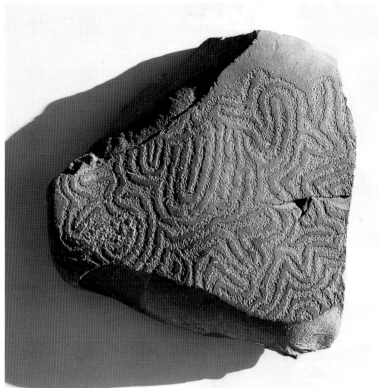

**Rock Engraving.** Morocco, Bronze Age. Stone, 52 cm high. Musée d'Archéologie, Rabat, Morocco, 89.5.1.5.

**Rock Engraving.** San, South Africa, ca. 1st millennium A.D. Andesite rock, 48 x 50 x 12 cm. McGregor Museum, Kimberley, South Africa, MMK RAC 47.

Eurocentrically called the "Pygmies"; the Bantu or the so-called "Negroes" in western Africa; and the Nilo-Saharans of the area now occupied by the Sahara desert.

By about 6000 B.C., in northern Africa, a group of people whom Desmond Clark has described as an "Afro-Mediterranean stock" developed its own characteristic tool kit, which was different from anything found in Europe or Asia. It consisted of suitably shaped microliths (used for scraping, cutting, and grooving) and arrow barbs, spear points, and sickle blades. This same tool kit appeared in the Sahara after 5000 B.C. and in eastern Africa at about the same time. The subsequent Aterian industry developed in northern Africa and characterized by tanged arrow and spear points was also widely adopted in the Sahara region and farther east and south. The widespread presence of the Microlithic and Aterian industries both in temperate northern Africa and in tropical Africa once more underscores the cultural and technological unity of peoples north and south of the Sahara.

### The Origins of the Sahara Desert

This area stretches from the Atlantic coast in the west to the Red Sea in the east and today constitutes a barrier between northern and southern Africa, but it has not always been so. We know that there were glacial periods in Europe during which the continent was covered with ice. In between were interglacial periods, during which the ice melted and the climate became warmer. In Africa, there were also wet periods, or pluvials, when heavy rainfall occurred, and these were separated by dry spells, or interpluvials. The penultimate dry phase in Africa, during which the Sahara region may have been uninhabited, took place about ten thousand years ago. This period was followed by a wet phase known as the Makalian, which brought green pastures, rivers, and lakes to the Sahara, transforming it into a place teeming with human and animal life.

Sometime between 6000 and 4000 B.C., peoples living in the Sahara were food gatherers and hunters of wild game—animals they memorialized by engraving their images on rock surfaces (see cat. nos. 91–92). (In southern Africa, rock art had begun much earlier, circa 25,000 B.C.) By 4000 B.C., because of the favorable environment, the Saharans began to cultivate grains and to herd horned cattle, sheep, and goats. They began to live in permanent or semipermanent settlements with their families and to paint on rock surfaces, using single or many colors, scenes of family life, herding, fishing, dancing, masquerading, and fighting, as well as representations of their gods. Due to benevolent conditions in the Sahara, groups must have expanded northward to mingle with Afro-Mediterranean peoples and southward to mingle with the peoples of the Sudan in western Africa. These movements are documented by a particular type of pottery decorated with dotted and wavy motifs found throughout the entire area. The fact that the people depicted in rock paintings were both black and fair-skinned also testifies to the mingling of peoples from north and south of the Sahara.

As the green Sahara began to dry up about 2500 B.C., heralding the onset of the present dry spell, some of the Sahara's inhabitants made herding their principal occupation. When conditions became unbearable, they had to move out of the area to the more favorable lands of the north, south, and east, toward the River Nile. In their new homes, they mingled with the indigenous cultures and peoples—the Afro-Mediterraneans to the north, the so-called "Negroes" to the south, and the Nilo-Saharans who settled at the edge of the desert, close to the Nile.

### Northern Africa

A fair-skinned Semitic people, speaking the Berber language, had migrated into northern Africa about 8000 B.C. and made their home

there alongside populations of the indigenous Afro-Mediterranean stock. A hardy people, the Berbers quickly dominated the area and began trading activities between northern and western Africa. This trade was facilitated by the use of chariots drawn by horses or donkeys along well-established trade routes between Morocco in the north and the Senegal area in the west and between Tunisia in the north and Goa at the bend of the Niger River in the Sudan. Through this trade, northern Africa was enriched by the products of the Guinea Coast and the Sudan, namely, slaves, gold, salt, ivory, and pepper. The products became a great incentive to more settler communities, which thoroughly exploited them. It was from these settlements, or cities, of the north that Europe also became enriched by western African exports.

Around the eighth century B.C., seafaring, fair-skinned Phoenicians from the eastern Mediterranean coastal cities of Tyre and Siddon, in what is now Lebanon, also established settlements on the northern coast of Africa. These settlements served as intermediate posts for Phoenician vessels on their way to exploit the silver mines of southern Spain. The most important of these settlements was Carthage, near present-day Tunis. Carthage became very prosperous, to the extent that it rivaled its homeland, subsequently breaking away from it and creating a separate empire of its own. Soon Carthage dominated the entire northern African region. The Phoenicians had brought with them material culture that consisted of the making of clay masks and votive stelae. They also brought knowledge of metalworking, writing, and agriculture. But their expansionist tendency in the third and second centuries B.C. brought them into conflict with Rome over the Mediterranean islands of Sardinia and Sicily. After a series of open hostilities known as the Punic Wars, Carthage was defeated and incorporated into the Roman empire in 146 B.C. The Romans followed this defeat by the annexation of Cyrenaica in Libya in 74 B.C. and of Numidia, a Berber kingdom on the plateau behind the coastal belt, in 46 B.C. The Romans introduced into northern Africa their characteristic baths, aqueducts, and amphitheaters. Mosaics were also introduced, although they were made more colorfully than in Rome.

Roman control of northern Africa ended in the seventh century A.D., when Muslims who were already masters of much of southwest Asia and parts of Egypt took control of the area. Between the eleventh and thirteenth centuries, two Islamic movements were formed—the Almoravids and Almohads—extending Islam into the Iberian Peninsula. The result was that northern Africa now adopted elements of Islamic culture, particularly its calligraphy and architecture—the latter in conjunction with forms of Hispano-Muslim Andalusian architecture. By the sixteenth century, Algeria and Tunisia had become part of the Ottoman empire; thus, Byzantine cultural elements were also introduced to the region. Behind these cities of the coastal strip was the Berber kingdom of

Numidia, whose inhabitants had adopted the Phoenician language but had continued to use their indigenous language as well. The Numidians also retained the practice of producing portable items associated with cattle herding and, in addition, engraved and painted animal figures on stone plaques and ostrich eggshells.

### Predynastic Egypt

Between 5500 and 2500 B.C., during the Makalian wet phase, the land now known as Egypt was under the waters of the Nile and the green Sahara must have stretched to its banks. At the end of this wet period, marshy land began to emerge on both sides of the river, as its waters shrank. The exposed land, made fertile by the alluvial deposit that resulted from this process, was soon settled. By 4500 B.C., the Nilo-Saharans had founded a settlement in the Fayum and had begun to cultivate emmer wheat, barley, and flax, which they reaped with stone-bladed sickles and stored in mat-lined silos. By 4000 B.C., another settlement was established at El Badari in what is now known as Upper Egypt, with domesticated cattle, sheep, and goats. Later on, there was yet another settlement at Merimde in the delta area of the river. Between 4000 and 3000 B.C., a series of cultures known as Naqada I, II, and III had come into existence.

All of these cultures excelled in the art of pottery making and their buff, white-, red-, and black-painted wares were much treasured items. The settlements' inhabitants also sculpted in stone, ivory, and wood, reaching remarkable heights of artistic achievement. The men and women of these communities were not yet known as the Egyptians; they are referred to today as Nilo-Saharans.

The more people came to settle along the banks of the Nile, the more difficult it became to organize agriculture, given the limited amount of land available. Large-scale irrigation required organized labor and, concomitantly, a high level of social organization. In response to these needs, the entire area was organized into two kingdoms: Upper Egypt, stretching from the first cataract of the Nile at Aswan to Memphis near present-day Cairo; and Lower Egypt, from Memphis to the Mediterranean coast. At the beginning, the two lands were under two different overlords who wore distinctive crowns. The single name of Egypt (Aigyptos) was given to this area by the Greeks only as late as 1400 B.C. The two lands seem to have enjoyed a peaceful coexistence, but when times became hard, probably due to adverse ecological factors resulting in diminished opportunities, they began to fight one another, resulting in changes in social organization and leadership.

### Dynastic Egypt

By 3100 B.C., a king known as Menes or Narmer united Upper and Lower Egypt by force and so became the first ruler of a unified Egypt. Narmer seems to have come from Upper Egypt; this is

suggested by the fact that he was buried at Abydos (in Upper Egypt) and the fact that a historical palette depicting the story of the unification was found at Hierakonpolis, also in Upper Egypt. This is a clear indication that the first king of Egypt did not come from outside Africa. So too, there is evidence that Egypt's religion was fundamentally African in nature. The two most important deities of Egypt, Re, the sun god of Lower Egypt, and Amon, the ram-headed sky god of Upper Egypt, were rooted in earlier religions of the green Sahara. In his *Short History of Africa* (1984), Werner Gillon illustrated an engraving showing rams with sun disks on their heads (seventh–sixth millennium B.C.) from Djebel Bes Seba in the Sahara Atlas in Algeria and a fired clay sculpture of a bovine with a disk on its head (1900–1550 B.C.) from Aniba, Nubia. The sun disk, cattle, and goddesses with sun disks on their heads, and the ram, which was sacred to Amon, are common features in Egyptian art and religion. Early Egyptian painting as well, some archaeologists believe, may have been rooted in rock art of the Sahara.

I do not wish, here, to go into any detail concerning subsequent developments of Egyptian culture, but merely to state what everybody knows: that Egypt was renowned and admired throughout the ancient world and, in consequence, attracted both friends and foes. The envy of its foes led to a series of conquests—by the Assyrians and Persians from Asia, Greeks and Romans from Europe, Arabs from Arabia, and Nubians from the south. Egypt, in turn, conquered part of Asia and annexed Nubia, making it one of its provinces. Furthermore, Egypt had maritime trade contacts with countries of the Mediterranean Sea, such as Cyprus and Crete.

All of the groups with which the Egyptians interacted left their imprints on Egypt, as much as Egypt left its imprint on the rest of the world. Consequently, there are in Egypt some foreign cultural traits, just as there are Egyptian traits to be found in other places and cultures. This is a natural phenomenon in a world that has no boundaries—a phenomenon that must be taken into consideration in discussions of Egypt's identity. In this situation, questions arise as to whether Ancient Egypt might be considered Assyrian, Persian, Nubian, Greek, Roman, or Arabian, since all of these cultures contributed to the emergence and growth of its character. The fact that one finds foreign cultural traits in a given country or state, however, does not mean that the country or state in question has ceased to belong to the area in which it is geographically situated. Here, as elsewhere, geography should not be displaced by ideology. The characteristics that define Ancient Egypt were developed in situ; therefore, though many have argued otherwise, Egypt is essentially African.

Though they are well known, the differences that distinguish Mesopotamian culture from Egyptian culture need to be understood here, because of the widely held misconception that Egypt is not in fact African. Many archaeologists have recognized that in Mesopotamian society the ruler was a deputy of the gods and not himself divine; in Egypt, in contrast, the Pharaoh was himself a god. Mesopotamian societies were ruled by a code of laws, while in Egypt, the Pharaoh was the law itself. Southwest Asian societies were organized into city-states, whereas in Egypt, the whole country (stretching over a distance of almost 400 kilometers) was one state ruled from wherever the capital happened to be at the time, in Memphis, Tell el Amarna, or Thebes. Egypt, thus, was distinct, culturally unlike Mesopotamia—a fact that underscores its African identity. Even Herodotus, the Greek historian, writing in 450 B.C., noted that Egypt was African because of its cultural ties with inland Africa, such as the common practice of circumcision and the frequent use of ram and python symbolism based on African religious idioms.

I should add one last point. When Herodotus wrote in 450 B.C. that "Egypt was the Gift of the Nile," he meant to say that without the Nile, there would be no Egypt. The Arabs called the section of the Nile that flows through Egypt "the Nile of the Egyptians" and the portion of it that flows for thousands of kilometers from the great lakes of eastern Africa to Egypt, the "Nile of the Blacks." I believe that had Herodotus known about the "Nile of the Blacks" he probably would have added that the "Nile of the Egyptians" was the "Gift of the Nile of the Blacks." We all know that for its annual inundation, without which life in Egypt would be impossible, the "Nile of the Egyptians" depends entirely on rain water from the heart of Africa, including Ethiopia. It is therefore the heart of Africa that nourishes Egypt, and so Egypt cannot be severed from its life source.

### Nubia

The Nilo-Saharans, who later became known as the Kushites, lived in the area of present-day Nubia. The name Kushite was given to them by the Egyptians. Nubia itself had been known to different peoples by different names. For example, the Greeks and Romans called Nubia "Aethiopia," meaning "land of burnt faces," a name they also applied to other black races, including modern Ethiopians. Around 3100 B.C., at the time of Egyptian unification, Nubia seems to have been united into a powerful kingdom whose rulers were buried for several generations in the same monumental cemetery at Qustul. Kerma is the best-known Nubian civilization; it emerged in the second half of the same millennium, with a stratified social organization comparable to Egypt. The city of Kerma was fortified with walls about ten-meters high and had four gateways. Its highest artistic achievement was the distinctive black-topped ceramic vessels with thin, red, polished bodies that its potters produced for use as objects of prestige.

It has been conveniently forgotten that, in addition to interacting with the countries of the Mediterranean and southwest Asia, Egypt also interacted with the Nubians to the south. Although Nubia was once a province of Egypt, it also conquered

Egypt; during the Twenty-fifth and Twenty-sixth dynasties, Egypt was governed by Nubian rulers. Prominent Nubian kings like Kashta, Piank, and Taharqa ruled both in Nubia and in Egypt. Although the Nubians were sometimes enslaved and were sometimes mercenaries in the Egyptian army, it is known that the wives of Pharaoh Mentuhotep II included three Nubians; the founder of the following dynasty, Amenemhat I, is believed to have had a Nubian mother. On the economic front, archaeologists have shown that without the slaves, gold, cattle, ebony, skin, incense, and so on imported from Nubia for use in Egyptian palaces and temples, Egypt might not have displayed as high a level of opulence as it did.

Because the history of Nubia is so intertwined with that of Egypt, Egyptian customs were adopted in Nubia, particularly the burying of kings and queens in pyramids, although these were smaller in size than those of Egypt. The Nubians also worshiped the Egyptian god Amon-re and built Egyptian-style temples such as at Musawarat es-Sufra. These practices, however, were confined to the higher strata of the society. The Nubians retained much of their indigenous culture, continuing, for instance, to bury their royalty in traditional tumuli, using traditional funerary beds instead of Egyptian-style coffins. They also retained the worship of their indigenous lion-headed god, Apedemak. Finally, as a corridor between Egypt and the interior of Africa, Nubia was never completely Egyptianized, but continued to interact with the countries of the African interior.

I have sought to remind my readers that sub-Saharan Africa is the homeland of humankind as far as the present evidence goes. In the area of technology, it played a leadership role, insofar as the first important steps toward development were concerned. Now that contemporary sub-Saharan Africa (identified mainly with black peoples) is lagging behind in technology, an attempt is being made to excise from the continent northern Africa (considered more developed because of settlements established there by European and Asian migrants), using as excuses the relatively recent phenomenon of the Sahara desert and the fact that the population of northern Africa is far more mixed than its counterpart to the south. What is easily forgotten is that the populations of every continent are always mixed. If one looks at the populations of Asia, Europe, and the Americas, one realizes how heterogeneous they are and how much their cultures differ from region to region. It is important to remember that it was only in the middle of the seventeenth century that the Afrikaner settlers from Europe came to settle in southern Africa—yet today they are Africans! Why, then, should northern Africa be "lifted" out of Africa under the pretense that its relatively recent cultures are more like those of Europe and Asia than those of sub-Saharan Africa? Today, northern Africans are playing soccer with sub-Saharan Africans; only the academics are dragging their feet.

One more often conveniently forgotten fact is that, throughout the history of the world, civilizations have been rising and falling. The leaders at one time become the followers at another. So too, the history of humankind shows that developments have always been uneven at any given time. For example, we know that cattle was domesticated in the Sahara before it was domesticated in England; that writing was used in Mesopotamia, now Iraq, two thousand years before it was used in ancient Greece; that the Mexicans built great pyramids when Europe was still in the Dark Ages; and that the past great cultures of sub-Saharan Africa—Nok, Igbo Ukwu, Ife, Owo, Benin, Djenne, Akan, Zimbabwe—were as glorious as any of their contemporaries. Thus, I would suggest, people everywhere should temper with humility the pride generated by the temporary ascendancy of technological achievement, for, in a world full of uncertainties and surprises, and where no condition is permanent, today's laggard may become tomorrow's leader.

# Historical Contacts and Cultural Interaction

## Sub-Saharan Africa, Northern Africa, the Muslim World, and Southern Europe, Tenth–Nineteenth Century A.D.

Peter Mark

For over one thousand years, sub-Saharan Africa has been linked to northern Africa and the Muslim world by commercial, religious, and cultural contacts. For five centuries, contacts have also extended to western Europe. A brief overview of these historical connections and of related cultural and artistic exchanges demonstrates that most of sub-Saharan Africa has not been isolated from the world of Islam or Christianity. The tremendous diversity of cultures in Africa makes it difficult to consider precolonial Africa as a cultural or historical unit. Nevertheless, the long history of trans-Saharan trade and the resulting spread of Islam across the desert have created longstanding cultural and religious continuities between the peoples of Muslim northern Africa and the inhabitants of the Sahel and Savanna region south of the Sahara.

Many of the objects in this exhibition illustrate the effects of long-distance economic and religious contact. Some of these pieces, several centuries old, are themselves historical documents that testify to specific contact with the outside world. Other works, of more recent origin, reflect the ongoing process of incorporating elements of foreign cultures. The capacity of societies from Senegal to Nigeria and from Zaire to Ethiopia to respond with resiliency to outside cultural influence and to assimilate Islamic or Christian rituals or symbols into local cultural traditions is indeed a unifying theme in African history and art history. The richness of African artistic production derives both from the diversity of cultures extant in Africa and from their capacity to enrich themselves through the incorporation of elements borrowed from foreign traditions.

### The Spread of Islam

The Sahara desert has not been an impenetrable barrier between north and south since the introduction of the camel to northern Africa in the mid-first millennium A.D. For 1500 years, regular traffic across the desert, following more-or-less fixed routes, has linked the Maghreb in the north to the Sahel. Indeed, the Arabic term *sahel*, meaning "shore," indicates that northern Africans viewed the desert not as a barrier but as an area to be crossed, much like sailors crossing a body of water.

Islam's spread through northern Africa in the seventh and eighth centuries A.D. had an almost immediate impact on the lands of the Sahel. Before the tenth century, northern African merchants had brought the new religion across the desert. There, communities of Muslim long-distance traders settled in trading towns. In the

empire of Ghana (which most historians identify with the "Wagadu" of local oral traditions), the capital of Koumbi Saleh had a separate quarter for its Muslim traders. Recent archaeological excavations at the probable site of Koumbi Saleh, in southern Mauritania, have uncovered a stone mosque whose earliest foundations date to the tenth century.[1] The mosque was enlarged in the eleventh century and embellished with tiles, some covered with Arabic characters and others bearing geometric designs. By the eleventh century, oral and written sources suggest that Islam had begun to spread to the Soninke population of Ghana. The pattern of Islamization, whereby the religion spread from a community of foreign merchants to the ruling court and then gradually to the rest of the urban population, before disseminating into the countryside, occurred again many times across western Africa from the twelfth to the nineteenth century.

Mali, the successor state to Ghana, was founded in the thirteenth century along the Upper Niger. Mali drew considerable wealth from long-distance trade. By the fourteenth century, Muslim traders from northern Africa were established in the trading town of Djenne, located in the inland delta of the Niger River. The Islamization of the Malian Court, in the late thirteenth century, is recorded both in oral traditions of the Mande people and in written accounts by contemporary Arab historians and travelers. In 1352, the geographer Ibn Batuta crossed the Sahara and spent a month at the court of the *Mansa*, or ruler of Mali. His account described a society where Islamic practice was integrated with local religious rituals. At the end of the fourteenth century, the historian Ibn Khaldun provided additional information about Islam and trade south of the desert; Muslim merchants, his accounts indicated, provided regular contact with northern Africa from Morocco to Egypt.

Ibn Khaldun also described the *hajj* (pilgrimage to Mecca) of *Mansa* (King) Musa, ruler of Mali, in 1324. Some seventy-five years after he traveled to Mecca, Musa was still remembered in northern Africa for the Islamic justice of his reign. On his return from the holy city, Mansa was accompanied by an Andalusian poet and architect, al-Tuwayjin, who at the ruler's request constructed a royal palace, described by Ibn Khaldun as "a square building with a dome . . . plastered over and covered with colored patterns so that it turned out to be the most elegant of buildings."[2] Al-Tuwayjin settled in Mali, where he and his descendants were held in high esteem. This instance of artistic borrowing reflects an openness to outside cultural influences, an attitude encouraged by the prestige accorded to older Muslim societies by western African peoples.

The most impressive monument to intercultural borrowing in ancient Mali is the Friday Mosque at Djenne, which was the major commercial center in the Inland Delta of the Niger.[3] There, salt from the Sahara and goods from northern Africa, including fine silks, were exchanged for gold, slaves, and ivory from lands to the south. Around 1320, the Muslims living in this multiethnic city constructed a monumental mosque, of sundried earthen bricks covered with a mud plaster. The present building is a reconstruction, built on the foundations of the original mosque in 1907.[4] The roughly rectangular, flat-roofed building, its walls supported by pilasterlike buttresses topped by finials and crowned by massive rectangular towers, clearly adjusts the original Islamic model to local building materials. The Djenne mosque very likely also echoes an older Mande architectural style.[5]

The mosque's façade is enlivened by rows of wooden posts, called *toron* ("horns"), protruding from the walls. The *toron* are a characteristic feature of local architecture. They serve as scaffolding when the façade is periodically replastered with clay. Aesthetically too, they play an important role; in the bright Sahelian environment, they cast shadows that enliven the broad expanse of sunlit wall. Significantly too, the multiple shadows of the *toron* move in unison across the façade, marking the sun's movement and indicating, to the faithful, the approach of the time for prayer.

Just as the Djenne mosque modified traditional Islamic religious architecture, so too Islam itself was transformed as it spread through the Sahel. As René Bravmann has stated, "African societies were not merely passive recipients of the faith: they actively shaped and molded the religion . . . [creating] a synthesis . . . [with] traditional beliefs, values and sensibilities."[6] While Islam has left an imprint on local western African cultures, those cultures in turn have transformed and broadened the range of Islamic cultural expression.

Among Saharan and Sahelian Islamic art forms are the leatherwork and metalwork of the Tuaregs of the southern Sahara. With its intricate geometric patterns, Tuareg leatherwork (see cat. no. 96) is an outstanding example of women's artistic expression in an Islamic society. Being readily portable, such leatherwork has spread to neighboring populations in the Sahel, including the Hausa. A similar aesthetic is seen in Tuareg amulets (of copper, brass, or silver) that contain protective charms in the form of koranic verses. These amulets are sold throughout Mali and Senegambia both to Muslims and non-Muslims.

Islamic amulets found a ready market throughout the Sahel and in the forest zone of southern Senegal and Guinea-Bissau. There, even non-Muslim groups such as the Jolas and Bijogos purchased koranic charms for spiritual protection. Some, but not all of these populations subsequently became Muslim. It is by no means uncommon for non-Muslims to incorporate Muslim amulets into their own ritual objects, including masks. In the eighteenth and nineteenth centuries, the Jolas (in southern Senegal) made initiation masks embellished by Arabic writing and by small packets that copy the form of koranic charms.

The assimilation of Islamic symbols into western African sculpture is, however, older than the eighteenth century. Among

the terra-cotta sculptures excavated—mostly illegally[7]—from the region near Djenne, dating from the eleventh to fourteenth century, are figures who wear (Islamic?) amulets around their necks. These terra-cottas, along with the Djenne mosque and contemporary accounts by Ibn Batuta, indicate that figurative sculpture, architecture, and ritual all incorporated Islamic forms no later than the 1300s.

The long history of commercial ties with Islamic northern Africa has had an impact not only on the Sahel but also on lands further to the south. As Bravmann observed, the Asante of Ghana, whose home lies hundreds of kilometers from the southern shores of the desert, obtained copper-alloy basins from Mamluk Egypt via the trans-Saharan trade. Influenced in part by the incised designs on Mamluk metalware, Asante artists had, by the eighteenth century, developed their own style of vessels, known as *kuduo* (see cat. no. 67).[8]

## Swahili Culture

Islam arrived in eastern Africa even earlier than in the western Sudan. Before the end of the first millennium A.D., perhaps by the eighth century, Muslim traders from cultures of the Indian Ocean had settled in commercial centers on the coast and on the offshore islands, from Somalia south to present-day Tanzania. The Swahili culture that developed from the merging of Arabic culture with local African culture was more fully hybrid than the essentially African early Muslim societies of western Africa. The population of the Swahili coast, too, conjoined Arabs and local Africans. In time, a trading language, KiSwahili, developed, which defined the culture, just as it brought together Arabic vocabulary and elements of African grammar.

The early religious architecture of the coast, consisting of mosques made of coral, is Arabic in style. Some mosques date to the twelfth and thirteenth centuries, but recent archaeological excavations suggest a late-first-millennium date for the first mosques.[8] Domestic architecture took the form of houses with plastered coral walls and with windows facing an inner courtyard. By the eighteenth century, when the Omani sultanate established commercial and political hegemony on the Swahili coast, two-story houses, associated with wealthy traders, had appeared at the major trading centers. Some of these, often identified in the literature as "stone houses," are still standing.

The Swahili culture also gave birth to art forms that are impregnated with a decorative style reflecting Arab/Islamic influence. Architectural elements such as carved wooden doors for the stone houses have the elaborate two-dimensional patterns and repetition of motif that typify the Swahili visual aesthetic. This art represents the culture of the elite and is not characteristic of the indigenous African populations. Nevertheless, such elaborate work, along with the mosques and stone houses, embodies the artistic

tradition that grew out of the marriage of eastern African and Islamic culture. If a common theme emerges here, as it does in the history of Ethiopia, it exists in the transformation and unification of local cultures, consequent to the spread of Christianity and Islam. The geometric patterns of Swahili art distantly reflect the abstract forms of leather and metalwork from the southern Sahara. Ultimately, all of these arts are inspired by the same Islamic decorative tradition.

## Ethiopian Christianity

In southern Ethiopia, Islam also had significant political impact by the fourteenth century. However, in central and northern Ethiopia, it is Christianity that has had the most profound influence. The kingdom of Aksum became Christian in the fourth century; subsequently, the Ethiopian state was founded on Monophysite Christianity under the Ethiopian Orthodox Church. The spread of Islam through Egypt and Arabia cut off Ethiopia from the rest of the Christian world; the result was the articulation of a unique ritual tradition, accompanied by distinctive art forms.[9]

During the fourteenth and fifteenth centuries, diplomatic and religious contact was established with western Europe, as both the papacy and the emperors of Ethiopia sought each other's aid to counter the spread of Islam. The medieval European legend of Prester John, a powerful Christian ruler said to rule in an unidentified region of Africa, was likely based in part on information about the rulers of the Zagwe dynasty in Ethiopia. During the reign of Zar'a Yacob (ruled 1434–68), Ethiopian pilgrims to Rome were so numerous that they were granted the use of S. Stefano in Rotondo; in 1441, two delegates from the Ethiopian Orthodox Church attended the Council of Florence. Contemporary reports also indicated the presence of a Venetian painter named Brancaleone in Ethiopia.

In 1520, the Portuguese arrived at the Ethiopian court. Their presence proved critical twenty years later, when a small group of Portuguese *arquebusiers* (gunners) turned the tide at the crucial battle of Mesewwa and defeated the Muslim general Ahmed Gran, thereby saving the Ethiopian state. The Portuguese then settled at Gondar and, for a century, maintained contact with Europe.

The most impressive artistic monuments to Ethiopian Christianity are the monolithic churches carved out of rock at Lalibala in Wallo province. The twelve rock-hewn churches, dating from 1190–1225, and first visited by a European in 1525,[10] are actually sculpture. They constitute the largest monumental sculpture in Africa. The interiors were hollowed out to form vaults and arcades, while the exteriors were carved into portals, buttresses (structurally unnecessary), and façades with (fake) projecting beams. These elements, along with barrel vaults and arched ribs, suggest that the churches were based on contemporary religious buildings, perhaps in Aksum, to the north. The Lalibala churches, along with other

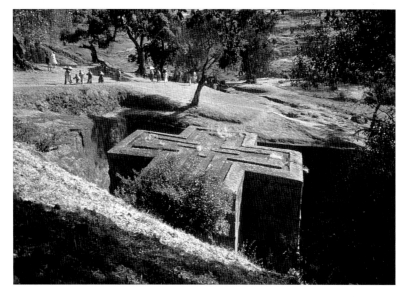

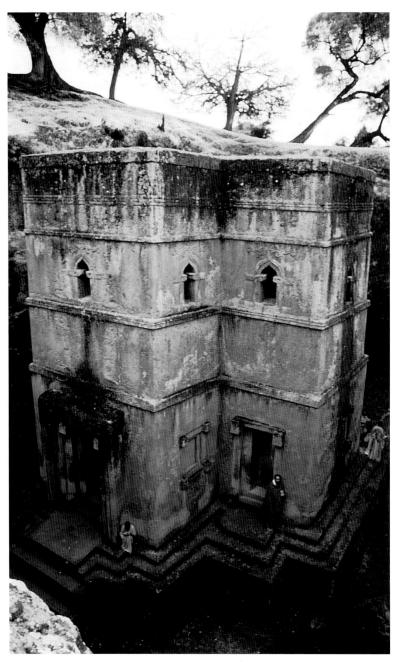

Bet Giorgis Church, Lalibala, Ethiopia.

rock churches in the Highlands, are a unique amalgam of Christian religious buildings, their tripartite division of space conforming to the ritual of the Ethiopian Orthodox Church, together with local Aksumite architectural traditions. Like the Sudanese mosques of the Sahel, they are a uniquely African formulation of the architecture of a world religion.

Ethiopian Christianity is also associated with characteristic forms of metalworking. The Cross is a dominant feature of Ethiopian Orthodox ritual processions. Metal crosses, embellished with elaborate filigree and meant to be carried or worn, are the most common ritual symbol in Ethiopian art (see cat. no. 16).

Ethiopian wall paintings date to the early second millennium A.D., while the earliest known manuscripts are from the fourteenth century.[11] These and later paintings are stylistically related to Byzantine art. Characteristic features include the hieratic presentation of the figures, typically shown frontally, and a two-dimensionality that derives from the absence of modeling. Color appears as flat areas or patterns. Human figures tend to be separated from the background by a thin black outline. The large, forward-staring eyes lend an abstract but penetrating quality to the figures. In a seventeenth-century manuscript illustration depicting the Evangelists (in the British Library, London), the symmetrical arrangement of the figures shown in one panel, and the geometric patterns of the figures' flat garments—perhaps inspired by Islamic decorative motifs—bear a remarkable similarity to the geometric patterns that surround the Ge'ez script in an adjacent panel. Composition and form thus link the highly iconic illustration to the decorative form of the letters. The visual unity reflects a shared meaning: sacrality of text and sacrality of image. If, by the seventeenth century, Ethiopian artists had absorbed Italian, Byzantine, and Islamic influences, the result was a distinctively Ethiopian style.

### The Portuguese

The history of Christianity in western and central Africa is linked to the arrival of Portuguese traders in the fifteenth century. Portuguese sea explorations, inspired in part by knowledge of *Mansa* Musa's *hajj*, during which the Malian ruler had showered his hosts in Alexandria with so much gold that the value of the Egyptian currency was debased for years, brought the Europeans to the Senegalese coast by 1445. During the following two decades, the Portuguese extended their trading as far as present-day Nigeria. In 1482, they constructed a stone fort at El Mina (on the Gold Coast), and a year later, Fernão da Po visited the kingdom of Benin. Also in 1483, Diogo Cão reached the mouth of the Zaire River, and a year later, Diaz reached the Cape of Good Hope. For the next century, Portugal dominated European commerce with western Africa. Only in the seventeenth century did the Dutch and the French supplant the Portuguese.

The European presence on the coast differed markedly from the northern African presence in the Sahel, both in scale and duration, and in the specific form of contact. Muslim traders had been established in the Sahel for six hundred years before the Portuguese arrived in western Africa. Muslim merchants and clerics were integrated into the social fabric of trading towns such as Djenne, and, with the passage of generations, some members of the *ulema* (learned religious scholars and clerics) came from the local populations. By the fifteenth century, Muslim religion and culture had become an integral part of local societies, at least in the courts and trading cities of such states as Mali, Kanem, Tekrur, and Songhai.

European culture, by contrast, was associated primarily with outsiders. With the exception of the Luso- (that is, Portuguese-) Africans, Europeans did not settle in western or central Africa. The Dutch in the seventeenth century and the French and English from the late seventeenth to the mid-nineteenth century remained in trading centers on the coast and along navigable rivers. Europeans in Africa were few in number, and they rarely stayed longer than a few years—two factors that helped to determine the generally limited influence of European religion and culture on African societies before the nineteenth century.

Christianity was spread by missionaries who had no ancestral ties and no immediate family in local African society. Unlike Islam in the Sahel, or Monophysite Christianity in Ethiopia, Christianity in western Africa was rarely assimilated into local cultures. For the most part, the "Africanization" of Christianity was a later phenomenon, associated with colonial and postcolonial western Africa. There were, however, two exceptions to this rule: one was Luso-African culture; the other was Bakongo religion.

In the fifteenth century, commerce was carried out during the annual visits of Portuguese ships, which stopped at specific rivers along the coast to trade with the local populations. The construction of forts (for example, El Mina in 1482) facilitated the installation of small numbers of Europeans, who were then better able to trade with long-distance African merchants coming from the interior. By 1500, some Portuguese merchants had settled in Senegambia, where they married local women and formed the core of Luso-African communities, whose members served as middlemen between African and European merchants. These Luso-Africans, many of whom divided their time between Senegambian trading towns and the Cape Verde islands, dominated the export trade until the late seventeenth century, after which they gradually lost their commercial ascendency to French and English merchants. Prominent among the goods that were exported were ivory and wax and, by the late sixteenth century, slaves. Further east at El Mina, gold and kola nuts were exported; the kola was then reimported to Senegambia, along with iron and glass beads.

In 1506, Valentim Fernandes, a German geographer living in Portugal who, although he never visited Africa, obtained information from coastal traders, reported that the Portuguese exported carved ivory from Sherbro Island in Sierra Leone.[12] This is the earliest reference to Afro-Portuguese ivories, a genre of carving produced by African artists for European patrons in the sixteenth century (see cat. no. 61). Art historians are now in general agreement that such ivories were produced not only at or near Sherbro, but also in Benin. These carvings represent a form of artistic expression that grew out of the commercial interaction of Portuguese traders and western Africans. Intercultural cooperation is indicated by the appearance of European motifs on some of these works. In addition, the transformation of a local artistic form, the side-blown trumpet, into hunting horns used by European nobility, shows how the growth of a foreign market affected the evolution of artistic forms.

The establishment of communities of Luso-African traders in the sixteenth and seventeenth centuries constitutes a rare but significant instance of sociopolitical assimilation between Europeans and western Africans. By the seventeenth century, many Luso-Africans were physically indistinguishable from other Africans, yet they considered themselves a group and referred to themselves as "Portuguese." Membership in this group was not based on complexion. Rather, consistent with widespread western African parameters, identity was based on economic specialization, on language and religion, and on material culture. The "Portuguese" were professional traders, spoke a distinctive language, Crioulo, and considered themselves Christians—whether or not they had access to a priest, the sacraments, or even a chapel. In addition, the Luso-Africans had a distinctive architectural style. To be "Portuguese" was to live in "Portuguese-style" houses: rectangular dwellings of sundried earthen bricks, with whitewashed exterior walls and, in front, a veranda or vestibule to receive traveling merchants.[13]

Portuguese-style houses were mentioned by Fernandes in 1506. By the seventeenth century in Senegambia, their distinctive architecture had become a symbol of social status and wealth. Local African rulers and merchants adopted the use of square, whitewashed houses with verandas, from the Luso-Africans. As the Luso-Africans had themselves appropriated local building materials and methods of construction, it is clear that architectural influence moved in both directions. In a broader sense, the Luso-Africans constituted a distinct ethnic group, one that was the product of the conjunction of western African and European cultures. For the "Portuguese," as for their neighbors (Bagnun, Floup, and others), complexion or physical features were not significant factors in the determination of identity.[14]

Christianity had only a very limited influence on the Luso-Africans' neighbors, though some wore Christian medallions as protective charms (much as they did Islamic amulets). A carved

ancestral shrine of the Manjak people of Guinea-Bissau shows how European elements could be assimilated into an essentially African symbolic image. This figure is distinguished by a top hat and a coat, items commonly given by Portuguese colonial officials to local chiefs in recognition of the chiefs' authority. The miniature gun suspended like an amulet from the figure's neck is also a reference to power—derived from the evident spiritual power of those whose culture was capable of producing firearms.

A more complex pattern of historical interaction between Christianity and local African religion occurred among the BaKongo of western Zaire and northern Angola. This religious interaction, the subject of numerous studies,[15] began with the arrival of the Portuguese in 1483, the "conversion" of King Nzinga Nkuwu in 1491, and the accession of his son, baptized Afonso I, in 1506. Both Nzinga and Afonso maintained diplomatic contacts with Portugal. Forty years later, a Jesuit mission was established at the Kongo capital. The spread of Christianity was hindered both by Portugal's (and the Church's) limited ability to send priests and by the active involvement of local Catholic clergy in the slave trade. Nevertheless, in the sixteenth and seventeenth centuries, the Kongo kingdom appeared at least superficially to have been transformed by Christianity. Members of the court converted, and Christian ritual spread widely. BaKongo artists too were influenced by the new religion, producing metal crucifixes (see cat. nos. 47–48).

Such an interpretation of religious conversion in the kingdom of Kongo is, however, misleading. As Wyatt MacGaffey has pointed out, the BaKongo assimilated Christian rituals into their own religion.[16] Christianity initially appealed to the king and nobles as a new and potent source of spiritual power, which Nzinga sought to appropriate for his own needs. Over the next two centuries, BaKongo religious movements assimilated Christian symbols and even Christian saints into local BaKongo revitalization cults. By the eighteenth century, Christian shrines had even been transformed into local healing and fertility cults. In this context, one can hardly speak of Christian "conversion."

Even the crucifixes betray the transformation of Christianity into an appurtenance of BaKongo religion. While some of the crosses are close to European models, others exhibit radical iconographic changes from Christian prototypes. Some images of Christ are hermaphroditic. Clearly, the Christian icon has undergone a radical transformation. An eighteenth–nineteenth-century crucifix (cat. no. 48) shows another transformation. The patterns incised on the loincloth are echoed by the linear rendition of Christ's ribs. The artist thus established linear rhythms, creating a uniquely BaKongo "riff" on the theme of the Crucifixion.

Crucifixes played an important role in one of the BaKongo religious movements. The "Antonines," led by Kimpa Vita in 1704, sought to renew the Kongo kingdom, while moving against both local nobility and European missionaries. As part of her movement,

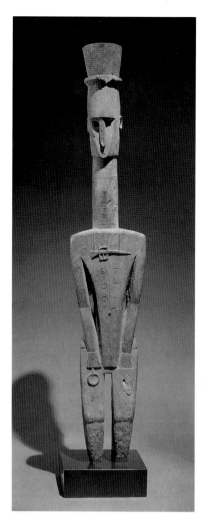

**Ancestral Figure.** Guinea-Bissau, Manjak, 19th–20th century. Wood, 94 cm high. The Walt Disney-Tishman Collection of African Art.

Kimpa Vita burned wooden crucifixes, which had become a symbol of the nobility. This iconoclasm derives its meaning from an attack on the Kongo social order, rather than as a direct anti-Catholic sentiment. Thus, both in terms of their iconography and style, and with respect to their particular history within the Kongo kingdom, crucifixes are best understood as manifestations of a specifically BaKongo culture. Christianity had an impact on that culture, but rather less than might be suggested by the proliferation of Kongo crucifixes. Here, as in western Africa, the role of Christianity before the nineteenth century was limited.

The vastness of Africa and the diversity of its inhabitants precluded the development of a common, continentwide culture or religion during the millennium that preceded the colonial period. Nevertheless, the historical growth of long-distance trade and especially of religious, political, and cultural contact between northern Africa and the Sahel, and between the eastern African coast and the Muslim world, indicate that a regionally focused and historically oriented approach to the continent may illuminate common patterns of intercultural contact and an attendant degree of cultural continuity across broad geographical areas. If the resulting map of Africa is traditionally divided (in many respects arbitrarily) into regions—West Africa, East Africa, and so on—it is evident that none of these regions remained totally isolated. Several patterns of cultural and religious contact emerge.

The first broad pattern coincides with the trans-Saharan trade. This pattern is characterized by the spread of Islam and the merging of Islam with local Sahelian cultures. Along the eastern African coast, a millennium of contact with Islam coupled with the

settlement of Arab traders created a pattern that bears some similarity to the Sahel. On the coast, Islam was implanted early, but the resulting Swahili culture entailed more radical transformation of local societies than occurred in western Africa, and the creation of a hybrid culture.

In Ethiopia, Christianity became the state religion at so early a date that the Ethiopian Orthodox Church has long been an integral part of local culture. From this context developed an artistic and architectural tradition that was no less Christian for being distinctively Ethiopian.

Coastal western and central Africa present a different pattern. On the western African coast before the nineteenth century, Islamic influence was limited to Senegambia. The relatively late arrival of European merchants, their extremely limited numbers and—with the exception of the Luso-Africans and a few Creole communities—their failure to settle in Africa the way Muslim merchants had, served to limit the impact of European culture and religion. As Christianity was part of this foreign cultural tradition, even when missionaries did convert a population, Christianity itself was transformed and even assimilated into local belief systems.

Comparison of these regional patterns of historical contact and of cultural and religious interaction suggests broader themes for the history of Africa between the late first millennium A.D. and 1800. No region was isolated entirely from the outside world. There is a widespread capacity—especially in western and central Africa and the Sahel—to integrate new religious structures (from Islam and Christianity) without sacrificing local institutions. There exists, in addition, a capacity to assimilate foreigners, whether northern African traders or Portuguese merchants, into local society. The continuing process of cultural interaction and change and the attendant construction and reconstruction of cultural identity resulting from this proceeded with little attention to physical characteristics such as "race." This fact, together with the long history of commercial contact and cultural borrowing across the Sahara, demonstrate that differences in complexion are of little use as tools in the study of Africa's past and that they do not provide a reasonable basis for separating the cultural history of precolonial northern Africa from that of Africa south of the Sahara.

## Notes

1. See Jean Devisse and Boubacar Diallo, "Le seuil de Wagadu," in J. Devisse, ed., *Vallées du Niger* (Paris, 1993), p. 103ff.

2. Ibn Khaldun, *Kitab al-'Ibar*, in N. Levtzion and J. Hopkins, ed., *Corpus of Early Arabic Sources for West African History* (Cambridge, 1987), p. 335.

3. R. and S. MacIntosh estimate the population of medieval Djenne-Jeno, the predecessor city to Djenne, at 12,000.

4. An excellent study of the chronology of the Djenne mosque is to be found in J.-L. Bourgeois, *Spectacular Vernacular, the Adobe Tradition.* (New York, 1989), p. 127ff.

5. On possible Mande prototypes, see L. Prussin, *Hatumere, Islamic Design in West Africa* (1986), p. 180ff.

6. René A. Bravmann, "The Sahel and Savanna," in Tom Phillips, ed., *Africa: The Art of a Continent* (Munich, 1995), p. 481.

7. Most of the Djenne terra-cottas have been dug up by art poachers in a manner that destroys the archaeological site and makes it impossible to date the objects. Their value as historical documents is thereby severely compromised.

8. For a concise treatment of early Islamic coastal culture, see the excellent study by Peter Garlake, *The Early Islamic Architecture of the East African Coast* (Oxford, 1966). For a fine study of later Swahili culture, see John Middleton, *The World of the Swahili* (New Haven, 1993).

9. For a comprehensive study of Ethiopian Christianity and art, see George Gerster, *Churches in Rock; Early Christian Art in Ethiopia* (New York, 1970). This book presents a detailed study of the churches at Lalibala.

10. Gerster tellingly cites this Portuguese traveler, Francisco Alvares, who wrote, "I weary of writing more about these buildings, because it seems to me that I shall not be believed." Ibid., p. 85.

11. For a discussion of Ethiopian painting, see ibid., p. 63ff.

12. Valentim Fernandes, *Déscription de la Côte occidentale d'Afrique (Sénégal au Cap de Monte)*, ed. and trans. Th. Monod (Bissau, 1951).

13. For a detailed study of Portuguese houses, see P. Mark, "Constructing Identity: Sixteenth and Seventeenth-Century Architecture in the Gambia-Geba Region and the Articulation of Luso-African Identity," in *History in Africa* 22 (1995), pp. 307-27.

14. In other words, the concept of "race," as it applies in twentieth-century American society, was not an element in what would today be called "ethnic identity."

15. In particular, see Wyatt MacGaffey, *Religion and Society in Central Africa, the BaKongo of Lower Zaire* (Chicago, 1986).

16. Ibid.

# Europe, African Art, and the Uncanny

Henry Louis Gates, Jr.

*I have felt my strongest artistic emotions when suddenly confronted with the sublime beauty of sculptures executed by the anonymous artists of Africa. These works of a religious, passionate, and rigorously logical art are the most powerful and most beautiful things the human imagination has ever produced.*

*I hasten to add that, nevertheless, I detest exoticism.*
—Pablo Picasso

*African art? Never heard of it!*
—Pablo Picasso

Charles de Gaulle was frequently heard to wonder aloud if without black Africa, from which he mounted the resistance to the Nazi regime, modern France would even exist. One might also wonder whether or not without black African art, modernism as it assumed its various forms in European and American art, literature, music, and dance in the first three decades of the twentieth century could possibly have existed as well. Especially is this the case in the visual arts, where dramatic departures in the ways of seeing, particularly in representing the human figure, would seem to be directly related to the influence of sub-Saharan African art. In this sense, it is not too much to argue that European modernity manifested itself as a mirrored reflection of the mask of blackness.

European encounters with visual arts in Africa have long been fraught with a certain anxiety, often calling to mind Sigmund Freud's account of the anxieties accompanying encounters with the uncanny, encounters that elicit a feeling of "dread and creeping horror." In the second edition of an essay entitled "Of National Characters," David Hume, writing in the middle of the eighteenth century at the height of the European Enlightenment, maintained that one could survey the entire area of Africa below the Sahara and find not even one work of visual or written art worthy of the name. In a survey of the world's major cultures, civilizations, and races, which in its first edition excluded completely any reference to Africans, Hume concluded in a footnote added to the second edition that all of black Africa contained "no arts, no sciences." Beauty, as perceived in all its sublimity in European cultures, at least since the time of the Ancient Greeks, is not to be found in black human or plastic forms.

Writing just a decade later, Immanuel Kant, in his *Observations on the Feeling of the Beautiful and the Sublime* (1764), meditated on Hume's conclusions about Africa, ratifying and extending them without qualification. In Section IV of his essay "Of National Character," Kant cited Hume's opinion favorably, then made the startling claim that "blackness" denotes not only ugliness, but stupidity as well:

*In the lands of the black, what better can one expect than what is found prevailing, namely the feminine sex in the deepest slavery? A despairing man is always a strict master over anyone weaker, just as with us that man is always a tyrant in the kitchen who outside his own house hardly dares to look anyone in the face. Of course, Father Labat reports that a*

*Negro carpenter, whom he reproached for haughty treatment toward his wives, answered: "You whites are indeed fools, for first you make great concessions to your wives, and afterward you complain when they drive you mad." And it might be that there were something in this which perhaps deserved to be considered; but in short, this fellow was quite black from head to foot, a clear proof that what he said was stupid.*

Here we see the bold conflation of "character"—that is, the foundational "essence" of a culture and the people who manifest it—with their observable "characteristics," both physical and, as it were, metaphysical.

Three decades later, a more liberal, or cosmopolitan, Kant would allow in *The Critique of Judgement* (1790) that black Africans no doubt had standards of beauty among themselves, even if they did not correspond to European standards of beauty—a bold speculation given the revolutionary transforming role that the cotton gin had begun to play in the nature of New World slavery and the increased traffic in African human beings that this major technological innovation engendered. (Georg Wilhelm Friedrich Hegel, however, was not persuaded by Kant's new generosity of spirit; in the *Philosophy of History*, written around the same time, he reaffirmed implicitly Hume's claim about the absence of civilization in black Africa, and added that because Africans had not developed an indigenous script or form of writing, they also lacked a history.)

If Europe's traffic in black human beings needed a philosophical justification, Enlightenment philosophy, by and large, obliged sublimely. European aesthetic judgement of African art and culture, in the eighteenth and nineteenth centuries at least, was itself encapsulated in, and became an integral part of, the justification of an economic order largely dependent upon the exploitation of cheap labor available to an unprecedented degree on the west coast of Africa, from Senegambia to Angola and the Congo. Never could the European encounter with the African sublime be free of the prison of slavery and economics, at the expense of African civilization and art themselves. The prison-house of slavery engendered a prison-house of seeing, both African peoples and their attendant cultural artifacts.

This curiously tortured interrelation between ethics and aesthetics, between an economic order and its philosophical underpinnings, remained largely undisturbed until the turn of the century. For a variety of reasons, too numerous and subtle to be argued here, revaluations of African art gathered momentum at the turn of the century. Antonin Dvořák's admiration, and formal uses, of African American sacred music as a basis for a bold, new approach to orchestral music is only the high-culture equivalent of Europe's and America's obsession with blackfaced minstrelsy as a popular mode of debased theater and dance. The role of the Fisk Jubilee Singers in this process of revaluation, performing spirituals on worldwide tours during these decades, cannot be gainsaid. But it would be in the visual arts where the role of African ways of seeing would become pivotal, in a manner unprecedented in the history of European aesthetics. The experience of African art profoundly shaped the forms that modernity assumed early in the twentieth century.

Modern art is often considered to have taken its impetus from the day in 1907 when Pablo Picasso visited the Musée d'Ethnographie in the Palais du Trocadéro, Paris. Indeed, Sieglinde Lemke has argued that there could have been no modernism without "primitivism"—a term, I confess, that I detest—and no "primitivism" without modernism. They are the ego and the id of modern art. How uncanny that encounter was for Picasso—and, by extension, for European art, its critics, and its historians—can be gleaned not only from his own account of the discomfort he felt at that moment, but also from the curious pattern of denial and affirmation propagated both by Picasso himself and later critics in relation to that great moment of transition in the history of European and African aesthetics, *Les Demoiselles d'Avignon* (1907).

Picasso's discomfort—and the discomfort of critics even today—with the transforming presence of African art in painting underlines the irony of an encounter that led to the beginning of the end of centuries of European disapprobation of African art—art that is now taken to be neither "primitive" nor "ugly," but to embrace the sublime.

Picasso's ambivalence about the significance of his chance encounter with the faces of Africa that day at the Trocadéro manifested itself almost as soon as critics asserted its importance. As early as 1920, Picasso was quoted in Florent Fels's *Action* as saying "African art? Never heard of it!" The literature is full of Picasso's denials, the energy of which seems only to emphasize Picasso's own anxieties about his African influences. Eventually,

in 1937, in a conversation with André Malraux not reported publicly until 1974, Picasso admitted the African presence in his work:

*Everybody always talks about the influences that the Negroes had on me. What can I do? We all of us loved fetishes. Van Gogh once said, "Japanese art—we all had that in common." For us it's the Negroes. . . . When I went to the old Trocadéro, it was disgusting. The Flea Market. The smell. I was alone. I wanted to get away. But I didn't leave. I stayed. I stayed. I understood that it was very important: something was happening to me, right? The masks weren't just like any other pieces of sculpture. Not at all. They were magic things. . . . The Negro pieces were intercesseurs, mediators. . . . I always looked at fetishes. I understood; I too am against everything. I too believe that everything is unknown, that everything is an enemy! Everything! Not the details—women, children, babies, tobacco, playing—the whole of it! I understood what the Negroes use their sculptures for. Why sculpt like that and not some other way? After all, they weren't Cubists! Since Cubism didn't exist. It was clear that some guys had invented the models, and others had imitated them, right? Isn't that what we call tradition? But all the fetishes were used for the same thing. They were weapons. To help people avoid coming under the influence of spirits again, to help them become independent. Spirits, the unconscious (people still weren't talking about that very much), emotion—they're all the same thing. I understood why I was a painter. All alone in that awful museum, with masks, dolls made by the redskins, dusty manikins. Les Demoiselles d'Avignon must have come to me that very day, but not at all because of the forms; because it was my first exorcism painting—yes absolutely.*

Françoise Gilot had reported a similar comment a full decade before Malraux's publication. It is even more dramatically open about Picasso's conscious indebtedness to African sources:

*When I became interested, forty years ago, in Negro art and I made what they refer to as the Negro Period in my painting, it was because at the time I was against what was called beauty in the museum. At that time, for most people a Negro mask was an ethnographic object. When I went for the first time, at [André] Derain's urging, to the Trocadéro museum, the smell of dampness and rot there stuck in my throat. It depressed me so much I wanted to get out fast, but I stayed and studied. Men had made those masks and other objects for a sacred purpose, a magic purpose, as a kind of mediation between themselves and the unknown hostile forces that surround them, in order to overcome their fear and horror by giving it a form and image. At that moment I realized what painting was all about. Painting isn't an aesthetic operation; it's a form of magic designed to be a mediator between this strange, hostile world and us, a way of seizing the power by giving form to our terrors as well as our desires. When I came to that realization, I knew I had found my way. Then people began looking at those objects in terms of aesthetics.*

In these idiosyncratic and cryptic statements, Picasso reveals that his encounter with African art was a seminal encounter. Yet, he dismisses the primary influence that African art had upon his work, its *formal* influence, a new way of seeing, a new way of representing. But why would Picasso suddenly identify with modes of representation peculiar to African art, thereby breaking the long-held tradition of disparaging those same black traditions as "ugly" or "inferior"?

What these passages reveal is Picasso's aesthetic wrestling with his own revulsion at the forms of African art, and, by extension, the traditional revulsion of the West toward African aesthetic conventions generally. Picasso vividly described his encounter in terms that Freud used to describe the uncanny. His description of the smell, followed by the realization that he was alone and his desire "to get out fast," which he managed to resist, are all symbolic. The description serves as a metaphor for a visceral repulsion of the artist and, as it were, the visceral repulsion of Western aesthetics itself. What is also striking about Picasso's recollections is his denial of the formal influence of African art—to which he was patently indebted—and the fact that thirty years later (when he made his confession to Malraux) he was still haunted by the memory of a tormenting odor. The unpleasant sensations are metaphors for Picasso's anxiety and for the very sublimity of this encounter with the black uncanny.

Perhaps even more bizarre, Picasso substituted for his own obvious embrace of formal affinities with African art a cryptic and obviously bogus claim to be embracing African art's *affect*, its supposed functionality, its supposedly "exorcist" uses, about which he knew nothing. In a way that he did not intend, this curious dichotomy would come together in his use of the forms of African art to exorcise the demons of his artistic antecedents.

Picasso's anxieties with his shaping influences are, in part, those of any artist wishing to be perceived as sui generis. But it is impossible to separate the anxiety about influence, here, from Europe's larger anxiety about the mask of blackness itself, about an aesthetic relation to virtually an entire continent that it represented as a prime site of all that Europe was not and did not wish to be, at least from the late Renaissance and the Enlightenment. Even in those rare instances early in the twentieth century when African art could be valued outside a Eurocentric filter, the deepest ambivalences about those who created the art still obtained. Thus Frobenius on his encounter with a classic work of Yoruba art, some time between 1910 and 1912: "Before us stood a head of marvellous beauty, wonderfully cast in antique bronze, true to life, encrusted with a patina of glorious dark green. This was, indeed, the Olokun, Atlantic Africa's Poseidon."

"Yet listen," Wole Soyinka, the Nigerian playwright, argued in 1986 at his Nobel Laureate address, "to what he had to write about

the very people whose handiwork had lifted him into these realms of universal sublimity":

*Profoundly stirred, I stood for many minutes before the remnant of the erstwhile Lord and Ruler of the Empire of Atlantis. My companions were no less astounded. As though we have agreed to do so, we held our peace. Then I looked around and saw—the blacks—the circle of sons of the "venerable priest," his Holiness the Oni's friends, and his intelligent officials. I was moved to silent melancholy at the thought that this assembly of degenerate and feeble-minded posterity should be the legitimate guardians of so much loveliness.*

The deep ambivalences traced here were not peculiar to white Europeans and Americans; African Americans, for their part, were at least as equivocal about the beauty of African art as were Europeans. As Alain Locke—the first black American Rhodes Scholar, who was to graduate from Harvard with a PhD in Philosophy, and then become the first sophisticated black art critic—put it in his pivotal essay "The Legacy of the Ancestral Arts" (1925), they "shared the conventional blindness of the Caucasian eye with respect to the racial material at their immediate disposal." Racism—aesthetic and other—Locke concluded ruefully, has led to a "timid conventionalism which racial disparagement has forced upon the Negro mind in America," thus making even the very *idea* of imitating African art for African American artists a most difficult ideal to embrace.

Locke's solution to this quandary, as Lemke has argued, is as curious as Picasso's waffling about influences upon him: by imitating the European modernists who so clearly have been influenced by African art (of whom Locke lists Henri Matisse, Picasso, Derain, Amedeo Modigliani, Maurice Utrillo, and ten others) African Americans will become African by becoming modern. The route to Africa, in other words, for black as well as white Americans and Europeans, is by way of the Trocadéro. Locke even points to the work of Winold Reiss, whom he chose to illustrate his classic manifesto of African American modernism, *The New Negro,* "as a path breaking guide and encouragement to this new foray of the younger Negro artists."

Judging by the "African-influenced" work that artists such as Aaron Douglas produced, and given the circuitous route that Locke mapped out for them as their path "back" to Africa, perhaps we should not be surprised that these experiments led not to the "bold iconoclastic break" or "the ferment in modern art" that Picasso's afternoon at the Trocadéro yielded, but rather to a sort of Afro-kitsch, the use of decorative motifs such as cowrie shells, Kente cloth patterns, and two-dimensional reproductions of "African masks," in which "Africa" never becomes more than a theme, as an adornment, not a structuring principle, a place to be visited by a naïve tourist. Ways of seeing, these experiments tell us, are not biological. Rather, they result from hard-won combat with received conventions of representation. They are a mysterious blend of innovation and convention, improvisation and tradition. And if the resurrection of African art, in the court of judgment that is Western art, came about as a result of its modernist variations, this exhibition is testament to the fact, if there need be one, that African art at the end of the century needs no such mediation. It articulates its own silent sublimity most eloquently. For centuries, it has articulated its own silent sublimity most eloquently.

Note

Quotations of Picasso are taken from William Rubin, ed., *Les Demoiselles d'Avignon,* Studies in Modern Art, no. 3 (New York, 1994); quotation of Immanuel Kant from *Observations on the Feeling of the Beautiful and Sublime,* trans. John T. Goldthwait (Berkeley and Los Angeles, 1960), p. 113. References to Sieglinde Lemke's ideas are based on her book *Was Modernism Passing?* (forthcoming from Oxford University Press).

# Enduring Myths of African Art

Suzanne Preston Blier

How African art is defined, and not defined, in terms of larger classifications—whether it is presented as art or craft, "primitive" or sophisticated, intuitive or intellectually considered, and whether it is seen as the province of fine-arts museums or that of institutions concerned with natural history and anthropology—is fundamental to one's perception of works like those presented in this exhibition. Questions of this nature often are as important to how the arts of Africa are seen by Western viewers as are lighting, wall position, background color hues, label captions, and other material factors that characterize the way in which they are exhibited. These questions in turn are related to a range of myths and misconceptions, broad generalizations that frame both popular and scholarly approaches to the arts of Africa. An examination of these myths offers striking insight into longstanding perceptions of Africa, its cultures, and its arts.

## The Myth of Primal, Timeless Africa

One of the most pervasive of all myths about African art is that it is both timeless and primal.[1] Regardless of its age, African art is often assumed to be early or primeval. In essence, it is seen as existing outside the realm of real time. In exhibitions and on the printed page, ninth- and nineteenth-century works are commonly presented side by side, as if the difference in a millennium were inconsequential. Ancient art forms are often explored from the vantage of recent cultural hegemonies; in this setting, viewers and readers are asked to follow a narrow stylistic trail that is said to connect what was then with what is now, within a fixed geographical area. Such juxtapositions result in confusion, and often in grave errors, as the present is interpreted in terms of the past and the past in terms of the present.

The myth of primal Africa also falsely assumes that changes in art forms over time, the identity of artists, and cultural constructs across broad and ethnically diverse areas—changes resulting from trade, war, political movements, or religious events—have become a serious concern only in the recent past. However, stylistic shifts that differentiate ancient from more recent works in a particular region of Africa—for example, ancient Ife and modern Yoruba art forms in present-day Nigeria—are every bit as pronounced as those that differentiate Medieval art from the arts of the Renaissance and Baroque periods in Western Europe. Stylistic changes across eras— such as those associated with ancient Djenne and modern Mande

societies in present-day Mali—make clear that the arts of Africa are decidedly *not* timeless and tradition bound. Yet, mythic ideas of Africa as a place of primal cultures often impact in important ways on readings of both ancient and modern works produced by artists south of the Sahara.

In exhibitions and printed texts, sculptures that suggest contact with the West—images of persons wearing European clothing or depictions of Europeans—are often left out, even though African artists have been producing such works since the early sixteenth century. Although some of Africa's greatest artists and patrons over the centuries have been deeply interested in interchanges between Africa and Europe—in the kingdoms of Dahomey, Asante, Kongo, and Bamun, for example—and have sought to integrate related concerns in their arts, these concerns are generally overlooked. Those who promote the idea of a mythic Africa often ignore the fact that European and Islamic art and culture have profoundly influenced the arts of many regions in Africa. Likewise, scant attention is paid to recent and contemporary African art, because this art does not conform to primal typologies or expectations and because, in many circles, despite overwhelming evidence to the contrary, it is believed that artistic production in Africa has long since come to a standstill.

One of the best ways to understand the problems of such approaches, longstanding in both African art books and gallery exhibits, is to contemplate a broad survey of European art in which the works are historically clustered by regions, into say Italian, French, German, Dutch, British, and Spanish traditions, with little concern either for dates or whether individual works are identified with Ancient, Medieval, Renaissance, or modernist idioms. If, in this fictive survey, arts of earlier periods are not examined separately, and works related to continentwide artistic or religious movements (Christianity, Judaism, Islam) are not addressed, readers and viewers will come away with a quite different and confused impression of European art in terms of history, style, and other issues. This is not to say that continentwide overviews of African art should not be undertaken—indeed, they are long overdue—but rather that scholars need to rethink the ongoing impact of the taxonomies we have been using.

## The Myth of African Art as Bound by Place

In addition to remaining conceptually "timeless" and largely untouched by real historical concerns, the African art of myth is also frequently presented, incorrectly again, as an art rigidly bound by place. Particular types of objects or particular styles, in this context, are identified with carefully circumscribed regions, as if objects and styles did not travel over time and space.[2] Such divisions of African art into regional clusters and styles, even when undertaken with great care, often fail to take into account fundamental social and historical concerns. As a result, they often have little real viability. The partitioning of sub-Saharan Africa into the broad geographical regions—West Africa, East Africa, and so on—common in general texts and exhibitions, while expedient, does little more than replicate Western divisions of the continent. Eastern and southern Africa became the purview of the British; central Africa was colonized, in large part, by Belgium; western Africa was divided among the French and the British; the Sahel and Sahara were French.

If the division of African art into broad and largely hermetic zones has been longstanding, it is also because this approach mirrors early European navigational routes around Africa, routes that allowed for a view of the coast and its immediate hinterland, but not one that penetrated beyond or could conceive of the continent in more complex ways. In "tours" of mythic Africa, one generally moves along one or another of the continent's coasts, stopping in at various ports of call, but never really penetrating into the interior. The Africa of myth is not the Africa of complex conquest histories and migration movements. Nor is it the Africa of long-distance traders who for centuries crisscrossed the continent in complex economic networks from north to south and east to west, transporting both goods and ideas, and continually proving the fantasy and falsehood of Western views, shared by the missionary-explorer David Livingston and others, that impenetrable forests and hostile deserts made such travel impossible.

Such mythic treatments of the continent are problematic not only because many works of African art speak simultaneously to the cultures and histories of several, supposedly distinct, geographical regions, but also because such divisions leave out essential parts of the historical record. Akan works from regions near the coasts of Ghana and Côte d'Ivoire, for example, must be understood not only in terms of the broad region to which they are generally ascribed (western Africa/the Guinea Coast), but also in terms of the Islamic

north. Palace art of the Cameroon grasslands—including animal-form slit gongs, building techniques, and shifting palace placement forms—have far more in common with court traditions of the Azande, Mangbetu, and cultures farther to the east than they do with traditions encountered in western Africa, the region with which they are most often associated. Many Igbo, Ibibio, Cross River, and Benue Valley works are closer stylistically to the arts of the Fang, Punu, Kwele, and nearby groups in central Africa than they are to objects produced in western Africa—the region with which they are usually linked.

## The Myth of African Art as Communitarian

That Africa is a place of predominantly small-scale and essentially isolated communities is another prominent myth. In exhibitions, exhibition catalogues, and general texts, the reader or viewer too often is required to conceptually jump from one object or culture example to another, with little sense of narrative flow. This is so because the myriad cultures encountered in Africa are believed in this myth to share few if any contexts of interaction. This belief, however, is contradicted by historical data. In any given region of Africa, one finds initiation associations, religious complexes, and traditions of healing, divination, and jurisprudence that cut across cultures, linking communities both large and small. Such links underscore the fact that cultural and artistic interchange has long been a characteristic of life south of the Sahara. Also encountered in Africa, but all too often ignored in overview exhibitions and general texts on the continent's arts, are important urban civilizations—many that are centuries old. The great Yoruba urban centers of Abeokuta and Ibadan, with their vast populations of several hundred thousand, are a case in point. Because they do not fit in with the concept of an Africa made up of isolated village communities, they are often left undiscussed.

In this myth of a largely "communitarian" Africa, we also get no sense of the complex political systems that once profoundly shaped the societies and arts of this continent. Discussions of African art held in this context generally avoid any in-depth treatment of the vast size and power of Africa's great monarchies—Songhai, estimated at 700,000 square kilometers; Lunda, 150,000 square kilometers; Yoruba (Oyo), 150,000; Kongo, 130,000–300,000; Benin, 100,000; Asante, 100,000; and Dahomey, 80,000. With the exception of the much larger Songhai state, roughly one-and-one-half times the size of France, these kingdoms were comparable in scale to England and the larger German principalities. The historian John Thornton, whose figures are cited above, noted that more than half of all people residing in Atlantic Africa lived in states or ministates of this sort.[3] Yet in overviews of African art, the importance of these kingdoms rarely is emphasized. Indeed, kingdoms are often indicated graphically in the same way as rural cultures, for example, by tiny dots on a map, as if to suggest that

vast polities are little different from small, community-based contexts of artistic production.

Longstanding exhibition and collecting practices that have stressed the selection of a few representative objects from a myriad of purportedly independent cultures have reinforced this idea that Africa is, or was, a place where political power goes no further than the village level. Other approaches, though more current, tend to compound the problem. Nowadays, it is fashionable to define works of African art by way of references to substyles, or even village names, following the dictum that the more detailed and narrower the identification the better. It should be emphasized, however, that definitions of this type are selected over equally valid labeling systems, which focus instead on the larger political, social, and historic relatedness of works within a larger sphere—broad terms or definitions such as Kongo or Mande, followed perhaps by the substyle or village name cited in parentheses.

The problems implicit in "representative" and broad, area-based selection principles can best be illustrated by returning to our fictive European survey and attempting to imagine the selected works not as examined or displayed according to dates, artists, and art-rich centers of creativity, such as Rome and Florence, but instead vis-à-vis a more representative program wherein one or two exemplary objects from each European city or town is chosen regardless of its size or artistic history. Through such a selection policy, any real sense of history, art historical and otherwise, gets lost as does any larger view of artistic influence and internal change. This is not to say that one should jettison culturally or politically "nonaffiliated" or community-based arts from surveys and exhibits of African art, but rather that one needs to be aware of how commonly employed selection and labeling practices have helped to promote ideas of a mythic Africa, lacking both broad-based and complex modes of sociopolitical organization. One must also be conscious of the pitfalls of geography. When overviews of African art are structured in terms of geography alone, they suggest to us, most inaccurately, that the great arts of this continent are to be understood as the product of environmentally bound societies, living outside of history and with little contact among one another.

Approaches of this kind tend also to underplay the complexity and diversity of African civilizations. For instance, arts of the great Christian states of Sudan and Ethiopia are often marginalized—this in spite of the long histories and important art-historical traditions for which they are known and the ties that have linked them, for centuries, to both Europe and Asia. Because Christian Africa is deemed too "distant," and African, to be of real interest to scholars specializing in Christian art forms developed in Europe, and too "different," and Christian, by scholars who identify themselves as students of "traditional" African art, the extraordinary art forms of these states are doubly marginalized.

It is important to emphasize the fact that Western views of

Africa have changed dramatically over time. In the Medieval and early Renaissance eras, Africa was often thought of as a land of vast wealth—a point well taken when one considers reports of a fourteenth-century Mali ruler, the famed *Mansa* (King) Musa, who spent so much gold in Egypt that he caused a crash in the Alexandrian gold standard. Recognizing Africa to be a place of complex civilizations and great wealth, Columbus and other early European navigators extensively sailed around the coast of western Africa in search of ports and routes into the interior prior to their attempts to cross the Atlantic. European travelers to Africa in the seventeenth and eighteenth centuries reported striking complementarities between what they saw of African courts and what they were familiar with in their own communities, noting, for example, similarities between the western African royal city of Benin and the Dutch city of Haarlem.[4] Indeed, their comments suggest, preindustrial Europe bore far more similarities to the Africa of the 1600s and 1700s than to present-day, post-industrial Europe. Such similarities, however, are rarely examined. Instead, parallels are drawn between the arts of Africa, Oceania, and Native America—three areas whose arts share little in common save a propensity to be seen by Westerners as timeless, place bound, and associated with simple, small-scale societies.

## The Myth of Tribal Africa
In the second half of the nineteenth century, at the brink of the colonial period, the nature of writings on Africa changed. Described in the seventeenth and eighteenth centuries as a place of powerful kings and lavish courts, the continent now became a place of heinous autocratic kings—tyrants who, it was said, needed to be removed from power for the sake of their own people and humankind more generally. Slavery practices promoted by European entrepreneurs had much to do with this. Indeed, the denigration of Africans and their cultures served to justify not only slavery but also missionary activity and the later overthrow of local authorities. At the conclusion of the period of colonial conquest, the continent was once again reframed; in maps and scholarly texts, it was now represented as a locale of discrete "tribal" entities, generally in conflict with one another and lacking any form of real political or economic sophistication. With traditional rulers and institutions of broader social control largely destabilized within the colonial setting, ideas of "tribal primacy" were reinforced by governmental institutions as well as by social theories of the period.

Today, scholars no longer use the term "tribe" in discussions of Africa's cultures and arts. This is so not only because it is a pejorative word, which one would not think of using in a European context (today, one would not speak of the Scottish or Irish as members of a tribe), but also because the notion of tribe carries with it ideas of hermetically sealed stylistic borders within which little, if anything, changes over time—ideas that contradict current

views of Africa, its cultures, and its arts. One of the things that scholarship has made clear in the last twenty-five years is the fact that African art is anything but insular. "Mangbetu" works—works once thought to have been made by Mangbetu artists for use exclusively by Mangbetu users—are now known to have been made by Azande carvers. A significant number of "Bamun" artists did not come from the Bamun kingdom, but from other areas of the Cameroon grasslands. Some of the most important "Dahomey" artists were of Yoruba or Mahi origin. Many arts associated with the Bushong/Kuba and Asante courts came from neighboring and more distant areas. Still, problems remain. Though most specialists of African art no longer believe that "for every tribe there is a style,"[5] the myth of the "tribe" remains conceptually strong and also has been projected back into time.

From this perspective, it is interesting to consider scholarly writings on the arts of ancient African civilizations. There is little in the way of archaeological information for Nok sculptures, but they have been dated through thermoluminescence to the latter half of the first millennium B.C. and the first centuries A.D. Nok statuary has been discussed for the most part as the work of community-based societies much like those that have populated north-central Nigeria in recent centuries. An underlying misconception is that these sculptures were produced for use in communities that did not incorporate or value hierarchical structures—this despite evidence within the sculptures themselves that individuals of elite status were important in this culture; this point is underscored by such features as complex jewelry and elements of costume design, as well as by scale differences that give greater prominence to certain individuals depicted. The signifiers of status found in Nok statuary suggests that these arts might be more fruitfully examined as expressions of a hierarchical polity, perhaps a kingship. That works of this genre have been discovered across a broad area and that, throughout this area, they retain a strong degree of stylistic unity would also seem to support this hypothesis.

The same is true with respect to the hilltop siting of Nok communities. Not only are hilltop locales common in African royal contexts but also, as in many African societies, capitals and palaces were moved or rebuilt with each dynastic change, thereby encouraging the spread of ancient court arts, much as might have occurred in the Nok area. Also, in many regions of Africa, ironworking—a technology closely associated with Nok sites—is intimately linked to rulership prerogatives. That, as of yet, little evidence has been uncovered indicating clearly that Nok was a kingdom should not be taken as proof that it was not. Indeed, one must remember that most of the sub-Saharan kingdoms known to us in the historic period—among these, Dahomey, Akan, Yoruba (excepting Ife), Kongo, Kuba, Luba, and Buganda—have left or, if they were to disappear, might leave little material evidence of their elite identity and broad-based political power.

Ongoing scholarly perceptions that Nok arts reflect small-scale community-based concerns accordingly are not framed by hard evidence but rather by a view of small-scale polities as the "fallback" model of choice in discussions of African societies. Not only are kingdoms incorrectly seen to be an anomaly here, but concerns of "tribe" and timeless, insular cultures are assumed to be the norm. Approaches of this kind reflect the enduring primacy of Western evolutionary theories for society, in which political forms are believed by definition to become more complex over time, but rarely less so. In Africa as elsewhere, however, there are numerous examples of kingdoms that have flourished at one period and then dissolved.

Related concerns can be raised for works coming from well-excavated sites, such as Igbo-Ukwu in southeastern Nigeria. Some have argued that works from this site are nonroyal, the products of essentially acephalous (decentralized) communities similar to those living in this area of Africa in the later historic period. Key iconographic features of these arts, however, suggest not only close links to exalted Nri priesthoods, but also to the royal polity of Ife, and to other lower Niger sites, where ideas of status differentiation are concomitant with hierarchical rule. While it is important that we not overstate the significance of such status markers and assume that all archaeological sites with elite indicators are necessarily royal, it is also important that we continue to rethink longstanding assumptions that Africa is a place primarily of community-based polities that have remained essentially static over time with respect to social organization and ethnic identity and have known little contact or interchange one with another.

### The Myth of Intuitive African Art
In discussions of African art as a primal entity, little is said about real artists who grapple with the history of art forms in their own region and with the arts of other, foreign, peoples as well; in such discussions, African art is viewed, again incorrectly, as responsive above all to community needs rather than to the needs or personal interests of individual artists, their patrons, and members of their public. Views of this kind have had a powerful impact on ways in which African art is categorized, particularly where matters of form and aesthetics are concerned. Especially striking is the way in which issues of abstraction have been addressed in general writings on African art. Whereas key twentieth-century art forms in the West bear the label "abstract art," comparable and much earlier forms produced by African artists are generally not labeled in this way because it is assumed that the Western works alone are intellectualized and intentionally abstracted from a naturalistic prototype. Their African counterparts are seen as the product of intuition or as the result of errors made in trying to copy from nature. Abstract works by European artists thus become part of a larger formal and

intellectual history of artistic discovery and invention; abstract works by African artists, while acknowledged to be visually powerful, remain the product of naïve or untrained individuals who are seen, a priori, to lack any real understanding of what they are doing as abstractionists.

Closely tied to views of this kind is the belief that African artists and their patrons and viewers are or were in the past uninterested in the arts of foreign civilizations. This too is a fallacy. Rulers of kingdoms as diverse as Kongo, Bamun, Dahomey, Benin, and Asante maintained collections of exotic, frequently foreign, art and cultural objects comparable in nearly every way to the curiosity cabinets of Europe's elites in the premuseum era. A number of African kings commissioned works for their courts from Europe, in Western and local idioms alike. A Dahomey memorial staff (*asen*) and ensemble of saint sculptures are among the better-known examples.

Common also is a general lack of attention to how ancient works were removed from archaeological sites or to what knowledge about their meanings was lost when they were collected—often illegally and, as a result, unscientifically. All too often, in the absence of contextual or archaeological data, works of art associated with ancient civilizations south of the Sahara are given fictive labels framed by primal myths, ideas of ancestor worship, or assumptions of generic ceremonial functioning. Not only are such concerns overexaggerated—proceeding from longstanding views that all African arts and their makers were concerned with the sacred—but sculptures that conform to such primal typologies are strikingly rare in the larger African art corpus.

### The Myths of "Art for Art's Sake" and "Primitive" Art
It is often said or assumed that works produced by African sculptors are "art" because they have been elevated to that position by "us." It is important to remember, however, that the term "art" has had a long and diverse etymological history in the West. In Europe, up until the Renaissance, the term "art" was in many respects synonymous with the term "craft" as we understand it today, referring as it did, primarily, to ideas of practical skill.[6] Both *arte,* the early Italian word, and *kunst,* the German term for art, were linked to ideas of practical activity, trade, and know-how. *Kunst* has its etymological roots in the verb *können* (to know) and related ideas of "know-how"; the Latin root *ars* (from which the Italian *arte* derives) has its source in the concept of *artus,* meaning "to join" or "fit together." In the fifteenth century, the poet Dante still called any craftworker an artist.[7] With word histories often functioning as important taxonomic arbiters, all pre-Renaissance art traditions in Europe can be said to share the same etymological grounding as craft. Historically, no qualitative, functional, or material distinctions were made between such works and objects considered to be "art."

The question of what constitutes art is an important taxonomic one for Africa. Although scholars have sometimes suggested that there is no word for "art" in African languages, as one is told is also true in many other non-European languages,[8] there are in fact a number of such words. But, as was the case in Italian and German, the term is often linked to ideas of skill, know-how, and visualization. The Fon of Benin use the word *alonuzo* to designate art. Literally, this term means "something made by hand" (*alo*: hand; *nu*: thing; *zo*: work). The nearby Ewe of Togo employ the term *adanu* to mean at once "art," "technique," "ornamentation," and "value." As Roberto Pazzi pointed out, the Ewe phrase *e do adanu* means variously "he is skilled (in the accomplishment of a work)," "he gives sage advice," and "he produces a work of value."[9] The Bamana of Mali use another type of linguistic signifier for sculpture: *mafile fenw*, *laje fenw*, meaning "things to look at."[10]

Issues concerning the definition of art have interested Western aestheticians since the eighteenth century.[11] Art hierarchies were gradually established in the West based on diverse, often contradictory, values ranging from function to feeling and expressive attributes. As this was occurring,[12] notions of craft and art came to be viewed as distinct. According to Giulio Carlo Argan, "the final transition of *Kunst* from the idea of 'trade' or *ars* in the Latin sense, to the modern meaning took place in the eighteenth century."[13] If today we tend to see "art" as something of beauty, or at least visual power, devoid of function, we should nonetheless bear in mind that "art," thus defined, is a wholly modern (eighteenth century and later), and essentially Western, label. We should also note that it is a strikingly arbitrary definition. Early as well as later European religious and political arts—to say nothing of modern architectural works expressing the value that "form should follow function"—by this definition would have to be expunged from a strict "art for art's sake" canon. If we were to envisage an exhibition of European art that was entirely devoid of arts having functional associations (religious, political, monetary, or psychological), it would be a very small exhibition indeed.

Western taxonomies have played an equally significant, and just as arbitrary, role in yet another setting. For decades, and in some contexts still, African art was defined as "primitive" art. Derived from the latin *primus*, meaning "first" or "prior," the term "primitive" has been used, historically, to define things that are either early or ancient, or which possess characteristics of simplicity or roughness associated with earlier forms. General usage often equates things defined as "primitive" with things inferior and/or archaic, as in primitive housing, plumbing, or motor skills.

Like the distinction between art and craft, the label "primitive" art, as applied to the arts of Africa, is a recent invention. At the turn of the twentieth century, "primitive" art encompassed early Flemish and Italian proto-Renaissance works, as well as a host of other European and non-European traditions including, among others, Romanesque, Byzantine, Iberian, folk, Persian, Egyptian, pre-Columbian, Javanese, Cambodian, Japanese, Oceanic, African, and Native American arts.[14] What tied these arts together? Nothing. The only unifying thread, here, was the factor of *not*. It is because of what these arts are *not* that they were grouped together. All lie outside the parameters or dominant lines of European artistic expression. Their common bond was their perceived distance and deviation from what was assumed to be the artistic norm. As certain of these arts have gained stature and defenders in the West, they have been wrenched from the arms of the "primitive" typology. By the 1920s, the word "primitive" no longer designated Romanesque, Byzantine, Egyptian, or Japanese arts, or arts associated with other European or Eastern traditions. Instead, it was used—almost exclusively—to designate the arts of Africa, Oceania, and Native America, and, alongside these, a new subcategory: the works of children and the insane. The assumption was that all such works were in some way primal and intuitive, that they lacked a history and so were incapable of any real change.

## African Art as Anthropologically Framed

Related taxonomic issues also have come up with regard to the establishment of museum collections and exhibitions of African art. Historically, African art found its way into anthropological and natural-history museums in Europe and America long before it was acceptable to collect and display it in fine-arts museums. In this light, it is of taxonomic and historical interest that the National Museum of African Art in Washington, D.C. (like the national museums of Asian and American arts) has its primary affiliation with the Smithsonian Institution, by tradition a natural-history and cultural museum, rather than with the National Gallery of Art, a prototypical fine-arts museum. Regardless of their various histories, however, most public fine-arts museums in the United States now have prominent African art collections and displays.

National identities and traditions of scholarship have also been important in exhibition contexts. With the exception of two private museums, the Musée Dapper in Paris and the Musée Barbier-Mueller in Geneva, African art in Europe has yet to effectively break through colonial taxonomies for purposes of ongoing display in fine-arts museums. So too, in most European institutes and university departments dedicated to training art historians, there has been relatively little engagement with African art.

If today the vast majority of art historians and fine arts trained curators specializing in African art are American, it is in part because African art officially became "art" to the wider museum-going public in the United States in 1935 on the occasion of the Museum of Modern Art's exhibition of African art. In the course of the intervening sixty years, American art historians specializing in African art have begun to outnumber anthropologists in examining this material. A grouping of important overview exhibitions and

written examinations of African art as "art" also has been undertaken. The most successful of these examinations have been concerned not only with displaying and discussing African arts of great beauty and visual power but also with addressing important intellectual questions as well. Without such a framework to move readers and viewers to think about the objects in a new way, these powerful works too often are essentialized by implying that their main interest is a Western-derived aesthetic one.

To conclude, when examining larger questions of African art history, it is imperative that one also take up the issue of what African art is not, because many such misconceptions and fictions, through ongoing repetition, have come to bear the onus of "fact." Continued belief in these myths reveals at once how strong a hold they have and the degree to which our continued embrace of them has blinded us to their ongoing impact. One of the hopeful outcomes of this exhibition is that it will be accompanied by reexaminations of and within the field at large—a reconsideration not only of the works of art themselves but also of the rich cultures, histories, and broader concerns that shape them.

## Notes

I wish to thank Karen Dalton, Dominique Malaquais, and Roy Sieber for their comments and suggestions.

1. See also my essay "African Art at the Crossroads: An American Perspective" in *African Art Studies: The State of the Discipline* (Washington, D. C., 1990), pp. 91–107.

2. See René Bravmann, *Open Frontiers: The Mobility of Art in Black Africa.* (Seattle, 1973).

3. John Thornton, *Africa and Africans in the Making of the Atlantic World, 1400–1680* (Cambridge, 1992), pp. 104–05.

4. As noted by the Dutch commentator Olfert Dapper, the early seventeenth-century royal capital of Benin "is certainly as large as the town of Haarlem, and entirely surrounded by a special wall. . . . It is divided into many magnificent palaces, houses and apartments of the courtiers, and comprises beautiful and long square galleries, about as large as the Exchange at Amsterdam." See Dapper, *Description de l'Afrique* (Amsterdam, 1686).

5. See especially Bravmann, *Open Frontiers*; and Sidney Littlefield Kasfir, "One Tribe, One Style? Paradigms in the Historiography of African Art," in *History in Africa* 11 (1984), pp. 163–93.

6. Part of this is taken from my essay "Art Systems and Semiotics: The Question of Art, Craft, and Colonial Taxonomies in Africa," *American Journal of Semiotics* 6, no. 1 (1988–89): pp. 163–93.

7. Giulio Carlo Argan, "Art," in *Encyclopedia of World Art*, vol. 1 (New York, 1959), p. 769. See Argan for a further discussion of the etymological grounding of the term "art" in Europe and the changes in its meaning that have occurred over time.

8. Douglas Fraser, *Primitive Art* (Garden City, New York, 1962), p. 13; Daniel Biebuyck, "Introduction" in *Tradition and Creativity in Tribal Art*, ed. Biebuyck (Berkeley, 1969), p. 6; Warren L. d'Azevedo, "Introduction" in *The Traditional Artist in African Societies*, ed. d'Azevedo (Bloomington, Indiana, 1973), p. 7; and Susan Vogel, "Introduction" in *ART/artifact: African Art in Anthropology Collections* (New York, 1988), p. 17.

9. Roberto Pazzi, "L'Homme, eve, aja, gen, fon et son univers: Dictionaire" (Lomé, Togo, 1976, Mimeographed), p. 214.

10. Kate Ezra, *A Human Ideal in African Art: Bamana Figurative Sculpture* (Washington, D.C., 1986), p. 7.

11. See among others Immanuel Kant, *Critique of Judgment*, trans. J. H. Bernard (New York, 1951); G. W. F. Hegel, *Aesthetics: Lectures on Fine Art*, trans. T. M. Knox (Oxford, 1975); John Dewey, *Art as Experience* (New York, 1934); R. G. Collingwood, *The Principles of Art* (Oxford, 1938); Suzanne Langer, *Feeling and Form: A Theory of Art* (New York, 1953); and Arthur Danto, "The Artworld," *Journal of Philosophy* (1964), pp. 571–84.

12. Hierarchies in art were also delimited early on by Borghini in 1584; see Argan, "Art," p. 767.

13. Ibid., p. 768. For a more recent discussion of the distinction between craft and art, see Collingwood, *The Principles of Art*.

14. For a fuller discussion of this subject, see William Rubin, ed., *"Primitivism" in Twentieth Century Art* (New York, 1984).

# Contributors

| | | | | |
|---|---|---|---|---|
| BA | Barbara Adams | | JDL-W | J. D. Lewis-Williams |
| DAB | David A. Binkley | | DM | Dominique Malaquais |
| HVB | Hilde Van Braeckel | | JM | John Mack |
| MCB | Marla Berns | | MRM | Rachel MacLean |
| MLB | Marie-Louise Bastin | | PRSM | Roger Moorey |
| NB | Nigel Barley | | SJMM | Stanley J. Maina |
| RAB | René A. Bravmann | | WM | Wyatt MacGaffey |
| AC | Anna Contadini | | PMcN | Patrick McNaughton |
| HMC | Herbert Cole | | AN | Anitra Nettleton |
| JC | Joseph Cornet | | JWN | John W. Nunley |
| JXC | Jeremy Coote | | KN | Keith Nicklin |
| KC | Kathy Curnow | | NIN | Nancy Nooter |
| MC | Margret Carey | | KNe | Karel Nel |
| SC | Stefano Carboni | | DO | David O'Conner |
| PD | Patricia Davison | | JP | Judith Pirani |
| EE | Ekpo Eyo | | LP | Louis Perrois |
| NE | Nadia Erzini | | AFR | Alan F. Roberts |
| AF | Angela Fagg-Rackham | | CDR | Christopher Roy |
| REF | Rita Freed | | CHR | Catherine Roehrig |
| RFF | Renée Friedmann | | DHR | Doran Ross |
| CMG | Christraud M. Geary | | ERR | Edna R. Russmann |
| MG | Michelle Gilbert | | MNR | Mary Nooter-Roberts |
| TFG | Timothy Garrard | | PAR | Philip L. Ravenhill |
| RH | Rachel Hoffmann | | ES | Enid Schildkrout |
| TNH | Thomas N. Huffman | | TT | Tanya Tribe |
| TAI | Timothy Insoll | | MFV | Marie-France Vivier |
| FJ | Frank Jolles | | DAW | Derek A. Welsby |
| JK | John Kinahan | | FW | Frank Willett |
| SK | Sandra Klopper | | GvW | Gary van Wyk |
| TK | Timothy Kendall | | RAW | Roslyn Adele Walker |
| ZK | Zachary Kingdon | | RJAW | Roger Wilson |
| BL | Babatunde Lawal | | RW | Rachel Ward |

# Ancient Egypt and Nubia

The southern boundary of ancient Egypt at Aswan (the site of the modern High Dam) separated it from Nubia. In these adjacent sections of the lower Nile Valley, distinct ancient cultures can be traced in the archaeological record as far back as the fifth millennium B.C.

Primarily, these separate cultural identities, which persisted throughout antiquity, reflect the presence of different population groups, but Egypt and Nubia were also affected by important differences in their physical environments. Egypt's part of the Nile Valley was far more fertile for agriculture; moreover, its location at the northeast corner of Africa gave it access, in addition to contacts with the south, to the rest of northern Africa and the Near East, and to goods and ideas that helped to stimulate its rise as one of the earliest great civilizations.

Egypt's distinctive culture, however, was a purely original creation. By about 4500 B.C., the inhabitants of that part of the Nile Valley had begun to develop, by continuous and gradually accelerating stages, a complex society based on the efficient management of land and other resources, sophisticated technical skills, and the beginnings of hieroglyphic writing. Shortly before 3000 B.C., this process culminated in the unification of the entire land under a single ruler, an event that the Egyptians considered the beginning of their dynastic history. For the next three thousand years, Egypt was to remain a major cultural—and often military—power. Today, we are still impressed by the rich legacy of this extraordinary civilization: huge structures, extensive written records, diverse artistic achievements such as portraits carved in stone, and spectacular goldwork.

Nubia's ancient past is more complicated than that of Egypt, and also less understood. Some of its cultures have left only scant traces, in archaeological remains or in Egyptian records. Egypt was always very interested in Nubia, especially as a source of trade, both for local products, such as gold, and for goods, such as ivory, brought from farther south. But despite Egypt's attempts to dominate and even control Nubia, several powerful cultures flourished in this area: the Kerma culture, the Napatan culture—whose rulers conquered Egypt in the eighth century B.C. and ruled as the Twenty-fifth Dynasty—and its successor state, the second of Africa's great ancient civilizations, the kingdom of Meroë.

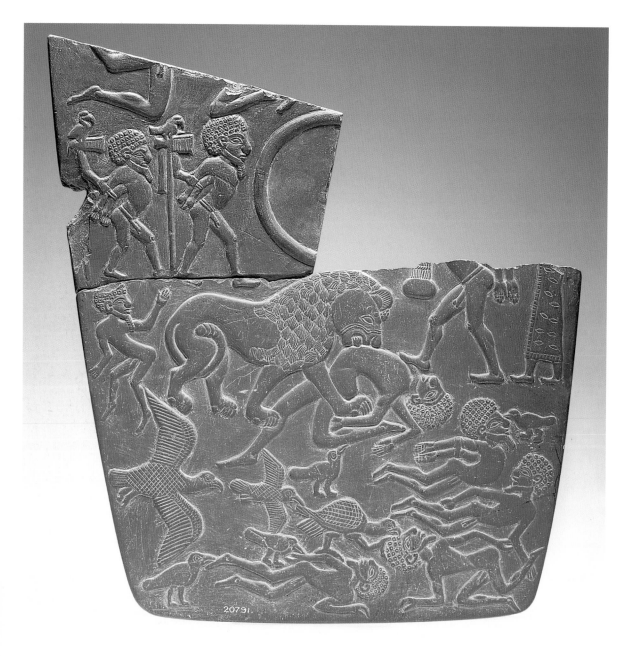

1. **Decorated ("Battlefield") Palette**
Egypt, late predynastic/Naqada III,
ca. 3100 B.C. Slate; upper section:
16.5 x 17 x 0.9 cm; lower section:
32.5 x 31 x 1 cm. The Visitors of the
Ashmolean Museum, Oxford,
1892.1171, and The Trustees of the
British Museum, London, EA. 20791.

Understanding the development of
pharaonic art and civilization depends
in large part on interpreting the
antecedents of its characteristic
images. The great decorated palettes
created at the cusp of the historic
period provide important illustrations
of the developments in imagery
and iconography that led to the
crystalization of the distinct dynastic
style.

Shown together, for the first time, is
the lower half of a gray-slate plaque
from the British Museum, with its
adjoining upper fragment from the
Ashmolean Museum. The plaque,
known as the "Battlefield" palette, is
carved on both sides in low raised
relief with interior modeling of the
forms. Each figure has been elaborated
with rounded details of anatomy;
incised lines depict feathers, hair,
eyebrows, claws, leg muscles, kneecaps,
and so forth. The surface bears fine
scratches made in the process of
carving out the background with tools
of copper and flint. Placed at the
palette's original center is an
undecorated once-circular area defined
by a raised ridge. This area was
reserved for the grinding of ores such
as malachite or ochre for cosmetic use.
For this reason, such plaques are called
palettes. Although decorated on both
faces, the side with the cosmetic pan
was the more important; on this and
other palettes, it bears the more
complex scenes.

The reverse face was often dedicated
to large central figures in more
straightforward compositions. In this

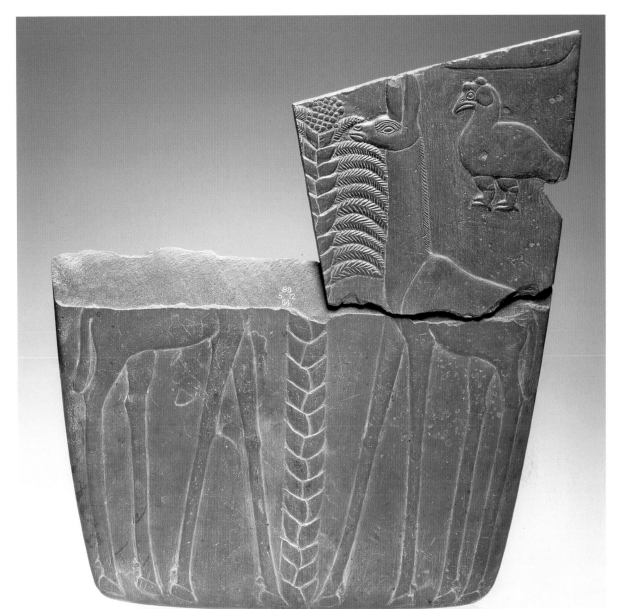

palette, two long-necked giraffe antelopes browse among the fronds of a date palm. The better preserved animal appears to inhale with extended nostrils the appetizing scent of the cluster of fruit at the apex. The textured treatment of the palm branches and trunk forms a decoration of elegance set in the simplicity of the remainder of this face. The palm tree flanked by giraffes is a composition that may have originated in the art of Nubia. It has been suggested that this combination is a metaphor for the king in his temporal aspect as the balance and mediator between symmetrical and complementary elements—a concept of kingship maintained throughout the dynastic period.

Behind the head of one animal is a bird with hooked beak, which has been identified as a helmeted guinea fowl (*Numida melegris*), later encountered in Egyptian art only as a hieroglyph used in the spelling of the word "eternity." Uncommon in Egypt but significant in Nubia, the guinea fowl in this, its earliest, depiction is characterized by the two protuberances on its head—common to the dynastic hieroglyphic sign—although in reality the bird has only one. An additional fragment of this palette (in a private collection) preserves an identical guinea fowl placed to balance the composition. Fragments of the upper scene, visible above the heads of the animals, are unclear but may include the hull of a boat.

The other, more celebrated, face of the palette portrays the gruesome aftermath of a battle. A flock of vultures and crows preys upon the bodies of fallen men. Dominating the battlefield is a stylized lion, which has seized one of the corpses by the abdomen and is attempting to tear it to pieces. The other vanquished soldiers are depicted in the extraordinary twisted attitudes typical of dynastic

scenes of the slain, but never again shown in such grisly detail. It is unclear whether the defeated—bearded, curly haired, and circumcised—are meant to be Egyptians or foreigners similar to those depicted on the famous palette of Narmer (in the Museum of Egyptian Antiquities, Cairo).

On either side of the raised ridge outlining the cosmetic saucer, men with bird-topped standards (on the left) and an official wrapped in a long-fringed mantle (on the right) march with bound captives. In front of one of the prisoners is an enigmatic oval object, which has been variously identified as a stone hanging around his neck or an ideogram representing his land of origin. The common Egyptian convention of supplying inanimate objects with human features is evident in the anthropomorphic representation of the ibis- and falcon-topped standards from which issue human arms that seize other captives.

The top of the palette seems to have been devoted to more representations

of the vanquished. The Ashmolean fragment shows a dead soldier and a scavenging jackal. As no more than one half of the palette is preserved, it is difficult to interpret the scene. Should it be seen as a vignette accompanying a depiction of the king on the now lost upper portion? Or should it be viewed as the main focus of attention, a celebration of the power of the king and the rout of the enemy?

The large lion probably represents the king defeating his enemies, but, like the vultures and crows, it scavenges among the bodies of the dead, humiliating rather than attacking the enemy. The vulture tearing at its victim was also used as a symbol of royal victory in predynastic iconography. In this formative period, the king is associated with various wild animals, his power being naturally derived and unchallengeable. Thus, it has been suggested that this battlefield scene should be interpreted as a sort of expanded litany detailing the victorious king in his many manifestations.

The form of this and other great plaques was clearly inspired by the common cosmetic palette, which in the predynastic period was sometimes adorned with surface decoration. That it was conceived as a cosmetic palette is evident from the circular pan for eye paint integrated into the decoration. The elaborately decorated palettes, however, are quite distinct in quality, size, and function from the common type; all probably came from temples. Only two, from archaeological excavations of the temple at Hierakonpolis, have a known context, but it is highly likely that the one shown here, among others, came from an early temple at Abydos. Their traditional function may have been connected with the ritual of the god's toilet, but the explicit symbolism of the carving makes it clear that they were primarily dedicated as votive objects by the rulers to celebrate great events and great, if perhaps only symbolic, victories. *RFF*

## 2. Female Figurine

Hierakonpolis, Egypt, 1st–
2nd Dynasty, ca. 3000–2700 B.C. Lapis
lazuli, 8.9 x 2.5 x 1.8 cm. The Visitors of
the Ashmolean Museum, Oxford,
1896–1908 E.1057 + 1057a, Gift of the
Egyptian Research Account and
Harold Jones.

The body of this naked female figurine, with a wooden peg surviving in the neck socket, was found in 1898 during excavations in the temple enclosure at Hierakonpolis; it was found beneath a brick wall to the south of the Main Deposit. Remarkably, eight years later, renewed excavations in the same area revealed the detached head, which fit perfectly on the peg. It is probable that the figurine never had feet, but fit directly to another object at that point, possibly to serve as the handle of a spoon. In later Egyptian art, naked servant girls appear in this role.

The use of lapis lazuli, the most highly valued ornamental stone in Ancient Egypt, immediately distinguishes this object. The closest source of lapis lazuli known to have been exploited in antiquity is that in Afghanistan, whence it had been reaching Egypt, perhaps by sea from Syria, for some time before this figurine was made. Neither in Egypt nor in the Near East would an object like this normally have been made from separate pieces of stone. The lapis lazuli used for the head is the rarer, deep-blue type most admired, whereas the body is of the commoner, more mottled variety. It is likely that the juxtaposition was either a deliberate economy or the result of an accident during manufacture (or afterward) requiring a replacement head.

It has been suggested that this figurine might have been made outside Egypt, closer to the lapis lazuli mines. However, the distinctive gesture of the hands and the stylization of the hair in tight little curls close to the head—characteristics found on other contemporary works of art certainly made in Egypt—make it more likely to have been created there. Indeed, such parallels suggest that the woman portrayed here may have been a member of one of the peoples on the periphery of the earliest centralized state in Egypt—people who were drawn into the Egyptian state in the late fourth millennium B.C. by the military activities of the first pharaohs.
*PRSM*

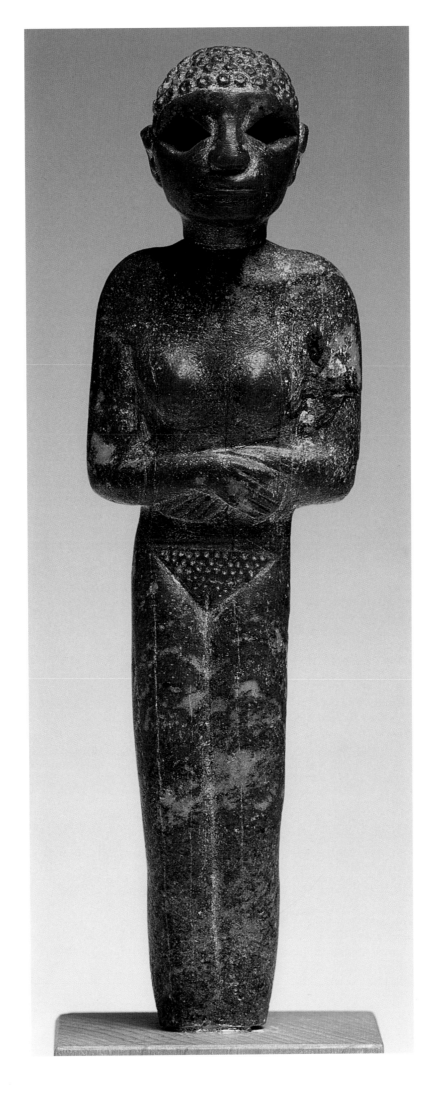

**3. Door Socket**
Hierakonpolis, Egypt, late predynastic/
Naqada III, ca. 3100 B.C. Dolerite
(diabase), 19 x 45 x 78 cm. University of
Pennsylvania Museum of Archaeology
and Anthropology, Philadelphia, Gift
of the Egyptian Research Account,
1898, E. 3959.

This very rare example of early
Egyptian three-dimensional art is of
exceptional aesthetic, symbolic, and
functional interest. Carved from a
single block of stone, the door socket
evokes, rather than fully depicts, a
bound prisoner, imagined prostrate or
doubled up in a kneeling position. The
head projects from one end and is
expressively uplifted; the arms, bent
inward to suggest that the elbows are
bound, are outlined more schematically
on top of the block. A deep depression
between the arms is regularly striated,
and served as the socket for the pivot
(metal or metal-sheathed) of a wooden
door. The top of the block and of the
head are carefully flattened, so that the
door could swing freely.

This door socket was found in situ
(although some doubt this) at
Hierakonpolis in a context suggesting
that it was once part of a now largely
vanished early temple. The socket's
base was left rough, as were the other
three sides, for they were concealed by
adjacent masonry; one corner was
dressed, perhaps to fit against an
adjacent, irregularly shaped stone,
possibly the threshold of the doorway
itself, which would have provided
access to temple or precinct. In this
same temple, the palette of Narmer (in
the Museum of Egyptian Antiquities,
Cairo) was perhaps once housed.

The head faced outward, and the
socket as a whole is the earliest
example of a frequent symbolic
element in later temples,
representations of bound prisoners
(nearly always foreigners) being

subjugated by the pharaoh. Most
relevant are slabs depicting a similar
head or heads, and used for doorways
and windows in which the pharaoh
literally appeared, seemingly treading
on their prostrate bodies. Foreigners or
Egyptian rebels were emblematic of
cosmic disorder or chaos manifest on
earth. The Hierakonpolis door socket
is, however, a unique variation, for here
the emblematic prisoner repeatedly has
the pivot of a temple door (daily
opened and closed for ritual) cruelly
grinding into his back. The temple
itself, rather than the Pharaoh,
represents the triumphant order.

The rendering of the head is
powerful but simplified into strongly
defined planes, lacking the more
careful detail seen in later but still
relatively early examples, and probably
dates to Naqada III, ca. 3100 B.C. or
even earlier. Whether a foreigner or, in
the turbulent days of national
unification, an Egyptian is meant
cannot be determined.  *DO*

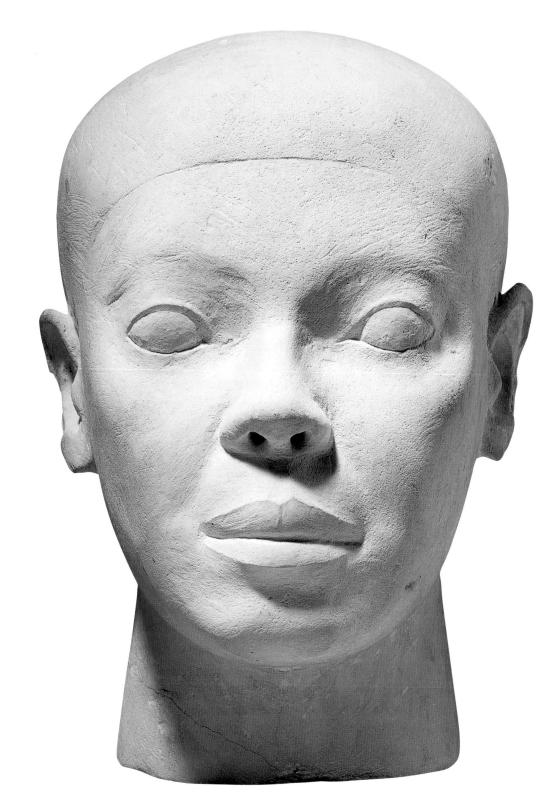

**4. "Reserve Head" of a Woman**
Giza, Egypt, 4th Dynasty,
ca. 2630–2524 B.C. Limestone, 29 x 19 x
25 cm. Museum of Fine Arts, Boston,
Harvard-Boston Expedition 14.719.

Egyptian artists generally created
idealized likenesses of their subjects
rather than true portraits, but in a small
number of instances there are possible
exceptions to the rule. Such is the case
with this life-size head, one
of a category of similar pieces known
as "reserve heads," most of which come
from Giza and date to the Fourth
Dynasty. Complete in itself, the
sculpture consists of a head wearing a
close-fitting wig (as indicated by a line
across the forehead). The features are
rendered naturalistically but sparingly,
and consist of faintly modeled brows
surmounting high arching eyes, set
far apart, and high cheekbones.
Shallow furrows and a "loving cup"
connect a short, straight nose with
drilled nostrils and a full but unsmiling
mouth. Its excavator, George Reisner,
labeled it a Negroid princess because
of its striking and non-Egyptian facial
characteristics. The round face with
its pronounced cheekbones and full
sensuous lips is comparable with
much later representations of Nubian
kings from Kush, Egypt's southern
neighbor. Whether it is a true portrait
of a Nubian or a more generic
representation, it is a striking and
beautiful sculpture that incorporates
the Old Kingdom ideals of restraint
and aloofness.

Exactly how these reserve heads
functioned has never been properly
explained. Recent research has
suggested that they served as models
for embalmers who reconstructed the
face (and sometimes also the torso) of
the deceased in plaster over the
mummy as one of the final stages of
the mummification process. Most,
including this example, were found

neither in the above-ground chapel nor
in the burial chamber, but seemingly
discarded in the vertical shaft leading
to the latter. Most are either damaged
or unfinished in some way, as if to
destroy their magical potency.

Giza tomb 4440 is a mastaba in the
cemetery west of the Cheops pyramid
(Western Cemetery), where that king's
high-ranking officials were buried.
Found in the burial shaft with the
reserve head shown here was a second
head with strikingly different features.
The identity of the owners of the tomb
was not preserved. *REF*

**5. King Mycerinus with Deities**
Giza, Egypt, 4th Dynasty, reign of
Mycerinus, ca. 2529–2501 B.C. Stone
and graywacke, 92.5 x 46.5 cm.
Museum of Egyptian Antiquities,
Cairo, JE 40679.

Mycerinus's pyramid at Giza is much
smaller than those of his predecessors,
Cheops and Chephren, but the
sculpture in his two pyramid temples is
much better preserved. Among the
statues found in the Valley Temple, was
a series of triads representing
Mycerinus with the goddess Hathor
and a personification of one of the
nomes, or districts, of Ancient Egypt.
Four, including this one, are intact.

Mycerinus stands in the center,
wearing the tall White Crown of
Upper Egypt, an artificial royal beard,
and the pleated, wrapped royal *shendyt*
kilt. At his sides, cylindrical objects are
held in his fists. As on most Egyptian
statues of standing men, his left leg is
advanced. The depiction of his
youthful, muscular body (its strength
emphasized by the tension apparent in
the clenched forearms, the high, broad
pectorals, and the tautness of the torso)
clearly represents a masculine ideal
rather than an individual. The
expressionless face seems equally
impersonal, although its rather bulging
eyes and fleshy cheeks, the slightly
bulbous nose tip, and the contours of
the full mouth are features found on all
statues of Mycerinus. This is a portrait
of the king, although highly idealized;
it is the face of a god on earth.

Hathor stands to the king's right.
She holds a *shen* sign, symbolic of

universality, and wears a headdress
composed of cow horns, emblematic of
her manifestation as a cow, and a sun
disk, signifying her close connection
with the sun god, Re. On the king's
left, the lesser importance of the nome
personification is suggested by her
shorter stature. Her headdress, carved
in relief on the broad back slab, is the
emblem of her nome, the Cynopolite
or Jackal nome of Upper Egypt. Each
woman has an arm around the king,
and both stand with their feet nearly
together, in the passive stance of
Egyptian female images. Hathor's left
foot, however, is slightly advanced, to
betoken her status as one of Egypt's
great deities. The women wear the
thick-tressed wigs of goddesses and
long dresses, whose shoulder straps
would have been indicated in paint.
This dress, a standard garment of
Egyptian women, was actually a
sacklike linen tube. It was represented
as unrealistically tight, in order to
display the body. This is the Old
Kingdom feminine ideal: young and
athletic looking. The emphasis on the
pubic area clearly indicates a woman's
paramount function in Ancient Egypt
as the bearer of children. The faces of
the goddess and nome personification,
modeled on the features of the only
god on earth, are softer, rounder
versions of the king's. *ERR*

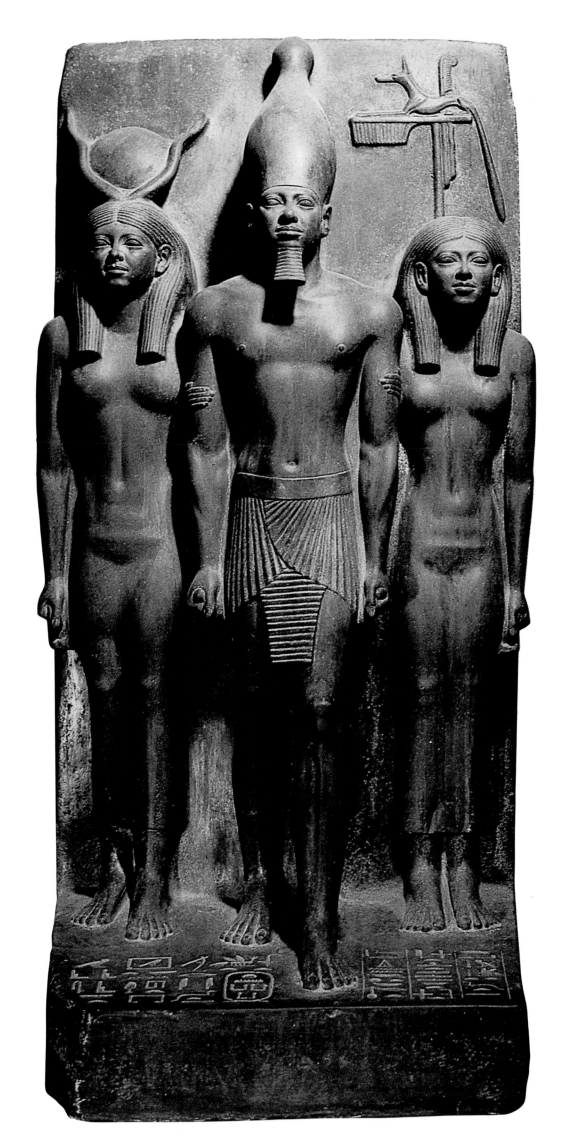

**6. King Pepy I Making an Offering**
Egypt, 6th Dynasty, reign of Pepy I,
ca. 2289–2255 B.C. Graywacke (schist),
15.2 cm high. The Brooklyn Museum,
New York, Charles Edwin Wilbour
Fund, 39.121.

Pepy I is shown kneeling to present
two round offering jars. For a king, this
humble pose was appropriate only in
the presence of a deity. Thus we can be
sure that this statuette was made to be
placed on an altar before the cult statue
in a temple belonging to one of Egypt's
many gods. It may have faced an image
of the goddess Hathor, to whom Pepy
seems to have been especially devoted.

Worship of the gods and goddesses
was one of the most important
functions of an Egyptian king. Himself
a sort of mortal god, he was believed to
receive familial affection and care from
all other deities. This relationship was
often symbolized by representing the
king being embraced by a deity, as on
the early Old Kingdom statue of King
Mycerinus standing between Hathor
and another goddess (cat. no. 5). While
he lived on earth, however, the king
was also a man and served as the
intermediary between his people and
the gods, whom he worshiped on their
behalf. Though Egypt had multitudes
of priests, the king was the only
true priest; for that reason, the walls
of temples were covered with endless
repetitions of the royal image,
making offerings and performing cult

rituals before the figures of the gods.

Pepy's statuette has a vivacity rarely
found in figures of Egyptian kings. In
the latter part of the Old Kingdom,
when he reigned, Egyptian sculpture
had changed, as we can see by
comparing this figure with the statue
of Mycerinus. The serene, highly
idealized style of earlier statues had
given way to equally stylized but more
expressive forms. Pepy's image has been
freed from the stone fill (negative
space) usually left in the interstices
between the limbs and body of an
Egyptian stone statue, and has been
further enlivened by a series of small
exaggerations. The statue's slightly
overlarge head compels attention, with
the almost hypnotic stare of its big
inlaid eyes and its wide but ambiguous
smile. The slenderness of the torso,
unencumbered by negative space,
increases the impression of unusual
length in the arms and legs, which in
turn draws attention to the
exaggeration of the fingers and toes.
The strong sense of presence conveyed
by this figurine makes it perhaps the
finest surviving example of the lively,
expressive qualities of late Old
Kingdom sculpture. *ERR*

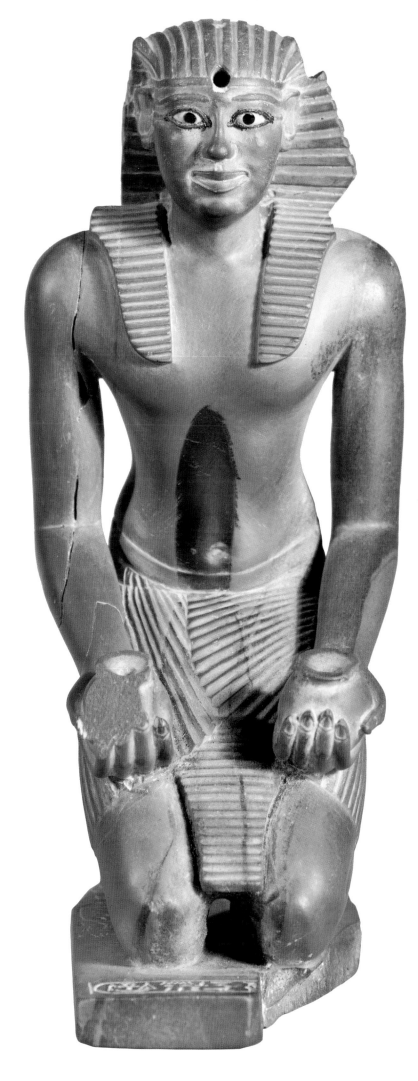

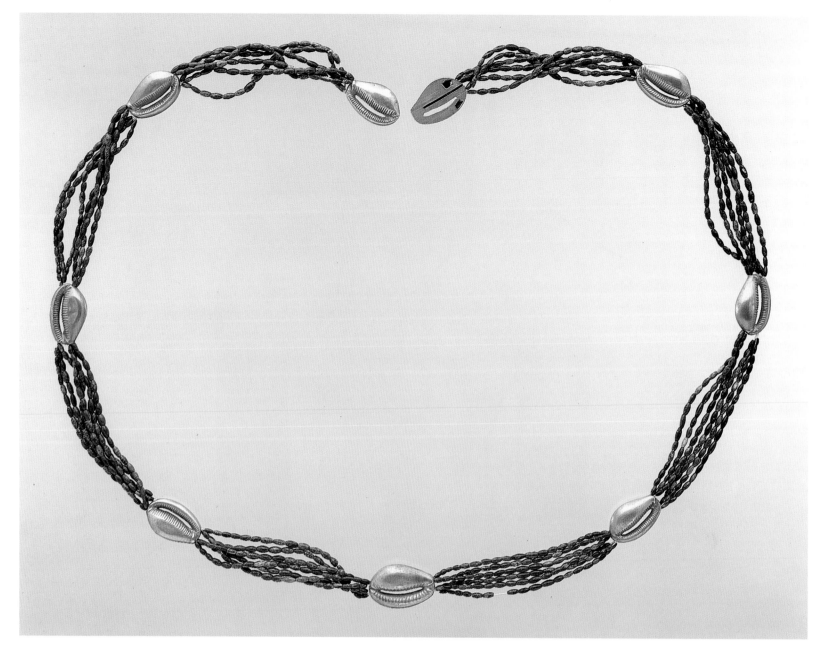

**7. Girdle**
Lisht, Egypt, 12th Dynasty, reigns of
Amenemhat II–Senusret III,
ca. 1929–1841 B.C. Gold and lapis lazuli,
78.5 cm long. The Metropolitan
Museum of Art, New York, Rogers
Fund, 1934, 34.1.154.

In Egyptian jewelry, cowrie shells were used as a decorative motif from prehistoric times. The cowrie seems to have been associated with female fertility and was used in girdles to be worn around the hips. Real shells continued to be used in dynastic times, but imitations of gold or silver are common in Twelfth-Dynasty jewelry of upper-class and royal women. Metal cowries were made in two halves that were either cast or punched with the same stamp and then finished by hand. Most metal cowries have small pellets, which would have made a noise as the wearer moved. One of the present examples retains its pellets.

The elements of this girdle were found in the coffin of a young girl named Hepy, whose intact burial was discovered in a small chamber off the construction shaft of a mastaba tomb at the site of Lisht. The stringing of Hepy's jewelry had decomposed, leaving eight metal cowrie shells and a variety of carnelian and lapis lazuli beads lying loose in the coffin. Only the small lapis barrel beads were numerous enough to have formed a girdle, and they were restrung with the metal cowries in the present form. One metal shell forms a sliding clasp. The date of the burial is still under discussion, but pottery and stone vessels seem to place it in the middle of the Twelfth Dynasty. *CHR*

**8. Statuette of a Dancing Pygmy**
Lisht, Egypt, 12th Dynasty, reigns of
Amenemhat II–Senusret III,
ca. 1929–1841 B.C. Ivory, 6.4 cm high.
The Metropolitan Museum of Art,
New York, Rogers Fund, 1934, 34.1.130.

This diminutive figure has often been
described as a dwarf, but its non-
Egyptian hairstyle and relatively well-
proportioned limbs leave no doubt that
the sculptor's intention was to portray
a pygmy. In ancient times, as today,
pygmies lived far to the south of
Egypt. There is evidence, however, that
individuals were occasionally captured
and carried northward along the
trading routes that led eventually to
Egypt. The most vivid of these
documents is a letter written shortly
after 2250 B.C. by King Pepy II, who
was then a child, to a southern
nobleman who had obtained a pygmy
and was bringing him to court. This
letter, which so greatly honored the
recipient that he had it copied on a
wall of his tomb at Aswan, is an
amusing blend of formal royal protocol
and lively expressions of the little boy's
excitement at the prospect of seeing so
rare a creature. Young Pepy was
familiar with travel on the Nile; he
worriedly enjoined the seasoned

soldier/trader to guard the pygmy
carefully, lest he tumble overboard.

The Egyptians valued pygmies for
their dancing, which was believed to
have religious meaning. The ivory
figure's clapping hands and bandy-
legged stance are a dancing pose. It
seems to have been the leader of a
group of three similar pygmy figures
found with it. The three (now in the
Museum of Egyptian Antiquities,
Cairo) were mounted in such a way
that when threads—possibly attached
to the statuette shown here—were
pulled, the figures twisted from side to
side. The effect must have been
comical, but the masterly, highly
detailed carving of each figure and the
religious significance of their dance
show that this set of dancing pygmies
was no mere toy.

The pygmy group was found, along
with a girdle (cat. no. 7) and other
jewelry, with the burial of a young girl
named Hepy. The delicate, rather
modest pieces of jewelry seem
appropriate to the girl's youth and to
her good, but by no means exalted,
social position. It is hard to imagine,
however, how Hepy came to be buried
with objects so rare and splendid as the
troupe of pygmy dancers. *ERR*

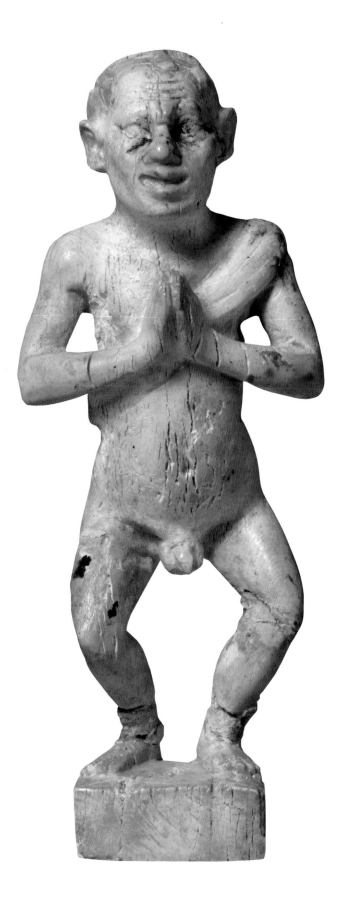

**9. Figure of a Protective Demon**
Thebes, Egypt, 18th Dynasty, reign of
Horemheb, ca. 1319–1307 B.C. Wood,
37 x 40.7 x 18 cm. The Trustees of the
British Museum, London, EA. 50703.

**10. Figure of a Protective Demon**
Thebes, Egypt, 18th Dynasty, reign of
Horemheb, ca. 1319–1307 B.C. Wood,
37 x 40 x 18 cm. The Trustees of the
British Museum, London, EA. 50704.

These bizarre figures, one with an antelope-like head and the other with a turtle for a head, come from one of the almost totally looted royal tombs in the Valley of the Kings. They are rare three-dimensional versions of the beneficent demons that were more often carved or painted on coffins and on the walls of tombs. Like the magical spells in the *Book of the Dead* and other funerary texts, these guardian demons were intended to protect the soul on its perilous journey to the afterworld.

Both figures sit with their torsos facing front and their lower bodies facing sideways. This unusual pose is sometimes regarded as a breach of the strong Egyptian preference for frontality in statue design. It is probable, however, that the twisting of these bodies was simply the result of faithful copying from two-dimensional prototypes that, like almost all Egyptian figures in painting and relief, would have had the shoulders in front view and the hips and legs in profile. *ERR*

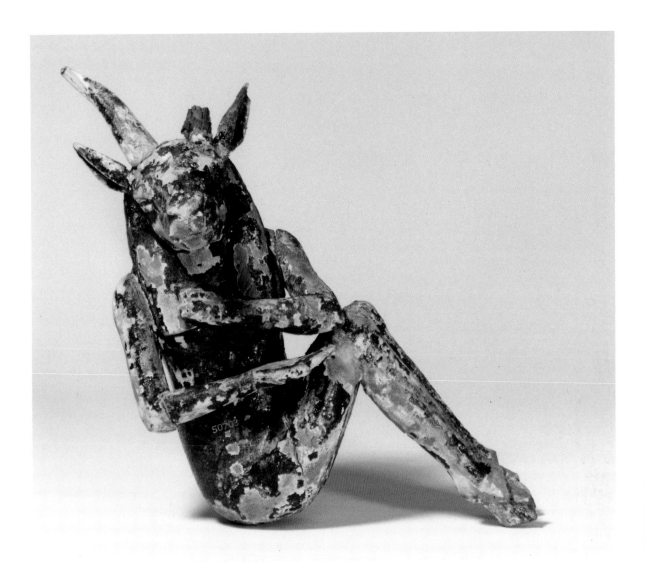

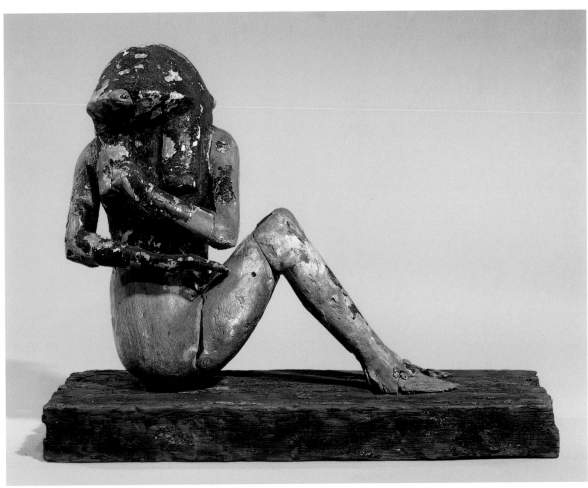

**11. Nubian Girl with Monkey and Dish**
Egypt, 18th Dynasty, ca. 1390–1352 B.C.
Ebony, 17.5 x 8.7 x 5.6 cm. Petrie
Museum of Egyptian Archaeology,
University College, London, UC. 9601.

This figure of a Nubian child is set on a rectangular base made separately of the same wood. It was reconstructed from fragments by the restorer Martin Burgess when he worked at the Petrie Museum in the 1950s. The slave girl is naked with her left foot forward, in striding mode. Her head is shaved except for four round patches of tightly curled hair. Her ears are pierced. The arms are made in two parts, joined at the shoulders and elbows. As is usual in Egyptian wooden statuary, the feet are made separately and attached to the legs. Pegs through the right and left sides of the base join the two pieces together.

The girl carries a large serving dish, decorated on the interior with a daisy-wheel design with dotted petals. This design is found impressed into bronze dishes of this period, and the shape is common in stone and faience in the New Kingdom. The zigzag decoration on the rim is also found on spoons of this period. The long, splayed foot of the dish rests on the head of a monkey, which faces out to the figure's left side. This type of monkey was especially popular in the reign of the pharaoh Amenhotep III toward the end of the Eighteenth Dynasty. The material of which this object is made would have been imported from elsewhere in Africa, as would such monkeys. *BA*

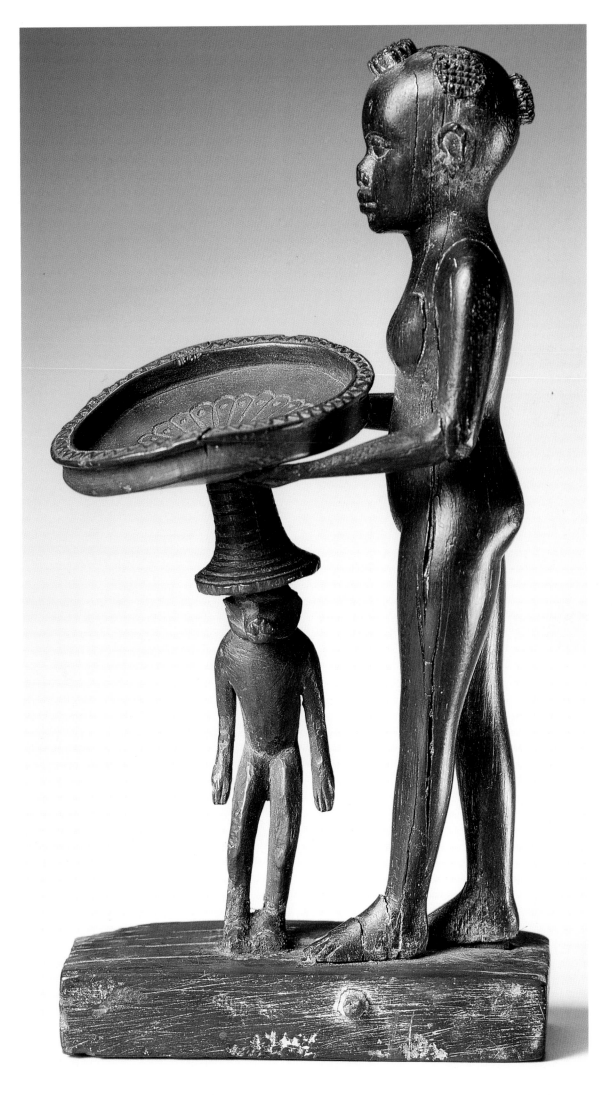

**12. Statue of King Senkamenisken**
Gebel Barkal, Nubia, Napatan,
643–623 B.C. Granite, 147 cm high.
Museum of Fine Arts, Boston,
Museum Expedition, 23.73.

This standing figure of King
Senkamenisken was excavated at Gebel
Barkal, in a part of Nubia that the
Egyptians called Kush. It was made for
one of several temples at this site
dedicated to the Egyptian god Amun,
and was carved by an accomplished
sculptor whose familiarity with
Egyptian style and royal imagery
suggests that he was trained in Egypt;
he may well have been an Egyptian.
Senkamenisken was the ruler of Kush,
but he is represented here as king
of Egypt. His pose is that of an
Egyptian king; his kilt is the traditional
Egyptian royal kilt, and in the well-
carved hieroglyphic inscription, he is
given the titles of an Egyptian king,
and his name is written in the oval of
the Egyptian royal cartouche.

Senkamenisken was a pretender to
the Egyptian throne, but his forebears
had actually ruled Egypt as the
Twenty-fifth Dynasty. As early as
747 B.C., the Kushite ruler Piye took
advantage of political weakness and
dissension within Egypt to invade and
conquer his northern neighbor. This
conquest was only temporary, but it
was repeated in about 715 B.C. by Piye's
successor, Shabako, who established
Kushite control over the entire country.
Shabako and his successors—of whom
the best known is Taharqa—were
effective rulers, but they never
managed to subdue the resistance of
local princes, whose disaffection was
exploited by leaders of the expanding
Assyrian empire. The Assyrians

invaded Egypt several times during the
Twenty-fifth Dynasty and, in 656 B.C.,
they caused its downfall by driving
Taharqa's successor, Tantamani, back
into Kush. Tantamani never returned
to Egypt, nor did his successors,
Atlanersa and Senkamenisken; but
they upheld their claim to Egypt, as
did the generations that followed.
Kushite interests gradually turned
southward, however, and Egyptian
influence declined. Eventually the
capital was moved from the vicinity of
Gebel Barkal to Meroë, much farther
south. There, the distinctive Meroitic
culture reached its full development.

The Kushite kings claimed that
Amun had called them to rule Egypt as
legitimate pharaohs. They were proud,
however, of their Kushite heritage; this
pride is reflected in their images, which
combine traditional Egyptian royal
costumes and poses with elements
based on their own traditions. They
expressed their special devotion to
Amun in his Nubian form of a ram or
ram-headed man (in Egypt he was
usually represented as a man) by
wearing ram's-head amulets on
necklaces and earrings. They were
shown wearing many of the traditional
Egyptian crowns, but frequently their
short-cropped hair was covered only by
a broad, non-Egyptian diadem. At the
forehead, where Egyptian kings had
traditionally worn a uraeus cobra, the
Kushite pharaohs wore two cobras.
Like the Egyptian elements of
Senkamenisken's statue, his Kushite
headdress with a double uraeus and his
ram's-head necklace (visible as a
roughening of the stone, to hold gold
leaf) expressed the Kushite ideal of
Egyptian kingship. *ERR*

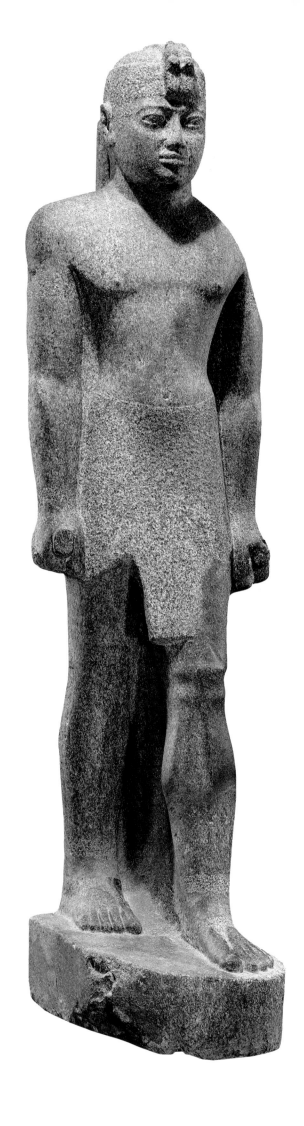

**13. Vessel in the Form of a Bound Oryx**
Meroë, Nubia, Napatan, early
7th century B.C. Calcite (Egyptian
alabaster), 8.2 x 17.3 x 6.5 cm. Museum
of Fine Arts, Boston, Museum
Expedition, 24.879.

One of the richest early graves discovered at Meroë was a rectangular pit burial, without superstructure, that contained the body of an adult female apparently lying on a bed. This burial had much in common with the contemporary tombs of the early Twenty-fifth Dynasty queens at El-Kurru. The deceased was surrounded by her funeral goods: toilet articles, jewelry, a pair of mirrors, pottery, nearly thirty bronze vessels and nine in calcite, of which three, like the one shown here, were nearly identical and took the form of bound oryxes. Although no exact parallel for such vessels is known, the stone from which they were made derived from Egypt. Since many calcite vessels are found in Kushite graves, it seems probable that they were made in Egypt and shipped to Nubia as containers for expensive oils and unguents.

The ovoid form of the oryx's body approximates that of the contemporary type of unguent vessel known as an alabastron. The normal alabastron rim has been altered to form the open-mouthed head of the animal, made as a separate piece, while the expected lugs have been replaced by the bound legs, which form a convenient handle. The animal's mouth, which is the vessel's mouth, would evidently have been stoppered. The tail and ears are rendered in low relief, and the testicles are carved in the round. The eyes were once inlaid, and there was an inset triangle of reddish material on the forehead, of which traces survive. Two holes drilled at the top of the head held horns, in another material, now lost. On the surviving original mate to this vessel (in the Sudan National Museum, Khartoum), the horns are made of carved slate, and the restored horns here duplicate these. *TK*

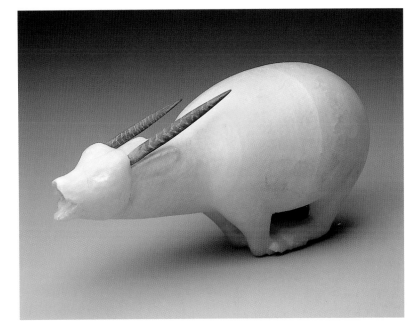

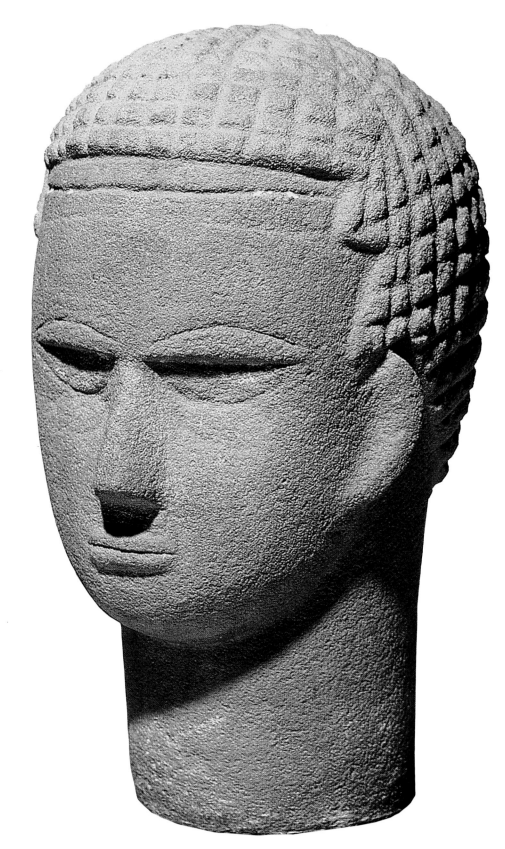

### 14. Male Head
Nubia, Sudan, Meroitic period,
2nd–3rd century A.D. Sandstone, 26.7 x
15.5 x 18.4 cm. Sudan National
Museum, Khartoum, SNM. 13.365.

This male head rests on a long
columnar neck. The opening between
the pouting lips is indicated by a
straight narrow slit. There is little
modeling of the long, pointed nose and
no indication of nasal arches and
nostrils. Slight depressions mark bags
beneath the eyes. The upper lids are
not indicated, their position being
occupied by horizontal orbital ridges
cut back vertically to the eyeball. By
the treatment of the eyes, the sculptor
imparted a powerful, brooding aspect
to the piece. Toward the hairline, the
smooth brow has a shallow horizontal
groove with another, much deeper
groove above. The close-cropped hair is
represented by a square lattice on the
top and by a diamond lattice on the
back and sides. The ears are simple
protrusions without modeling. The
skin was painted a reddish-brown, and
the hair was black. The eyelids, upper
line on the brow, and neck bear traces
of white paint.

This head's stylized form is highly
unusual, and it is difficult to find
convincing parallels among the large
number of human heads from northern
Nubia that come from *ba* statues.
(Often depicted as a human-headed
bird, the *ba* represented the soul of the
deceased.) These are more naturalistic,
with lentoid eyes delimited by upper
and lower lids, arched orbital ridges,
and realistically modeled ears.
Nonetheless, a number of parallel
details can be found on *ba* statues,
particularly the incised lines on the
forehead, thought to represent
cicatrices rather than a diadem.

Significantly, however, the lower end
of the neck has been dressed flat. This
head thus falls into the category

referred to as "reserve heads" (see cat.
no. 4). Such heads may have taken the
place of the more traditional *ba* statue
in the pyramid chapels as a
representation of the deceased. Reserve
heads are rare in Nubia, but another is
known from Gemai, again with the
diamond lattice pattern used to
represent hair but with facial features
executed in a very different manner. A
painted representation of reserve heads
is to be found on a Meroitic jar from
the cemetery at Nag Gamus in
Egyptian Nubia. *DAW*

**15. Incense Burner**
Ballana, Nubia, X-Group,
late 4th–early 5th century A.D. Copper
alloy, 25.7 cm high; pedestal:
11.4 cm wide. Museum of Egyptian
Antiquities, Cairo, JE 70924.

This incense burner is in the form of a
pine cone. The scales on the upper half
of the cone are tightly closed, while
those on the lower half are open. Each
is decorated with a veined pattern and
with small concentric circles. A lid on
the top of the cone is hinged and
pierced by a large hole and a row of
smaller holes to allow the fumes to
escape. The cone is supported on an
openwork, slightly tapering cylinder
decorated with two registers of a
swirling leaf and tendril motif. At the
base of the cylinder, a band of spherical
beads masks the point of contact with
the "Attic" base. This sits on a square
pedestal, the sides of which are
decorated with an openwork floral
pattern, as on the cylinder. Each panel
is delimited by a vertical register at the
corners of incised concentric circles and
with a register of rope pattern above.
*Ankh* signs are incised in the top
corners. The pedestal is supported by
four lion's paws.

The character of this piece puts it
firmly among the repertoire of the Late
Antique period. There is some doubt as
to its place of manufacture, whether it
is a Nubian product or whether it was
made in Egypt north of Aswan. L.
Török has compared it with a similar
piece, probably from Faiyum. There
was certainly much imported material
among the grave goods found in the X-
Group graves at Ballana and the nearby
cemetery at Qustul. It was found lying
on the floor adjacent to the burial of a
female adult in the antechamber of the
tomb, probably that of a queen. *DAW*

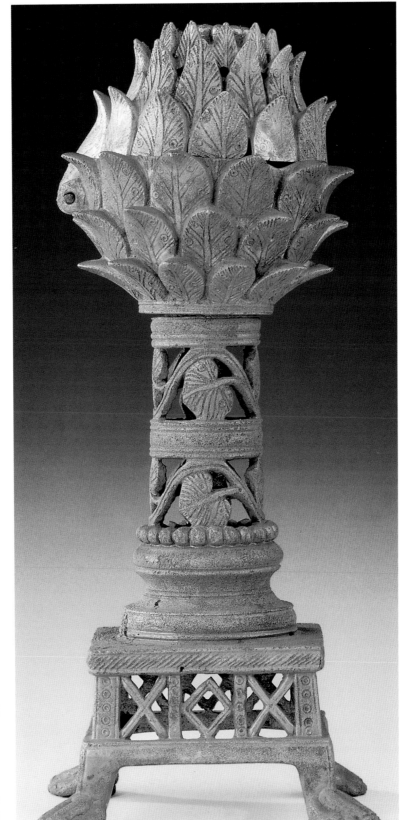

# Eastern Africa

Eastern Africa is geographically complex, ranging from the mountains of central Ethiopia to coastal plains and offshore islands. Farther inland are the great lakes of Africa, forests, and the Rift Valley, the cradle of humankind. Tools and fossil remains of the earliest humans have been found in an area that extends from the Olduvai Gorge in Tanzania and northward into Ethiopia.

Much more recently, eastern Africa has, like much of the continent, witnessed migrations and population displacements, which have created an area that is culturally and linguistically complex. The incursion of Bantu peoples from the west displaced earlier hunter-gatherers. Eastern Christianity came to Ethiopia from a base in northern Egypt in the fourth century. Later, through trade and holy wars, Islam conquered much of the Mediterranean littoral, the Nile Valley, and the eastern coastal regions. Like the Christians, the Muslims brought literacy in the combined names of religion and mercantilism. Still later, explorers, traders, and missionaries—first from Portugal and later from most other European countries—introduced Roman Catholicism and a variety of Protestant faiths to the coast. In 1864, Africa was partitioned among the European powers. The colonial period ended in the mid-twentieth century with the independence of most states not only in eastern Africa but throughout the continent.

This complex past is reflected in the arts of eastern Africa. These include the manuscripts and processional crosses of Ethiopian Christianity, as well as objects associated with Islam. Farther south, along the coast, are architectural forms influenced by Arabic sources via the Indian Ocean trade and adapted for local uses; the unique blend of art forms and ideas that resulted is called Swahili. In southern Sudan, in Kenya, and as far south as the island of Madagascar are found memorial statues dedicated to the distinguished dead, ranging in style from extremely abstract renditions of the human body to detailed tomb sculptures. Many works relate to changes of status, from initiation into adulthood for young women and men to induction into leadership roles. Each group has its own objects and system of symbols, though some have been shared among several groups. Within each group, individuals may announce or underscore their status by displaying personal objects, furniture, clothing, or body arts.

**16. Processional Cross**
Ethiopia, before 1868. Metal,
47 x 35 cm. The Trustees of the British
Museum, London, 1868.10-1.16.

For the Ethiopian church, the cross is not merely a symbol of Christ's suffering and death but, more importantly, a mark of his resurrection. The image of the cross is often portrayed in Ethiopian paintings in place of the Crucifixion, not only signifying respect for the dead Christ but also functioning as an icon that conveys the salvational and protective effect of averting evil. Such a function is clearly expressed in the prayer known as "The Rampart of the Cross." Cruciform decorative designs fill in the window openings of the thirteenth-century rock-hewn churches of Lalibala, one of which is itself shaped like a cross, and the cross can be seen on the roofs of churches, signaling the building's holy function.

The numerous processional crosses held by priests during religious services and ceremonies also powerfully establish a space of holiness and salvation, and act as symbolic markers pointing out the way for the faithful. Processional crosses are mostly made of metal (iron, copper, bronze, silver, and,

rarely, gold) or occasionally wood. The early processional crosses of the twelfth and thirteenth centuries were mainly of copper and bronze, cast in the lost-wax method. Another technique involved the tracing of the desired cross image onto a sheet of metal, which was then cut or punched out. Iron staff crosses of the seventeenth and eighteenth centuries were cast and then hammered. To reinforce the Christological message of the Ethiopian church, designs were incised or stamped on the cross, communicating well-accepted truths and thus increasing the rhetorical power of these holy insignia. Their iconography included God the Father, the Archangels Gabriel and Michael, and the Four Evangelists. The image of the Virgin and Child was also popular, particularly after Emperor Zar'a Yacob bolstered the Virgin's cult in the fifteenth century. In this example, the intricate interlocking design echoes decorative forms found on the screens and friezes of Ethiopian medieval churches. *TT*

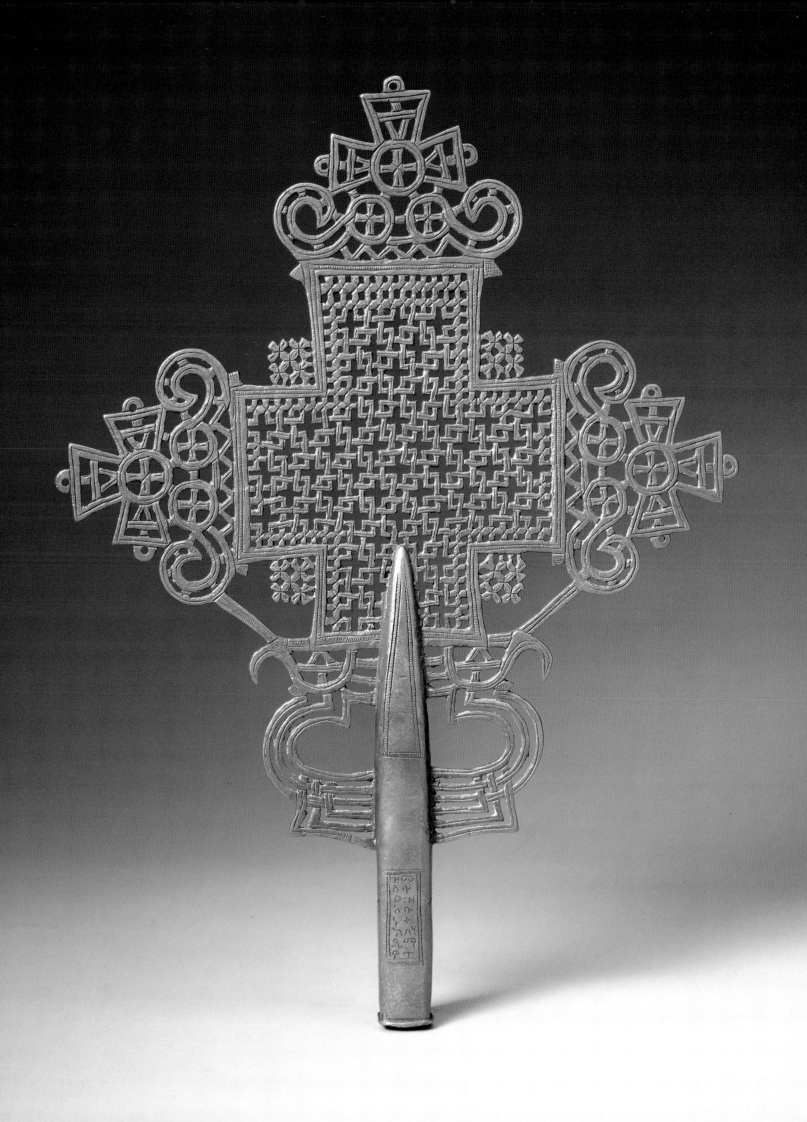

## 17. Slit Drum

Bahr el-Ghazal, Omdurman, Sudan, 19th century. Wood, 80 x 271 x 60 cm. The Trustees of the British Museum, London, 1937.11-8.1.

Wooden slit drums like this have long been associated with prominent chiefs and leaders in the southern Bahr el-Ghazal region of Sudan and in neighboring portions of the Central African Republic and Zaire. Massively conceived, such drums serve as voices of authority: they are "tongues of chiefs" and their scale is dependent on the rank of their royal owners. The grand scale of this particular drum attests to its pivotal place in late nineteenth-century Sudanese history. Captured by Horatio Herbert Kitchener, Commander of the Anglo-Egyptian forces, from the Khalifa Abdullahi, it serves as a memorial of the decisive British victory at the Battle of Omdurman in 1898. The defeat of the Khalifa brought to an end Sudanese resistance to British and Egyptian rule as well as the dream of Mohammed Ahmad, the self-proclaimed Mahdi or Messiah, of establishing an independent state based on the principles of Islam.

The Holy War against the British Empire lasted nearly twenty years and left both sides exhausted. In triumph, the British returned home with ample evidence of the defeated foe; the sheer quantity of war trophies testified to the epic dimensions of the struggle against the Mahdist's forces. Of the thousands of objects brought back from the Sudan, few can compare with this impressive drum, presented by Kitchener to Queen Victoria. Apparently owned by Khalifa Abdullahi, who succeeded the Mahdi upon the latter's death on June 22, 1895, it had surely been used in order to lift the spirits of the Khalifa's troops.

It is distinguished not only by its size, but also by the incised designs carved along both flanks of the bullock. Slit drums in the form of cattle, goats, or other animals from the Bahr el-Ghazal are typically not only smaller, but their bodies are sculpted smoothly and devoid of decorative effects. In this case, however, mathematically precise floral patterns, a fretted crescent, meander patterns, and a single reference to a long-bladed scimitar are carved in broad bands across the flank surfaces, their geometric regularity and precision reminiscent of ancient Islamic shapes expressing God's unity and presence. It is assumed that the drum was originally carved in the distant non-Muslim parts of southern Sudan (or by someone from that region) and adapted to a militant Islamic context. A traditional southern Sudanese figured drum, used in the service of the Khalifa and for fighting in the path of God, has been emblazoned with the signs and patterns of Muslim belief. *RAB*

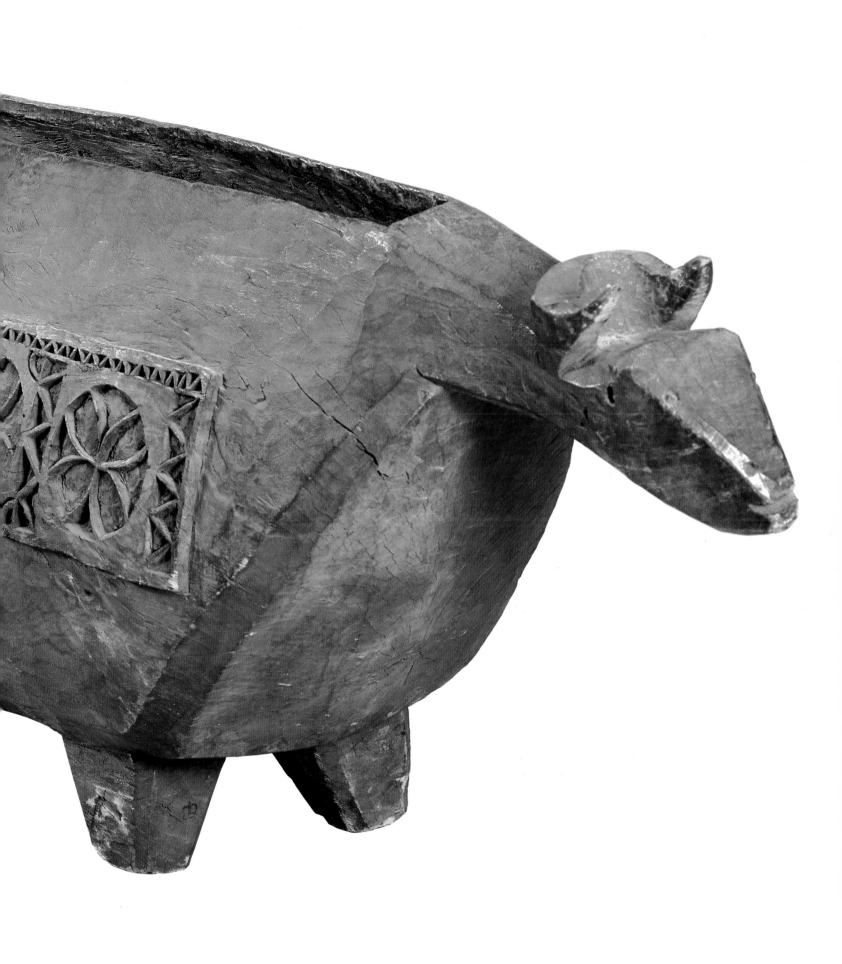

## 18. Dance Shield

Kikuyu, Kenya, early 20th century. Wood, 60 x 42 x 8 cm. Collection of Marc and Denyse Ginzberg.

Among the Kikuyu in central Kenya, as in many parts of Africa, initiation is—or has been—a significant spur to artistic activity. For boys, initiation is the prelude to entering the social status formerly associated with warriors. Those initiated in a particular territory once formed a unit that executed raids and ensured the defense of villagers. Some aspects of the initiation process, such as the display of shields in initiation "dances," make reference to these military activities, which were once expected of initiated men.

In the early 1900s, initiation shields were of various kinds; unlike war shields (*ngo*), which were crafted from animal hide, they were made of wood or bark. Those of the type shown here were usually carved from a solid piece of light wood by specialist craftsmen for a display of dance known as *muumburo*. As they have an armhole on the inner face of the shield, they could

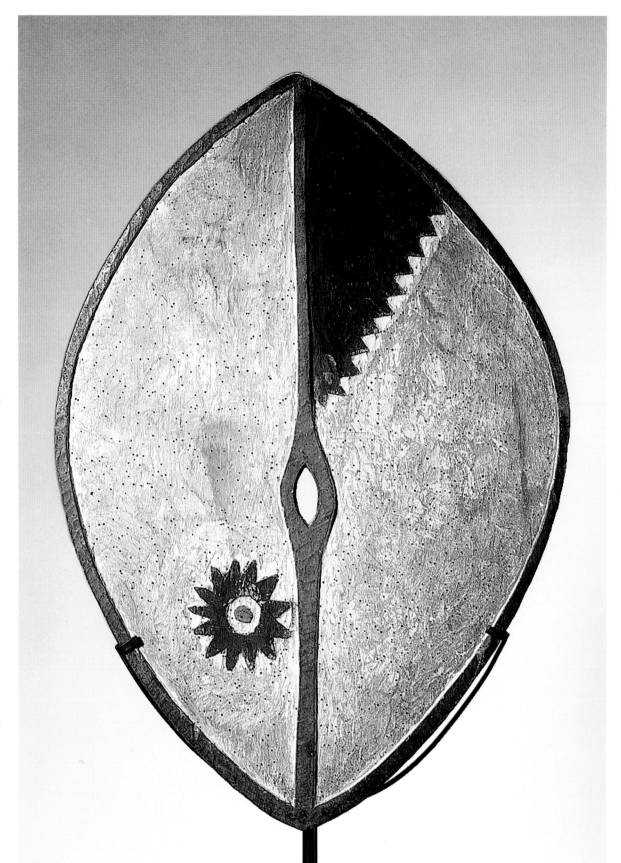

be manipulated by flexing the arm rather than being held in the hand.

All wood shields were decorated with nonfigurative motifs on the outer surface and usually on the inside as well. These designs were by no means arbitrary. The patterning had to be agreed upon in advance of each initiation, and then applied onto the surface of shields to be used on that particular occasion. Such patterning varied both by territorial unit and initiation period. Shields used at the same initiation were not necessarily identical. Boys usually passed their dance shields on to their younger relatives. Many scraped off the old decoration, replacing it with the pattern chosen as the "insignia" of their particular initiation group. Only when more than one boy from a family was to be initiated on the same occasion was a wholly new shield commissioned with patterns selected for that year. Surface ornamentation was also applied to the back of the wooden shields— often in a form reminiscent of an eye and eyelid. *SJMM*

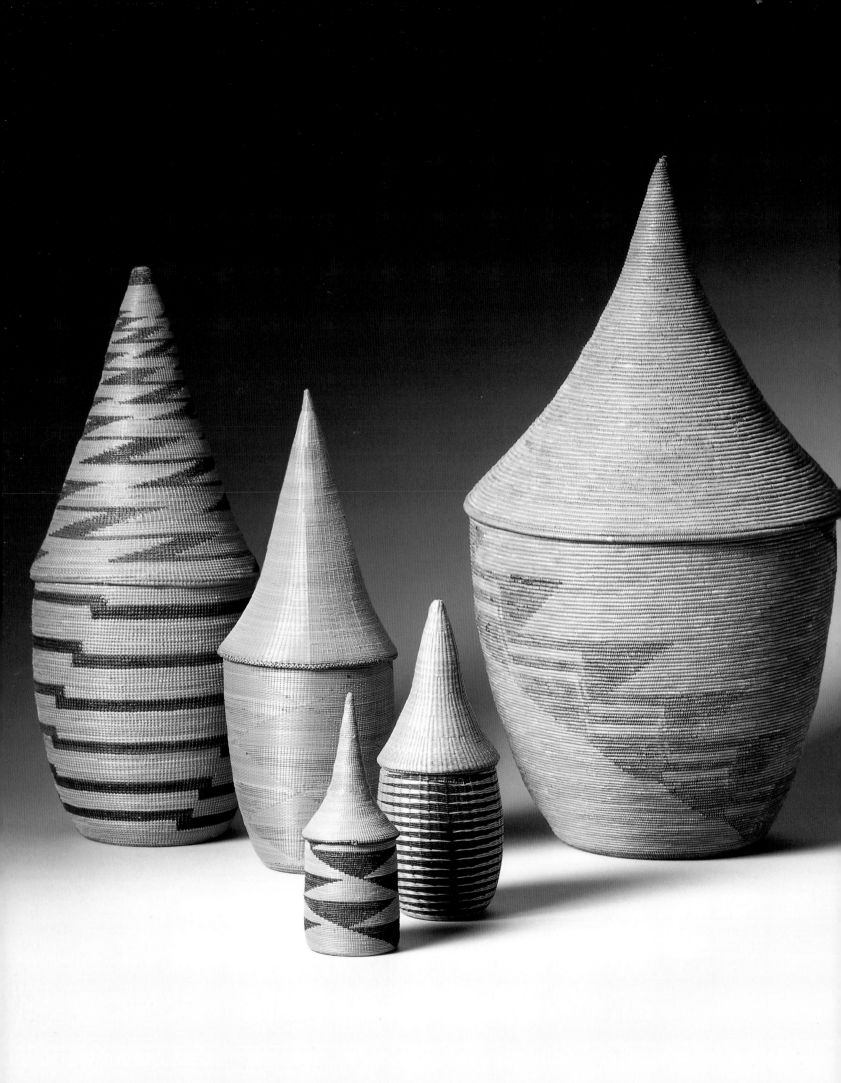

## 19. Five Miniature Baskets

Tutsi, Rwanda and Burundi, first half of the 20th century. Dyed grass; left to right: 28 x 11 cm; 23 x 9 cm; 33 x 18 cm; 14 x 6 cm; 11 x 4.5 cm. Private collection.

Coil-sewn baskets (*agaseki*) with conical lids were made by Tutsi women of the aristocracy. The fine coil sewing and the precisely worked-out spiral patterns, many of which have names, were time-consuming to produce, and called for exact calculations in the stitching. Since the Tutsi were the ruling group in Rwanda, their women had the leisure they needed to perfect their skill in making these elegantly patterned containers. Often, the baskets they created were miniature marvels, some no more than fifteen centimeters high. The restrained color palette and subtle variations of pattern, based on spiral lines and zigzags with triangles incorporated, make this among the world's most refined achievements in basketry.

The traditional colors were the natural pale gold of the grass with the pattern in black or red. Black came from boiling banana flowers; the sap gave the black dye *inzero*. The red dye came from boiling the root and seeds of the *urukamgi* plant. By the 1930s, imported dyes had expanded the range of available colors to include green, orange, and mauve.

Earlier baskets, such as these lidded ones, show a delicacy of design that later examples, made at craft centers for sale to tourists, lack. Baskets made in Rwanda have a plain, undecorated lid; lids of those made in Burundi may be patterned. *MC*

FOLLOWING TWO PAGES
## 20. Skirt

Iraqw, Tanzania, early 20th century (?). Dressed animal skin, glass beads, sinew thread, and metal bells, 170 x 70 cm. Commonwealth Institute, London, T/TANZ/134.

The Iraqw peoples, numbering today perhaps as many as 300,000 or more, inhabit the Arusha region of northern Tanzania. Although they are often said to be Southern Cushitic-speaking, the classification of their language remains disputed. The Iraqw keep livestock and grow crops on a plateau to the west of the Rift Valley. Their neighbors are the Maasai, Hadza, Barabaig, and Gorowa, as well as several Bantu-speaking peoples. Their art and material culture have been little studied.

Iraqw beaded skirts are arguably the most elaborately decorated items of dress in eastern Africa, and the skirt shown here is an excellent example of the tradition. It consists of four hide panels, on which thousands of glass beads have been applied with a lazy-stitch to form a number of bands and geometric motifs. It is also adorned with three bells. The central panel was worn at the back; in front, the right edge was wrapped over the left. The skirt must be imagined tied around the waist of a young woman whose movements, whether walking or dancing, are constrained by the weight of the skirt (some three-and-one-half kilograms or more) and emphasized by the swaying of the fringe and the tinkling of the bells. A fully dressed girl would also be adorned with anklets, wristlets, bracelets, and necklaces; her skin would be oiled and perfumed and her hair specially dressed. The range of colors of the beads employed here—predominantly white, red, and black, with some dark blue and a little yellow—is typical of earlier eastern African beadwork; later examples incorporate a range of other, complementary colors, such as light green and light blue.

The history of this skirt before 1979, when it came to its present home, remains uncertain; any attempt to date it is speculative. The traditional context in which such skirts were made and used, the girls' initiation ritual known as Marmo, was abolished by the government-appointed chief, at least publicly, in 1930. In this rite of passage, girls of the age of fourteen or so were secluded for a period of six months to a year and underwent a symbolic death and rebirth. During this time, they were fed rich foods so that they became fat; their bodies were oiled, perfumed, and decorated, and they were taught sexual manners, as well as the secrets of the exclusively female Marmo Society. The rite also seems to have had an important purifying aspect, so that the young girls were reborn with a new innocence and dignity. During this period, each girl turned the leather cape with which she entered seclusion into an elaborately beaded skirt adorned with a design of her own choosing.

Despite its public abolishment, elements of Marmo have survived. Songs associated with the ritual continue to be sung at ceremonies and beaded skirts continue to be worn. It is also possible that at least some women have continued to practice a version of Marmo, the secrets of which remain guarded by initiated Iraqw women.

While it seems likely that the motifs decorating this and similar skirts have symbolic significance, their meanings are unknown to outsiders. In other contexts, the color white (*awaak*) has associations with light, clarity, health, well-being, healing, curing, and purification. It may be that the white beads that dominate this and other skirts symbolize in some way the new purity of the Marmo initiate. *JXC*

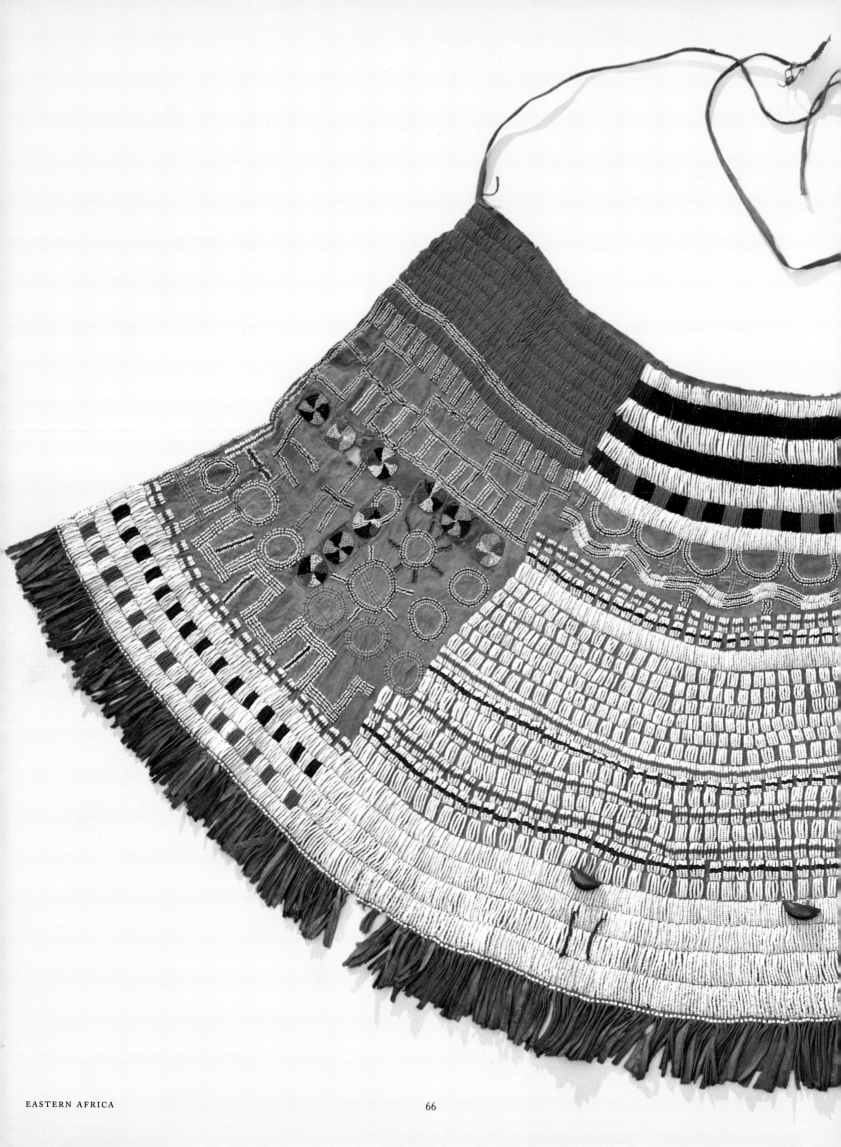

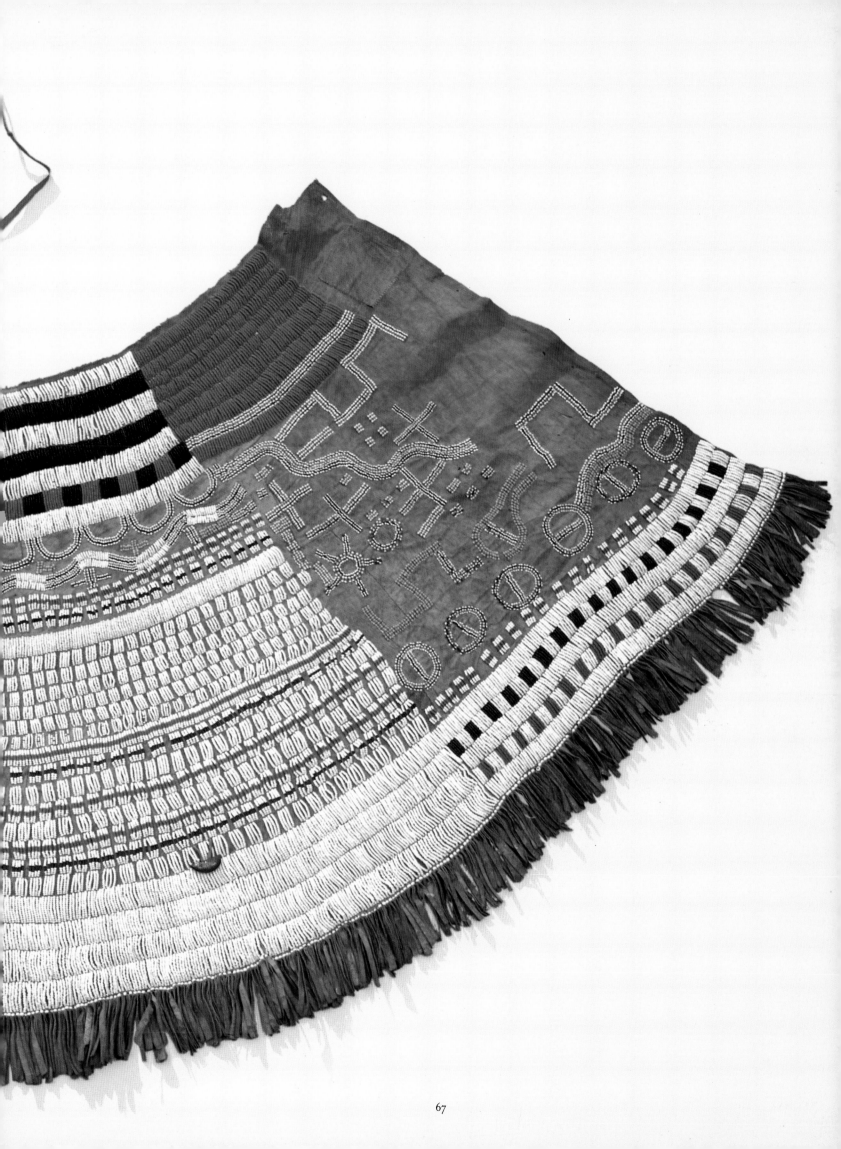

**21. Female Figure**
Nyamwezi, Tanzania, ca. 1900. Wood, 74.5 x 18.5 x 13 cm. Private collection.

The people known as Nyamwezi are a large, loosely connected agrarian group with shared cultural traits but diverse origins who live in north-central Tanzania. Since the early nineteenth century, they have been organized into small semi-autonomous chiefdoms, except for a period in the late nineteenth century when two strong chiefs, Mirambo and Nyungu ya Mawe, established separate hegemonies in extensive portions of Unyamwezi (the land of the Nyamwezi). At this time, the Nyamwezi were increasingly involved in the caravan trade that crossed their territory, and many of them traveled between the Congo (now Zaire) and trading towns located on the Indian Ocean. It was on the coast that they were given the name "Nyamwesi," meaning "people of the west" (sometimes translated as "people of the moon," because the new moon is visible only as it sets in the west).

Because of the extensive size and ethnic diversity of Unyamwezi, the art from this area shows considerable variation in style, even though the principal art forms, such as discrete human figures and figurative high-backed stools, are of similar type. Ancestors and chiefs have been of considerable importance in the belief system and sociopolitical structure of the Nyamwezi. Consequently, most of their art relates to themes of rulership and ancestorship. Theirs is one of the richest art traditions in Tanzania.

This figure exemplifies some of the finest qualities of Nyamwezi sculpture. Its animated facial expression, enhanced by the beaded eyes and open mouth garnished with teeth, as well as its taut and vigorous posture, are expressive of strong feeling and kinetic energy. Bursting with dynamism and exuberance, it has a compelling emotional quality.

The figure's grimacing countenance and the addition of hair and teeth suggest that it comes from an outlying area of Unyamwezi, probably influenced by the art traditions of an adjacent people to the east, such as the Sukuma, in whose masks and figures similar features are sometimes seen. While the central Nyamwezi style is usually characterized by a contained serenity of aspect and form, Sukuma art is more expressionistic and animated. Like virtually all free-standing sculptures of the Nyamwezi, this piece probably represents an ancestor. *NIN*

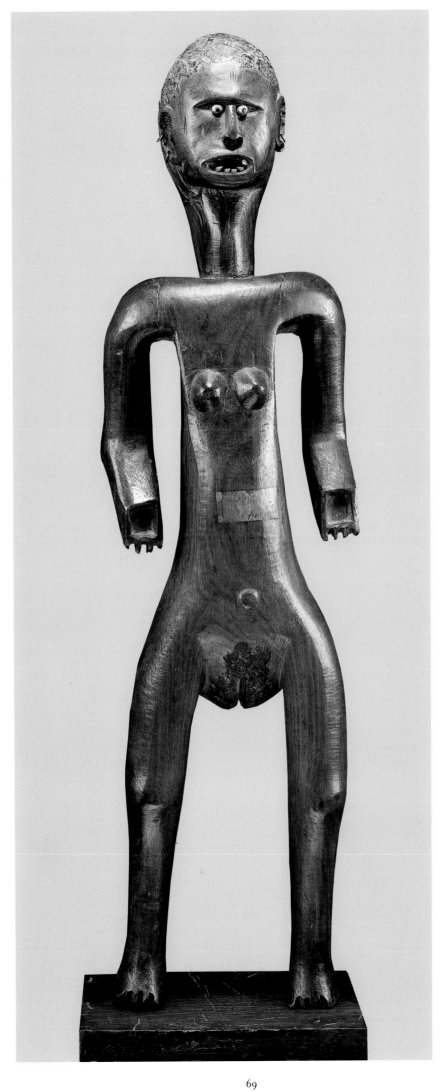

## 22. Grave Figure

Bongo, Sudan, late 19th–
early 20th century. Wood and metal,
203 x 23 x 16 cm. Musée Barbier-
Mueller, Geneva, 1027-1.

A category of tall, slim figure
sculptures is attributed to the Bongo,
an agricultural people of the
southwestern Sudan. These share a
general polelike form in which a
human figure stands with flexed knees
on a post and, generally, with arms
held close to the body. Apart from
facial features (including occasionally
the inlaying of eyes with beads, as in
the grave figure shown here), there is
rarely any other sculptural detail.
These carvings are often compared
with memorial figures of other eastern
African peoples, such as the Konso and
Gato of Ethiopia and the Giryama of
Kenya, but in fact there are few formal
similarities between these figures and
their Bongo counterparts.

While detailed provenances are
available for a number of grave figures
held by museums in Khartoum, little is
known about the origins of most
examples in European collections.
Much of the published material is
based on notoriously unreliable
nineteenth-century accounts by
travelers and explorers. It is not clear if
figure sculpture was produced in all
Bongo communities, nor is it clear that
all figures identified as such were
produced by Bongo carvers. Some may
have been created by sculptors working
among neighbors of the Bongo (the
Belanda, for instance).

It was the practice among at least
some Bongo groups to honor a
deceased hunter-warrior by erecting on
his grave a carved wooden effigy
(*ngya*). This was done by relatives at a
graveside feast held a year or so after
his death, to ensure him a good place
in the village of the dead. During his
lifetime, a Bongo man could gain

prestige and status through successfully
hunting large animals and killing
enemies in battle, as well as by
performing meritorious feats. The
effigies erected on graves were a
reflection of the title and rank achieved
by the hunter-warrior during his
lifetime. They were often accompanied
by notched posts that recorded the
number of kills carried out by the
deceased and sometimes by effigies of
his victims.

It is not clear to what extent the
figures were supposed to resemble the
deceased, but in some cases at least the
sculptor represented some of the dead
man's personal adornments, such as
scarification patterns and bracelets. It
may well be that the scarification
marks on the grave figure shown here
represent those borne in life by the
deceased. The series of metal nails
running across the brow of the figure
may have formerly held in place a
headdress, a hypothesis substantiated
by reports that Bongo men and women
wore feather headdresses at feasts and
dances. It has also been reported,
however, that effigies of victims were
characterized by the incorporation of
carved legs, so that the piece here may
represent an enemy felled by a Bongo
warrior.

It is not clear how the Bongo
regarded the removal of effigies from
the graves of their ancestors. It seems
that the sculptures received little if any
attention after their erection and were
left to the depredations of bush fires
and the weather. Still, it seems unlikely
that the Bongo would have acquiesced
to the removal of figures celebrating
their forebears. Possibly, they would
have minded less if the figures removed
were representations of foreign victims.
If indeed this was so, it may suggest
that at least some (and perhaps many)
Bongo grave figures in European
collections are images not of Bongo
men but of their victims. *JXC*

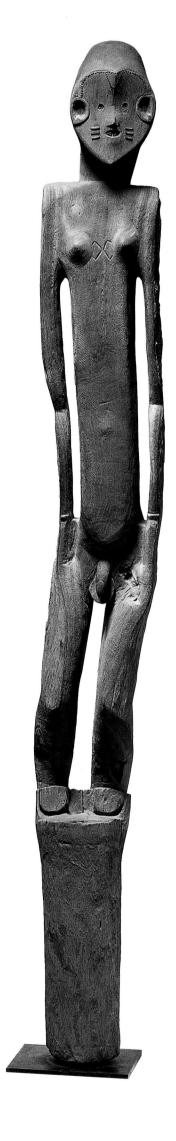

### 23. Tomb Sculpture

Mahafaly, Madagascar, 19th–
20th century. Wood, 193 cm high.
Private collection.

The carvings placed on tombs by the
Mahafaly of southwestern Madagascar
are arguably the most familiar, yet the
least understood, of all the art forms
produced on the island. Indeed,
although the term by which this type
of sculpture is known, *aloalo*, is now
often applied to other unrelated types
of object, the word itself remains
inadequately translated.

The Mahafaly live in an extensive
area of thorny semidesert. They are
predominantly cattle pastoralists, and
the humped zebu cattle, which are the
basis of their livelihood, also provide a
leading theme in their figurative art,
not least on *aloalo*. In visual terms the
most prominent feature in their
landscape are tombs—vast solid boxlike
structures of cut and natural stone—
which sit isolated in the countryside,
often topped with a series of tall
sculpted poles. As many as thirty such
sculptures are recorded at single sites.
Such graves are reserved to chiefly or
royal lineages, one large tomb for each
of the deceased of sufficient standing to
be worthy of the expenditure involved
in their creation.

The sculpture displayed on these
stone platforms, though it has
continued to evolve in form and
content until today, retains an
identifiable set of elements. The whole
construction is generally carved from a
single piece of wood, the lower part
sometimes plain and sometimes with a
standing figure. Above is an openwork
structure of geometric forms, usually
crescent shapes and circles that are
conventionally interpreted as referring
to the full and half moons. The image
on the top of the sculpture shows the
greatest variability. Humped cattle and
birds are the most frequent subjects,
cattle being sacrificed as part of
funerary rites and the horns planted in
the stone tomb alongside the *aloalo*.
The birds depicted are generally ducks
or teals: birds known to return each
evening to the same place. This would
seem to be a reference to the tomb as
the new residence of the deceased.
More recent *aloalo* also include groups
of figures, aeroplanes, buses, and other
attributes of modern life.

At one level the sculpture, as the
construction of the tomb itself, has a
clearly honorific function. However,
the term *aloalo* is normally interpreted
as deriving from the word *alo*, meaning
messenger or intermediary. *Aloalo*
are distinguished from another
category of Mahafaly carving known
as *ajiba*, figurative sculpture in a
different style erected away from sites
as a form of cenotaph. This contrast
tends to support speculation that the
purpose of the *aloalo* is less that of a
directly commemorative device than
that of an intercessor of some kind
between the world of the living and
the realm of the dead. As in many parts
of Madagascar, the ancestors (*razana*)
provide a point of reference in seeking
to understand the tide of human affairs
and a channel by which to influence
their course.

*Alo* has a more general meaning as
well. It is a word applied to situations
that create a linkage of any kind. In
this sense, it is sometimes used to
describe techniques of weaving. In the
case of Mahafaly funerary sculpture, it
can refer to the interlocking geometry
of circles and crescents that provide the
central element of the sculpture, and
which, by comparison with carving
elsewhere on the island, is the
distinctive feature of this genre of
statuary. *JM*

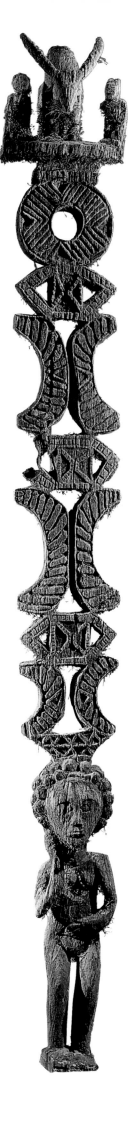

**24. Male Funerary Figure**
Vezo, Madagascar, 19th–20th century.
Wood, 57 x 17 x 13 cm. Private
collection.

**25. Female Funerary Figure**
Vezo, Madagascar, 19th–20th century.
Wood, 46 x 17 x 13 cm. Private
collection

These two funerary figures are by an
unknown Vezo artist whose sculptural
intentions have been adapted by the
abrasive action of sand. The objects
seem to come from one of the nine or
so funerary sites in the region of
Morondava on Madagascar's western
coast. The Vezo are a fishing
population who should be
distinguished from the surrounding
Sakalava with whom they are often
confounded and to whom Vezo
funerary art is sometimes erroneously
attributed. Vezo tombs are located in
forests and sandy clearings distant
from villages and are visited only for
the purpose of burying the dead. The
sculpture placed on tombs is to that
extent largely invisible both to Vezo
and to visiting ethnographers. Indeed,
there is no unique indigenous term by
which it is known, unlike the *aloalo*
that surmount Mahafaly tombs.

A significant number of the carved
figures (but not those shown here) now
in European and American collections
were stolen in the post–World War II
period from isolated Vezo cemeteries,
mostly sawn from the poles that
supported them. There is no tradition
of reerecting tomb complexes that fall
over, and it would seem from the
extensive abrasions on these pieces that
they may have been removed (at some
unknown time) directly from the sand
rather than from a standing
monument.

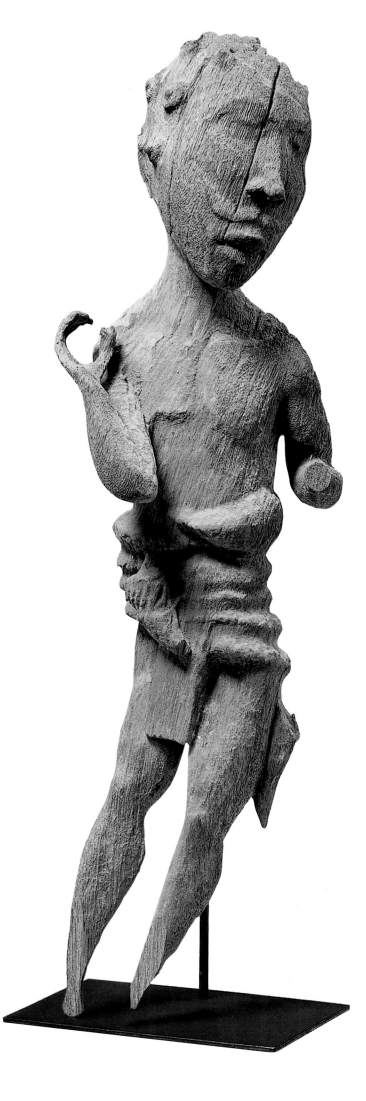

The two figures shown here have been photographed in the past as if in intimate relationship. Some Malagasy figures are indeed carved in amorous embrace. It is, however, possible that, as with other Vezo tomb sculpture, the two carvings shown here originally stood at opposite corners of a rectangular boxlike wood structure. The figure positioned at the sacred northeast corner would have been of the same gender as the deceased. The northeast, the place where the sun rises, is associated with the dawn, a time of propitious events—an ideal time to be born, to perform circumcisions, or remove a corpse that has been laid out in a hut. It is a sacred ancestral direction. At the opposite, southwest corner would have stood the second figure—a relationship expressing the ideal union of people and destinies as calculated by the time and date of birth of individuals and applied to directions (or cardinal points).

There are, however, features of these two pieces that are striking and unusual. Both are much more poised than is common; the tilt of the head and gesture of the hands contrast with the upright single figures that are more familiar. In the end, however, it is difficult to say how far these attributes are fully representative of the original sculptural program of the carver and how far they are the chance result of extensive weathering. *JM*

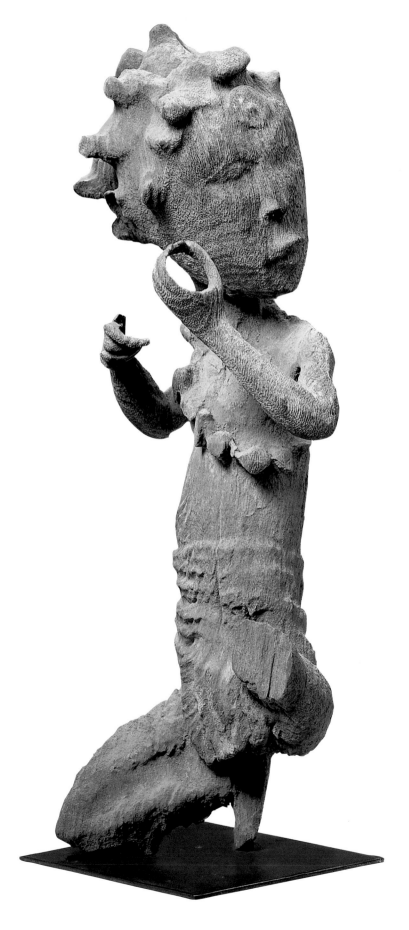

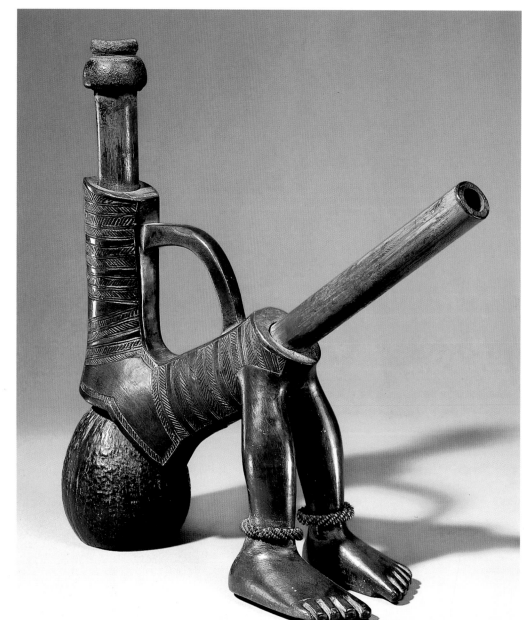

## 26. Water Pipe

Makonde, Mozambique, 19th century.
Terra-cotta, wood, coconut shell, and
beads, 27 cm high. Private collection.

Tobacco has long been an important,
highly desirable commodity among
the Makonde and, in the past, it was
widely exchanged for goods and
services. It appears to have been
associated with personal qualities such
as generosity. Use of tobacco
constituted one of the principal
pleasures and privileges of elders. It
was usually smoked or taken as snuff
in a social context, especially by
elderly men as they sat in the central
men's house (*chitala*) conversing or
reminiscing about the past.

The water pipe (*nyungwa*) shown
here is characteristic of the finest
Makonde utilitarian art in its
inventiveness, in its witty suggestion of
the human form, and in its remarkable
economy of design. Constructed from
four detachable components, it is a
masterpiece of suggestion. By sculpting
a pair of lower legs to complete the N-
shaped stem-holder-cum-stand, the
maker (or makers) of this pipe created
a form that subtly alludes to that of a
seated human figure, with the bowl of
the pipe representing the head and the
coconut-shell reservoir representing the
buttocks.

Figuratively elaborated and finely
decorated water-pipes generally
belonged to individuals of high status
such as village or clan leaders and ritual
experts. This example is unique in that
it incorporates a terra-cotta holder
decorated with a delicate pattern of
incised lines typical of some Makonde
pottery. Modeling and potting in clay
were women's arts in Makonde society,
and the virtuosity displayed in this rare

piece suggests that it was made by an
expert potter; the stems and bowl of
the pipe were probably carved by a
man, carving being a male art. The
terra-cotta holder includes a
convenient carrying handle and its
sculpted legs are decorated with
miniature beadwork anklets. It may
have been made for the potter's own
use or she may have made it for
another in exchange for other goods. In
either case, the pipe would have been
intended to serve not only as an
effective smoking apparatus but also as
an object of display to be carried
around, handled, admired, and
contemplated. It would have been
closely linked with the identity of its
owner and treasured as an intimate
personal object. *ZK*

**27. Body Mask**
Makonde, Southern Tanzania,
late 19th century. Wood, 9.5 x 34.5 x
13.5 cm. Private collection, London.

Among the Makonde of southeastern
Tanzania, initiation is still one of the
most important ritual cycles. Boys and
girls must undergo a period of
seclusion, generally six months, during
which they learn songs and dances and
are taught various practical activities.
The initiation rites involve male
circumcision and indoctrination into
the secrets of gender. Everyone is
taught the rules of adult behavior,
about sex, and the rights and
obligations of married life. The
celebrations that accompany the
coming-out ceremonies involve
feasting, dance, and the masquerades
of *midimu* (singular, *ndimu*) spirit
maskers.

The body mask shown here was part
of the costume of a *ndimu* masker
called *amwalindembo*, who represented
a young pregnant woman. Pieces such
as this were usually carved with a
swollen abdomen decorated with raised
tattoos applied with beeswax or carved
in relief, as here. They were always
worn by a male masquerader together
with a matching female face mask. The
*amwalindembo* performed a sedate
dance, usually accompanied by a male
*ndimu* masker. This performance
dramatized the agonies of childbirth.
Although body masks are no longer in
use today, scenes depicting various
aspects of community life continue to
be performed by masked or maskless
performers during the coming-out
celebrations. *ZK*

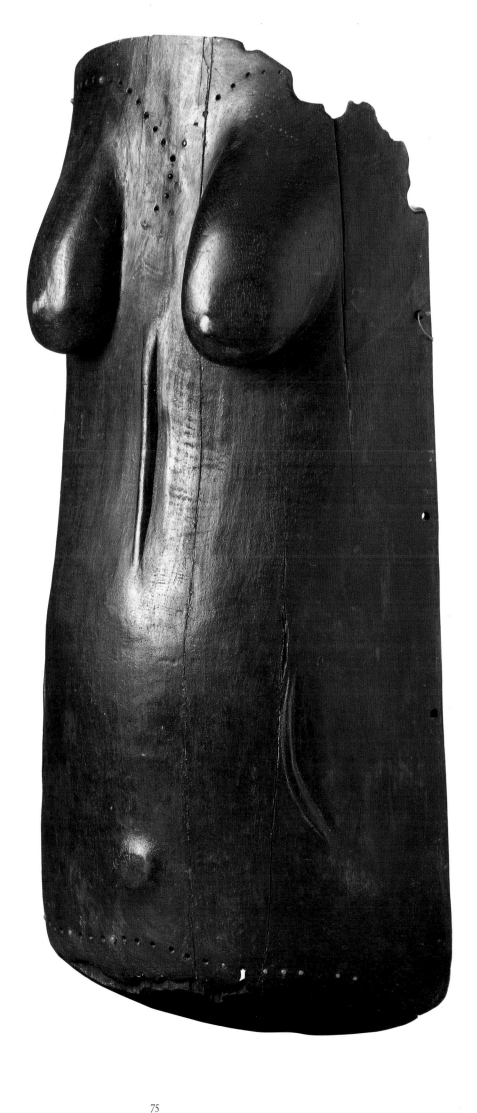

**28. Helmet Mask**
Makonde, Mozambique/Tanzania.
Wood and human hair, 26 x 36 x 30 cm.
Bareiss Family Collection.

This mask was apparently collected in southern Tanzania, which would suggest either that it was made by Mozambican Makonde migrants settled there or that it was traded from its place of origin. Before their conquest by Portuguese colonial troops in 1917, the Mozambican Makonde kept mainly to their plateau stronghold. During colonial times, however, a great many migrated across the Ruvuma River to work on sisal estates or farms in Tanzania. Many remained to settle on available agricultural land or to find work in urban areas. Wherever they have settled, Makonde migrants continue to hold initiation rites for boys and girls, and masquerade remains an important fixture at the public celebrations connected with these rites.

*Lipiko* (plural, *mapiko*) is the name that Mozambican Makonde men give to maskers who perform in initiation-related dances. These dances are accompanied by an orchestra of drummers. The "head of the *lipiko*" (*muti wa lipiko*), or mask, is carved out of very light, balsalike wood and fits over the masquerader's head like a helmet. It is always worn with a cloth, which, tied around its bottom rim, falls loosely over the masquerader's shoulders, forming part of an elaborate costume to conceal his identity.

The mask is typically carved in a realistic style and its naturalism is often accentuated by the inclusion of human hair. Many of the older masks portray a Makonde woman complete with lip plug and decorated with raised tattoos applied to the surface of the carving with beeswax. Such masks are invariably carved with the face angled upward, often with hooded eyes and with the ears positioned low, more or less level with the mouth. *Mapiko* masks in use today display greater stylistic diversity and tend to portray a variety of contemporary characters. The lip plug exhibited in the mask shown here is typical of examples intended to represent female elders, but the unusual horizontal prognathis and upper canine teeth are baboonlike features.

Makonde men conceal the true identity of their masker from the uninitiated. Women and children are told that the *lipiko* is something nonhuman that has been conjured back from the dead. The secret, true identity of the masker is revealed only in the context of male initiation rites. During such rites, Makonde boys are forced to undergo a frightening ordeal in which they must overpower and unmask the *lipiko*. In this manner, they learn that the masker is human.
*ZK*

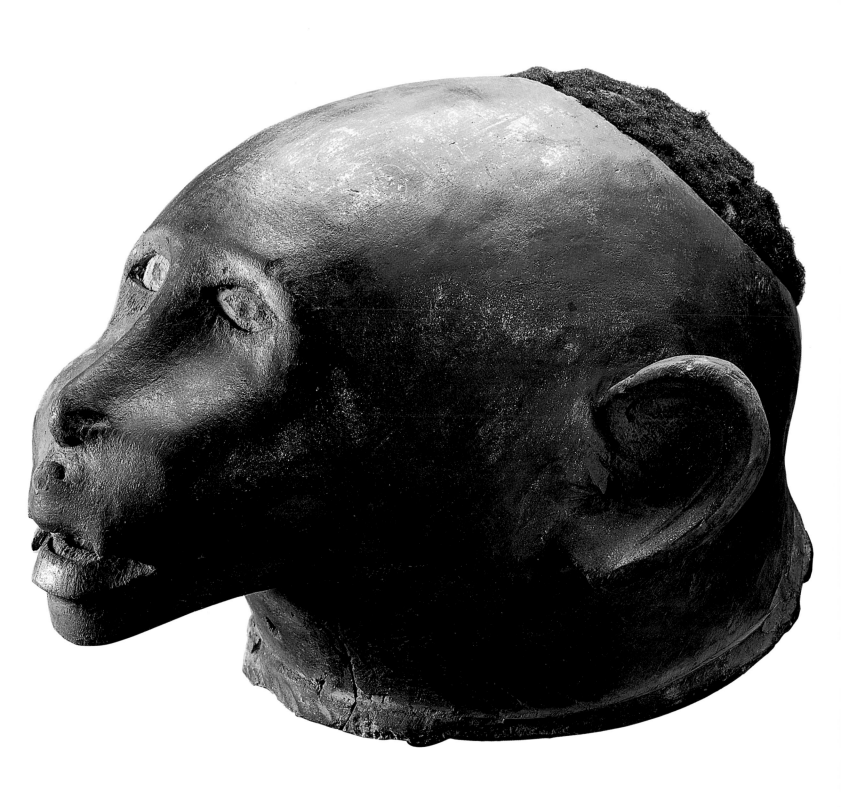

# Southern Africa

The best-known arts of southern Africa are the rock paintings and engravings that were produced by the San peoples and are found mostly in the eastern mountainous regions. Many of the sites where such paintings and engravings appear show evidence of use over long periods of time, suggesting that they had ritual significance, such as healing ceremonies or for attracting game animals or rain. The earliest examples have been dated to twenty-seven thousand five hundred years ago and are thus contemporary with the cave art of Europe. The most recent date from the nineteenth century.

With the exception of rock painting and engraving, the arts of southern Africa have tended to be underrated and underreported outside the area. The region's impressive stone ruins, especially those of Great Zimbabwe, were long attributed to outsiders on the assumption that Africans were incapable of producing such imposing architecture. Recently, however, it has been clearly established that these sites are African in origin and concept. The inland trading empires that produced them, such as that of the Shona, the builders of Great Zimbabwe, were supported by the Indian Ocean gold trade.

The exceptional find of terra-cotta heads at Lydenburg in the Eastern Transvaal are the earliest-known sculptures from southern Africa. They have been dated to the sixth through eighth century A.D. Although their use is unknown, several may have been worn as masks, possibly for initiation rituals.

The relative absence in southern Africa of the practice of using masks and the rarity of figurative sculpture of the sort prized by Europeans led to the region's many rich utilitarian arts being neglected by outsiders. The peoples of this area often expended great skill and effort on objects of everyday use. Such works include headrests, ceramics, and—after the introduction of tobacco from America by way of Europe—pipes and snuff containers. Objects of personal use were much prized; they served as markers of their owners' positions in society and were often buried with them.

**29. Rock Engraving of Giraffe**
San, Namibia, 3000 B.C.–1000 A.D.
Shale, 70 x 66 x 45 cm. State Museum
of Namibia, Windhoek.

The arid western Erongo Province of Namibia contains one of the largest concentrations of rock art in Africa, including many superbly painted rock shelters and extensive open-air engraving sites. While the paintings are dominated by human figures and the engravings by representations of animals, some subjects are common to both. Prominent among these is the giraffe, a species that also shows great variety in treatment, color, and style of execution.

Although naturalistic depiction is uncommon, and many examples show only the backline and profile of persons or animals rendered, such paintings and engravings are not necessarily incomplete, for the rock art resonates with imagery and physical experiences associated with states of altered consciousness. The belief of shamans, in southern African hunter-gatherer communities, that the spinal column serves as a conduit for ritual potency, might explain the evident importance of the giraffe in rock art of this region. Certain features of the species receive particular emphasis in this context. These include the pattern of body markings and the short upright mane. The variegated markings of the giraffe bring to mind the fractured vision associated with the onset of trance, while the erect mane evokes one of the common physical symptoms exhibited by dying game animals. As a visual cue for the peculiar rising sensation

experienced by shamans during ritual trances, the extreme height of the giraffe would most likely have been of great interest and would have reinforced the animal's ritual importance. Despite these suggestive associations, however, no specific meaning seems to have been attached to the giraffe in rock art. In all likelihood, it served as a general metaphor of the continuity between ritual, social life, and the natural environment.

The engraving shown here was produced by the pecking technique on a block of indurated shale, at the foot of the Dome ravine on the southern side of the remote Brandberg massif in western Namibia. The Dome ravine site is unusual in that it combines both paintings and engravings in an area containing more than 1,000 painted sites. Although the site and the engraving are undated, archaeological surveys conducted in the same area have revealed evidence of intensive hunter-gatherer occupation over the last 5,000 years. Many of the rock art sites in the area were used repeatedly during this period as dry season refuges. While the giraffe engraving might not be as old as 5,000 years, it is probably over 1,000 years old, for in this area the hunting way of life, together with ritual and rock art traditions, was rapidly displaced during the last millennium by the rise of nomadic pastoralism. *JK*

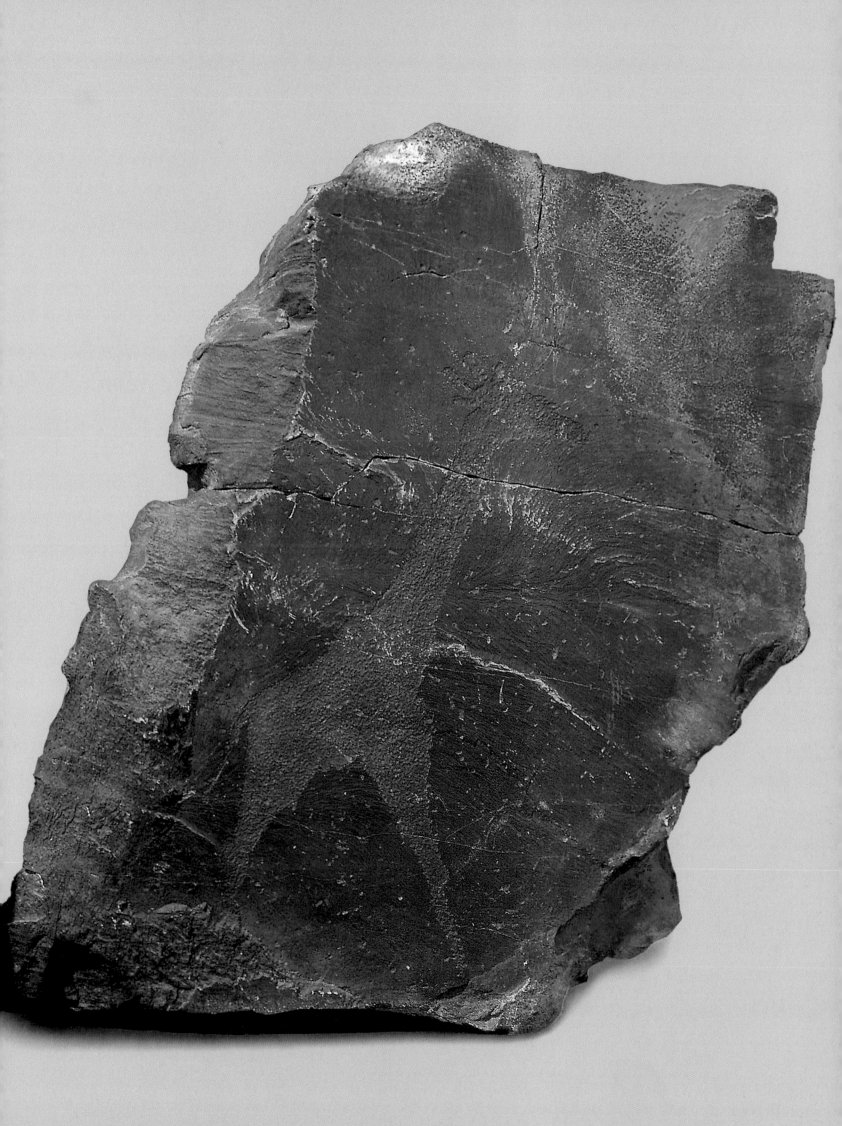

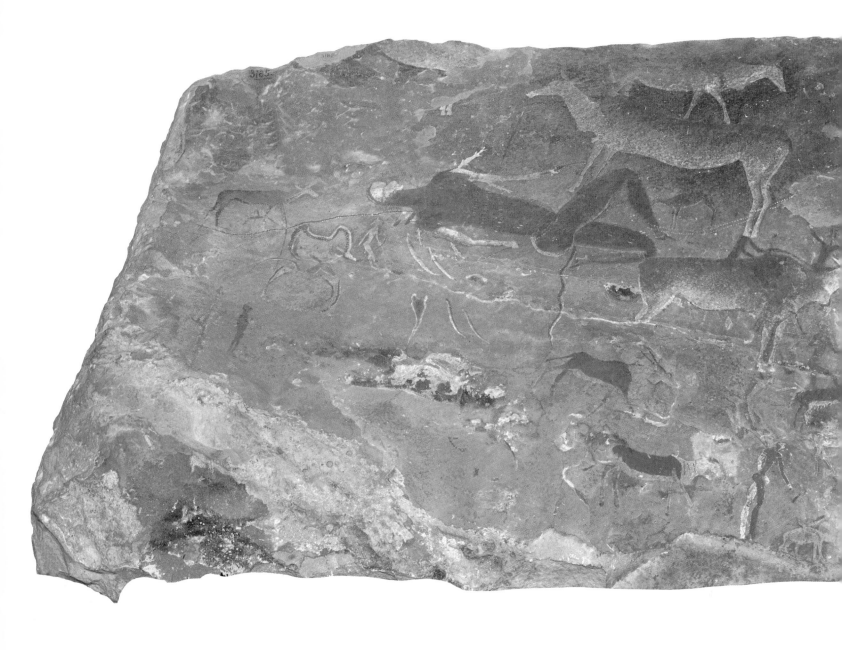

### 30. Linton Panel

San, South Africa, 18th–19th century (?). Ochre and other pigments on stone, 85 x 205 x 20 cm. South African Museum, Cape Town, SAM-AA 3185.

The paintings of the Linton panel form a web of interconnected images, an aggregation of religious symbols, metaphors of shamanic experience, and depictions of hallucinations associated with such experiences. Many of the images are linked by a bifurcating red line fringed with meticulously painted white dots. This line, a common motif in San rock art, is thought to represent the route of shamanic travel or, perhaps simultaneously, the supernatural potency that permeated the San universe, a power San shamans harnessed in order to enter the spirit world (through trance), to control the movements of animals, heal the sick,

make rain, and transform themselves into animals. The southern San believed that this potency resided in certain large animals, chief of which was the eland (*Taurotragus oryx*), an animal that held multiple symbolic associations for them. The depictions of elands in the Linton panel are symbols of this potency and, at the same time, "reservoirs" of power from which San shamans, and possibly other people, could draw spiritual energy.

Images appearing in the left part of the panel are metaphoric allusions to the experience of shamanic trance. The large supine figure depicts a shaman partly transformed into an animal; it has cloven hoofs rather than feet. The figure holds a fly switch, an artifact used almost exclusively in the trance, or medicine, dance. A key San metaphor, "death" (entry into the spirit world), is represented by the antelope that impinges slightly upon one of the

supine figure's legs. It bleeds from the nose, as San shamans often did when they entered trance. "Death" is also represented by the buck-headed snake that lies brokenly on its back; it too bleeds from the nose. The spotted rinkhals snake feigns death in this way and then springs to life. The fish that surround the supine figure and the eels below it represent another metaphor, the "underwater" experience of which San shamans speak. A sense of weightlessness, difficulty in breathing, affected vision and hearing, and eventual unconsciousness are experienced by people underwater and by shamans entering trance.

Visual hallucinations experienced by shamans in trance are also depicted in the panel. A small doglike creature with six legs is painted to the right of the central figure, which depicts a standing shaman. Just above this creature is an antelope head peering

from a circle of paint marked with white dots. The spirit world was believed to lie behind the rock on whose surface the panel appeared, and creatures of that world, it was thought, could be coaxed out of it by the application of paint. Further to the right, a human head, bleeding from the nose, also emerges from an area of paint.

The Linton panel was removed in 1918 from a rock shelter in the southern Drakensberg mountain range. Many associated paintings were destroyed in the process of removal. Those that were left in the rock shelter were subsequently severely damaged by natural weathering processes. The Linton panel probably comprises the richest and most complex set of African rock paintings in any museum collection. *JDL-W*

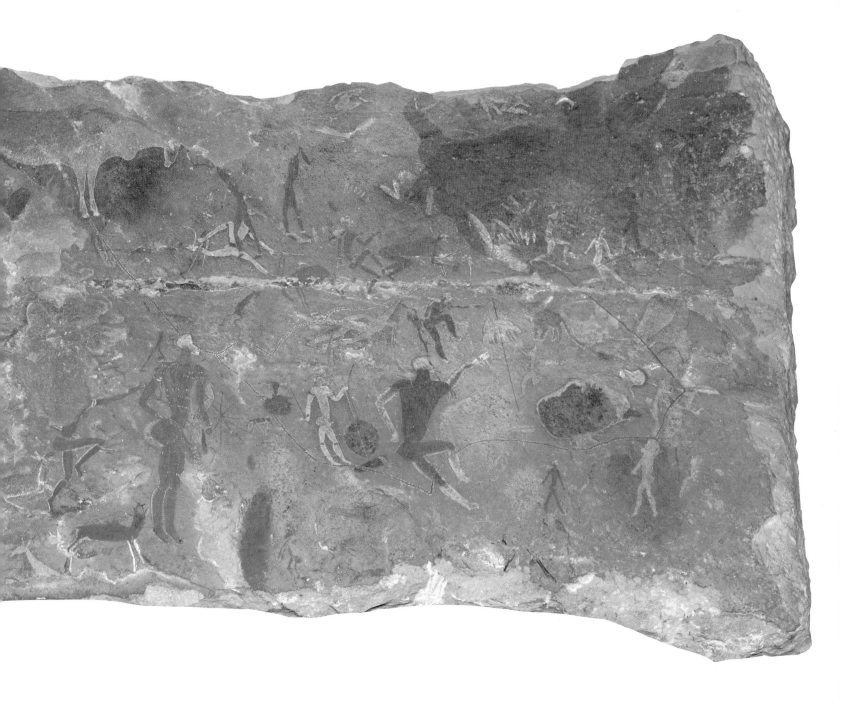

### 31. Lydenburg Head

Eastern Transvaal, South Africa, ca. A.D. 500–700. Traces of white pigment and specularite on clay, 38 x 26 x 25.5 cm. University of Cape Town Collection at the South African Museum, Cape Town, UCT 701/1.

Seven terra-cotta heads, known as the "Lydenburg Heads" after the site where they were found, are the earliest known sculptural forms in southern Africa. Fragments of the modeled heads, together with shards of domestic pottery, beads, and metal ornaments, were found in an eroding gully, and charcoal from the site was later dated by the radiocarbon method to the sixth century A.D. Later excavations confirmed this date and indicated that the heads had been buried in a pit, suggesting that they had been deliberately hidden when not in use.

Reconstruction of the fragments yielded seven fired earthenware heads, resembling inverted U-shaped vessels. Incised bands of diagonal hatching encircling the necks of the heads echo the characteristic decoration of domestic pottery from the site. Two of the heads are large enough to have been worn as helmet masks, and the smaller heads have a hole on either side of the neck that might have been used for attachment to a structure or costume. Distinctive facial features are formed by the application of modeled

pieces of clay. All the heads have cowrie-like eyes, wide mouths, notched ridges that may represent cicatrization, and raised bars across the forehead and temple to define the hairline. Panels of incised cross-hatching are found on the backs of all the heads. The large heads, however, differ from the others in having clay studs applied behind the hairline bar, and in being surmounted by modeled animal figurines. Traces of white pigment and specularite are visible on all the heads.

Although the original function and significance of the heads remains elusive, archaeologists have suggested that they were possibly used in the performance of initiation rituals. If this was so, the heads would have been ceremonial objects used during the enactment of rites that marked the transition to a new social status, or the acquisition of membership in an exclusive group. The aesthetic power of the heads, enhanced by white slip and shimmering specularite, adds credence to the argument that they were used in a ritual drama to enthral spectators, and to mediate visually between the spirit world and that of everyday experience. Ultimately, the meaning of the heads remains enigmatic, but they testify to a complex aesthetic sensibility among early agricultural communities in southern African, a millennium before the advent of European colonization. *PD*

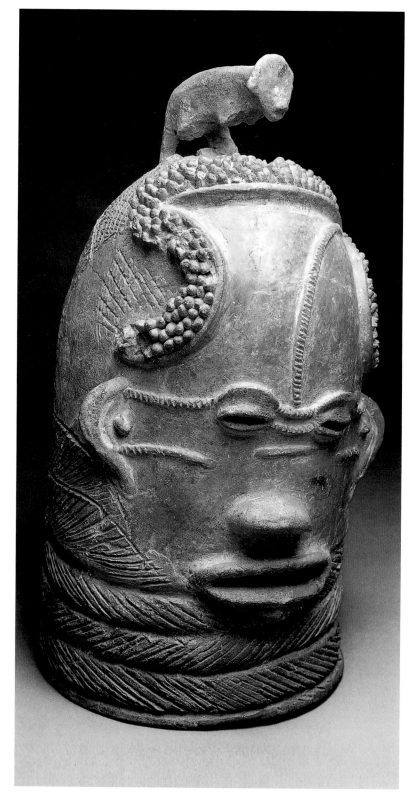

**32. Carved Soapstone Bird**
Zimbabwe, 13th–15th century. Steatite, 100 cm high. Groote Schuur Collection, Cape Town.

Eight soapstone birds were found at Great Zimbabwe, the 13th–15th century capital of the Shona kingdom. All came from parts of the capital originally reserved for private and sacred functions. Seven came from the Hill Ruin, the secluded palace of a sacred leader. One was associated with the king's sanctuary (*chikuva*) at the back of the Western Enclosure. The other six had apparently been mounted on low stone terraces in the Eastern Enclosure, a national ritual center. The eighth bird was placed in a *chikuva* in the Philips Ruin or Lower Homestead, near the place where the king's pregnant wives were confined. These locations alone point to a religious significance.

Although each carved bird is different, all eight incorporate a mixture of human and avian, or more properly eagle, features. The Western Enclosure bird, for instance, has lips rather than a beak, and they all have four or five toes rather than three talons. The meaning of these carvings is thus tied to roles played in Shona culture by both birds and humans.

In Shona belief, birds are messengers, and eagles, such as the bateleur, bring word from the ancestors. Ancestral spirits in turn are supposed to provide health and success. Soaring like an eagle to heaven, the spirits of former leaders were supposed to intercede with God over national problems such as rain. Indeed, this ability to communicate directly with God was the essence of sacred leadership in the Zimbabwe culture. The carvings, then, were a stone metaphor for the intercessionary role of royal ancestors.

Since each bird is unique, they probably represented specific leaders. Furthermore, their postures may have had gender significance. For example, the stone bird from the royal wives' area perches in a "sitting" position, while the one associated with the king's *chikuva* is "standing." According to custom, the king's first wife (*vahozi*) would have been in charge of the royal wives, and the sanctuary in the Lower Valley was probably established to propitiate her ancestors. The most important woman in the capital, however, would have been the king's ritual sister, the senior woman of the ruling line and the great "aunt" of the nation. The "sitting" birds from the Hill Ruin probably represented the ancestral spirits of such women. The "standing" birds symbolized the spirits of important male leaders.

Somewhat surprisingly, similar carved birds have not been found in other Zimbabwe culture settlements. This uniqueness may be due to the particular circumstances of Great Zimbabwe's rise. When Great Zimbabwe was established as the kingdom's capital, the supporting population was not familiar with sacred leadership, for this feature of government had evolved 300 kilometers away at the site of Mapungubwe. To legitimize the new social organization, the Zimbabwe leaders would have needed to glorify their ancestors. This would explain why all the birds from the Hill Ruin appear to have been carved by the same person. By the time Great Zimbabwe was abandoned, sacred leadership was widespread, and ideological justification of a new dynasty was no longer necessary. *TNH*

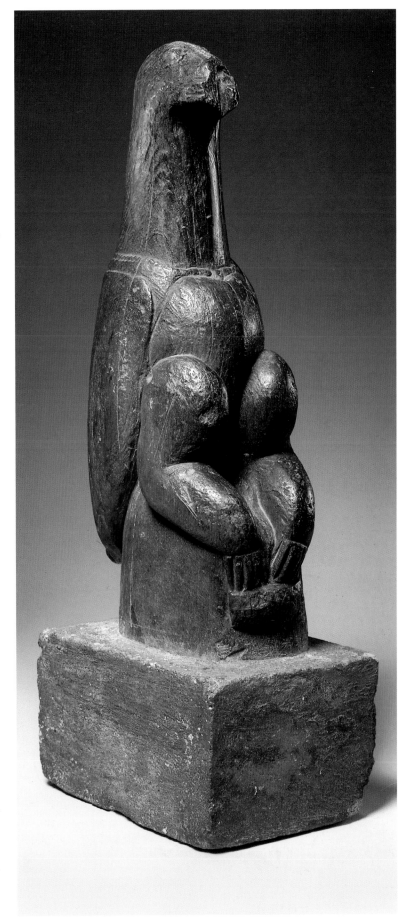

**33. Headrest**
Shona, Zimbabwe, late 19th–early
20th century. Wood, 13.3 x 16.5 x 7 cm.
Collection of Marc and Denyse
Ginzberg.

**34. Headrest**
Shona, Zimbabwe, late 19th–early 20th
century. Wood, 12.7 x 15.6 cm. National
Museum of African Art, Smithsonian
Institution, Washington, D.C.,
Museum purchase, 91-17-1.

Headrests of this type—with lobed bases, carved supports, and horizontal platforms, all carved in one piece—are used with variations of design by a number of different southern African peoples. The examples conventionally classified as "Shona" have supports that all vary to some extent in their composition, but which also demonstrate the persistent use of common motifs. These include two concentric circle motifs sandwiched between two triangles, the upper triangle being inverted vertically over the lower. There is often a rectangular element placed either horizontally between the two circles or vertically from base to platform.

Headrests using these design elements have been claimed to be common to Shona-speaking peoples living in eastern, central, and north-central Zimbabwe, that is, among the Manyika, Zezuru, Korekore, and possibly Karanga subgroups.

Many commentators have remarked that headrests of this style appear to represent a human figure with the upper platform as the shoulders, the vertical support as the torso, and the base as the lower limbs, although this identification has been challenged.

The designs on the headrests appear to have a semiotic multivalence. For example, the concentric circle motifs may refer to the discs cut from the base of white conus-shells (*ndoro*) and thus bearing the ridges of the shell's spiral, which were worn as signs of status especially by chiefs and diviners. Another reference suggested for this motif has been the ripples in the pool made after a stone has been thrown into it, and, possibly by inference, the eyes of a crocodile, especially where such motifs appear on Shona divining apparatus (*hakata*). Pools are an important locus for many Shona

groups in contacting their ancestors. The raised keloid shapes at the centers of some of these circular motifs make a clear reference to bodily scarification (*nyora*) that used to be common among the Shona, but only for women. Such scarification patterns were often quite abstract, but there are records of patterns that depicted lizards or crocodiles on the abdominal regions of women, possibly linking the womb of the woman metaphorically to the ancestral realm envisaged as a pool.

All the decorative motifs on the headrests are called by the same name as scarifications, *nyora,* and have been claimed to indicate the patriclans from which their users come. Thus the designs, through their reference to scarifications (keloids, triangles, and chevrons), to the ripples in pools and to *ndoro* shells (concentric circles), call to mind both the ancestors (*mudzimu/mhondoro*) of the lineage and the women who guarantee its fertility. As it was only women who were scarified in this fashion, with designs on the shoulders, lumbar region, chest, abdomen, and around the pubis, this reference to *nyora* must indicate a feminine identity for the headrests.

Headrests were, however, used only by mature men among the Shona. When a man slept and dreamed he was said to be visiting his ancestors, the source of knowledge and prosperity. The headrests as female figures without heads further amplify this ancestral connection. When a man marries a woman, the Shona say that he owns her body, but that her head (the seat of her ancestral "being") belongs always to her father. This clearly refers to the fact that, among the Shona, a woman's fertility is considered to be on loan to her husband's lineage, of which she never becomes a part, and thus the vast majority of the headrests do not have

heads of their own. When a man slept on a headrest (*mutsago*) of this type, it was his head, his ancestral affiliation, that completed the human and specifically female image suggested by the headrest itself. When he died, this vehicle of ancestral communication, which also symbolized the reproductive potential of the wife (or wives) transferred to his lineage on his marriage, was buried with him or passed on to his descendants. Headrests of this type are also used today by Shona diviners as part of their symbolic paraphernalia linking them with the spirit world.

While very few such headrests are still being used today among the Shona, and even fewer are made, the tradition can be traced back to ancient ruins in Zimbabwe, including Khami and Danangombe (also known as Dhlo Dhlo), and possibly even Great Zimbabwe itself.

Headrests were personal items and appear to have been cherished by their owners. They were often carried on long journeys and were generally buried with their owners at death. Most of the older Shona headrests are carved in a hard wood and have acquired a deep, dark brown patina and shiny surfaces from continual handling and use. A man using such a headrest would be able to protect his elaborate hairstyle, the wearing of which was common among Shona men until the end of the nineteenth century. In this way his head would be doubly adorned, both by the visible physical elevation afforded by the headrest and by the physical decorative elaboration afforded by the hairstyle. Simultaneously, the female character of the headrest and its design would act as an affirmation of the importance of women in the social fabric of Shona life and in the perpetuation of lineages.
*AN*

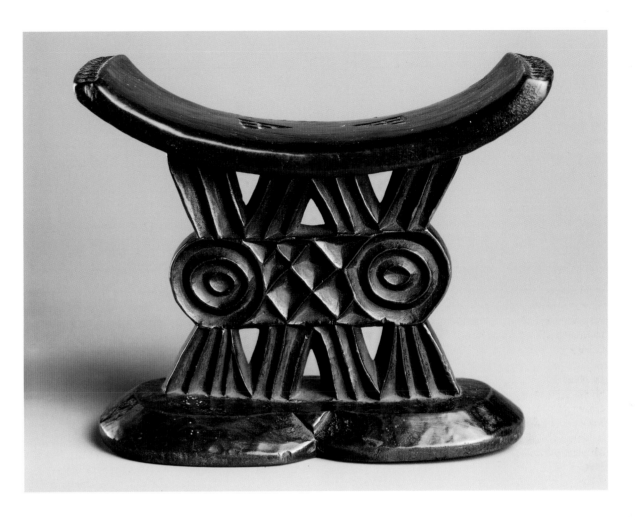

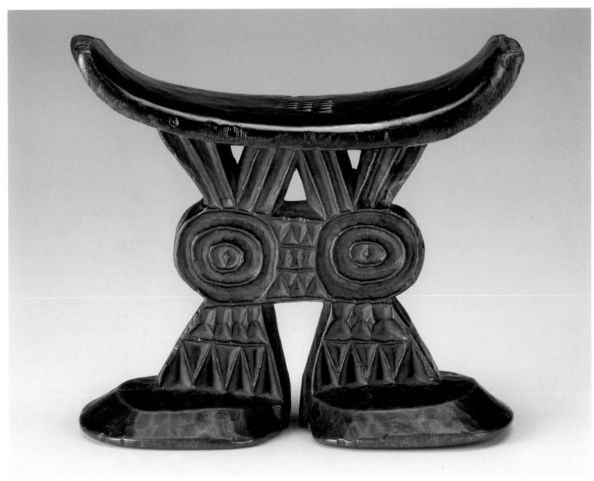

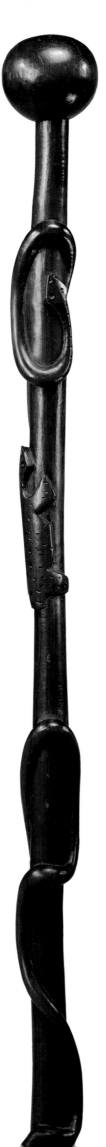

**35. Staff**
Zulu, KwaZulu-Natal, South Africa.
Wood, 141 cm high. Collection of
Merton D. Simpson.

Figurative and nonfigurative staffs and clubs were produced throughout southeastern Africa in the nineteenth and early twentieth centuries. Many of these were made by carvers from Tsonga-speaking groups, who are known to have supplied the Zulu kingdom with staffs as part of the tribute they were forced to pay to Shaka and his successors.

Staffs were made for a variety of markets, but most were evidently intended for use by chiefs. This category of chief staffs, like the examples shown here, includes those with abstract or semi-abstract details with hornlike projections and the generally very tall staffs surrounded by single or intertwining coiled snakes.

There is evidence to suggest that the style and iconography of the staffs used by chiefs varied considerably from one region to another. Thus, for example, in contrast to the coiled snake staffs, which appear to have been popular among groups in southern Natal, those featuring a variety of geometrically conceived motifs probably were associated only with important office

bearers in the Zulu kingdom. Often surmounted by the horns of cattle (or similar motifs), staffs of this kind underline the importance of cattle as symbols of wealth and fertility and, perhaps more especially, as the means through which people maintained communication with royal and other ancestors. This is not to suggest that all motifs found on chief staffs were carved with the intention of conveying specific meanings. On the contrary, staffs seem also to attest to an appreciation of the artist's ability to juxtapose carefully balanced shapes and forms, sometimes accentuated through the addition of wirework patterns.

Clubs with bulbous heads, some of which were also covered with complex wirework, suggest a similarly careful attention to shape and surface detail. Clubs made of rhino horn were reserved for chiefs as symbols of status. During the reigns of Shaka and Dingane in particular, comparatively heavy, hardwood clubs were said to have been used to execute offenders. But, more often than not, these clubs were used for hunting. *SK*

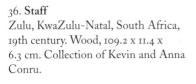

**36. Staff**
Zulu, KwaZulu-Natal, South Africa,
19th century. Wood, 109.2 x 11.4 x
6.3 cm. Collection of Kevin and Anna
Conru.

**37. Club with Wire Ornamentation**
Zulu, KwaZulu-Natal, South Africa.
Wood, copper, and brass wire, 71.1 x
10.8 x 10.8 cm. Collection of Marc and
Denyse Ginzberg.

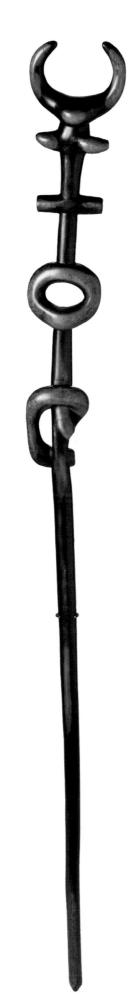

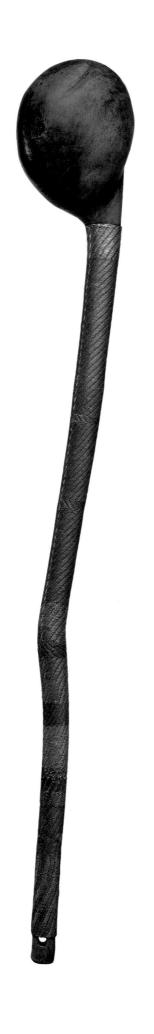

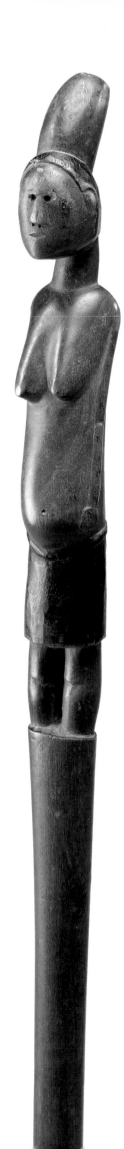

### 38. Figurative Staff
Zulu (?), KwaZulu-Natal, South Africa, late 19th century. Wood, 106.7 x 3.8 x 4.4 cm. Private collection.

### 39. Figurative Staff
Basotho, Lesotho, late 19th century. Wood, lead inlay, beads, metal wirework, 101.6 x 6.4 x 6.4 cm. Private collection.

A wide variety of staffs were, and still are, used by southern African peoples. These intensely personal objects are associated with their owners' earthly and spiritual identities. Staffs that are figurative or highly embellished with beads, metal, fur, medicines, or other powerful materials are generally associated with diviners and chiefs.

It is often difficult to determine the makers, users, and functions of late-nineteenth- and early twentieth-century figurative staffs from this region. The colonial period brought many dramatic changes. New art markets and patrons emerged.

In KwaZulu-Natal, free-standing curio figurines were carved with distinctive elements of Zulu dress. Similar features had appeared on some staffs made for earlier indigenous use. Today, a few staffs survive that show Zulu women wearing the married woman's peaked hairstyle and black leather apron seen in the first staff shown here. Collected in KwaZulu-Natal, most were obtained by white buyers who cut off the figurative finials.

During the 1800s, African societies were drawn into conflict and alliance with the British and the Boers, who vied for regional control. From the 1870s, African migrant laborers' dependence on their chiefs was eroded by the earning of wages. Wages brought status. They also bought guns, and gun motifs are common in staffs from this era and region. The finial

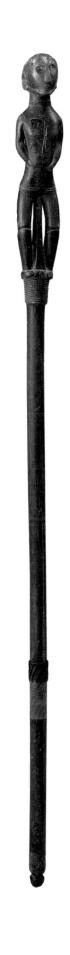

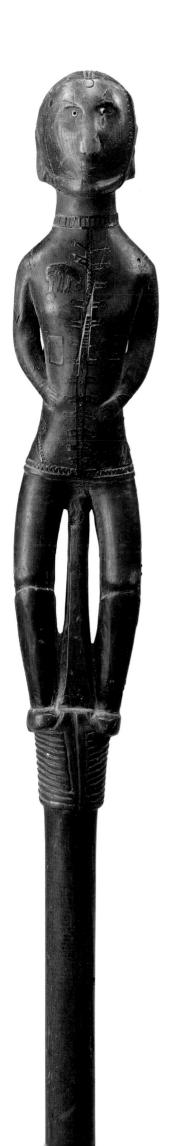

figure of the second staff shown here wears a British uniform and appears to straddle a gun. The word *pitso* is inscribed on the top rear of the shaft. A *pitso* is the official general assembly of all Basotho men, summoned to discuss national issues. All the minute details of the uniform and the lettering are painstakingly inlaid with lead, introduced over serrated incisions that provide a grip for the metal. This unusual staff may be understood in terms of the following circumstances.

At a *pitso* held in Basotholand in October 1879, the government of the Cape Colony, which had replaced British rule there, ordered the Basotho nation to surrender its hard-earned guns. The motive was to disarm all black populations in order to persuade the Boer Republics to join the British colonies of the Cape and Natal in forming a unitary South Africa. The Basotho rebelled. The ensuing Gun War of 1880–81 cost the Cape Colony three million pounds and caused the government to fall. This great victory distinguished the Basotho as the only African nation in southern Africa to retain its arms. The Basotho, long loyal to Britain, were greatly relieved , in 1884, when Britain resumed control of Basotholand from the Cape Colony. The new British administration adopted a strategy of indirect rule that bolstered the power of local chiefs, and it is most likely that this lead-inlayed staff—combining themes of national unity, military prowess, British affiliation, and the display of power— was carved and used as a means of celebrating enhanced chiefly prestige.

This piece also retains a small section of wirework binding that once embellished its shaft. Such expert decorative wirework is a little-remarked, though key, feature of southern African staffs and weapons (see cat. no. 37). *GvW*

**40. Pair of Snuff Containers**
Nguni, South Africa, 19th–
20th century. Horn and copper wire,
16.5 x 3.8 x 3.8 cm. Collection of Marc
and Denyse Ginzberg.

FACING PAGE, TOP:
**41. Snuff Container**
Cape Nguni, South Africa, 19th–
20th century. Hide scrapings, clay, and
blood mixture, 10.1 x 6.3 x 11.4 cm.
Bowmint Collection.

FACING PAGE, BOTTOM:
**42. Snuff Container**
Nguni/Zulu, South Africa, 19th–
20th century. Wood, 11.1 x 4.4 x 4.1 cm.
Collection of Marc and Denyse
Ginzberg.

Throughout southern Africa, the
taking of snuff and smoking of tobacco
are valued as activities that help to
sustain social relationships. They are
also associated with the ancestral
world, with both virility and fecundity,
and with concomitant displays of
wealth, power, and generosity. Snuff
containers are among the smallest but
most personal objects produced in
southern Africa. Being discreet but
portable tokens of status, receptacles
for snuff were worn as accessories by
both men and women. They adorned
the waist, neck, or arm and, among the
Zulu, they were inserted through
pierced earlobes. In addition, they were
attached to cloaks or carried in bags.

Small as they are, snuff containers
reflect the full range of aesthetic
production, from abstract austerity and
purity of line to figurative stylizations
of human and animal form. References
to cattle in shape and choice of
material underscore the significance of
cattle within a complex of beliefs
associated with ancestral spirits,
patriarchal authority, and wealth.

The forms of snuff containers vary
dramatically. Tiny gourds, calabashes,
or fruit-shells were often used, and the
shape of a small gourd seems to have
been the model for snuff containers
carved from horn and ivory. The use of
rare materials, such as rhinoceros horn
and elephant ivory, was the prerogative
of chiefs and was associated with
hunting prowess, as well as the regal
power of these particular animals.

A pair of bulbous snuff containers
joined by a carved wooden chain is
typical of those produced by the
Tsonga people of the northeastern
Transvaal and Mozambique. These
droplike snuff containers have tapering
stoppers, and are often found singly as
well as in pairs. They are also
frequently found attached to the ends
of elaborate headrests.

A very distinctive type of snuff
container, historically associated with
Xhosa-speaking people in the eastern
Cape, is made of a combination of hide
scrapings mixed with blood and small
amounts of clay. It has been suggested
that these substances were collected
from the hides of animals that had
been offered to ancestors, thus giving
the container a protective talismanic
quality. The unusual mixture was
worked over a clay core that was later
removed when the modeled material
had hardened to a stiff, leathery
consistency. The outer surface of these
particular snuff containers is usually
spiky, the raised points having been
made by lifting and stretching the
surface membrane with a sharp
implement while it was still malleable.

Many still have sharply pointed
surfaces. This seems to indicate lack of
wear; they might have been kept at
home or safely within bags rather than
being worn. These small sculpted
forms were usually shaped like cattle or
bulls with large horns. *KNe.*

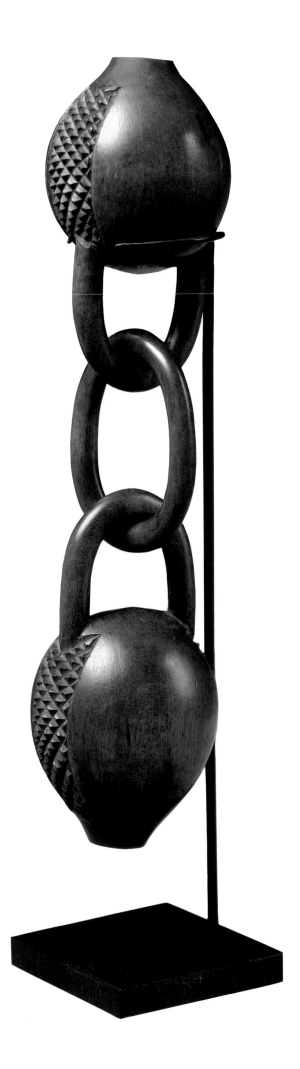

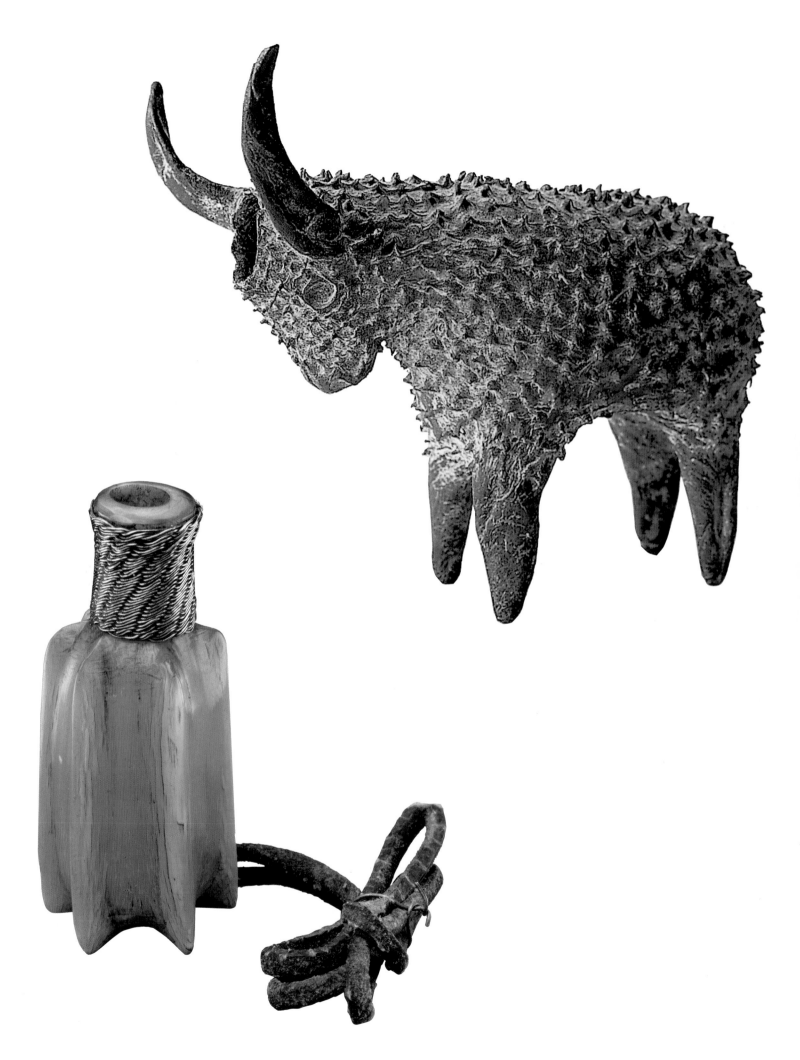

93

43A. **Pair of Earplugs**
Zulu, KwaZulu-Natal, South Africa,
20th century. Pierced wood and paint,
ca. 6 cm in diameter. Collection of
Jonathan Lowen.

43B. **Pair of Earplugs**
Zulu, KwaZulu-Natal, South Africa,
20th century. Wood, vinyl asbestos,
glue and panel pins, ca. 6 cm in
diameter. Collection of Jonathan
Lowen.

43C. **Pair of Earplugs**
Zulu, KwaZulu-Natal, South Africa,
20th century. Pierced wood and paint,
ca. 6 cm in diameter. Collection of
Jonathan Lowen.

43D. **Pair of Earplugs**
Zulu, KwaZulu-Natal, South Africa,
20th century. Wood, vinyl asbestos,
glue, and panel pins, ca. 6 cm in
diameter. Collection of Jonathan
Lowen.

The development of earplugs
(*iziqhaza*) is related to the custom of
ear piercing, still widely practiced in
southeastern Africa, especially among
Zulu-speaking people. Historically, ear
piercing was an important ceremony
performed on every Zulu child before
puberty. It incorporated some of the
features of the circumcision and
initiation ceremonies, which are still
practiced by many southern Nguni but
which fell into disuse among the Zulu
during the early nineteenth century. In
Zulu practice, the earlobe was pierced
with a sharp piece of iron; thereafter,
small pieces from the top of a corn
stalk were placed in the newly made
holes. As the ear healed, larger and
larger pieces were put into the hole
until it was big enough for pieces of
reed to be used. Early records mention
conical earplugs made of polished ivory,
horn, or baked clay; they also note that
snuff boxes shaped like slender barrels
were worn in the ear.

By the second quarter of the
twentieth century, much larger plugs
made of wood had come into fashion.
Accordingly, the hole in the earlobe had
to be distended considerably. Three
sizes of plug (about forty-five
millimeters, fifty-five millimeters, and
seventy-five millimeters in diameter)
were commonly encountered. The
simplest and presumably earliest type
consists of plain polished discs made
from the wood of the red ivory tree
(*Rhamnus zeyheri*), from which they
took their name (*umnini* or *umncaka*).
This type of earplug is often slightly
convex and occasionally decorated with
one or more metal studs. From the
1930s to the mid-1940s, a relatively rare
genre of pierced and painted plugs was
developed (for example, the first and
third pairs shown here).

Plugs of various woods with finely
worked plastic mosaic overlays glued or

nailed onto one or both sides had
appeared by the late 1920s. Such plugs
reached their most intricate and
sophisticated patterns (sometimes even
incorporating letters of the alphabet)
with the advent of vinyl asbestos as a
flooring material around 1950 (see
second and fourth pairs shown here).
Most were made by Zulu craftsmen in
Johannesburg for sale to fellow Zulu
migrant workers. In the 1960s and
1970s, vinyl asbestos was replaced by
the thicker and more brittle perspex
and occasionally by other plastics. As
the new materials were more difficult
to work, the designs became simpler,
relying for their effect on larger bold
areas of color, a highly polished finish,
and, frequently, metal studs. They were
usually overlaid on both sides and
followed the regional patterns and
colors of the Msinga district of
KwaZulu, where many were produced.
Finally, in the 1980s medium-sized
clip-on earplugs began to be made in
Johannesburg. They consist typically of
two fifty-five millimeter discs,
connected in the center by means of a
tight rubber band. They have a perspex
mosaic on one side and are painted
white on the other.

The earplugs of the 1950s to 1970s
tend to follow the color conventions of
regional beadwork. The colors available
in vinyl asbestos closely resembled the
colors of the glass beads traded in
central KwaZulu at that time. They
could be used to indicate the domicile
of origin and possibly the clan
affiliation of their owners, and certain
color combinations evoked associations
with stages in the cycle of life. Most
significantly, perhaps, the wearing
of earplugs and the presence of
conspicuously pierced earlobes
identified a person as being Zulu.

*FJ*

# Central Africa

The most conspicuous geographical characteristic of central Africa is the huge saucerlike area drained by the Zaire River (formerly called the Congo) and its tributaries. To the north are great forests. The south is more sparsely forested, with open and wooded savannas. The population includes many agriculturists, who keep some animals as well, although, in distinction to eastern and southern Africa, cattle are not herded here. Some peoples of the region practice fishing and trapping; a few are nomadic hunters and gatherers.

Central Africa has seen the rise of many kingdoms, mostly in the period before European contact. Some, such as the Chokwe and Kongo kingdoms, seem not to have lasted long after the arrival of Europeans. Others, such as the Luba, Kuba, and Lunda, also precolonial in origin, have lasted into this century. All developed royal arts related to the political and religious sources of leadership.

Among many groups, rites of passage became a significant focus for the arts. Masking was associated with an intensive period during which boys were initiated into the knowledge and responsibilities of adulthood. Analogous ceremonies existed for girls, although the use of sculpture was far rarer in their case. Among some groups, special induction ceremonies were held for healers, diviners, ritual experts, blacksmiths, sculptors, singers, and dancers.

Belief in the efficacy of spirit ancestors to aid the living gave rise to sculptures of various types, ranging from portraits to figures that protected the relics of the dead. *Minkisi*, objects of power, are found from the west coast and, among the peoples of southern Zaire, as far as the great lakes. Many, but by no means all, *minkisi* are in human form yet symbolize spirits. Carved by sculptors and empowered by ritual specialists, they are used to neutralize misfortune. The specialist adds various empowering objects, including mirrors, shells, nails, and feathers, which may be attached over time. Thus, the sculptor's product becomes an armature for ritual additions over the lifetime of the object's use. Under the specialist's guidance, these power figures may be employed by individuals, families, cults, or the larger community as a link to the supernatural.

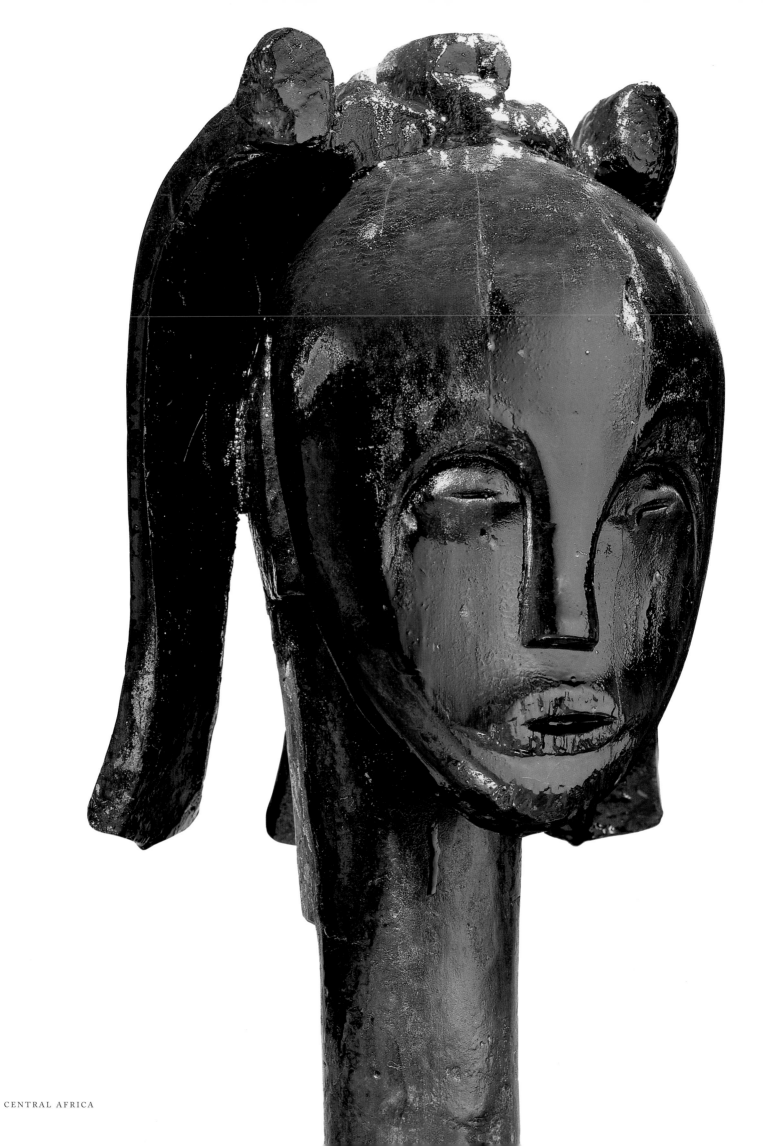

**44. Reliquary Guardian Figure**
Fang, Gabon, 19th century. Patinated
wood, 34.9 x 19 cm. Private collection.

Fang reliquary chests, from southern
Cameroon to the Ogowe Valley in
Gabon, were generally surmounted by
statuettes, but also sometimes by heads
alone, particularly among the Ntumu
(northeast of Rio Muni and the upper
Woleu Valley) and the Betsi (Okano
Valley and central Ogowe). The
question of whether the style of the
heads predates the style of the busts
and erect statues was first raised by
G. Tessmann in 1913; heads collected
between 1880 and 1920, however, do
not appear to be any older than statues
collected during this same period.
Which of the two genres was more
common is unclear as well. Because of
their relative fragility (wood is difficult
to preserve for any great length of time
in an environment with a very unstable
climate, where wood-eating insects are
rife), heads are scarcer in museum
collections today than they were
originally in Fang villages.

As far as representations related to
the *byeri*, the cult of lineage ancestors,
are concerned, it appears from the
relics still extant (mainly fragments of
skull, or occasionally complete heads
with jawbones) that the single head
was the most common of the two
genres. During the theatrical ritual of
*melan* (one of the initiation rituals of
*byeri* during which the Fang
"reanimated" their ancestors before
calling them individually by name and
presenting them to young men being
initiated), however, it was the statues
that were used as puppets, not the
single heads.

The *byeri* heads are stylistically very
homogeneous, in contrast to the

relative diversity of the whole figures.
The only feature that varies
significantly from one head to another
is the hairstyle. Three different styles
can be distinguished: the helmet-wig
with multiple plaits (*ekuma*), the
helmet with a central crest (*nlo-o-ngo*),
and the transverse chignon. Fang
hairstyles were always wigs made of
hair, fibers, and vegetable wadding,
decorated with glass beads, cowries,
and metal chains. It is assumed that the
heads with a chignon, where the hair
itself was plaited close to the scalp
(high on the forehead and on the top
of the head), represent females.
Presumably, the more richly decorated
hairstyles, also plaited, are masculine;
they are significantly more common,
which is to be expected in a patrilineal
society.

The head shown here is one of the
most famous examples of classical Fang
statuary. It has a broad, admirably
bulging brow, and the face is carved in
a soft heart-shape, with half-closed,
almond-shaped eyes, a long, flattish
nose, and mouth pouting forward.

The delicacy of this carving
continues to surprise; it was produced
in a village environment by people who
had been constantly on the move since
the beginning of the nineteenth
century. This suggests that the Fang
statuary first discovered at the end of
the nineteenth century may be the
culmination of a long tradition, dating
back to before the last migration of
groups from the eastern savannas of
Cameroon and central Africa. *LP*

### 45. Staff Handle

Solongo, Angola/Zaire, 19th–
20th century. Ivory, 11 cm high. Private
collection, Brussels.

According to Raoul Lehuard, this staff
handle (*mvuala*) is a Solongo piece.
The Solongo live on both sides of the
Zaire estuary and along the Atlantic
coast from Banana to Ambrizete.

Staffs are insignias of power. They
are often presented to future chiefs at
initiation ceremonies, or handed down
from generation to generation.
Possession of a carved staff permits its
bearer to take part in political and legal
proceedings.

The figure shown on this staff
handle combines two well-known
positions for this type of carving: the
head turning sideways (*kebo-kebo*—the
turned head indicates a person keeping
watch), and the kneeling position with
hands on thighs (*ye mooko va bunda*).
Generally speaking, the kneeling
position such as the one shown here is
characteristically female. It expresses
deference and obedience; the hand on
the thigh indicates waiting.

Carved staffs occur frequently in the
arts of Lower Zaire and the sur-
rounding regions. (Recently, copies of
antique staffs have pushed the number
even higher.) Ivory-carving techniques
developed in this area have produced
some exquisite works, indeed some
masterpieces. *JC*

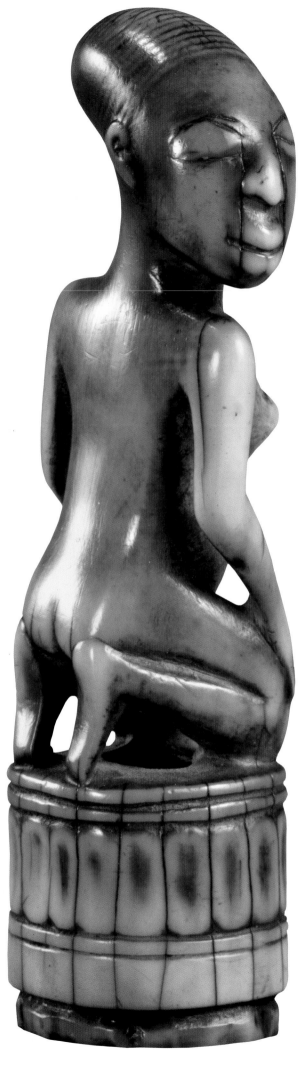

### 46. Staff Handle

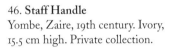

Yombe, Zaire, 19th century. Ivory,
15.5 cm high. Private collection.

This handsome handle (*mvuala*) of a
dignitary's staff comes from a known
workshop. The Koninklijk Museum
voor Midden-Africa in Tervuren,
Belgium, possesses a piece by the same
hand, as does the Musée Barbier-
Mueller in Geneva.

The handle shows a kneeling woman
with her left hand on her thigh and her
right hand placed against her cheek,
signifying contemplation. The position
is traditional, particularly on staffs
belonging to chiefs. The elaborate
hairstyle (*mpu*) indicates an importance
shared with that of the chief. The
naturalistic style of carving is typical of
Kongo sculpture.

The figure's copious scarification is
characteristic of the Mayombe area.
Women in the region of Lower Zaire
adorned their bodies with some of
the most elaborate and elegant
scarifications found in Africa.
Particularly prevalent, in this context,
were lozenge patterns associated with
fertility. Patterns of this type were
found also in the decorative plaiting
characteristic of this area, an art form
often employed to illustrate proverbs.

A staff such as this symbolized the
legitimacy of its bearer, or of the person
entrusted with it. It connected his
power with the power of his ancestors.
It seems fitting that women should be
given such an important role in this
type of artifact, for it is their fertility
that allows power to be passed on
through the generations. *JC*

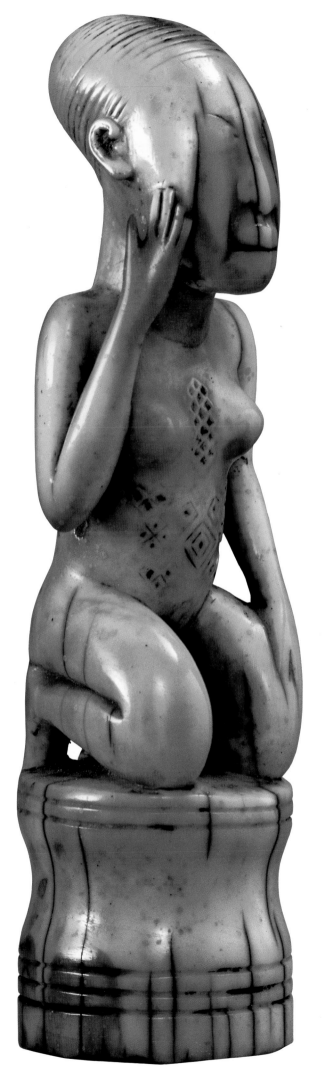

**47. Crucifix**
Kongo, Zaire, early 17th century.
Bronze, 26.7 x 19.1 x 1.9 cm.
Collection of Ernst Anspach.

**48. Crucifix**
Kongo, Zaire, 18th–19th century.
Bronze, sheet metal, tacks, and wood,
29 x 19 cm. Bareiss Family Collection.

According to oral traditions collected
in the late sixteenth and early
seventeenth centuries, the Kingdom of
Kongo probably emerged at the end of
the fourteenth century as one of several
modest states located south of the
River Zaire. Gradual expansion
through alliances and military conquest
made the capital, Mbanza Kongo, the
center of a large and powerful state.
Portuguese sailors arrived there in 1483;
at this time, Portugal was a powerful
mercantile nation, intent on establish-
ing new trade routes to the Indies. Its
commercial expansion was
accompanied by a committed Catholic
missionary spirit that actively sought to
convert any peoples encountered. In
1499, Pope Alexander VI granted King
Manuel I of Portugal patronage over all
African lands that had been or were to
be discovered by the Portuguese. In
1512, Manuel in turn sent a document
to the king of Kongo, proposing a plan
for the organization of the Kongo state
on the model of a Christian monarchy.
Various local Kongo rulers were
converted to Christianity, among them
the king himself, who was baptized
with the name Alfonso I (1506–43).
Conversion was reinforced by the use
of religious images. Among these were
bronze figures of the Virgin and the
Portuguese-born Saint Anthony of
Lisbon (also known as Saint Anthony
of Padua), cast by Kongolese artists
after Portuguese models.

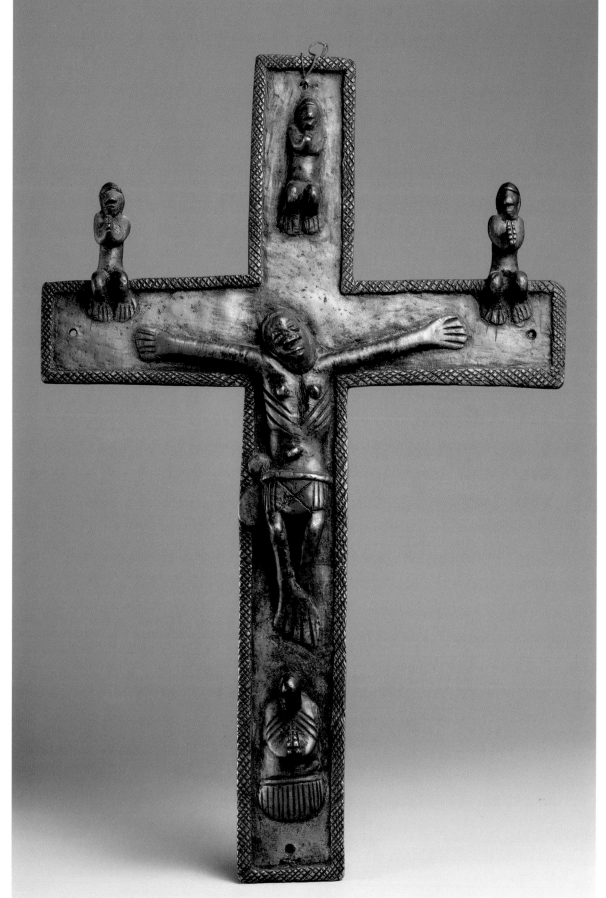

Crucifixes played an important role in the elaborate ritual life of the Christian Kingdom of Kongo. A wide variety of types were carved and cast, in a range of sizes and styles. Sometimes small orant figures were positioned underneath Christ's feet and/or placed above him. Occasionally, a small orant figure was located at the bottom of the cross; this represented the Virgin Mary, in her role as mediator between humankind and Divine Glory. Often, however, the Savior was shown alone. The decidedly African features of Christ figures such as the two shown here, a characteristic encountered in numerous examples, distinguish Kongo crucifixes from their European counterparts. This distinction, in turn, raises questions about the production and reception of artistic forms within diverse cultures. It points to shifts in significance that crucifix imagery underwent upon contact with Kongo ideas, transformations in meaning that turned objects meant to spread the Christian faith into vehicles for the transmission of local concepts and beliefs. Prior to the arrival of Europeans, cross forms had been perceived by the Kongo people as a visual analogy of their own relationship to their world, a crossroads, that is, between "this world" (*nza yayi*) and "the land of the dead" (*nsi a bafwa*). This local understanding of cross forms had a decisive impact on the reception of Christian cross imagery, an impact still felt today. Such shifts in meaning were visually reinforced by shifts in form. Among these was the introduction of decorative elements derived from local tradition, such as the round bosses seen in the second cross shown here. *TT*

**49. Cushion Cover**
Kongo, Zaire, Angola, early
17th century (?). Pigment on raffia,
24 x 47 cm. Pitt Rivers Museum,
University of Oxford, 1886.1.254.1.

This is one of forty or so seventeenth-century raffia palm-fiber cloths from the kingdom of Kongo that survive in European collections. The history of this particular cloth cannot yet be established with certainty, but it seems likely that it is the "table-cloath of grasse very curiously waved" that was listed by John Tradescant, a botanist and gardener, in the catalogue of his and his father's collection published in 1656.

It has often been reported that the raised patterns on these cloths were produced by a technique of "cut-pile" embroidery similar to that used in the late-nineteenth and early twentieth centuries in making the so-called "Kasai-velvets" created by the peoples of the Kuba kingdom some 1,120 kilometers to the northeast. Closer examination, however, reveals that a weaving technique was used to produce the patterns on this particular cloth. Although plain weave has been widely employed in Zaire, in some areas weft floats have also been used to create geometrical patterns, generally lozenges and zigzag lines. (When only one color is used, the result is similar to European damask, but the pattern may also use a contrasting color for the supplementary weft.) Among the Kongo, Mongo, and Pende peoples, a technique has been developed in which the weft floats are cut and the ends of the cut thread are rubbed so as to create a pile cloth. Although woven cut-pile and embroidered cut-pile cloths look similar, the design of a cut-pile weave is limited by the necessity of repeating simple patterns, whereas the design of an embroidered cut-pile cloth is freer and may, as in some Kuba

cloths, consist of what seem like randomly scattered motifs. The similarities in the style of the two traditions suggest historical links, but the art-historical relationship between Kongo and Kuba cloths has not been established; that the techniques used are different makes this more difficult than it has seemed to some scholars.

This particular cloth is unusual because not all the weft floats are cut, resulting in a combination of damasklike areas and areas of cut-pile tufts. Because weft floats reflect and cut tufts absorb light, this also results in variations in the basic tan color. Here, greater emphasis has been created by painting some tufts with black pigment. The use of an additional color makes this piece apparently unique; all other known Kongo cloths are monochrome. For a whole Kongo cloth to be filled with an oblique interlaced design is also unusual, most other known cloths being made up of isolated designs enclosed in squares, repeated within an overall pattern. Only two other known examples bear a similar design. The first is a cloth in the National Museet in Copenhagen, the second was a cushion cover once in the collection of Manfred Sittala in Milan, and now known only from its appearance in a mid-seventeenth-century watercolor by Cesare Fiore.

The name and significance of the pattern here are unknown, but are recognizably Kongo. As the indigenous weaving industry died out after the establishment of European contact, it is only the motifs used that link this early Kongo art visually with the body and sculptural arts that are well known from nineteenth- and twentieth-century accounts and collections. The designs are the same on both sides of the cloth, though the fact that they do not match at the edges suggests it was made from two cloths (probably two parts of one larger cloth) rather than

from folding a single cloth. The decorative edging of small but intensely packed pompoms, as well as the four large pompoms at the corners, are also made of raffia and are a common feature of Zairean textiles.

Raffia cloths and mats formed part of the accoutrements of the Kongo nobility. The form of this cloth suggests that it is a cushion cover without a filling, though a possible additional (or alternative?) role as a bag or purse is suggested by the small opening at one end and by the fact that the Kongo king is said to have possessed a cushion in which he kept his jewels. *JXC, HVB*

**50. Nkisi Nkondi**
Kongo, Zaire, before 1878. Wood, cord, iron, and cloth, 83 cm high. Koninklijk Museum voor Midden-Africa, Tervuren, Belgium, MRAC 22438.

Most of the objects widely admired as Kongo art fall into the category called *nkisi* (plural, *minkisi*), an untranslatable term. The Kongo, speakers of the Kikongo language, number about three million people, distributed among the republics of Angola, Zaire, and Congo on the Atlantic coast of central Africa. *Minkisi* are ritual procedures for dealing with problems ranging from public strife, theft, and disease to the hope of seducing women and becoming wealthy. *Minkisi* are not meant to appear or act alone. They are a part of an elaborate ritual program, which includes a variety of participants, objects, and activities. Among these are the *nganga*, the initiated expert who performs the ritual; his or her costume and other paraphernalia; the client; prescribed songs to sing and rules to be observed; sacrifices, invocations, dancing, and drinking. *Minkisi* as found today in museums are no more than selected parts of the material apparatus necessary for the performance of rituals in pursuit of particular goals. Most *minkisi* date from between about 1880 and 1920. Colonial administrators repressed the use of *minkisi*, which, though they continue in active use to this day, no longer take the public and visually explicit forms that they did in the past.

The basic idea of the *nkisi* object is that of a container of forces directed to some desired end. The container held relics of the dead, or clay from the cemetery, which brought the powers of the dead into the *nkisi* and made it subject to a degree of control by the *nganga*. It also held medicines (*bilongo*), which metaphorically represented the

uses to which this power was to be put. Other *bilongo* were attached to the outside, where their function was to impress the public by their visual intricacy, suggesting the unusual capacities of such composite objects.

The outer attachments of some *minkisi* consist of beautifully carved miniatures that serve as a reminder of their powers. Among these are objects that represent in miniature the musical instruments that would be played during the activation of the *nkisi*, such as a slit-gong, a clapperless bell, and a double-ended wooden bell.

The most powerful, most spectacular, and now (in the art world) the best-known Kongo *minkisi* belonged to the class called *nkondi*, a name that means "hunter." The business of *nkondi* was to identify and hunt down unknown wrongdoers, such as thieves and those who were believed to have caused sickness and death among their neighbors by occult means. *Nkondi* could also punish those who swore false oaths and villages that broke treaties entered into under their supervision.

The container of *nkondi* found in museums is usually, as in this case, a wooden figure, to which medicines are added in one or more packets sealed with resin and located on the top of the head, on the belly, between the legs and elsewhere. Not all *nkondi*, however, were carved in the form of human images. Many, which did not attract the attention of collectors (and are therefore lost), were contained in clay pots. To arouse the *nkisi* to work, it was both invoked and provoked. Invocations, often in

extraordinarily bloodthirsty language, spelled out the problem, urging *nkondi* to punish the guilty party:

*Lord Mutinu! open your ears, be alert. The village, the houses, the people, do you not see us? My pig has disappeared, I can't hang on to a chicken, a goat, a pig, or any money in the house. The villagers, they have their animals, they have many children, they are content. I have not quarreled with any one, man or woman. Mwene Mutinu, if anyone is angry with me and it is only a daylight matter, overlook it; but if it is witchcraft— proceed! Seize whoever is causing me harm, whether man or woman, young or old, plunder and strike! May his house and his family be destroyed, may they lose everything, do you hear?*

To provoke *nkondi*, gunpowder was exploded in front of the container, insults were hurled at it, or—most commonly—in the case of a wooden figure, nails, blades, and other hardware were driven into the *nkisi*. Angered by these injuries, *nkondi* would mysteriously fly to the attack, inflicting on the wrongdoer similar harm. A few days later, if anyone in the village were to fall ill with chest pains, it would be said that *nkondi* had found that person and punished him or her. To make sure the *nkisi* knew just what was expected of it, bits of rag, hair of the stolen goat, or some other token (called a "dog") were attached to it, often to the nails, each time it was invoked. As time passed, the *nkisi* visibly accumulated the evidence of successful cursing, adding greatly to its fearsome appearance. *WM*

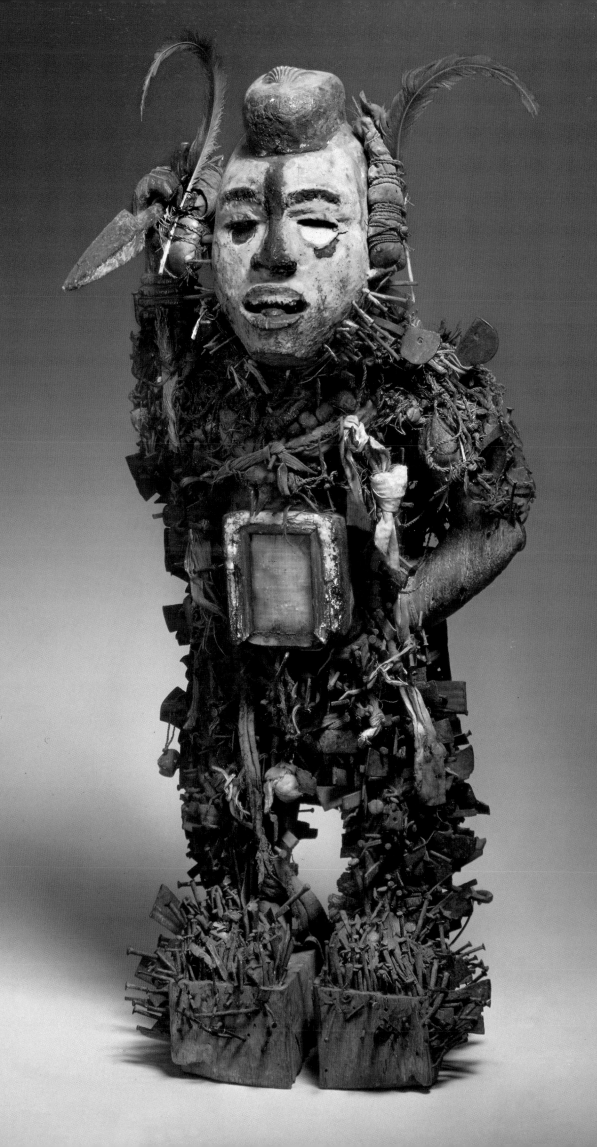

### 51. Power Figure

Songye, Zaire, 19th century. Wood, horn, metal, beads, cloth, and leaf, 76.2 x 25.4 x 20.3 cm. Collection of Allan Stone Gallery.

The term by which the Songye designate their magical figures—*nkisi* (plural, *minkisi*)—is encountered elsewhere in widely dispersed parts of central Africa. In southern Zambia, the Mbunda used it to identify their masks. Equally, it is used among the Kongo on the Atlantic coast as a generic term with a wide range of reference, including the magical figures that the Kongo themselves create (see cat. no. 50). *Nkisi*, then, is a "key word" deeply embedded in many different Bantu languages. Taken as a whole it becomes virtually untranslatable by reason of the the very diversity of objects, substances, and activities that it serves to designate. What all the various usages have in common, however, is that they allude to an assemblage of objects and entities whose efficacy and capacity to influence the affairs of the living depend upon some external agency, usually identified with spirits or with ancestors.

Among the Songye, it is only magical figures that are identified as *minkisi*. Masks, to which Songye figures are in some senses contrasted, are identified separately under the term *kifwebe* (plural, *bifwebe*)—though elsewhere in the Bantu world they too may be included in the reference of the term. Among the Songye, there are two kinds of *nkisi*. One, which is small in scale (and by far more numerous), is personal in application and ownership, which is restricted to individuals or, at most, to households or nuclear families. The other kind, such as the figure shown here, is much larger and, in its deliberate attempt to embody strength and power, more formidable in conception. Such carvings function on behalf of entire communities, and—occasionally, where their powers are widely extolled—they may serve a more extensive constituency.

The efficacy of *minkisi* has several sources. Most important are the many different types of substances and paraphernalia applied to the figures. Most of these additive materials are regarded as inherently powerful or aggressive: substances such as parts of lions, leopards, snakes, bees, and birds of prey; the sexual organs of crocodiles and earth from the tracks of elephants; and human elements taken from such exceptional categories of people as suicides, sorcerers, epileptics, or twins. Items of regalia may also festoon the figure, recalling the typical attributes of chiefly dress or hunter's attire. The figures themselves are always male and incorporate a combination of characteristics that constitute a generalized reference to the ancestors.

The most important and detailed study of Songye masks and figures published to date is by Dunja Hersak, who noted that the efficacious substances listed above are thought of as dating back to the beginning of creation, and are said to have been originally contained in horns and calabashes. Containers of this kind are attached to the object shown here. In general, however, the head and the swollen abdomen of the figure hold the empowering concoctions, which—as in Kongo magical figures—may themselves be regarded as in a sense "containers," vehicles of mystical force. There is no prescribed formula or choice of elements unerringly adhered to in the creation of a magical figure: each is empowered by a variety of substances, assembled in varying combinations according to the preferences and experience of the ritual specialist, the *nganga*, who "creates" the object. It is significant that the carved properties of the figure are considered secondary. It is unquestionably the

substances applied subsequently that are the critical element; indeed the *nganga* credited with the creation of the object may or may not be its sculptor as well.

As a result of the individualized treatments it receives, each figure is seen as imbued with its own identity. Each is given an individual name, often that of a renowned chief. This, in due course, is further embellished by a biography of accomplishments, of causes effectively resolved. Each figure is treated and attended to with care; it is fed, anointed, and receives sacrifices. It is also individualized in the sense that it has its own particular life cycle. Although it is kept in a special hut and has its own designated guardian, in the end it will suffer physical decay. Should the *nganga* responsible for its existence die, its own powers are conceived as commensurately reduced; in time, the community may decide that it needs to be replaced.

Communal *minkisi* are used to achieve benign ends. Persistent dreams of imminent danger among those charged with their care—premonitions expressed in visions of lightning and fire, or of deep ravines—signal a need for their magical intervention. To counteract these adverse signs, the *nkisi* is brought out. In public, it is manipulated by poles fitted into holes carved under its arms. Like many things associated with or identified as *nkisi*, these poles are retrieved from burial grounds. Each pole is held by a villager, and the *nkisi* is walked through the village, attacking and challenging unseen yet threatening forces that may be present. Although dedicated to ensuring the health and welfare of the community, these figures are not gentle or soothing. They are confrontational objects, objects with attitude. *JM*

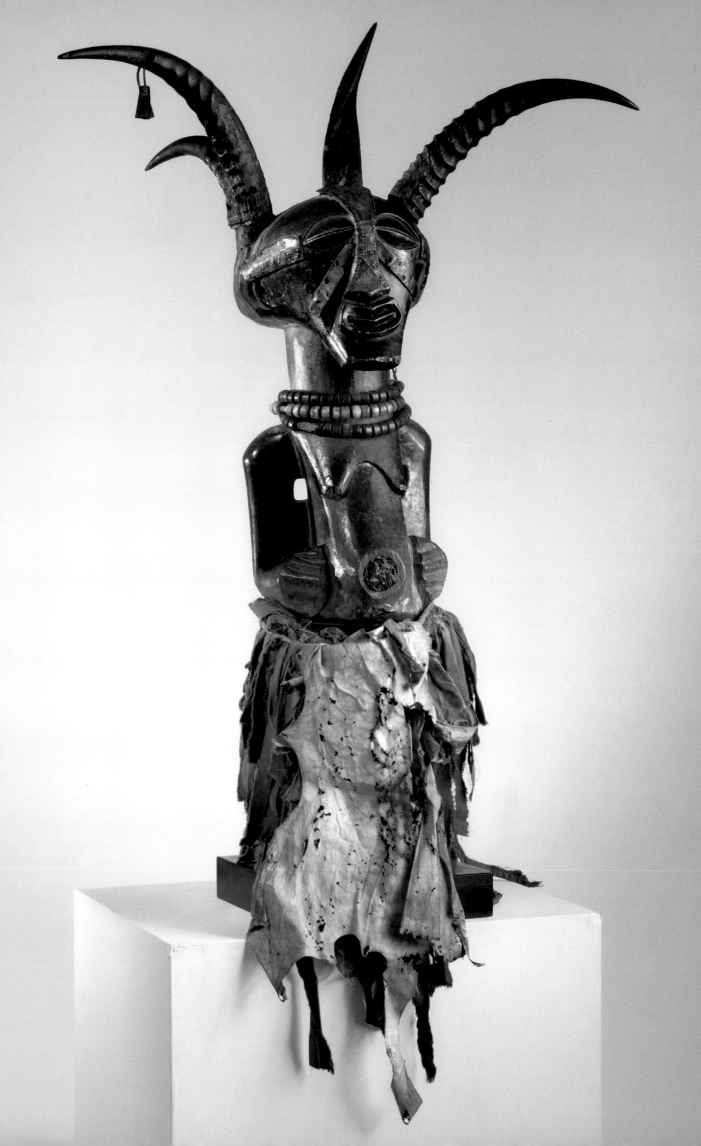

**52. Headrest**
Luba, Zaire, 19th–20th century.
Wood, 17 x 13 x 9 cm. The Trustees of
the British Museum, London, 1956.
AF. 27.270.

A headrest serves as a pillow that is
both cool and comfortable in a tropical
climate, and protects elaborate
hairstyles by raising the head above the
surface of the bed. In addition to the
great personal attachment that Luba
people developed for their headrests,
these were also seen as the seat of
dreams. Luba consider dreams to be
prophetic; dreams foretell important
events, provide warnings, and
communicate messages from the other
world. It is therefore fitting that
headrests should be supported by the
female priestesses who serve in real life
as intermediaries and interlocutors for
the spirits of the other world. The
women on this headrest wear the most
popular hairstyle among the upper
classes during the nineteenth century.
Hairstyles were not merely decorative;
as with all Luba cosmetic adornments
(scarification, genital elongation,
hairstyling), there is a spiritual
dimension to beautification. Women
are rendered ideal receptacles for
the containment of spirit through the
embellishment and "civilization" of
their bodies and heads. *MNR*

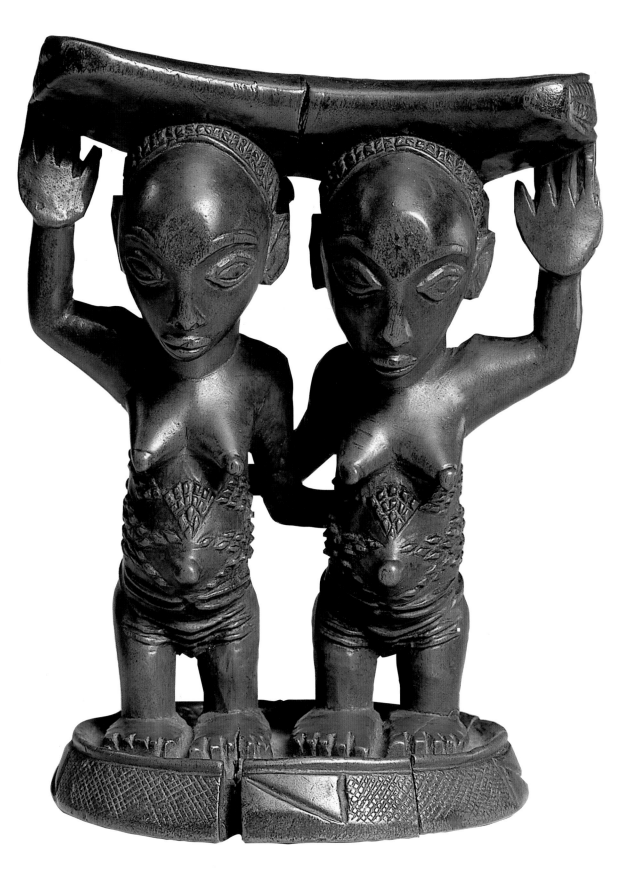

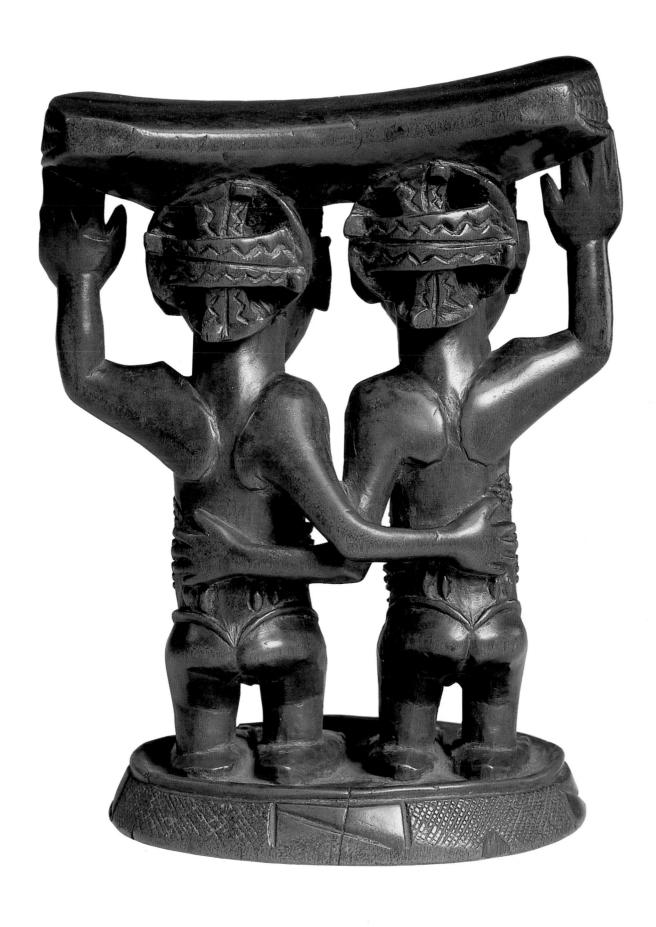

## 53. Stool

*Hemba*, Zaire, late 19th century. Wood, 52 x 27.5 x 22 cm. The Trustees of the British Museum, London, 1905.6-13-1.

The famous stool shown here is one of about twenty objects considered to be from the "Buli" school, after a village in southeastern Zaire, located near the confluence of the Luvua and Lukuga rivers, where several objects of the style have been collected. This is an area associated with the Kunda clan, thought by some to be ancient residents of these lands and the progenitors of Luba royalty. The Luba culture heroes Mbidi Kiliwe and Kalala Ilunga are said to be Kunda, as are several other important chiefs and kings of the region. During the colonial period, small clans and chiefdoms in the Buli area were attributed Hemba ethnicity. Hemba refers to the east, and anyone living in that direction from the Luba heartland along the Lualaba River may be called by this name. Nowadays, people in the area call themselves Hemba, as a convenient identity in national politics.

F. Neyt has attributed this stool and another at the Metropolitan Museum of Art in New York to the hand of Ngongo ya Chintu, a man who once lived in Kateba village. Stools of the sort were possessed and used by chiefs and kings, especially among peoples who were either Luba themselves or who emulated Luba sacred rule. Objects of the distinctive Buli style were used across a broad area. Often those possessing stools such as ones commissioned from the Buli workshop were members of the Mbudye Society, the purpose of which was to extol a Luba model of power, refined behavior, and communication with the world of spirits. Stools are still used as seats of power and prestige, but they are also places of memory, situating power and memory in the past and present, and their subtle iconography can be read as sculptural narrative. Stools and other objects are used as mnemonic devices by people in this part of central Africa to remember what is right and glorious. In particular, a stool may be considered a *kitenta* or "spirit capital," that is, a place joining a chief and his people to the ancestors and other spirits seeking to guide everyday affairs. Stools are not for sitting, then, except in the most exceptional of circumstances, when a chief or king means to demonstrate his position as sacred intermediary between worlds.
*MNR, AFR*

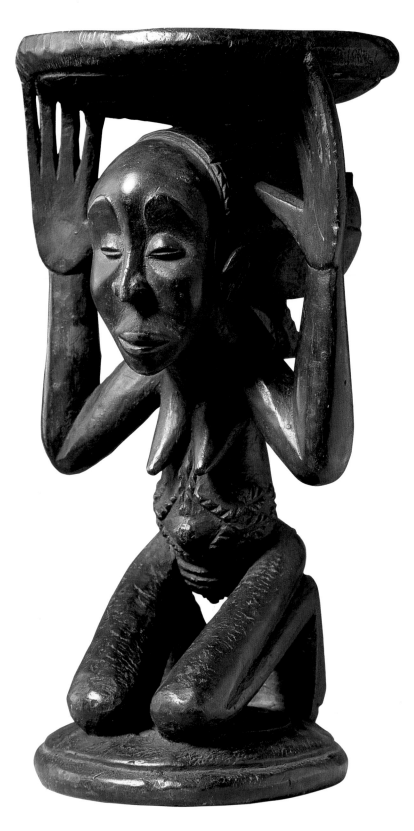

### 54. Ndop Portrait of King Mishe miShyaang maMbul

Kuba (Bushoong), Zaire, 18th century.
Wood, 49.5 x 19.4 x 21.9 cm.
The Brooklyn Museum, New York,
purchased with funds given by Mr. and
Mrs. Robert E. Blum, Mr. and Mrs.
Alastair Bradley Martin, Mr. and Mrs.
Donald M. Oenslager, and Mrs.
Florence E. Blum Fund, 61.33.

The Kuba of south-central Zaire are
famous for arts associated with royalty
that include highly decorated drums,
backrests, boxes, baskets, elaborate
architectural ornamentation, textiles,
and costume regalia. Significant, but
small in number, among Kuba artistic
production is the royal figure (*ndop*)
that is considered a conventionalized
representation of a Kuba paramount
ruler (*nyim*).

*Ndop* figures present the ruler seated
cross-legged on a raised platform. The
principal focus of the composition is
the large head of the figure whose
countenance suggests both aloofness
and composure. The left hand of the
figure holds a short sword. This sword
and the elements of costume regalia
such as belts, armbands, bracelets,
discoid shoulder ornaments, and
projecting royal headdress are
identified with Kuba chieftaincy.
Directly in front of the figure is an
object that identifies the ruler—a
symbol (*ibol*) that was selected by the
ruler during his own investiture.

Much scholarly discussion has
surrounded the *ndop* figures since four
of them were first observed by the
African-American, Presbyterian
missionary William Sheppard at the
Kuba royal capital in 1892. Subject to
debate are the origins of this figural
tradition, the paramount rulers that are
represented by *ndop*, and whether some
of the figures may be copies made after
the original examples were lost,
damaged, or destroyed. Discussion

especially centers on five figures
belonging to the so-called "archaic"
style. Current interpretation suggests
that these figures were all made during
the eighteenth century. The Brooklyn
Museum's *ndop* may be the oldest,
dating to 1760 or possibly earlier. This
*ndop* represents the *nyim* Mishe
miShyaang maMbul, who reigned at
the beginning of the eighteenth
century. The symbol of his reign is a
drum prominently displayed in front of
the seated monarch.

The figure is thought to have been
commissioned by a ruler during the
latter half of the eighteenth century
to honor his predecessor and in respect
for his predecessor's wives who still
lived in the royal compound. It is
also assumed that some rulers
commissioned their own *ndop*, and that
it was employed during the ruler's
lifetime. Because the figure was
believed to represent the spirit of the
*nyim*, it was kept in the compound of
the ruler's wives and was placed near a
woman during childbirth to safeguard
a successful delivery. This suggests that
for the Kuba, the person of the *nyim*
enhanced fertility and protected
women in childbirth. At the ruler's
death and before burial, the *ndop* was
placed near the dead body. From this
point, it became a memorial to the
deceased ruler and a point of contact to
his spirit. It is suggested that his
successor was secluded in an enclosure
with the *ndop* during the period of
instruction that preceded the
investiture of the new ruler. *Ndop*
figures were also displayed on
important occasions, such as when
Sheppard visited the ruler Kot
aMbweeky II in 1892.

The relative rarity, size, and
naturalism of *ndop* figures classifies
them as masterpieces. This has led to
the creation of various-sized
reproductions by recognized artisans at
the Kuba royal court. *DAB*

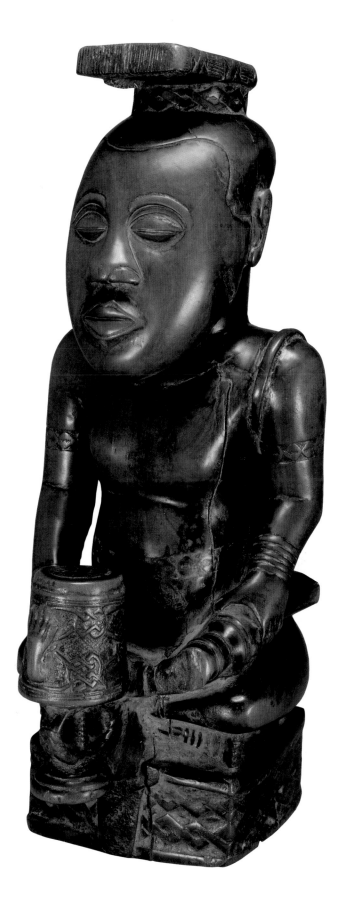

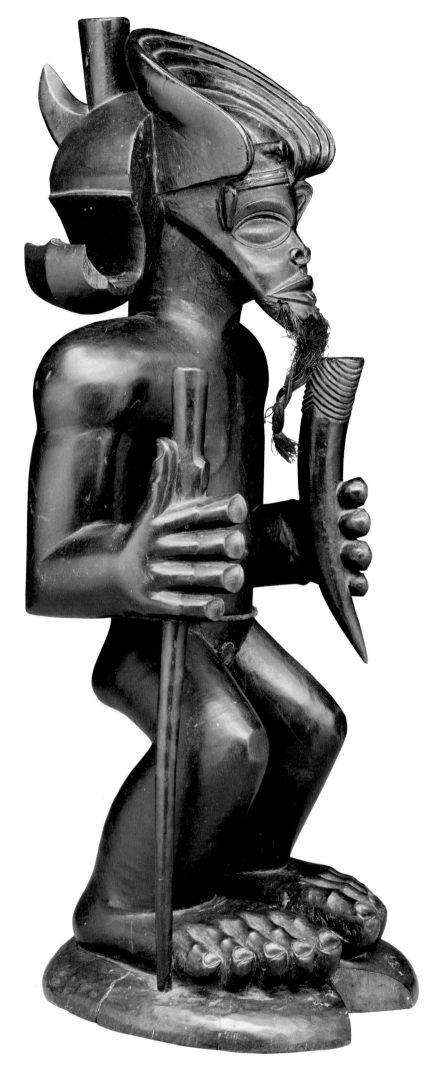

**55. Figure of Chibinda Ilunga**
Chokwe, northeastern Angola,
19th century. Wood, hair, and hide,
40.6 x 15.2 x 15.2 cm. Kimbell Art
Museum, Fort Worth, Texas.

Some time before 1956, a Namuyanga soothsayer in his eighties explained to me the identity of Chibinda Ilunga, the person commemorated in the figure shown here; the entire Lunda people and anyone in their sphere of influence were already celebrating his memory. Victor W. Turner's *Lunda Love Story* (1955) gives a good résumé of the tale written down by H. Dias de Carvalho in 1890 while staying at Musumba, near the River Kalanyi. It was Dr. Paul Pogge, however, the first European officially to have reached the capital of the Mwata Yamvo empire in 1875, who made a record of this dynastic epic.

Chibinda Ilunga, the prince of "sacred blood" (*mulopwe*), came from the eastern Luba lands ruled over by his father Kalala Ilunga. He was a passionate huntsman and, having crossed the Kalanyi-Bushimai, arrived in an area owned by the young female chieftain of the Lunda, Lweji. She was the keeper of the traditional symbol of authority, the bracelet (*lukano*), inherited from her father, Konde; the *lukano* gives its possessor seniority over other lineages and preeminence at the Council of Elders. At that period, the Lunda lands, between the Kalanyi and the Lulua, knew nothing of centralized power, and their hunters still used only bludgeons and catapults. The noble stranger, raised in more sophisticated court circles and venerated by his retinue, used hunting weapons of metal, their efficacy reinforced by auspicious spells. Lweji, agreeably impressed and attracted by her guest, welcomed Chibinda Ilunga enthusiastically to her domain; one day, after their marriage, she handed him

the symbolic *lukano*. Her brothers and other important elders were displeased by this seizure of power and left for the west, beyond the Kasai, in search of new lands. They took with them, however, some of their newly acquired customs and knowledge. These they transmitted to the people occupying the high wooded plateau, the fertile valleys, the sources of the Kasai and the Kwango, the land of the Chokwe or Uchokwe (also known as "Tchiboco"), a land rich in game, favorable to the cultivation of cereals and vegetables, and where honey could be gathered in abundance.

Through an intricate series of marriages, they became completely integrated into the local population, which, as luck would have it, already had a long history of wood carving. Thus, as powerful chiefdoms were formed over the years, a court art developed in each one. Their rulers, wanting to commemorate this cultural hero of yore, commissioned their celebrated professional sculptors (*songi*) to make images of Chibinda Ilunga. The prince was portrayed in full hunting regalia (including, from the end of the eighteenth or early nineteenth century, a flintlock rifle), and his due complement of charms. He was also shown proudly wearing the royal headdress of the Lord of the Chokwe (*mwanangana*).

This carving returns the hero to his traditional role: he is a haughty and dignified figure, in spite of his powerful musculature and the exaggerated size of his extremities. His long, carefully tended beard emphasizes his aristocratic origins. *MLB*

## 56. Harp

Mangbetu (?), Zaire, collected by
Herbert Lang in Niangara, Zaire, 1910.
Wood, pangolin scales, hide, plant
fiber, and pitch, 57 cm long. American
Museum of Natural History,
New York, 90.1/3969.

Not long after Europeans "discovered"
the Azande and Mangbetu living in the
area that is now the Sudan and
northeastern Zaire, musical
instruments, particularly ivory horns
and harps, attracted special attention.
Graceful harps, usually with five strings
stretching diagonally from a carved
neck to a hide-covered resonator, were
common in the area at the end of the
nineteenth century. Those of the
Ngbaka were conceived as full-body
sculptures with the legs suspended
from the resonator; those of the
Azande often had sculpted heads, and
sometimes limbs, carved into and
around the neck. But the earliest
western account of the Mangbetu, by
Georg Schweinfurth in 1874, noted that
they had no stringed instruments.

After the turn of the century,
however, many beautiful harps were
made with elaborate carved heads
representing the Mangbetu. Early
observers surmised that the harp was
introduced to the Mangbetu by the
Azande from the north, and many of
the so-called Mangbetu harps may
have been made by Zande carvers.
More recently, such scholars as Didier
Demolin have suggested that the harp
was in fact introduced from the south,
although the practice of adding
decorative figurative carving may have
come from the north. In contrast to
other musical instruments, like ivory
horns, many types of drums, and iron
gongs, harps were not played in the
musical ensembles at the courts of
Mangbetu kings. Rather, they were
used as instruments of entertainment,
played to accompany individual singers,
most often the harp players themselves.

This particular harp was collected in
1910 by Herbert Lang during a six-year
expedition sponsored by the American
Museum of Natural History. The
woman's fanlike hairstyle emphasizes
her elongated skull—the result of the
practice of infant head wrapping,
which was common at that time. The
face and body is incised with lines that
represent the body painting then
fashionable among Mangbetu women.
The unusual resonator is covered with
scales of the pangolin, suggesting that
this harp may have been awkward to
play and may have been made as a
display piece for a local ruler or foreign
visitor. ES

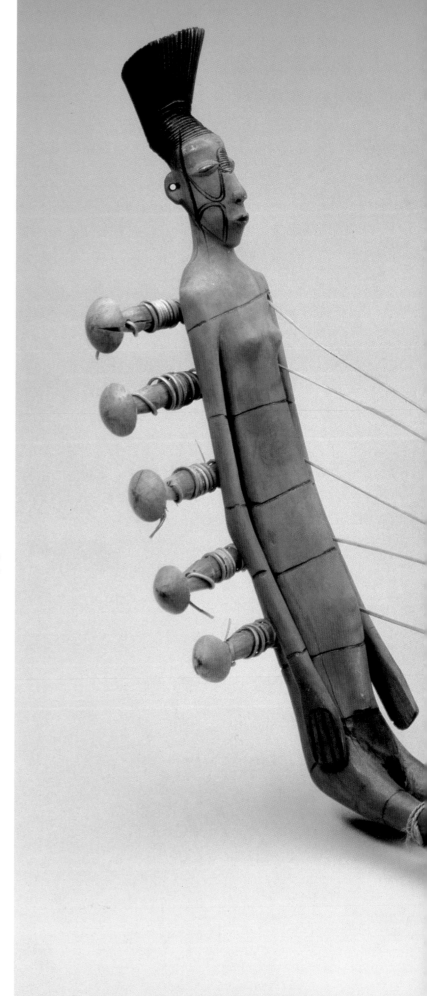

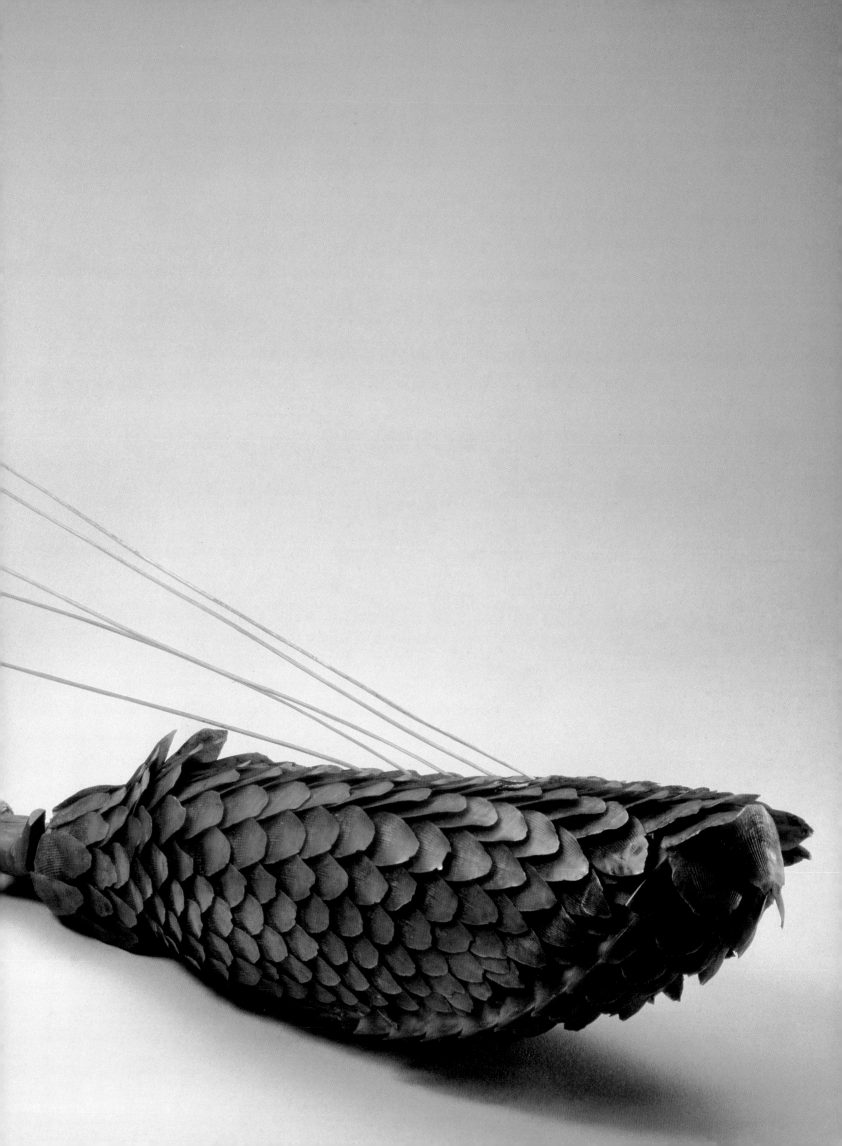

# Western Africa and the Guinea Coast

The peoples of the Atlantic coast of western Africa, from Cameroon to Senegal and as far inland as the Savanna, have developed exceedingly sophisticated art traditions.

Many languages are spoken in western Africa. The Bantu language probably spread from the Nigeria-Cameroon border over much of Africa south of the Sahara. Ironworking technology probably dispersed from the same area, although its origin may have been farther north or east.

Western Africa is rich in archaeological finds. Metalworking and ceramics appeared in this area about two thousand years ago. Iron tools allowed for efficient clearing of the forest, tilling of the soil, and harvesting of crops, leading to the establishment of settled agricultural communities, a prerequisite for major art production. Iron also facilitated the carving of sculpture in wood. Clayworking led to efficient storage and cooking vessels and allowed for the development of ceramic statuary.

The ceramic sculptures of the Nok culture of northern Nigeria, dating from about 500 B.C. to A.D. 200, are the earliest known examples of figurative sculpture south of the Sahara. It has been suggested that they were made by women, an idea in part based on later evidence from Ghana that Akan women potters made that society's heads and figures portraying the royal dead.

The practice of casting metal sculpture, in copper alloys of varying composition, appeared at Igbo-Ukwu in eastern Nigeria in the tenth century, in Ife (along with clay sculpture) about two centuries later, and at Benin still later. The casting of copper alloys continued to flourish at Benin as late as the end of the nineteenth century, ending as a royally sponsored art only with the British Punitive Expedition of 1897, which removed thousands of works that had decorated the king's palace and the royal ancestral altars.

Many sculptural traditions in wood (a medium that does not survive archaeologically) developed in western Africa. Some were associated with leadership: the royal arts of the Akan of Ghana, the kingdoms and chieftaincies of the grasslands in Cameroon, and the richly diverse artistic traditions of the Yoruba of Nigeria. Works of art were produced to celebrate chiefly prestige, to decorate shrines, for divination, and to control supernatural forces.

Farther west in this area are found a variety of masks associated with coming-of-age ceremonies and voluntary associations. Most of these are used by men's groups, with the unique exception of the masks and figures produced for women's societies in Sierra Leone and Liberia.

## 57. The Dinya Head

Nok Valley, Kaduna State, Nigeria, ca. 500 B.C.–A.D. 200. Fired clay, 36 x 22.5 cm. The National Commission for Museums and Monuments, Lagos, 79.R.1.

Discovered in 1954, face down in a narrow channel in bedrock overlain by some three-and-eight-tenths meters of alluvial deposits, this spectacular life-size terra-cotta head is characteristic of the Nok style. Broken at the neck, it appears to have been part of a figure that, when complete, would probably have been at least one-and-one-half meters high. Fingermarks of the maker are visible on the interior, but the exterior has been tooled to a fine surface finish. While its striking countenance is impressive today, originally, as part of a complete figure, it must have been awe-inspiring. The buns of hair plaited at intervals around the face are perforated, but why remains a mystery. This is the largest complete Nok head to have been recovered and preserved in Nigeria's museums, although fragments of even larger heads exist.

The Dinya Head was nearly destroyed when unearthed by a tin-miner's pickax but, fortunately, was saved by the quick-witted actions of a laborer who had worked part time for the Nigerian Antiquities Service. The miner's destructive impulse was probably due to the fact that these terra-cottas often appeared in pockets of the tin-bearing deposits when the tin was running out.

This particular object is one of several fragmentary terra-cotta figures that form the core of the corpus of material known as the Nok culture. Early on, it was suggested on geological grounds, and later supported by associated radio-carbon dates, that these figures, occurring in stratigraphically similar deposits, were some 2,000 years old. In 1970, a thermoluminescent date of about 500 B.C. obtained from the Jemaa Head reinforced the previous assessment. *AF*

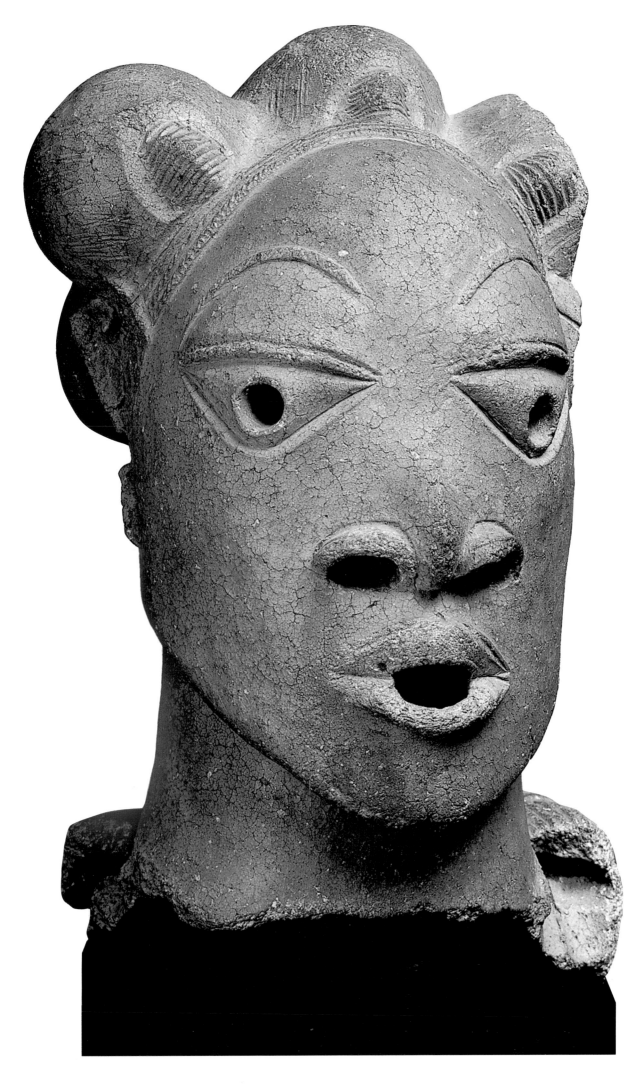

## 58. Head

Yoruba, Ife, Nigeria, 12th–15th century. Zinc-brass, 35 x 16.5 x 22 cm. The National Commission for Museums and Monuments, Ife, Nigeria, 11.

In 1938, ground was being dug to construct a house in Wunmonije Compound, now immediately behind the palace in Ife, but formerly within the enclosing palace wall. The workers found two groups of castings. Most were of life-size heads like this one, two were smaller than life size and wore crowns, and there was the upper part of a figure that closely resembles that of a king (*ooni*) found in 1957 at Ita Yemoo. Their portraitlike naturalism astounded the Western art world despite the fact that the German explorer and ethnographer Leo Frobenius had called attention to this art as early as 1910, when he discovered a crowned metal head and a score of terra-cotta sculptures. It was not considered in 1938 any more than in 1910 that this could really be the work of African sculptors unless they had worked under a European master. Soon after World War II, William Fagg argued persuasively that these were indeed objects made by Africans before Europeans first landed on the Guinea Coast.

The head was cast from a wax original over a clay core. The top of the head was cut back on the wax before casting to make it fit an existing crown. Holes were provided in the neck to allow it to be attached either to a column or more likely to a wooden body. It is not clear how such heads were used. Perhaps they carried the crown and other emblems of office of a dead ruler in a second burial ceremony to show that, though the incumbent had died, the office continued, or they may have been used in annual rites of purification and renewal for the ruler and his people. *FW*

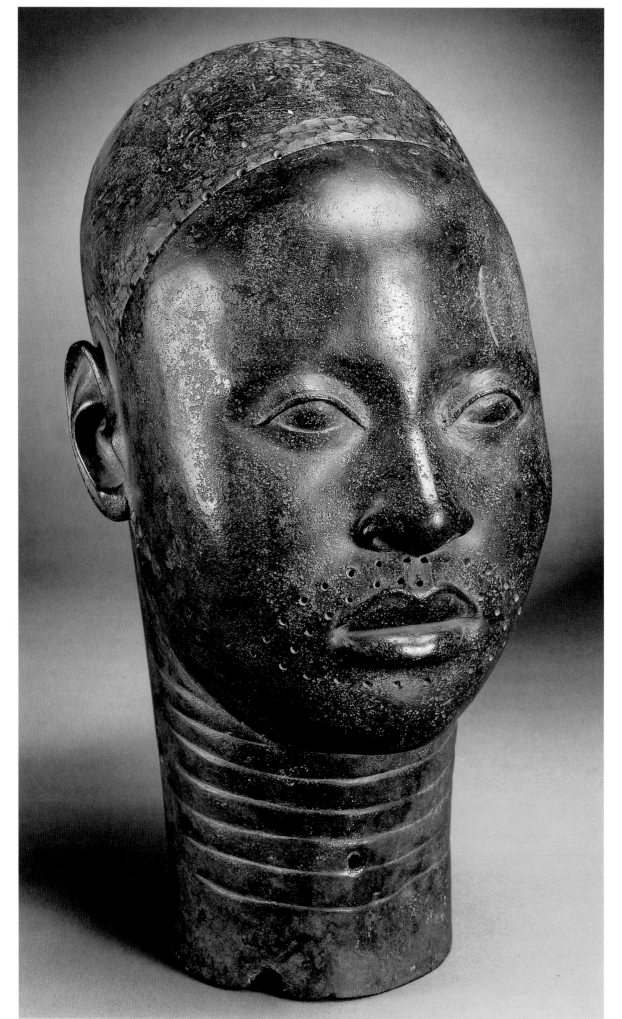

**59. Head of a Queen**
Yoruba, Nigeria, Ita Yemoo, Ife,
12th–13th century. Terra-cotta;
25 x 17 x 13 cm. The National
Commission for Museums and
Monuments, Ife, Nigeria, 79.R.7.

The accidental discovery of a group of
cast figures at Ita Yemoo in 1957 led to
excavations of this site. During the first
season, the remains of a shrine,
composed largely of worn-out
grindstones with terra-cotta sculptures,
were discovered. Four heads were
found, but as seven left feet were
discovered as well, there must have
been at least seven figures originally.
Most had been dug away and
incorporated into the walls of two
nearby houses. One house has been
demolished and contributed pieces that
could be joined to those excavated.
Two of the four heads were without
headdresses of any kind and are
thought to have depicted attendants.
They are about two-thirds life size.
The other two wore crowns and were
three-quarters or more life size. The
flanged crown on the head seen
indicates that the wearer is a queen. It
has been possible to reconstruct the
front of a female body from the
excavated fragments, but they do not fit
this head. It appears that at least two
queens were represented on the shrine.
Originally, this head had a crest on the
front of the crown like that worn by
the brass figure of a king (*ooni*) that
was discovered at this same site. *FW*

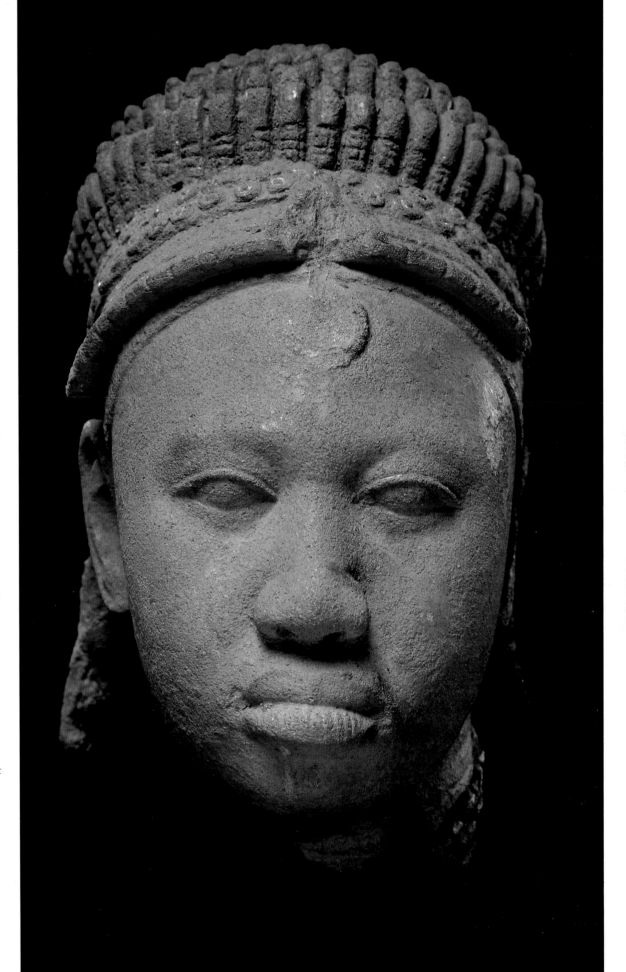

**60. Seated Figure**
Yoruba, Tada, Nigeria, 13th–
14th century. Copper, 53.7 x 34.3 x
36 cm. The National Commission for
Museums and Monuments, Lagos,
79.R.18.

This is the supreme masterpiece of the Ife smiths' art. Its proportions are naturalistic, whereas normally the head is a quarter or more of the height of the figure. The limbs and usually the torso are generally no more than cylinders, but here the legs and remaining parts of the arms are lifelike. The figure wears a wrapper that is overlain with a net of beads. On the left hip, a sash is tied around a folded cloth. Originally, the right foot may have projected below the level of the base, which prompted William Fagg to suggest that the figure might have been intended to sit on a round stone throne.

The metal used to cast this piece was almost pure copper. The sculpture, weighing (in its broken state and without the enclosing mold) about eighteen kilograms, was too heavy to cast by joining the mold to the crucible, so it was probably cast by partly burying the mold in the ground and melting the metal in several sealed crucibles. When ready these would have been taken to the mold, their tops knocked off, and the metal poured in.

One can distinguish on the back of the figure the lines separating the different pourings, as the metal chilled when running into the mold and did not fuse completely.

Until recently, this piece was kept in a shrine in the Nupe village of Tada on the River Niger 192 kilometers north of Ife, where the villagers took it down to the river every Friday (being observant Muslims) and scrubbed it with river gravel to ensure the fertility of their wives and of the fish on which they live. This accounts for its smoothed appearance. Bernard Fagg persuaded the villagers that they were destroying the sculpture and with it the fertility they were trying to promote. He provided them with special cloths to keep it bright. By 1956, the cloths had worn out and the habit had been lost. The figure was already developing its dark protective patina.

It is not clear why this piece and several others were found so far north. It may well be that its location indicates the ancient northern frontier of the Ife kingdom. *FW*

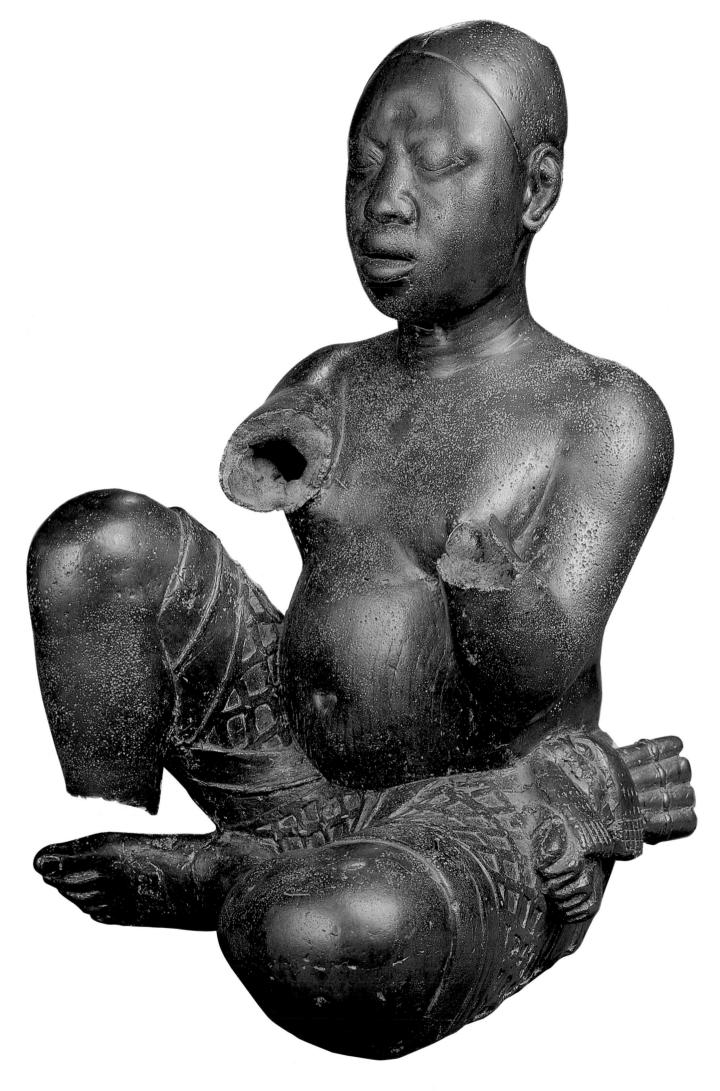

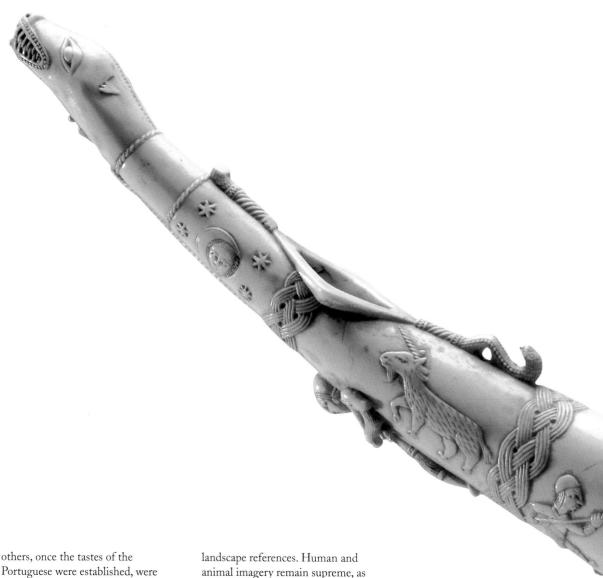

## 61. Oliphant

Afro-Portuguese, Sierra Leone, ca. 1530. Ivory, 49.5 cm long, 8.9 cm in diameter at opening. Private collection.

The Portuguese were the first Europeans to venture to western Africa, reaching coastal Sierra Leone in the 1460s. There, they encountered the Temne and Bullom living in small city-states, each with its own leader. Ivory was plentiful, and the Portuguese bought many raw tusks. Observing local artists' skills, they also purchased worked pieces, about one hundred of which survive. These were export objects, made expressly for foreigners. Their forms—oliphants (hunting horns), cutlery, pyxes, and saltcellars—usually followed European models and were decorated with heraldic, Christian, mythological, and other alien motifs from books and sources the Portuguese supplied. Despite these adaptations, the artists also incorporated snakes, crocodiles, parrots, and other references to their own world. They continued local canons of proportion, geometric patterns, and spatial expression as well, creating true hybrid works. Their small-scale export industry produced some works—having very specific imagery—as direct commissions;

others, once the tastes of the Portuguese were established, were apparently made and stockpiled for export. At least nine workshops carved for the Portuguese from the late-fifteenth to about the mid-sixteenth century. Those workshops showing the closest adherence to Portuguese prototypes seem to have been centered at a port on the Sierra Leone Estuary. Products showing less evidence of direct contact with Europeans were probably made by artists living elsewhere in the region.

About thirty-two Afro-Portuguese oliphants from Sierra Leone survive. All closely related, they were carved by the same Estuary workshop. Characteristically, the oliphant shown here includes European hunting scenes, as well as other foreign images such as a unicorn, a centaur, wyverns, and anthropomorphized celestial bodies. The artist treated the surface with sparer, less-crowded ornamentation than that of most horns; his work seems closer to the style apparently preferred by local patrons. Although he attempted to duplicate alien modes of representation, such as figures in motion, he avoided Western spatial conventions and, in his quotations of hunting prints, stripped them of

landscape references. Human and animal imagery remain supreme, as they still are in sub-Saharan art.

No Portuguese supervised the making of this horn, for it includes two characteristics buyers would never have requested. The artist's imperfect knowledge of foreign iconography led him to invert prominent representations of the Portuguese coat-of-arms, an error he committed on other horns as well. And, although this example includes standard export features—European-style suspension lugs, animal-headed end, banded composition, and three high-relief figures on the convex side—its lozenge-shaped mouthpiece is unique. Its lateral orientation reflects the local manner of playing; European horns (and other Sierra Leonean oliphants made for Europeans) always have end-blown mouthpieces. While this horn's hybrid nature demonstrates how Sierra Leonean artists adapted to foreign requests, it also proves their compromises were not total. Despite the work's departures from a European norm, the worth of the ivory itself and the piece's curio value ensured a buyer; similar Afro-Portuguese horns were disseminated from Portugal to royal collections throughout Europe. *KC*

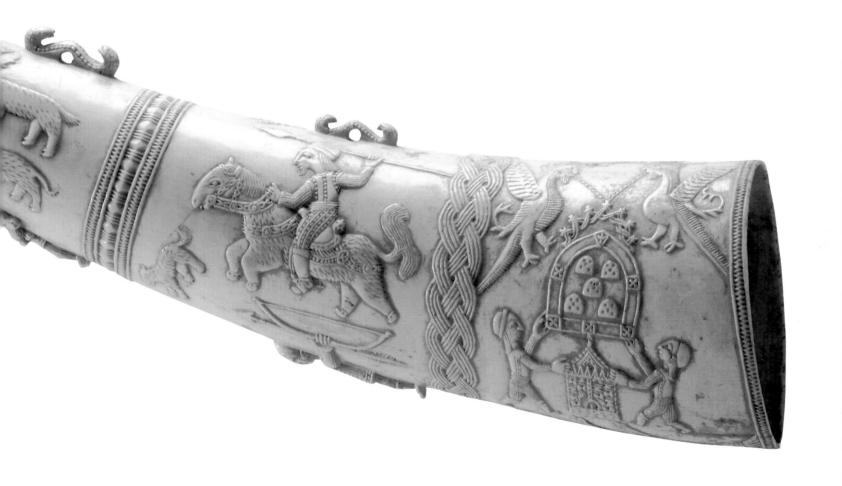

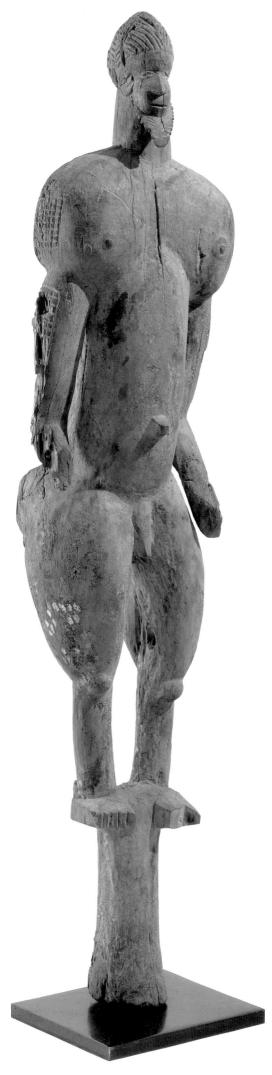

**62. Male Figure**
Mboye, Central Nigeria, 15th century.
Traces of pigment on wood,
176.5 x 35.6 x 35.6 cm. The Menil
Collection, Houston.

Very little is known about the history of this monumental piece, which is said to have been carved by the Mboye on the Bauchi Plateau of central Nigeria. The Bauchi Plateau, which is populated by a many small, independent (or acephalous) communities, has received only scant attention from scholars. Until the advent of Islam in the area during the nineteenth century, its inhabitants practiced traditional religions, often in tandem with elements of Muslim belief, for many had converted to Islam (at least nominally) early on. As a result of the Fulani *jihad*, the holy war of Islamic proselytization that swept through all parts of northern Nigeria in the 1800s, they became a part of the Fulani emirates. In these Moslem-controlled areas, the use of figural imagery was frowned upon. Until the 1960s, traditional religious carvings were still being burned there, as happened in 1965 in the village of Pindiga. One is tempted to think that it was perhaps during one such auto-da-fé that the figure shown here (and two others similar to it) left Nigeria.

Susan Vogel has described this figure as being typical of African approaches to the human body—approaches that conceive of the body as a series of geometric forms. She sees three discrete clusters of forms: the breasts and arms as a unit; the buttocks, thighs, and legs as another; and the torso as a third. The bearded,

comparatively small head of the figure, topped with a coiffure or a knitted cap, is mounted on a stout neck. Like the head, the legs are reduced. The piece may have been carved in this way to make the trunk more visible; it may also have been done out of respect for the shape of the tree from which the figure was crafted. This is supported by the fact that the width and the breadth of the figure are the same.

It is not known how this figure was exhibited in its original home. It would have been difficult for it to stand upright, as its comparatively thin legs, and the cylindrical pedestal on which they rest, seem too frail to support the massive torso. What the figure was used for is equally unclear. The cap and crosshatched decoration on its shoulders would seem to suggest that it was meant to represent not a spirit figure but an individual, perhaps a known ancestor.

The figure has been dated to the fifteenth century, which makes it one of the oldest surviving wooden sculptures in sub-Saharan Africa. Its survival may have been due to the hardwood from which it was carved. As mentioned, two similar sculptures (both in private collections) are known. One is a head broken off from a figure. The other is riddled with "channels of age"; it is approximately 110 centimeters high. *EE*

**63. Head of a Queen Mother**
Benin, Nigeria, 16th century. Brass, 35.5 x 14.5 x 16.5 cm. The Board of Trustees of the National Museums and Galleries on Merseyside, Liverpool Museum, 27.11.99.08.

When British forces entered Benin City in 1897, they were surprised to find large quantities of cast brass objects. The technological sophistication and overwhelming naturalism of these pieces contradicted many nineteenth-century Western assumptions about Africa in general and Benin—regarded as the home of "fetish" and human sacrifice—in particular. Explanations were swiftly generated to cover the epistemological embarrassment. The objects must, it was supposed, have been made by the Portuguese, the Ancient Egyptians, even the lost tribes of Israel. Subsequent research has tended to stress the indigenous origins of western African metallurgy. Yet it was the naturalism that proved decisive. After some hesitation between the categories of "curio" and "antiquity," these objects became unequivocally "art." Their status was marked by the establishment of the resonant term "Benin bronzes," despite their being largely of brass—the noble material locating them firmly within the tradition of Western art studies.

Since then, a great deal of archaeological, historical, scientific, and anthropological inquiry has been undertaken. Works have been classified by period according to the familiar art-historical terms Early, Middle, and Late, with the last implying a tailing off in quality. Controlled production, exclusively for the court and within a guild system, might seem to favor relatively simple models of development. Yet the precise chronology of much of the Benin corpus and its relationship to other African casting traditions remain open to question. Present datings depend largely on the assumption that Benin casting traditions were derived from the naturalism of neighboring Ife and on the hypothesis that a direct connection (or at least a relatively straight line of descent) exists between castings of the Early and Middle periods and the "stylized" forms of the late nineteenth century—a hypothesis bolstered here and there by outsider descriptions of the Benin court, oral histories, thermoluminescent datings of clay cores, and metal analyses. Whether differences of style are a result of date alone, rather than a result of differences in function or origin, however, remains unclear.

The head of a queen mother shown here is normally ascribed, on stylistic grounds, to the sixteenth century, that is, the end of the Early period. The title of queen mother was apparently introduced to Benin by King (*Oba*) Esigie about the beginning of the sixteenth century to honor his own mother, Idia. The first brass memorial heads of this form are, accordingly, assigned to this period. The peaked coiffure, representing a headdress of coral beads, is peculiar to the queen mother and, according to one version, is termed "the chicken's beak." While the *oba* was associated with powerful aggressive animals such as the leopard, queen mothers had a special link with the cockerel, representations of which appeared on altars dedicated also to the mothers of kings. This head was presumably kept on those same altars in the queen mother's palace at Uselu, outside the capital. There, it would appear, such heads functioned as means of contact with the divine realm. Indeed, it seems to be the case that brass heads in general served as bridges between the spirit and the ordinary worlds. Naturalistic though some of these heads may have been, however, it appears that no tradition of personal portraiture was known at the Benin court. *NB*

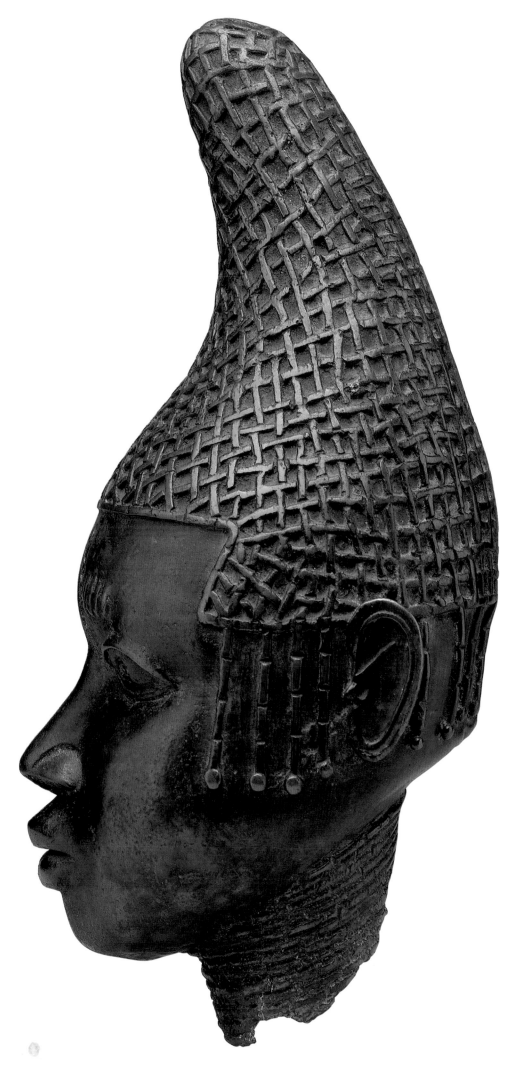

## 64. Memorial Head

Akan, Ghana, 17th–19th century. Terra-cotta, 33 x 19 x 18 cm. Private collection.

Although it is common for terra-cottas such as the memorial head shown here to be labeled Asante, the vast majority are southern Akan, with the most northerly concentration of sculpture coming from Adanse Fomena. In scale, heads such as this one vary widely, from small solid pieces five to eight centimeters high to nearly life-size sculptures. Free-standing heads coexist with full figures, and styles range from abstract to highly naturalistic. While facial features may be modeled simply, considerable attention is paid to scarification patterns and to details of coiffure. Some terra-cottas are left unpainted while others have been painted with black or other colors. Years of exposure have removed much evidence of surface pigment.

Terra-cotta funerary sculpture has at least a 400-year history among the Akan in what is now southern Ghana. Pieter de Marees wrote in 1602 of the burial of a chief: "All his possessions, such as his weapons and clothes, are buried with him, and all his nobles who used to serve him are modeled from life in earth, painted and put in a row all around the grave, side by side." Thermoluminescent tests confirm that a number of such sculptures date from at least as early as this account, although most fall within a seventeenth-to-nineteenth-century span. The tradition continued in a few areas until the 1970s.

Probably the most detailed description of an ensemble of Akan funerary figures comes from the nineteenth-century missionary Brodie Cruickshank:

*They also mould images from clay, and bake them. We have seen curious groups of these in some parts of the country. Upon the death of a great man, they make representations of him, sitting in state,*

*with his wives and attendants seated around him. Beneath a large tree in Adjumacon, we once saw one of these groups, which had a very natural appearance. The images were some jet black, some tawny-red, and others of all shades of colors between black and red, according to the complexion of the original, whom they were meant to represent. They were nearly as large as life, and the proportions between the men and women, and boys and girls, were well maintained. Even the soft and feminine expressions of the female countenance were clearly brought out. The caboceer and his principal men were represented smoking their long pipes, and some boys upon their knees were covering the fire in the bowls, to give them a proper light.*

Memorial terra-cottas were created by female artists to honor deceased chiefs and other important elders, both male and female. As is clear from the above quotation, surviving members of the chief's entourage or family members of the deceased were also represented. The ensemble of sculptures was not typically positioned on the grave, but rather at a sacred grove close to the cemetery where rituals were performed with libations and offerings of food and prayers. In addition, a rich variety of ceramic vessels was assembled at the site to receive the offerings. In certain locales, selected pots were ornamented with elaborate figural or other representational motifs. Some of the smaller terra-cotta heads in collections may have been broken off such pots.

It is clear that Akan terra-cottas did not function exclusively as ancestral memorials in static funerary contexts. Fired clay sculptures have also been documented as processional figures and in shrine and stool rooms. DHR

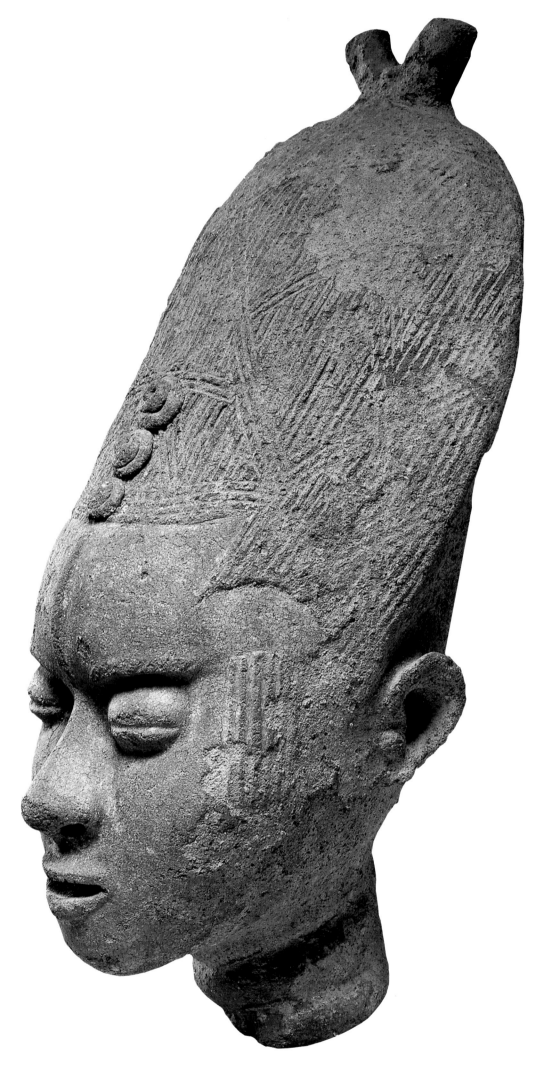

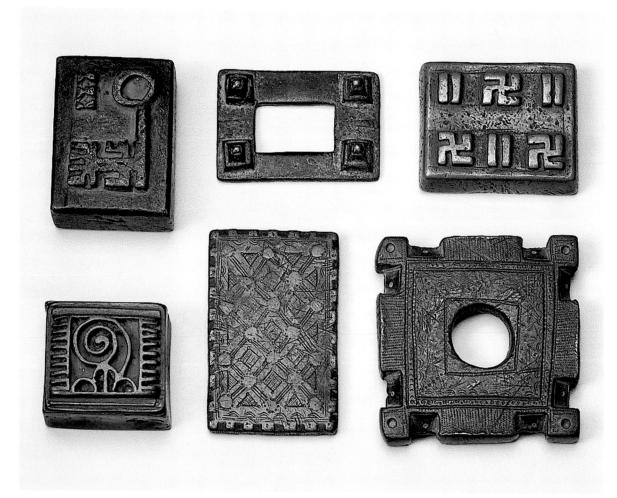

## 65. Geometric Goldweights
Akan, Ghana, 15th–19th century. Brass, with copper plugs, each ca. 2–4 cm high. Private collection, London

Akan weights, in their immense diversity, were employed to weigh gold dust over a period of about five centuries, from 1400 to 1900. They were used by the Akan and Akan-related peoples of southern Ghana and neighboring regions of Côte d'Ivoire.

From about the late fourteenth century, gold mined in the Akan forest began to be traded northward. It passed first to the towns of the western African Sahel, and then across the Sahara desert to northern Africa. To meet the needs of this trade the Akan began to make weights equivalent to those of their Sahelian trading partners. These weights were of two series, one based on an Islamic ounce used in the trans-Saharan trade, and the other on the *mithqal* of gold dust (about four-and-one-half grams, or one-sixth of an Islamic ounce).

When the Portuguese began trading along the western African coast from the 1470s, the Akan made further weights to the standard of the Portuguese ounce. After 1600, when the Dutch introduced the heavier troy ounce, this series too was assimilated by the Akan. Thus, the Akan eventually had four series of weights for trade with all their external partners. Over the centuries these became merged into one long traditional table of about sixty different units of weight. Up to 1900 goldweights were made in accordance with all these units.

As if the great variety of cast brass weights was not enough, the Akan also used seeds, pottery disks, European nest weights, and many scraps of European metal as aids in the weighing process. There was also a complex array of other apparatuses including scales, spoons, shovels, sieves, gold-dust boxes, brushes, touchstones, and small cloth packets. In the Akan world the weighing of gold was a complicated and time-consuming art.

The first Akan goldweights were various geometric forms, which became increasingly diverse and elaborate over the centuries. They are by far the most common of Akan goldweights. The weights shown here are conventionally ascribed to the Early period (fifteenth–seventeenth centuries).

A number of early geometric forms made by the Akan are characterized by notched or indented edges and, very often, an incised or engraved surface decoration of fine lines, dots, and punch-marks. Some are further embellished by inset copper plugs. This technique of decorating cast brass was known in the Middle Niger region, for instance at ancient Djenne, and its reappearance among the Akan suggests that they may have had contact, at a very early period, with goldsmiths from the Middle Niger region.

From about the sixteenth century onward, many early geometric weights had a raised surface decoration, often of bars and swastikas. Some were more elaborate; the first example shown here (top row, left) is a superb large weight from a chief's treasury, probably of the seventeenth century. It comes from coastal Ghana and bears the symbol of a European key, perhaps representing some such proverb as "Death has the key to open the miser's chest." It represents the Akan unit of five *pereguan* (about 352 grams).

Late-period weights of the eighteenth and nineteenth centuries took innumerable forms. Some are variations on the motif of the ram's horn (bottom row, left), signifying force, and courage.

These various geometric weights continued to be used up to about 1900, when goldmining in the region was brought under European control, and the gold-dust currency was replaced by colonial coinage. *TFG*

**66. Pectoral Disk**
Akan/Asante, Guinea Coast,
19th century. Gold, 8.57 cm in diameter.
Detroit Institute of Arts, Founders
Society Purchase, New Endowment
Fund and Friends of African Art Fund,
81.701.

This jewel belongs to a varied class of disk-shaped gold ornaments that includes some of the most beautiful examples of goldwork produced by Akan artists. Usually, such disks were worn as pectorals, suspended over the chest by a white cord. But usage varied, and sometimes they were attached to a cap, or used as the centerpiece of a necklace. In other instances, they were be tied to a person's hair, or even worn around the ankle.

Such disks are usually referred to in the literature as "soul-washer's badges" (*akrafokonmu*). Many were worn by the the chief's *okra*, a young official who "washed" or purified the chief's soul. This, however, was but one of the many uses to which such objects were put. Some were worn as the insignia of a royal messenger, others as that of a herald, linguist, war leader, subchief, or junior official. Occasionally, they were displayed by the chief himself. In the past, they were sometimes worn by girls at puberty ceremonies. Today, in Asante, they can indicate the principal mourner at a funeral; in this context, they are referred to as *awisiado* rather then *akrafokonmu*.

In the example shown here, the absence of surface ornament serves to fix attention dramatically on the central motif, four arms radiating from a focal point. This is probably the Akan symbol of a crossroads (*nkwantanan*). It has proverbial significance, indicating the power and authority of the chief: "the chief is like a crossroads, all paths lead to him."

Several factors combine to suggest that this pectoral disk dates from the nineteenth century. During the twentieth century, the size of such disks has tended to increase, while their standard of workmanship has declined. The present example is relatively small. It is also of exquisite workmanship. In particular, it retains traces of an old and curious technique (abandoned in the twentieth century): in the original wax model, the flat parts of the design were not cut out from a sheet of wax but rather built up from thin wax threads, which were laid side by side and subsequently smoothed.

Another detail is significant. The four small circular holes in the design, as well as the central hole, have not simply been punched in the wax model. Each hole has been carefully reinforced by an applied circlet of wax thread. This superlative attention to detail recurs in a number of other early castings. It is found, for instance, in a series of magnificent crocodile heads cast in silver, which were almost certainly produced in the royal workshops of Asante before the fall of the capital, Kumasi, in 1874. This raises the possibility that the pectoral disk is not merely of nineteenth-century date, but indeed part of the extensive loot that the British obtained from Kumasi at that time. *TFG*

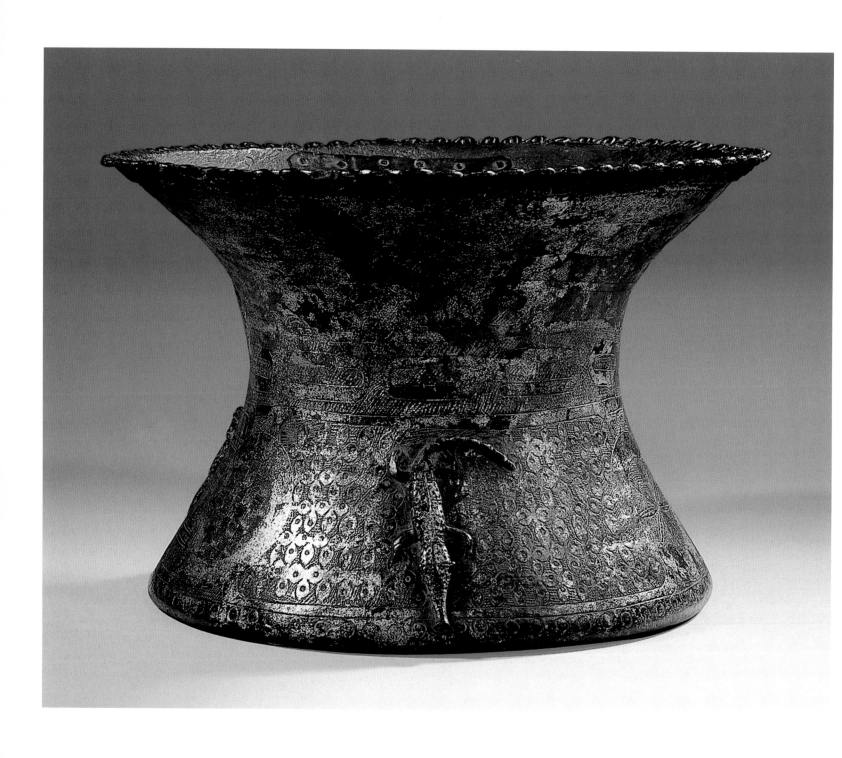

**67. Kuduo**
Asante, Ghana, 18th–19th century (?).
Gilded copper alloy, 17.8 x 27 cm.
Collection of George Ortiz.

Asante culture has long been at the vortex of historical events that tie it not only to the European presence on the coast of Ghana but also to an ancient network of trade extending from Muslim northern Africa to the heart of the Ghanaian forest. The Asante people have themselves been active historical agents; their artists have always gladly accepted items imported from the wider world, assimilating and transforming them in a continuing search for new and more fully realized Asante cultural forms.

Inspired by fourteenth- and fifteenth-century Arabic-inscribed basins from Mamluk Egypt (six of which survive in varying states of disrepair within greater Asante) and other imported Islamic bowl, goblet, and cup forms, Asante metalcasters also drew upon European trade wares in the creation of luxury containers for this highly class-conscious society.

Over generations, the Asante artistic imagination was to reshape these models, resulting in a remarkable range of containers known as *kuduo*, vessels cast of various copper alloys.

One of the most elegant is this fine example, an open-mouthed vessel with flared sides and a delicately scalloped rim, which blends the purity of medieval Islamic design with Asante creative ingenuity. Its silhouette is time-honored among Muslim craftsmen, and containers of this shape, known as *tisht*, are still a popular item in the *souks* of northern Africa. The measured and densely worked bands of designs and the medallions containing rosette patterns that encircle this *kuduo* fully echo Islamic prototypes. The Asante artist has enhanced this container, however, by including three crocodile figures and adding gold leafing to its surface. *RAB*

**68. Ram Ornament**
Owo-Yoruba, Nigeria, 17th–
19th century. Ivory, 15.2 cm high.
Collection of Eric Robertson.

Costumes are important markers of status among the Yoruba people. Among the Owo-Yoruba, a red costume (*orufaran*) is worn by the highest ranking chiefs as a privilege granted by the king (*olowo*). The costume is said to have been introduced into Owo from the kingdom of Benin in the seventeenth century by *Olowo* Oshogboye who, as a prince, received training at the Benin court. It consists of a top shirt made of imported red flannel that is scalloped to resemble the scales of an anteater or pangolin. Like the scales of a pangolin, the costume protects its wearer from harm by rendering him invulnerable. Sewn onto the scalloped shirt are a series of carved ivory ornaments (*omama*) depicting powerful animals such as the ram, crocodile, leopard, or horse. In addition, there are carved ivory full human figures, heads, faces, miniature shoulder plaques depicting the chief (sometimes with attendants), and miniature bells that jingle when the wearer of the costume moves, thus drawing attention to himself. *Orufaran* is worn over a pair of embroidered trousers or layers of expensive cloth wrapped around the waist.

In the past, the woodland country of the Owo kingdom harbored a large quantity of elephants. Elephant tusks were not only a very important economic asset but also a prestige emblem. Owo tradition demanded that when an elephant was killed, one tusk be given to the *olowo*; the other was retained by the hunter, who could make it available to ivory carvers. Owo is regarded as the center of Yoruba ivory carving, and it is known that Owo carvers worked for patrons in other Yoruba areas as well as in Benin City. Indeed, some of the earliest African artworks to enter European collections in the sixteenth century came from Owo. These comprised intricately carved ivory spoons and bracelets. It is known that no European visited Owo until late in the nineteenth century, therefore it must be assumed that either Owo ivory carvers worked through intermediaries or they traveled to the coast, where they could deal directly with European traders, despite restrictions imposed by the king (*oba*) of Benin, who controlled the ivory trade throughout the area.

The use of ram imagery in Yorubaland is a metaphor for power and strength, for the ram is noted for its pugnacity in using its strong horns for defense and offense. Although the elephant was not as important as the ram in Owo thought, it was nevertheless an important metaphor for royalty because of its size, strength, and durability. The use of ivory as a medium for carving a ram image underscores and reinforces the status of the image's owner.

Although the Owo rightly claim to have migrated from Ile-Ife, the ancestral home of most of the Yoruba kingdoms, from the middle of the fifteenth century, their culture was greatly influenced by Benin, which was then experiencing its greatest period of expansion. Evidence of this influence is seen in the age-grade system, titles, palace architecture, and costumes of Owo, which have their counterparts in Benin City. However, Benin influences were not adopted unmodified. The *orufaran* costume offers an excellent example of this. The attachment of carved ivory ornaments to *orufaran* is an Owo practice. The ram symbolism in particular has developed in Owo more than in any other part of Yorubaland or in Benin. In Owo, carved wooden ram heads or carved wooden human heads with ram horns, *osomasinmi*, for example, are used in decorating lineage altars (*oju'po*). They represent the attributes of courage, pugnacity, speed, and strength, all of which the lineage ancestors are supposed to possess in order to be effective as protectors of the lineage's living members. Ram images are carved on altar lintels and are also cast in bronze and used as pendants.

The ram *omama* shown here, one of a pair (the other is in the Metropolitan Museum of Art in New York), probably came from the *orufaran* of the chief (*ojomo*) of Ijebu quarter, originally located on the outskirts of Owo town proper. Ijebu quarter was created by *Olowo* Elewuokun for his brother, Oladipe, who helped him ascend to the throne in the last quarter of the eighteenth century. The *ojomo* ranked only second to the *olowo* but, like other chiefs, he was expected to salute the *olowo* kneeling down. However, he was allowed to wear his own crown, to appoint his own chiefs, and to wear crossed-baldrics of beads (*pakato*) like the *olowo* over his *orufaran*. In many aspects of behavior, the *ojomo* rivaled the *olowo* and would sometimes try to upstage him by the display of opulent costume. The two ram *omama* were probably part of the *ojomo*'s costume. If he inherited the costume from the first *ojomo*, Oladipe, then it can be dated to the last quarter of the eighteenth century.

The pair of ram *omama* were very likely made by the same carver. A third (in the Museum für Volderkunde, Hamburg) was probably by a different hand. Traits of Owo carving styles manifest in these carvings include inlaying of the surface of the ivory with wood or coconut shells, crosshatching, boldness of form, and an elegant use of negative space to define features. *EE*

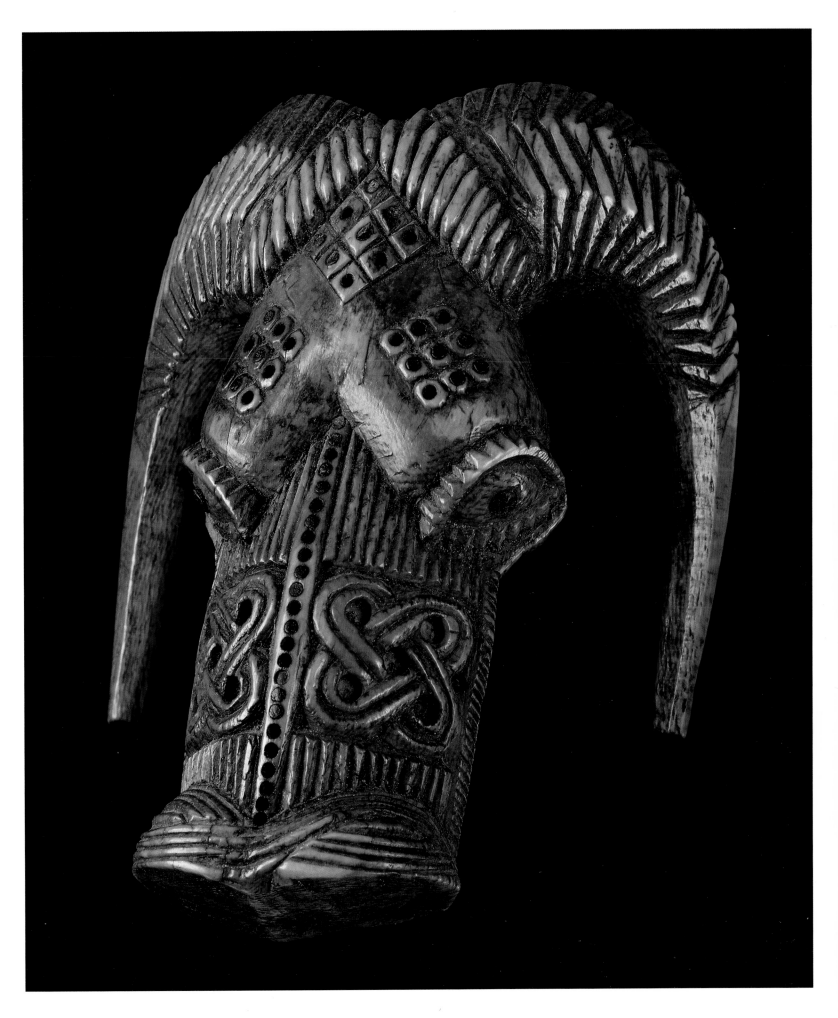

### 69. Swordfish Mask

Bijogo, Bissagos Islands, Guinea-Bissau, 19th–20th century. Pigment on wood, 127 x 65 cm. Private collection.

The Bijogo are known from early chroniclers' accounts for their daring raids—using huge canoes—on shipping along the African coast. Martial virtues were cultivated by an age-set system that associated young men with powerful beasts of the sea and land. In this context, masquerades had an important role. While young boys might wear calf and fish masks, older uninitiated youths wore masks depicting wild bulls, sharks, hippopotami, and swordfish. Their dances were unpredictable and violent, to accord with the character of the animal represented and their own undomesticated nature. They spent much of their time grooming, dancing in various villages, and developing love affairs.

The swordfish mask shown here would be worn with the proboscis pointing forward, the hollow at the rear resting on top of the head and fastened with ties of green raffia. Unlike a bull mask, it would not cover the face. Typically, the dancer would also wear a large wooden dorsal fin attached to the middle of his back. He would carry a shield and stick with bells while swooping and ducking in performance. Masquerade headdresses such as this are best known from the island of Uno. *NB*

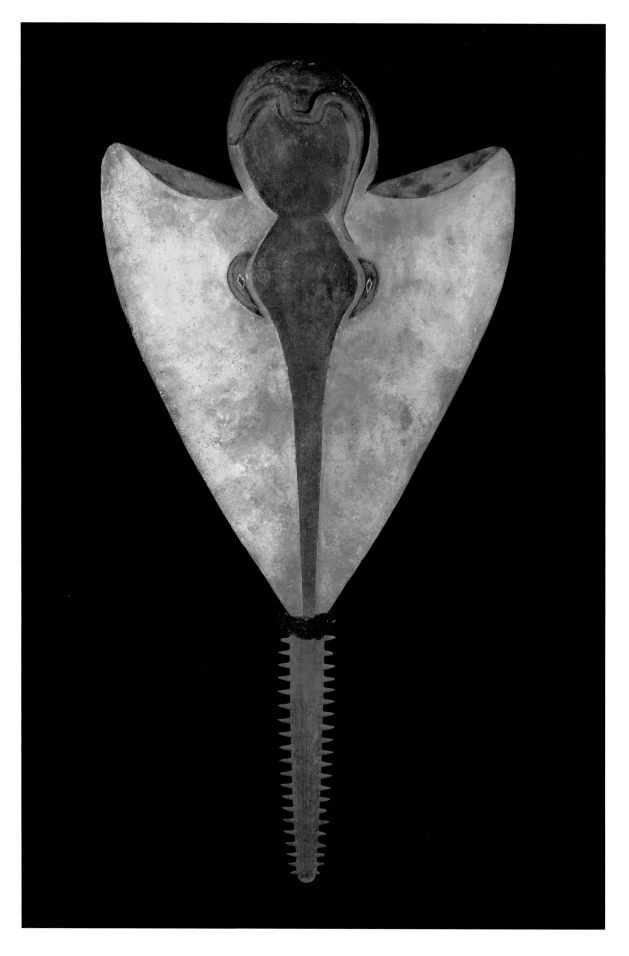

## 70. Mask

Nafana, Bondoukou District, Côte
d'Ivoire, 19th century. Pigments on
wood, 144 x 71 x 15 cm. The Trustees of
the British Museum, London, 1934.2.

This impressively sculpted and painted
face mask is one of the treasures of
African art in the British Museum.
Collected at the very end of the
nineteenth century by Captain Sir
Cecil Armitage, it was acquired at a
critical juncture in British and French
relations on the western African coast.
Both powers were seeking to extend
their spheres of influence inland, and
competition between the two was
intense. Each dispatched numerous
official missions to the interior between
1879 and 1889 in the hope of
establishing diplomatic and
commercial ties with Ardjoumani, the
powerful Abron ruler of Jaman. Of
particular interest to both was
Bondoukou (Bontuku), the principal
town of the kingdom and an ancient
Mande commercial emporium. Both
sides were not only aware of its
economic stature, but also recognized
its strategic position as the gateway to
the north and to Islamic territories that
were believed to stretch as far as the
Mediterranean. After nearly ten years,
Ardjoumani accepted the French flag,
signed a treaty, and opened trade routes
between his kingdom and the French
post at Krinjabo on the coast.

It is from this period that the earliest
accounts of *sakrobundi* (a cult, and
the masquerade associated with it,
dedicated to the eradication of
witchcraft) emerge. R. A. Freeman, a
medical officer and member of the
British Mission from Cape Coast to
Bondoukou in 1888–89, encountered

*sakrobundi* in two communities in the
Gold Coast interior: at the Bron town
of Odumase and in the Nafana village
of Duadaso, only ten miles east of the
French frontier at Bondoukou. He
recorded his impressions and sketched
for posterity "the Great Inland Fetish,"
a masked presence concealed in a
full-length raffia costume. Thirteen
years later, Maurice Delafosse
documented the paramount shrine of
*sakrobundi* in the Nafana community
of Oulike, northeast of Bondoukou,
illustrating the mud reliefs of a
*sakrobundi* mask with a coiled snake
and staff on the walls of the shrine.
*Sakrobundi*, at this time, was clearly a
powerful spiritual presence in Jaman
and adjacent portions of the Gold
Coast, and especially in Nafana villages
within the shadow of Bondoukou
(which was under the spiritual
leadership of Imam Malik Timitay, the
Muslim authority of the city).

*Sakrobundi* was to retain its
influence, despite the growing colonial
presence, well into the 1930s, when it
was suppressed by French and British
missionaries. Their assaults drove the
masquerade itself out of existence, but
the tutelary spirit survived and was still
functioning in the 1960s. As the public
face of a cult noxious to colonial
sensibilities, the *sakrobundi* was retired
or, as the Nafana elders of Oulike said,
"it was put to rest." This *sakrobundi*
mask from Jaman in the British
Museum is a vivid example of the
evanescence of masking traditions
under duress. In its time this large, flat,
oval-faced mask, crowned with horns
and richly painted in red, white, and
black patterns, was undoubtedly a
powerful spiritual presence. *RAB*

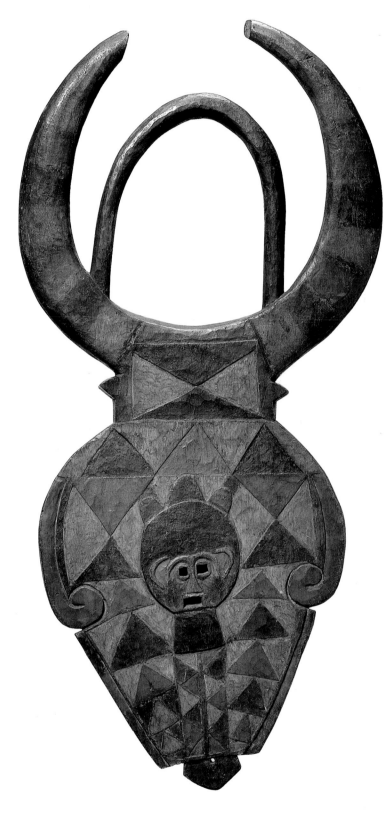

**71. Entertainment Mask**
Baule, Côte d'Ivoire, 19th–
20th century. Wood, 34.8 cm high.
Private collection.

Baule face masks (*ngblo*), unlike ritually charged helmet masks (*bonu amuin*), appear during daytime entertainment masquerades (*gbagba*). As very public masks, *ngblo*—in the guise of wild or domestic animals, or people—are worn to enact a series of characters who dance to music with a participatory audience. The performance climaxes with the arrival of *ngblo* in human form, especially portrait masks inspired by actual people. The subject portrayed in, and honored by, a mask may dance with it and address it affectionately as "namesake" (*ndoma*).

As in Baule figurative sculpture that depicts otherworldly mates or bush spirits, the face of the mask is critical to Baule ideas of personhood and verisimilitude. It is in looking at the mask's gaze that one perceives it as a person with a living presence. For the Baule, the eyes are the critical metaphor for sentient awareness and personhood, as in the two sayings "his eyes are open" (*i nyi wo su*; i.e., he is alive) and "his eyes have been opened" (*i nyi a ti*; i.e., he has reached the age of reason, or is open to new ideas). The

gaze signals consciousness and encourages human interaction, especially the utterances of ritualized greetings through which the other's existence is obligatorily acknowledged.

In carving a portrait mask, the Baule artist renders and details the physical facial features—eyes, eyebrows, nose, mouth, ears—as a complex composition of continuous or broken planes, curves, and surfaces that yields a wholly three-dimensional form. In the mask shown here, the rendition of coiffure, beard, and facial scarification complement physical beauty by cultural notions of propriety, goodness, and relative age. In its details and specificity, the form is recognizable as an individual person. The depiction of a beard indicates that the person portrayed is an elder, one who has created a family, lived fully, and gained the wisdom and respect that comes with age. This mask evokes individual character and personal accomplishment, simultaneously symbolizing for younger people the societal goal of adult fulfillment. *PLR*

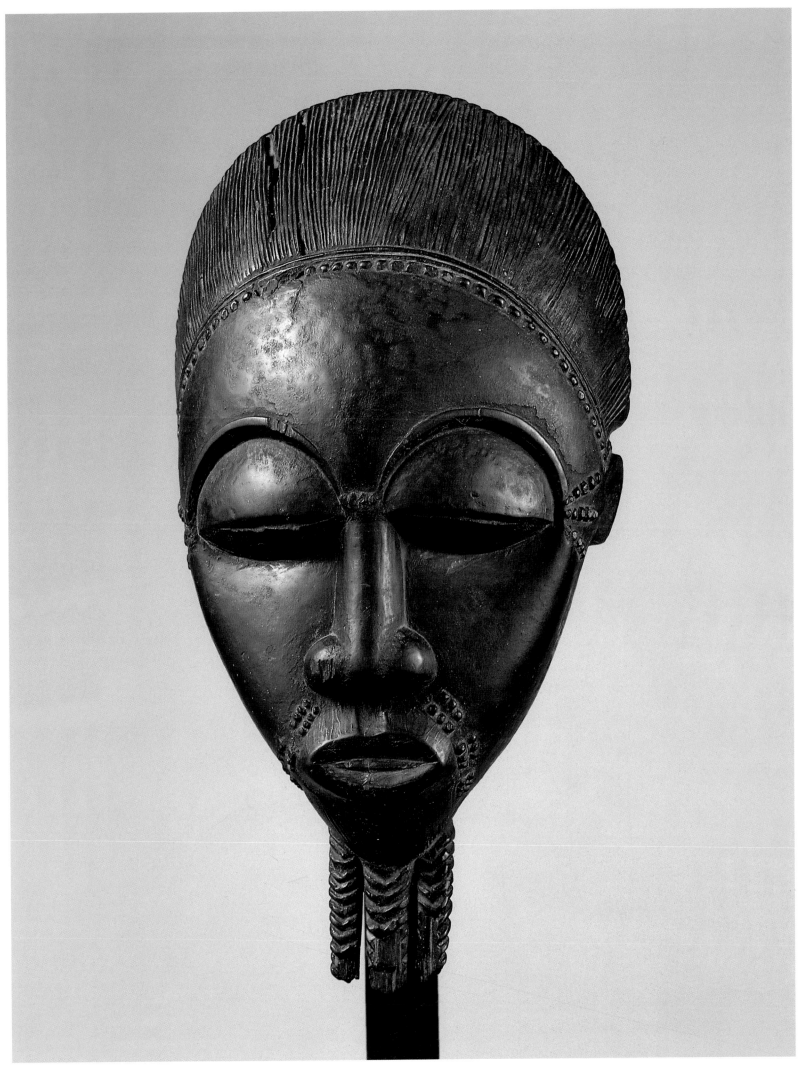

**72. Linguist Staff** (detail)
Akan (Asante kingdom), Ghana,
20th century. Gold leaf on wood,
166.4 cm high. Virginia Museum of
Fine Arts, Richmond.

**73. Linguist Staff Finial** (detail)
Akan (Asante kingdom), Ghana,
20th century. Gold leaf on wood.
Private collection.

The Akan kingdoms, of which the
Asante are the largest and best known,
have long been admired both for their
splendid golden regalia, which
metaphorically allude to the king's
power, and for their eloquent and
ambiguous proverb-laden formal
rhetoric. This complex of visual and
verbal aesthetic metaphors is
symbolically represented in the person
of the royal *okeayame* (often
mistranslated as "linguist"; plural,
*akyeame*), who is counselor,
spokesperson, and intermediary for the
king, and also in the insignia of his
office. Both are part of a system of
triadic communication that is
characteristic of the public enactment
of all formal authority among the Akan
and many of their neighbors in Ghana
and Côte d'Ivoire.

The *okyeamepoma* ("linguist" staff) is
a symbol of authority, owned by the
king and held by his *okyeame* in the left
hand when he makes a formal speech
or represents the king. *Akyeame*
mediate in all formal verbal discourse
with an Akan king; they relay the
words of others to him and elegantly
repeat the king's softly spoken
"incomplete" words for the public,
embellishing the speech with poetic,
historical, and metaphoric ornament.
The word "*okyeame*" may mean
"Someone who walks beautifully in
front of the king" (*kyea* is to walk
gracefully), or the word may come from
*kyem* ("complete"), so the *okyeame* is "he
who makes it perfect or complete."

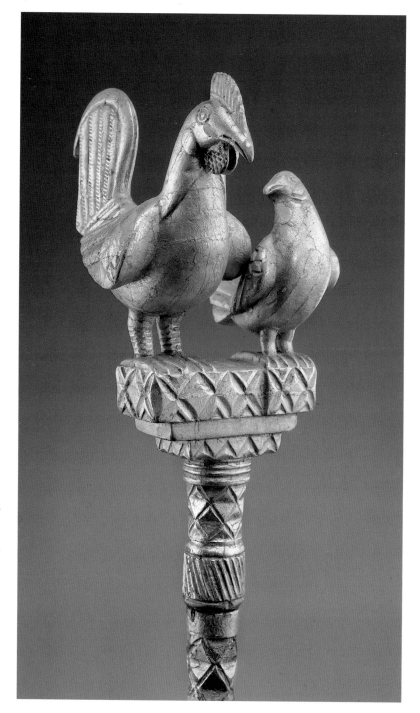

Besides acting as verbal mediators, *akyeame* offer official libations and prayers and are advisers, confidants, and political troubleshooters.

The king is sacred, dangerous to others, and yet in need of protection from mystical pollution. He is surrounded by taboos and is said never to die. Communication with the king is by way of words, but words contain power. The *akyeame*'s mediation both protects the people from the danger of the king's word and protects the king from pollution by the people's words. This mediation preserves the sanctity of royal space and the distinction between sacred and mundane.

"Linguist" staffs are carved in wood and generally covered with thin sheets of hammered gold leaf, silver, or goldlike metal, which are glued or (more rarely) affixed with tiny golden staples. The staff itself is carved in two pieces. The finial is removable and interchangeable; it presents a message in place of the spoken word.

The staff showing a cock and hen depicts the proverb "the hen knows when it is dawn, but leaves it for the cock to announce" (*Akokoberee nim se adee bekye nso ohwe akokonini ano*). It refers to traditional gender roles and possibly to the decision-making power of the king (cock), the head of the kingdom, in contrast to the wisdom of the queen mother (hen), who knows genealogy and selects him.

The finial shown here of a man trying to eat a bird is said to represent

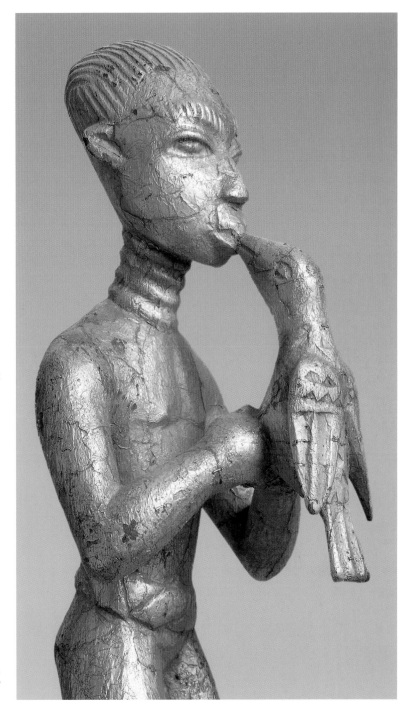

the saying "Even if the bird is small, you cannot swallow it all because you cannot eat feathers" (*Se anoma no sua a yemmene no, ene ne ntakra nyinaa*). Depending upon the context, this might imply that someone has bitten off more than he can chew and is overburdened; that he made a wrong move and can do nothing about it; or that he can do what harm he wants to a feeble old man but he cannot get his wisdom.

Most Akan kings have two or more staffs that are used singly or together depending upon circumstances. The motifs refer either to proverbs, icons symbolizing historic events (e.g., a prisoner about to be sacrificed with bound hands and a ritual knife through his cheeks), or emblems (e.g., a parrot signifying a particular clan). Newly made staffs may depict well-known proverbs or changing circumstances, such as a judge writing in a book, or a hand holding a Christian bible. Many motifs are ambiguous both because one motif may represent more than one proverb and because interpretations of proverbial messages vary. If the interplay between the visual, proverbial, and nonverbally implicit is not carefully foreseen, serious diplomatic crises may result.

Besides these golden staffs, *akyeame* also carry other staffs that are black from sacrificial anointment and have no finial. These are taken to funerals or to deliberations on serious state matters. *MG*

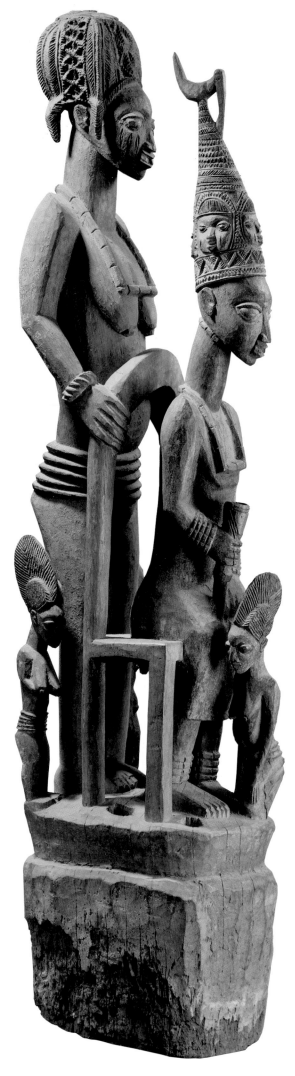

**74. Veranda Post**
Olowe of Ise (ca. 1873–1938)
Yoruba, Ise, Ondo State, Nigeria,
ca. 1910–14. Pigments on wood,
165.1 cm high. Private collection.

The artists who created the masks, figures, and other artwork reproduced in this publication did not sign their work, but they were known to their patrons and townspeople. Highly regarded artists were famous far beyond the towns in which they worked. Their names are unknown to us because most of the early collectors failed to ask who made the art.

The sculptor who carved this veranda post was Olowe of Ise, a renowned artist who was active during the early decades of the twentieth century. According to Olowe's praise song (*oriki*) and written accounts by Philip Allison and William Fagg, the sculptor was born about 1873 in Efon-Alaye, a small town in modern Ondo state in southwestern Nigeria and an important center of Yoruba carving. He moved to Ise, where he served as a messenger at the court of the *arinjale*, the king of Ise. Olowe's descendants claim that he was self-taught, but it is likely that he was apprenticed to a master sculptor. Eventually, Olowe became the master at the *arinjale*'s palace, which he decorated with elaborately carved doors and veranda posts including this one. As Olowe's fame grew, other Yoruba kings and wealthy families commissioned similar objects for their residences.

Elaborately carved posts support the eaves of the roofs of the verandas surrounding numerous courtyards in Yoruba palaces. This veranda post was originally installed on the veranda where the *arinjale* received visitors, in front of a built-in cement throne. Fagg's photographs of 1958 show that although it had a capital extending from the female's head, the post was decorative rather than functional: cement pillars carried the weight of the roof. This veranda post was probably previously installed in an older part of the palace (where it was functional) and was later brought forward when the palace was renovated.

The subjects Olowe depicted on the veranda post are the *arinjale* and his wife. The seated king wears a conical beaded crown topped by a bird. As Fagg's photographs indicate, the *arinjale* originally held a fan. His wife, who stands behind him, is dressed like a bride, wearing only waistbeads and the dorsal scarification that signifies betrothal. The smaller male figure standing next to the royal wife represents a messenger-musician and the two females, one standing and the other kneeling, probably represent other royal wives or daughters.

Olowe carved the *arinjale* smaller than his consort. The disparity between their sizes does not reflect actual practice, but is probably meant to symbolize woman's important role in Yoruba society, and especially that of an *arinjale*'s senior wife. Yoruba women have traditionally been major contributors to the economy, religious leaders, and creators of ritual objects. But, more important, they are childbearers and possessors of awesome spiritual powers (*ashe*) that can be used either for or against society. In addition to these roles, an *arinjale*'s senior wife (the *olori*) participates in his enthronement; it is she who places the conical beaded crown on her husband's head, thereby validating his status. The crown is topped by a bird, which represents women's intangible *ashe* in visual art. By carving the bird parallel to her head and having her carry the capital of the veranda post, Olowe seems to reinforce the consort's role as the source of life and of royal authority.

Olowe honored the Yoruba canon of style, but expressed his own highly personal vision in this veranda post. The prevailing type of veranda post seems to have been two or more tiers with figures, all of which are contained within the dimensions of the capital. In contrast to this pattern, Olowe has carved only one tier and he has downsized the capital to accentuate the royal couple whose dimensions project beyond its width and depth. Such innovations made Olowe a famous artist in his own time. *RAW*

### 75. Gelede Headdress

Yoruba, Otta, Nigeria, 20th century. Traces of pigment on wood, 27.9 x 20.3 x 27.9 cm. Collection of William Hughes Hayden.

The Gelede Society is found primarily among the western Yoruba living on either side of the Nigeria-Benin border. The society teaches Yoruba social values through Gelede costumes, songs, and dances. The patrilineal Yoruba believe that women, especially elderly females, female ancestors, and female deities, possess extraordinary spiritual powers (*ashe*) that can be used for the benefit or destruction of the community. The Gelede Society, whose membership is primarily male, appeals to these women to use their powers constructively. Such appeals are made at an annual public masquerade held in honor of "the mothers," as these women are affectionately called. Gelede masquerades also occur at the funerals of prominent members and during life-threatening crises.

Gelede masquerade costumes include carved and painted wooden headdresses that are worn on top of the head, cloth veils with eyeholes to cover the face, and cloths to cover the body. Socks or stockings and gloves complete the disguise. All masqueraders are men. Those representing male characters wear voluminous garments with panels of printed or richly embroidered and appliquéd cloths. Those representing women wear false breasts and layers of cloth to exaggerate the female physique. Masqueraders appear in pairs, wearing identical costumes.

Most Gelede headdresses are composed of two parts: face and superstructure. The face depicts a human being and is usually carved in naturalistic style. It may be painted an unnatural white to convey spirituality. The superstructure is often complex: pythons, birds, and other creatures; men's turbans or women's headties; or scenes depicting daily activities surmount the head. The headdress shown here displays a special coiffure rather than a complex superstructure. The plaited hairstyle is that of a priest or royal messenger. In the past, the heads of Yoruba priests, royal messengers, and military generals were shaved and magical/medicinal substances were inserted into cuts made in the scalp. After the scalp healed, the hair was grown in patches and then styled according to the wearer's profession or affiliation. *RAW*

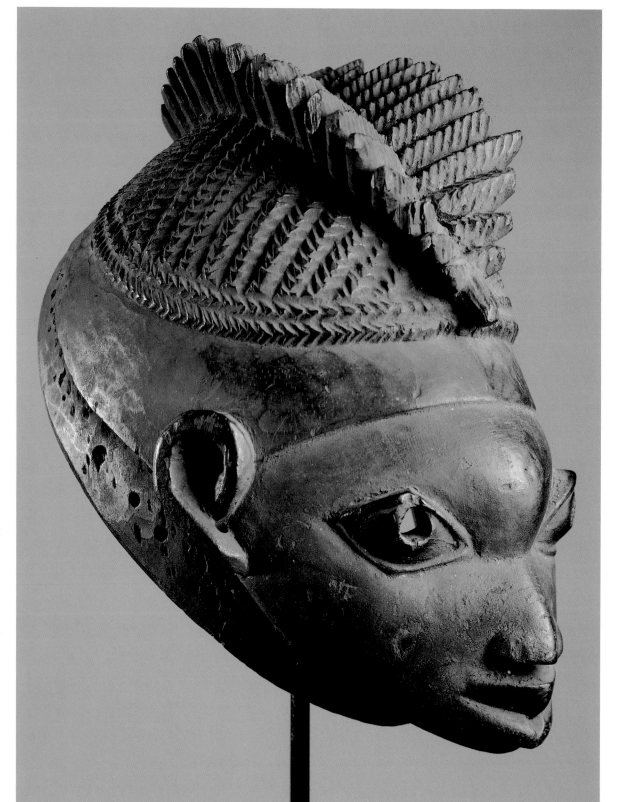

**76. Sango Shrine Figure with Bowl**
Yoruba, Nigeria, early 20th century.
Wood, 51 x 15 x 15 cm. Collection
of Ian Auld.

The devotees of Sango, the Yoruba
deity (*orisa*) of thunder and lightning,
place carvings (*ere*), such as the one
shown here, on altars dedicated to him.
Yoruba oral traditions often identify
Sango as one of the early kings
(*alaafin*) of Oyo-Ile. He is described as
a strange and unpredictable character:
violent, temperamental, and vindictive,
yet handsome, loving, caring, and
generous. He was a great warrior and
magician who had the power to attract
lightning, with which he vanquished
his enemies on the battlefield. The
circumstances surrounding Sango's
death and deification are unclear. Some
stories claim that he voluntarily
abdicated the throne after a long reign
in the fifteenth or sixteenth century
and disappeared through a hole in the
ground as a sign of his transformation
into an *orisa*. Others allege that his
subjects forced him to abdicate after
becoming tired of his political intrigues
and military escapades. In the end, he
committed suicide. But shortly after,
according to one legend, Oyo-Ile
experienced a series of unprecedented
and devastating thunderstorms that the
king's former subjects interpreted as a
manifestation of his retributive justice
and wrath. As a result, they dedicated
shrines not only to pacify him, but also
to harness his power for communal
benefit. Since his military successes
reportedly laid the foundation for the
political ascendancy and economic
prosperity of Oyo-Ile, Sango worship

was a state religion from the
seventeenth to the early nineteenth
centuries, when the kingdom was at
the apex of its power.

As the controller of rainfall, Sango
represents the dynamic, fecund
principle in nature. This explains the
emphasis on female imagery in Sango
art and rituals. Initiation into the
priesthood symbolically converts a
devotee, regardless of gender, into a
female medium subject to possession
by Sango, thus providing an
appropriate receptacle for the virile and
fertilizing power of the deity. During
possession, a devotee becomes Sango
incarnate, performing acrobatic dances
and magical feats, speaking with the
voice of the deity, and praying for the
well-being of the society.

The kneeling figure with a bowl
shown here shares many stylistic
elements with carvings from the Ilobu-
Erin-Osogbo triangle in central
Yorubaland. The double-ax motif on
the coiffure is a metaphor for the
thunderbolt (in the form of a polished
stone ax) that, according to popular
belief, Sango hurls down from the
sky during thunderstorms. It also
signifies the male–female interaction,
recalling the stage during initiation
ceremonies when a novitiate has a
polished stone ax tied to his or her
head to symbolize the union of the
human and superhuman. The kneeling
pose communicates respect, worship,
and supplication. The bowl carried
by the figure is a "give-and-take"
symbol. Its presence encourages Sango
to reciprocate the sacrifices offered
to him by showering the devotee with
all the desirable things of life. *BL*

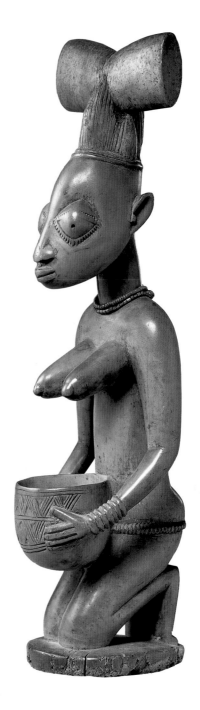

### 77. **Deity Figure**
Igbo, Nigeria. Painted wood and metal, 172 x 45 x 31.7 cm. Private collection.

The religious beliefs and practices of Igbo-speaking peoples identify a constellation of tutelary deities known as *alusi* or *agbara*. As the children or deputies of the high god Chukwu (literally, *chi*: "god" or "spirit"; *ukwu*: "great"), they are accessible to human petition and sacrifice. These unseen, proximate deities (encompassing places, principles, and people) include the earth, rivers, and other prominent features of the landscape, markets (and the days on which they are held), war, remote founding ancestors, and legendary heroes. Overall, the deities and their cults are considered responsible for the health, prosperity, and general well-being of the people and the productivity of fields and streams; they uphold the moral, social, and ecological order. Each major cult has a priest and other attendants who pour libations weekly, offer blood sacrifices periodically, and oversee an annual festival honoring the gods.

Such supernaturals are often symbolized by hardwood figures varying from about forty-five centimeters in height to over life size. They are carved in conventionalized, symmetrical, rather static poses, and are given the attributes of titled individuals. They exist in several regional styles, and in any given area as many as a dozen or more are housed together as generic "families" in more or less elaborate shrines usually at the center of each village group, often adjacent to markets or dance grounds. Their shrine buildings or compounds are sometimes large and well decorated, especially in the north-central Onitsha/Awka region, and in the eastern Igbo communities—the source of the impressively large

figure shown here—of Abiriba, Ohafia, and other village groups (Abam, Arochukwu, Bende, and Afikpo). Without collection data it is impossible to determine which deity is represented, or even if the figure was considered a deity symbol. This mother with child could in fact equally be the wife of a major god, although its size suggests it was a deity. The name of the sculptor is also unknown.

While male sculptors are invariably carved such images, several different hands are known from Abiriba and other eastern Igbo areas. Comparisons with figures photographed in Abiriba men's and deities' houses suggest that this carving came from that village group, although it is not unlikely that artists traveled from one community to another. Women normally painted these figures, renewing their pigments periodically, often before a major festival of homage to ghe gods. White chalk and orange-red camwood were used to beautify the image, just as many worshipers embellished themselves for celebratory events. Here, the abdominal scarification patterns are emphasized; they were affected as signs of personal beauty and as an indication the wearer had achieved fully socialized adult status

The eastern Igbo men's houses sheltering such carvings, sometimes called "houses of images," also typically had a group of supporting genre figures (warriors, masqueraders, women carrying water pots, hunters, court messengers, and so on). Programs, however, varied from house to house, so that today there is no way of knowing what additional images appeared with this carving. Figures were arranged around the walls of the shrine/meeting house as if they were the entourage of the major deities, whose figures were large and often centrally located. *HMC*

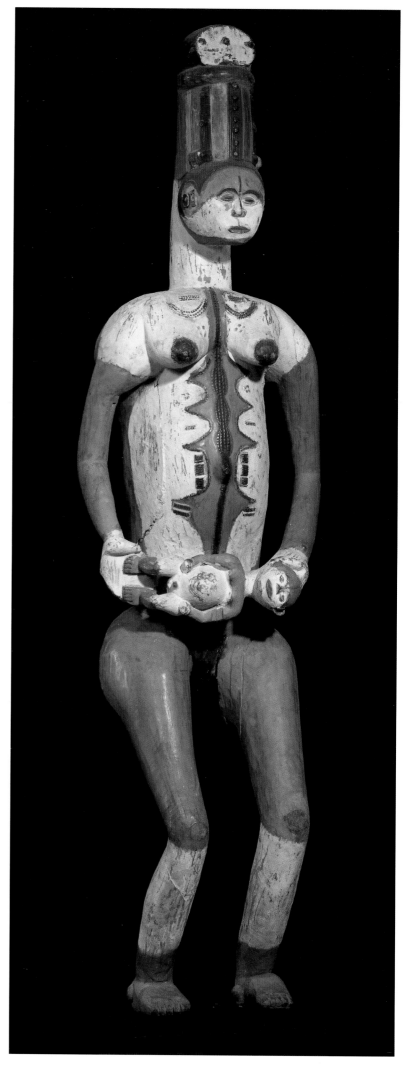

## 78. Female Figure

Jukun, Nigeria, late 19th–
early 20th century. Wood, 59.7 x
20 x 22.2 cm. The Menil Collection,
Houston, 71-05 DJ.

The Jukun live both north and south of
the River Benue, dispersed across a
wide swath of the middle belt of
northern Nigeria. Distinctive to Jukun
culture is the institution of divine
kingship and the maintenance of cults
providing access between the living and
their ancestors. Figurative sculpture is
made primarily by the northeastern
Jukun, especially those living between
the towns of Pindiga and Kona.
Figures occur mostly in pairs,
designated as husband and wife and
often representing a deceased chief and
his consort. These sculptures, in the
past, often had ancestral connotations,
facilitating contact between living
chiefs and their predecessors, who were
enlisted to maintain community well-
being or to avert disaster.

This female figure relates to the
examples Arnold Rubin observed
among the Jukun subgroup called the
Wurbo, who live scattered along the
banks of the River Taraba. Such figures
were not specifically ancestral but were
used in a possession cult called Mam,
which was instrumental in treating a
variety of personal illnesses or in
alleviating community crises like
epidemic disease or crop failure. They
were used to incarnate spirits, to whom
offerings were made. Like other
Wurbo figures, especially those Rubin
saw in the village of Wurbo Daudu,
this piece is carved of heavy hardwood
and is distinguished by a pronounced
facial overhang, distended earlobes
with cylindrical ear plugs, sharply
conical breasts, long arms bent forward
and ending in large hands with deep
gouges suggesting fingers, and
rudimentary legs and feet. The surface
details on this particularly striking
female figure also reveal elements of
Jukun regalia and body decoration:
incised carving around the upper arm,
forearm, and waist represent cast brass
ornaments, some with the openwork
designs typical of Jukun craftsmanship;
the deeply carved loaf-shaped
projection from the top of the head
captures an elaborate coiffure; and the
markings at the sides of the face and
across the chest depict patterns of
scarification. Absent here, but typical
of the genre, are small metal plugs set
in the eyes. *MCB*

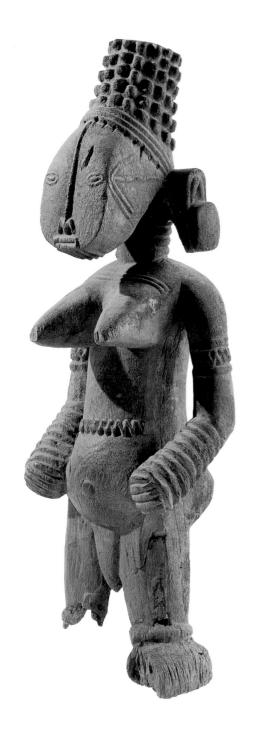

## 79. Cap Mask

Ejagham/Anyang, Cameroon, 19th century (?). Pigment on wood and fiber, 29 x 17 cm. Private collection, Paris.

It is usual for mask makers of the Cross River region to enhance the realism of their work by applying a layer of animal skin and then painting it with plant dye to accentuate facial features. There is some evidence in this piece of black or dark brown pigment having been applied to the face and head for this purpose, though directly onto the wood. Other modes of decoration normally associated with skin-covered mask art are also to be seen, for example, the remains of pegs, which would have been used to secure a coiffure to the carving; and a metal inset to form the eye, pierced by a wooden peg depicting the pupil. A vertical row of copper studs represents scarification marks on the temples. The carving does not, however, have a basketry base of the type often associated with skin-covered cap masks.

The color and finish of the headdress indicate that it was once repeatedly rubbed with palm oil. Unlike certain classes of African mask that were allowed to decay after use, cap masks and helmet masks from this region were often looked after with great care in periods between masquerades. They were regarded as valuable property by the warrior and hunter groups who owned them. Nevertheless, this piece has suffered some termite damage. It was probably made by a master carver of the Anyang, a small Ejagham-speaking group in southwest Cameroon. *KN*

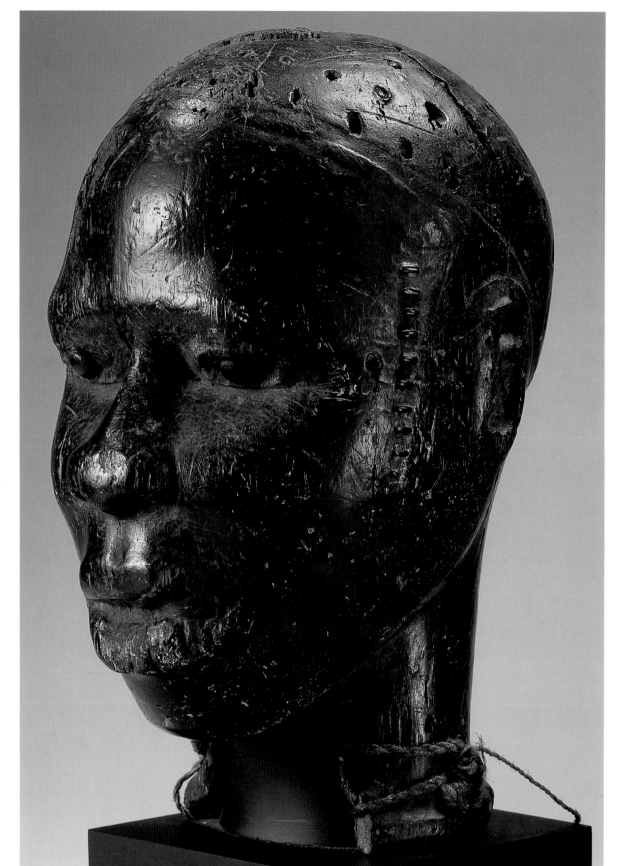

## 80. Face Mask

Middle Cross River, southeastern Nigeria, 20th century (?). Wood, 32.5 x 15 cm. Private collection.

This face mask is remarkable for the pronounced and protruding lips, for the area of the eye sockets in the form of an upper and lower rounded rectangle, as well as for a series of prominent vertical bars on the forehead. The teeth are roughly rendered in the large mouth. The overall impression is that of a man/ape, the latter characteristics derived from the mandrill (*Papio sphinx*), a species of western African baboon hunted for food in the Cross River rain forest.

Among various peoples of the Middle Cross River region of Ikom and Ogoja, age sets and other groups perform masquerades involving a female "Beauty" and a male "Beast." While the female wears a wooden cap or helmet mask (sometimes skin covered) and a long cloth gown, the male is dressed in a shaggy, net-fiber costume, with or without a carved face mask. The latter typically behaves in an aggressive, lewd manner associated with ape behavior. Such performances occur at funerary ceremonies and first fruit or "New Yam" festivals connected with the beginning of the agricultural cycle.

The artistic treatment of the mouth in this face mask and the deeply scored brow is comparable with that of some Janiform helmet masks of the Middle Cross River. *KN*

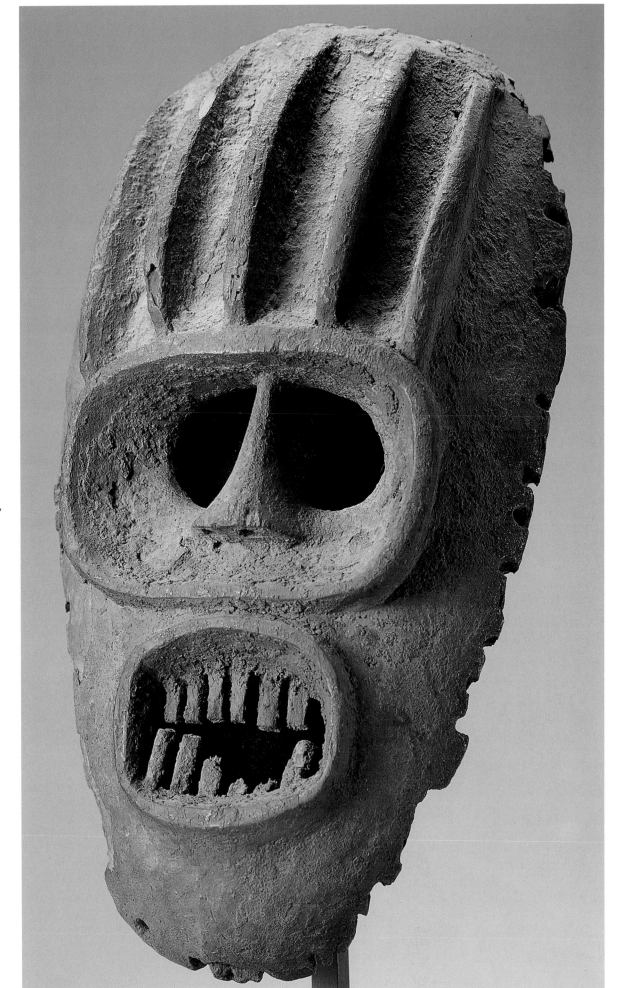

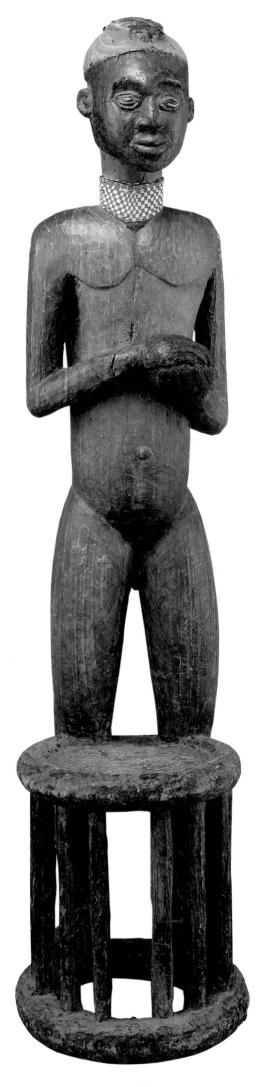

**81. Memorial Figure of Queen Mother**
Kom kingdom, Cameroon,
mid-19th century. Wood, glass beads,
brass (bronze) sheathing (on hands
and face), human hair, and red wood
powder, 175 cm high. Seattle Art
Museum, Katherine White Collection
81.17. 718.

Memorial figures of kings, queens, and queen mothers of the Kom kingdom are among the outstanding works of art from the Cameroon grasslands. This idealized portrait of a royal woman, linked with a stool at the knees, is serene and dignified. The composed gesture of cupped hands resembles the pose of deference royal wives assume when greeting the king by clapping their hands. Bronze overlay models the delicate, yet conventional features of the face. The large, balanced scale indicates a certain robustness, a quality that is appreciated in women. Broad shoulders allude to a woman's ability to work in the fields and to provide for her family. A rounded belly alludes to her role as a mother. The coiffure with attached human hair seen here resembles a shaved hairdo common among Kom women in the nineteenth century. A beaded necklace adorns the figure's neck. The portrait fully embodies Kom canons of female beauty and desirability.

Memorial figures such as the one shown here belong to a category of objects known as *ufwu-a-Kom* ("things belonging to the Kom people"). Several, all heavily beaded, are still in the palace at Laikom, the capital of the Kom kingdom. According to Eugenia Shanklin, they are considered to be innately powerful; it is said that they are capable of controlling the behavior of others and of producing a desired reaction in them. In the past, rulers at Laikom would occasionally put the

*ufwu-a-Kom* on display during annual festivals held at the palace, inspiring awe in onlookers.

These tall, elegant sculptures first came to the attention of the West during the German colonial period in Cameroon, which ended in 1916. In 1904 and early 1905, the German military subdued Kom, a polity of 15,000 to 20,000 inhabitants that had resisted German occupation at the behest of its ruler, King (*Foyn*) Yu (ca. 1830–1912). After the defeat, the Germans ransacked the palace at Laikom, the repository of many fine sculptures and masks.

This female figure was part of a pair that Reinhold Rhode, a German missionary, acquired in Laikom in 1904, under unclear circumstances. Initially, these two sculptures went to the Museum für Völkerkunde in Frankfurt, which sold the female figure in 1934 to Arthur Speyer, a German collector and art dealer. In the 1960s, it finally came to the Katherine White Collection, which is now at the Seattle Art Museum.

In the original data accompanying the sculpture, Rhode designated the figure as a portrait of *Foyn* Yu's great-grandmother, whose name (according to Paul Nchoji Nkwi) was Naya. Shanklin confirmed this identification. In the matrilineal Kom society, queen mothers assume important roles. Naya was in fact the mother of two kings, Tufoyn (ruled ca. 1840–55) and Kumeng (ruled ca. 1855–65). *CMG*

**82. Door Frame**
Bamileke, Baham chieftaincy,
Cameroon, early 20th century. Traces
of pigment on wood; left: 256 cm high,
right: 264.2 cm high. Collection of
Murray and Barbara Frum.

In the mid 1920s, Chief (*Fo*) Pokam of Baham, a powerful Bamileke ruler, posed for a missionary's camera. In the resulting image, he is shown framed by an elaborately carved portal, the entrance to a building located in his compound. To his left and right are jambs adorned with a multitude of human and animal figures, rendered in an airy openwork style. These are joined at the top by a lintel upon which five small skulls appear, rendered in high relief, and, at the bottom, by a beam decorated with images of coiled snakes. The two jambs shown here are what remains today of this exquisite door frame.

In 1928, shortly after he was photographed, Pokam was dethroned by French colonial administrators and replaced by his son, *Fo* Kamwa. Upon coming to power, Kamwa embarked on a program of architectural renovation, building a new palace for himself and replacing several structures in his father's compound. At about this time, the edifice once graced by the door frame was abandoned. In the late 1940s, while on a visit to Kamwa's court, a Frenchman named Raymond Lecoq photographed the portal's left jamb, leaning alone against the façade of an unidentified building. By this time, the right jamb had already made its way to Europe. A final in situ photograph of the left jamb was taken in 1957 by Pierre Harter. Soon thereafter, that carving left for Europe, as well. The two halves were reunited by the present owners. However, the lintel and cross beam that held them together have been lost.

In the grasslands of western Cameroon—the heartland of Bamileke country—figurative portals are the prerogative of chiefs. Only rulers and a small group of selected notables—men of means and rank—are, in theory, entitled to possess architectural

elements of this kind. In the 1800s, and well into the twentieth century, those outside this privileged circle who chose to adorn their compounds with such carvings soon found themselves in open conflict with the court. Throughout the region, tales are told of compounds set afire by allies or attendants of chiefs angered by the presence therein of architectural elements reserved for use by the ruling elite. Even today, few would venture to display such forms of ornamentation. Those who embellish their homes with sculpture most commonly do so in understated ways, commissioning door frames decorated with incised geometric patterns rather than figural imagery rendered in high relief or (as here) in the round.

Typically, figurative portals are meant to be read. To decipher their meaning, Charles-Henri Pradelles de Latour has shown, one usually starts at the bottom and moves up. According to several authors (Harter, William Fagg, Herbert Cole), the Frum portal tells the tale of a man condemned to death for committing adultery with a chief's wife. At the base of the left jamb, the chief appears, smoking a pipe; he is flanked by another of his wives, who is shown bearing a calabash of palm wine. Immediately above her stands a chiefly attendant holding the severed head of an infant: the illegitimate child born of the liaison. Above is a woman, possibly the adulteress herself, who hides her pubis and breasts. Second from the top is her paramour, his hands bound before him and a noose around his neck. The right jamb appears to tell a more general tale of courtly life and protocol.

Though, as Fagg noted, the story recounted on the left was most likely a cautionary tale—a statement about laws and the dangers faced by those who infringe them—it may also refer

to a specific occurrence, an event said to have taken place in the chieftaincy's early days. Michel Kenmogne, a Bamileke scholar, recorded the following tale in Baham. Well over a century ago, *Fo* Moudjo, the ruler of a neighboring chieftaincy, committed adultery with the wife of a Baham chief. To punish him, a trap was set. The adulterer was lured into a house under construction; the door through which he had entered was then walled over. With no exit available, *Fo* Moudjo suffocated. From this event, Kenmogne explained, came the name "Baham" or, more properly, *pa* ("people") *hòm* ("who cause others to suffocate"). The tale told by the portal's left jamb may be tied to this early account, not as a literal description— such things are rare in Bamileke art— but as a reminder of its protagonists and their fate.

The identity of the artist commissioned by *Fo* Pokam to carve the portal is unclear. According to Harter, he was not a local sculptor, but one associated instead with the powerful court of Bali Nyonga, several hundred kilometers to the north and west. This identification is substantiated by the handling of figures in both jambs. The rounded (almost full-round) treatment of human and animal bodies, the substantial amount of open space that separates one figure from another, and the focus on asymmetry recall the style of artists working for the Bali-Nyonga court in the early 1900s. It was common in the past for Bamileke rulers to turn to foreign artists when commissioning works of ceremonial or political importance. By way of this practice, alliances were brokered and bonds of friendship forged between polities— ties that allowed chiefs to enhance their prestige both at home and abroad.
*DM*

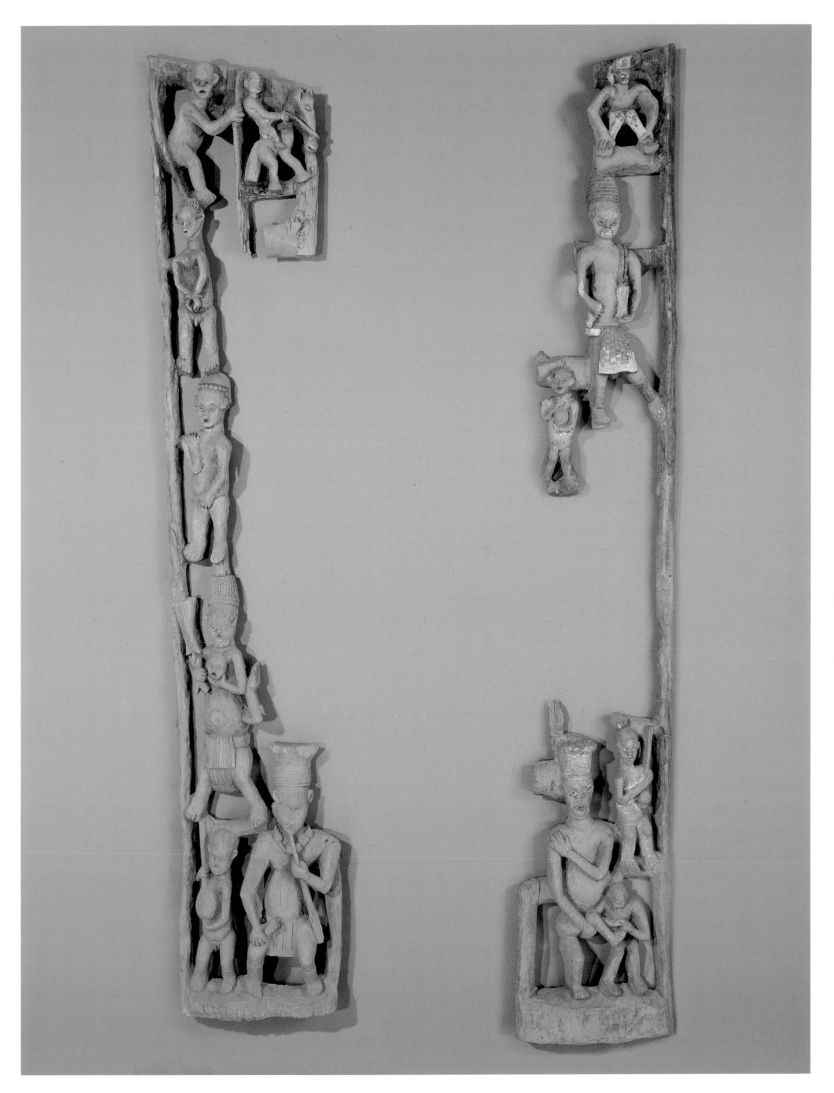

# Sahel and Savanna

Between the Sahara desert and the rain forests near the western African coast lie the Sahel and the Savanna. The term *sahel* is Arabic for "shore"—it is the southern boundary of the Sahara desert, which was likened to a sea. The term *savanna* refers to a treeless or sparsely forested plain. However, the desert was not an impermeable barrier. A number of trade routes crossed it from early times, giving impetus to many empires, including those of ancient Ghana, medieval Mali, and Songhai. Beginning in the seventh century, traders from the north brought Islam and literacy, which had great impact on traditional beliefs and paved the way for *jihads* (holy wars) across much of the Savanna. By the nineteenth century, these wars reached deep into western Africa.

Islam also brought with it architectural innovations, including an array of house and mosque types. In addition, textile patterns, the horizontal loom (used primarily by men), and clothing styles in this region echo northern prototypes.

The Niger River flows from west to east through much of the area, turning south through Nigeria to empty by way of a large delta into the Gulf of Guinea. In Mali, the river separates into a number of streams that later reunite in an area called the inland delta. Here, an early civilization flourished, named Djenne after a nearby city renowned as a center of commerce and learning. A host of brilliant terra-cottas and metal sculptures known from this area have for the most part been illicitly excavated and are consequently not included in this publication.

The inland delta is the homeland of various cultures, such as the Bamana and Dogon of Mali, that resisted Islamic proselytizers. It is also home to major art-producing peoples such as the Mossi and Gurunsi (in what is today Burkina Faso) and the Lobi and Moba (in areas bordering on western Africa). Masks and figures associated with initiation and funerary practices are widespread among these groups, although the impact of both Islam and Christianity has been felt.

Throughout the region, artists are members of special groups. Often referred to as "castes," these are perhaps more like guilds of artisans. The specialists associated with these guilds include blacksmiths (whose wives are potters), leatherworkers, and bards.

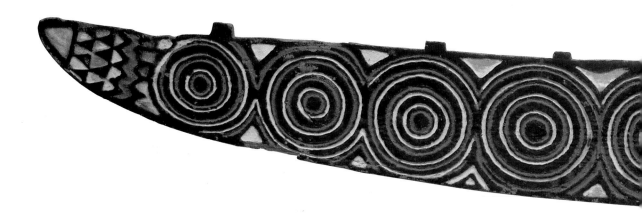

**83. Mask**

Bwa, Burkina Faso, 20th century.
Pigment on wood, 25.4 x 245.1 x
17.8 cm. Collection of Thomas G. B.
Wheelock.

The Bwa, numbering about 300,000 today, have inhabited regions of present-day Mali and Burkina Faso for centuries. The most important social unit in their decentralized village communities is the clan. Masquerades affirm and celebrate the relationship of the clan to ancestors and nature spirits. The Bwa depend upon hunting, gathering, and—most heavily—on farming for survival; thus, the spirits that control the success of these activities must be honored and negotiated with. Masking is one means by which this is accomplished.

Original to the Bwa are masquerade costumes—made of leaves, vines, and feathers—used to perform in honor of *Do*, the primary life force of the land, said to be the son and earthly representative of the creator. Wood masks, in contrast, come to them from the neighboring Winiama and Nunuma. Such masks are particularly common in the southern Bwa area. The vegetal and wood masking traditions coexist in any given village.

*Do* masking represents nature spirits, whereas wood masks represent the worlds of animals and humans and their interactions. Hawks, antelopes, monkeys, roosters, snakes, buffalo, fish, owls, and butterflies are among the animals that wood masks represent.

The particular mask shown here was collected in the southern village of Dossi in 1955. The anthropologist who saw the mask believed it to be a representation of a water snake. Current scholarship designates it as a butterfly. Informants at Boni (also in the south) spoke of a similar mask to Christopher Roy as a depiction of a butterfly (*yehoti*). I would argue, based on my field experiences with the Sisala, the Bwa's neighbors to the south, that the mask can be seen as both a snake and a butterfly.

Two sets of five concentric circles stretch across the surface of the mask. These represent sacred water holes and at the same time sacred snakes, shown in the coiled position. The circles converge, creating four sets of owl-like eyes on each side, a feature of some importance as the Bwa celebrate the owl for its wisdom. The feather-tip end sections of the mask may represent the outstretched primary feathers of a bird of prey. Roger Birkel, a zoologist, has

pointed out that the bird may be a representation of a vulture because of the large wing span. Moreover, the bird would have been seen in flight with its head down, which would correspond to viewing the front of the mask rotated forward ninety degrees. That vultures descend on their food in concentric circles may add further meanings to those patterns.

The butterfly element of the mask is restricted to the central section of its frontal surface. That butterflies are commonly seen swarming above pools of water after a rain, in this region, and that the butterfly here is surrounded by pools, lends support to this interpretation. The front of this mask, with its lozenge-shaped mouth, also suggests the appearance of a bat. Bats hunt at night, and they are particularly attracted to moths, which are also nocturnal. Thomas Wheelock has suggested that the protuberances rising from the top of the mask may represent the atrophied claws appearing on the wings of bats. This interpretation raises the possibility that the central image may also be a moth.

On the rear of the mask, carved and painted designs appear as well. These (and the back of the carving as a

whole) are divided into five zones. Near the tips of the mask, triangular forms appear, flanked by checkerboard patterns bordered with vertical bands. According to Roy, checkerboards, in this context, represent the darkened cow hides and the white, clean and fresh, hides on which elders and youths, respectively, sit during initiation ceremonies.

This mask reveals many concerns central to the Bwa belief system. Snakes assure human fertility, and water guarantees that the granaries are full. Butterflies indicate the arrival of the rainy season; bats speak of successful hunts. Farming and hunting, mostly the pursuits of men, are occupations that the newly initiated must learn as they pass into manhood. As Roy has stated, geometric shapes on masks communicate moral and historical ideas, which must be taught to initiates. It is on and about the squares, triangles, and zigzags that the world of the animal spirits and natural elements play. This use of signs and symbols sustains Bwa culture, particularly that of males, in a region where forces of nature interact intensely in the daily life of human beings. *JWN*

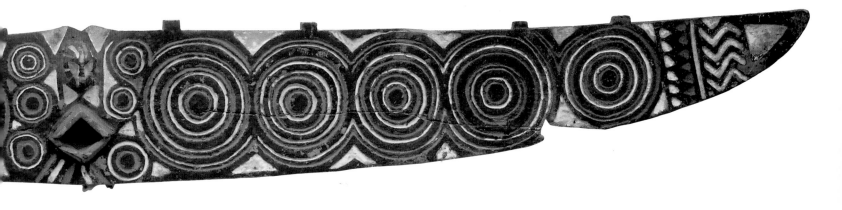

## 84. Head

Lobi, Burkina Faso/northeastern
Côte d'Ivoire, 20th century. Wood,
31 cm high. Private collection, Paris.

Large heads depicted atop a post or
stake form a unique category of Lobi
sculpture. They are found on both sides
of the international boundary that runs
through Lobi territory. Many examples
are sculpted with great care and
attention to detail, and, unlike the full-
bodied figures, they often show a triple
scarification at the temple. The present
example also depicts a lip plug. Until a
generation ago, the women of the
region commonly wore lip plugs of
wood or quartz, and occasionally these
can still be seen.

These sculpted heads were fixed into
the ground at various shrines, both in
the shrine room and in the open air.
They are also found with their spike set
into the top of an external wall, where
they served as guardians of the house.
For this reason the end of the spike is
often eroded, and in the present
example it seems to have been cut
away. *TFG*

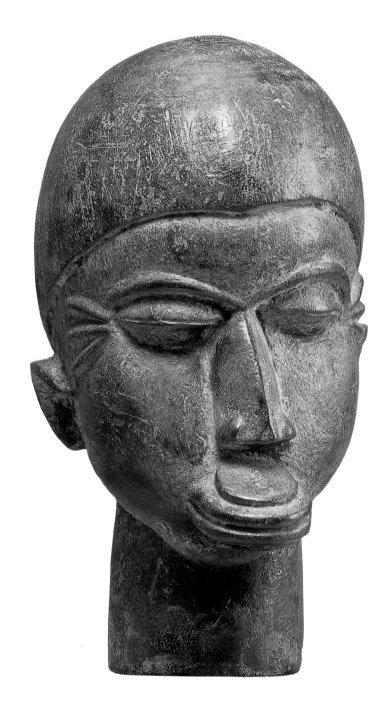

## 85. Diviner's Figure

Nuna, Burkina Faso, 20th century (?).
Wood, 83 cm high. Musée Barbier-
Mueller, Geneva, 1005.4

This large and impressive diviner's
figure (*dimbien*) was used by a religious
specialist or diviner (*vuru*) among the
Nuna people in south-central Burkina
Faso to represent a spirit from the
wilderness with which he could
communicate and whose supernatural
power he could control for the benefit
of his clients. Such figures are kept
together with nonfigurative objects,
including jars, bottles, and stones, on
shrines in dark corners of the diviner's
home, where they become covered with
a thick crust of offering material,
especially millet porridge, beer, and
chicken blood. That material has long
since been cleaned from this figure. It
was collected near the Nuna town of
Leo in southern Burkina Faso in the
early 1970s by the (then) director of the
national museum.

The Nuna are one of several peoples
in Burkina Faso whose communities
are formed around the worship of
nature spirits, which in turn establish
religious laws that control the moral
and ethical conduct of life in the
communities. There are traditionally
no chiefs or other representatives of
secular power in these communities,
although the French attempted to
create such centralized power during
the colonial period.

Such figures serve the same function
as the spectacular masks from the same
peoples; they make the invisible nature
spirits concrete and permit the
congregation to offer their prayers and
offerings. The geometric scarification
patterns on the chest and back are part
of a large body of graphic patterns that
are used by the Nuna and their
neighbors to communicate visually
religious laws and moral values. Such
patterns also appear on their masks,
human bodies, pottery vessels, and the
clay walls of buildings. *CDR*

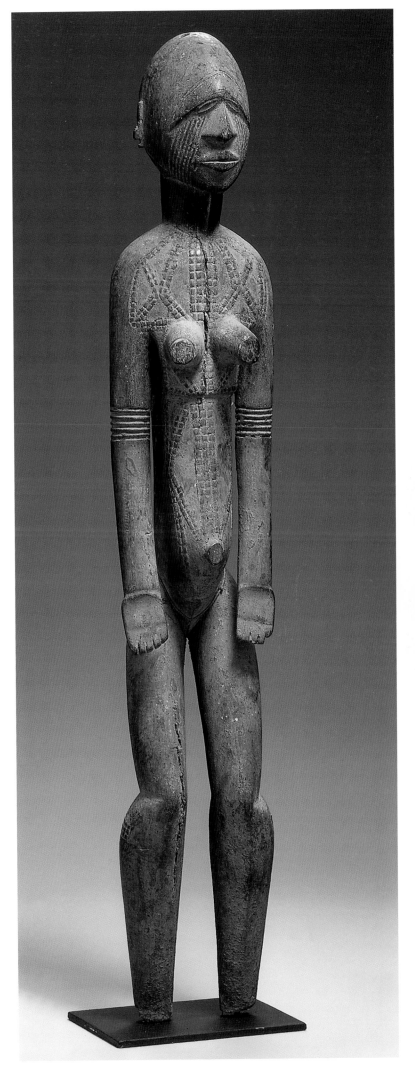

## 86. Equestrian Figure

Dogon, Mali, 18th century (?). Wood,
55 x 16 x 24 cm. Private collection.

The chronicles of Muslim travelers
throughout the Sahara and Sahel tell of
the existence of the horse in Mali's
ancient empires. From the mid-
eleventh century, royalty is known to
have displayed its authority, and
kingdoms to have flourished their
military might, with the aid of
equestrian prowess. This equestrian
figure exhibits such characteristics.
Larger even than his powerful mount,
the rider sits proudly upright, his feet
secured in stirrups, his left hand
holding the reins. His beard indicates
that he has earned respected elder
status, the scarification marking his
temples suggests affiliation with or
initiation into a particular social group.
The jewelry that adorns his neck,
arms, and ankles—a motif repeated on
the lower legs of the horse—denotes
personal achievement and wealth.

Among today's descendants of Mali's
historic inhabitants are the Dogon:
a society with neither the royalty nor
the military of early empires, but
whose sculpted equestrian figures
remain an adapted, and continually
adaptable, sign of privilege and power.
Riders may represent warriors,
invaders, or emissaries from afar,
respected deceased leaders of the local
community, bush spirits that appear
to passersby, or the spiritual supremacy
of the village priest (*hogon*), all of
whom possesses a link to ancestral
realms and have the means to own a
horse and the power to discipline it
to his will. *RH*

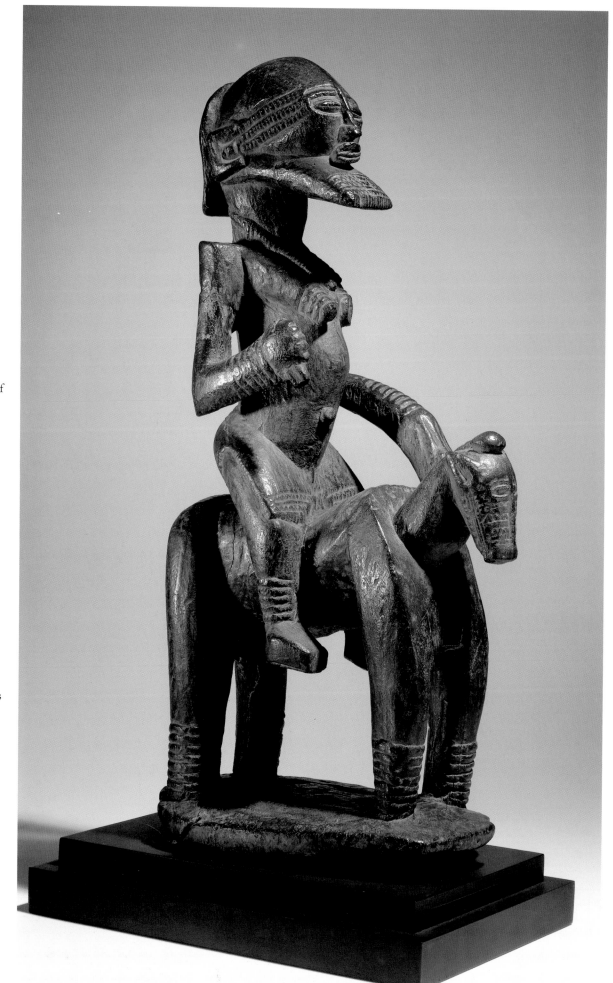

**87. Seated Male Figure**
Dogon, Mali, 16th–20th century.
Wood and iron, 73 x 29 x 32 cm.
The Metropolitan Museum of Art,
New York, The Michael C. Rockefeller
Memorial Collection, Gift of Nelson
A. Rockefeller in 1965, 1978.412.455.

An interpretation of Dogon cosmology
suggests that the universe is composed
of two disks—the earth and the sky—
connected by a tree at the center. In
addition to the tree, if we were to span
the disks at each of the four cardinal
points with relief carvings of ancestors,
and seat a *hogon*—a village priest of
high authority—on top of the upper
disk, the configuration would resemble
this carving and could be read as an
*imago mundi*, a primer on fundamental
Dogon social and belief structures.

The object is carved from a single
piece of wood. The disks are incised at
their perimeters with motifs suggesting
the path of Lèbè Serou, an ancestor
incarnated as a serpent and associated
with the *hogon*'s power. The disks are
connected at the centers by a straight
unadorned cylinder—the tree—and at
the edges by four bowed cylinders
carved on their exteriors with reliefs of
human figures. These figures, kneeling
and standing, may portray the four
original ancestors of humankind
(*nommo*) who mediate between the two
realms. The seated figure is the *hogon*,
the elder whose knowledge of both
spiritual and temporal affairs accords
him great local authority. *RH*

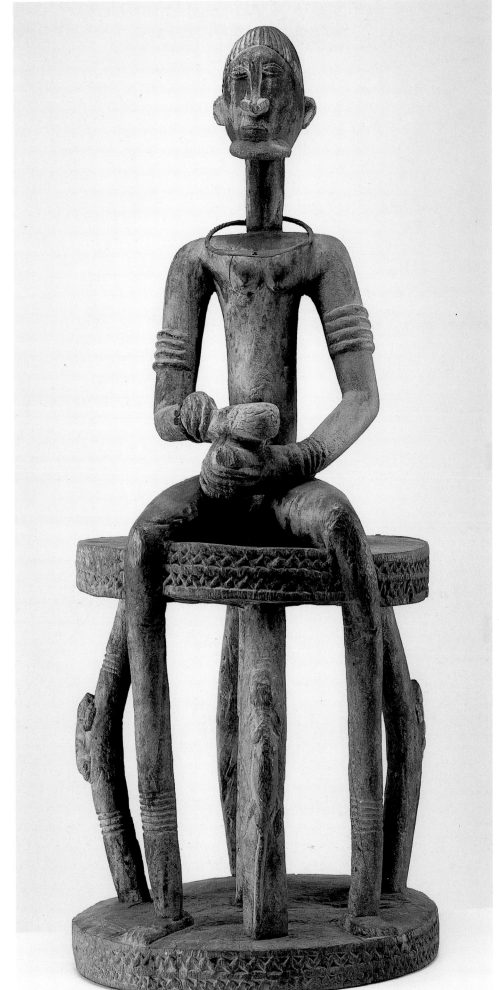

## 88. Mask
Bamana, Seqou region, Mali,
20th century. Wood and cowrie shells,
71.1 x 21.6 x 17.8 cm. Collection of Marc
and Denyse Ginzberg.

This *Ntomo* mask has many of the
hallmarks of classic Mande sculpture:
the elongated face with subtly puckered
cheeks and pursed lips; the block ears
with rounded edges; the long, narrow,
keel-like nose; and the compositional
strategy of collision (where harsh edges
meet graceful curves and hemispheres).
The female figure standing atop the
mask carries this style into the social
realm of beauty, strength, upstanding
social character, and powerful
femininity. Her hairstyle is elaborately
beautiful. Her posture is straight
and strong. Her hands are open, hiding
nothing. Her breasts and stomach
herald sensuality, fertility, and the
physical as well as social wherewithal to
offer her children complete
nourishment. The row of four horns
echoes this femininity, because four is
said to be the female number, in the
complex and often esoteric system of
Mande numerical symbolism.

*Ntomo* masks are part of a network
of images, objects, conceptualizations,
and practices that young Mande boys
experience before circumcision, on
their way to adulthood. Some scholars
have described *Ntomo* as the first of six
associations (*Ntomo, Komo, Nama,
Kono, Ci Wara, Korè*) through which
males traditionally passed, according to
a carefully organized hierarchy of
increasingly subtle and refined
knowledge and increasingly powerful
articulations of personhood. Others
think the associations have always been
more loosely and flexibly configured,
with functions that varied according to
particular historical and regional
situations.

The *Ntomo* association teaches boys
about family values, interpersonal

relationships, community
responsibilities, and the basics of
Mande spiritual beliefs and practices.
The association plays a prominent role
in processes of socialization, where
elders and older men, already married
and leading adult lives, strive to instill
their values in potentially rebellious
youth. Often they heap considerable
abuse on the boys, taxing and
tempering them with endless demands
on time, intelligence, stamina, and
endurance. Mask performances (at
annual *Ntomo* festivals and initiations)
reflect these trickle-down values from
seniors. For example, young masked
members often take turns flogging each
other, the goal being to demonstrate
self control by not crying out in pain.
This fits an axiom the association
teaches: young people should be silent
and listen to their seniors, just as they
should defer to seniors in all matters.

*Ntomo* teaches children how to
become upstanding citizens and proper
elders, from the vantage point, of
course, of the current elders. But the
association also blurs and subverts
these clear messages of socialization,
and so do its youthful members. For
example, the songs the boys sing
during their performances satirize the
wives of their senior taskmasters,
shattering with gusto the interdiction
of silence; this also gives an added
dimension to interpretations of the
women carved atop the masks'
foreheads. The taskmasters themselves
subvert their own socializing practices
by offering members information that
is intentionally confusing and then
refusing to present any explanation.
Neophytes are constantly exposed to
clear-cut axioms and mores that help in
their education, but they are also
constantly exposed to gibberish and
statements so cryptic that the youths
cannot interpret them. Old men have
said that the enigmas they heard as
youths still command their

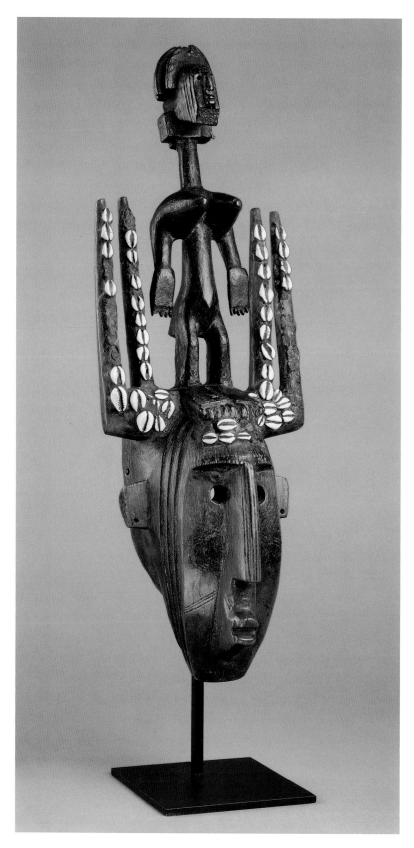

contemplation and offer no easy
answers. *Ntomo* masks are said to
depict youth in its unblemished
innocence. But boys hurling satire
already lack innocence, and instructors
teaching enigmas are knowingly
planting seeds that grow into complex

views of the world and the contentious
social, intellectual, and emotional
activities within it. *Ntomo* helps prepare
youth for the more opaque experiences
and mysterious maneuverings that they
will encounter as they grow into their
adult lives. *PMcN*

### 89. Staff with Female Figure

Bamana (Bambara), Mali, 19th–
20th century. Iron, 161 x 15 x 15 cm.
Private collection.

Staffs of this type, *nege muso*, are the
most technically difficult of all the
artworks Bamana and other Mande
sculptor-blacksmiths make. Typically,
the shaft is forged out of several pieces,
which are joined by inserting the top of
one into a socket formed from the
bottom of the next, and then heated
and hammer-welded together.
Frequently, the shaft is expanded into
cagelike protrusions, and on most
examples hooks sweep down, out, and
up from the shaft, usually at the
sockets. The hooks end in rounded
knobs, which may be reminiscent of
little brass heads seen on similar staffs
called *sono*. Less frequently, as in this
example, the sweeping hooks are
inverted, and end in little iron rattles or
bells, much like many Dogon staffs.
Many examples end in a spear blade at
the base, but the creator of this piece
has moved the blade from the bottom
to the top (again like many Dogon
examples) and embellished it with
groups of five tooth-shaped extensions.
The cages, inverted hooks, and
embellished spear blade work
exquisitely together to create a
powerful composition that frames and
helps to highlight the marvelously
sculpted female figure in the middle.

The figures on most staffs are
standing women or equestrian men,
and they are generally placed at the
top. This, however, is not the case in
the example shown here, in which the
figure carries a container on her head.
The elongated limbs and flexed knees
are typical, but the overall articulation
and embellishment is masterly.

Mande blacksmiths overflow with
the same spiritual energy (called
*nyama*) that is said to animate the
universe and allow for every action in

it. This is the energy that makes
amulets effective, and these staffs
become amulets themselves, because as
smiths forge them they also infuse
them with *nyama*. They may also add
additional power through secret recipes
that combine science and ritual.

These staffs were used in many
situations: they could be set on top of
the tombs of leaders and town
founders, or in front of family
residences to help honor ancestors.
Some chiefs apparently used them as
family insignia, and also used their
power as amulets to enhance their own
leadership abilities. Some staffs were
considered so powerful that they could
be employed to turn away attacking
armies.

Bamana secret initiation associations
also used the staffs around their altars,
or put them near or even in sacred
trees. The beauty of the staffs was said
to make the altars more powerful, as
was the power embedded in the iron.
This power strengthened the
association, but the beauty of the staffs
also enhanced funerals of association
members, when they were carried in
procession, or regular business
meetings, when members danced with
them.

Symbolism, as in much Bamana
sculpture, is ambiguous and subject to
various interpretations. This is
particularly true of the forged figures.
They may be ancestors or characters
from Mande legend, such as Muso
Koroni, the first woman on earth,
semidivine, and bringer of tremendous
chaos; or (if male) Ndomajiri, the
world's first blacksmith and bringer of
stability and medicines. The hat worn
by this figure resembles those worn by
hunters and sorcerers, and its presence
on a woman signals awesome occult
power. The spear symbolizes power in
the more tangible world of aggressive
military deeds. *PMcN*

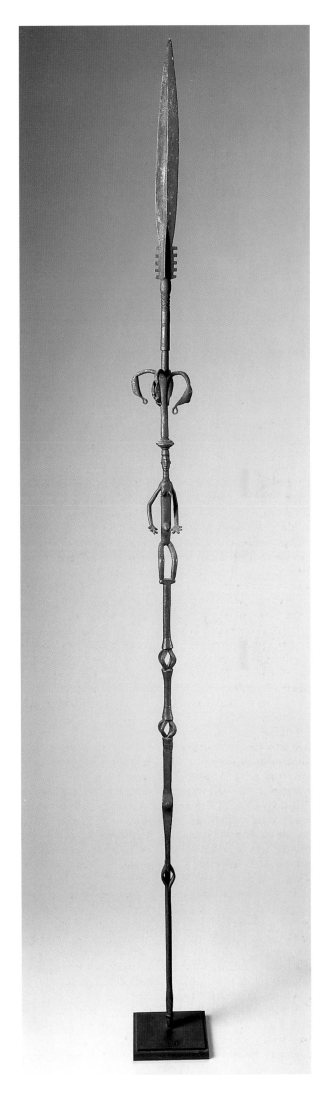

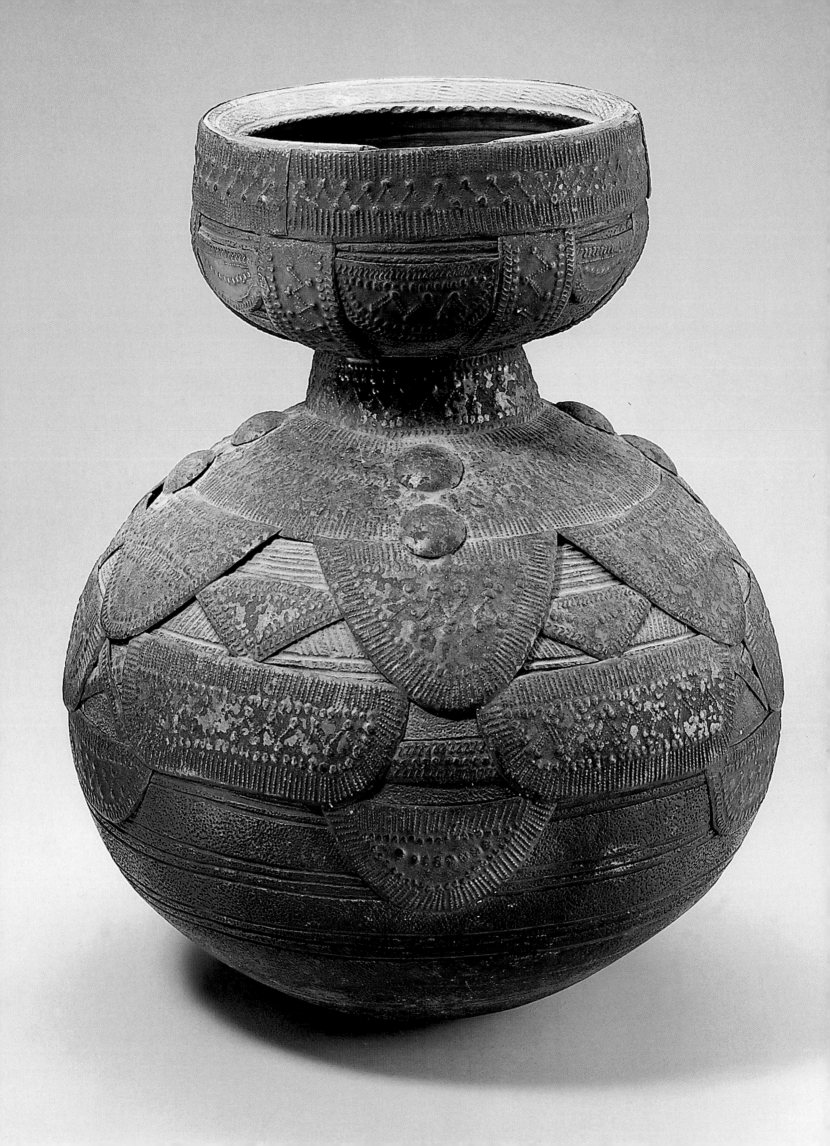

**90. Gourd-Shaped Vessel**
Nupe, Central Nigeria, late 19th–
early 20th century. Terra-cotta and
brass fittings, 38 x 32 cm. Private
collection, Munich.

The Nupe live along the northern and southern banks of the middle Niger River in Nigeria. During the nineteenth century, they were conquered by Muslim Fulani who took over the leadership role of the Nupe ruling élite and incorporated the Nupe into the Islamic state called the Sokoto Caliphate. Nupe craftsmen work a wide variety of materials including wood, cloth, metal, and ceramics. This ceramic vessel represents a collaborative effort on the part of a female potter and a male brass smith.

Pottery centers are located throughout Nupe country, especially at riverine sites where the finest sources of clay are found. Large gourd-shaped ceramic vessels like this one are produced in pottery centers, including the town of Muregi near the confluence of the Kaduna and Niger rivers. With a globular body and narrow funnel-like neck that terminates in a small bowl, these pots are among the most distinctive products of the Nupe pottery industry. Similar vessels are also made by Nupe and Gwari potters in the Kakanda, Bassa Nkwomo, and Bassange regions located near the confluence of the Niger and Benue rivers. The vessels were an important commodity in the Nupe canoe trade from Jebba Island to the Niger–Benue river confluence. The widespread distribution of this distinctive vessel form suggests that it is a hallmark of the middle Niger River ceramic style.

Such vessels are used as storage containers for palm wine and water. The potter starts the base of the pot using a convex mould technique and after the base dries to a leather-hard state, she continues to build the walls with a pull-coil and scraping technique. The smaller bowl that forms the top of the pot is begun in the same way. A hole is cut in the bottom of the leather-hard smaller pot, which is then joined to the mouth of the larger pot by coils of clay to form the neck. The entire surface of the pot is textured with a stippled pattern made by rolling a roulette. The pot is then subdivided into several rows articulated by horizontal bands incised with a small stick. The surface has irregular small, smooth, burnished patches placed around the pot.

The vast majority of gourd-shaped vessels have a russet color due to an oxygenated firing process. In some regions, however, the pot is basted with a locust-pod slip (immediately after the firing) that imparts a glossy brown sheen to the surface.

In the past, after purchasing a ceramic storage vessel from the market place, a wealthy patron who wished to transform the pot into a prestige container would take it to a Bida brassworker, who dressed it with hammered brass fittings that were decorated with repoussé designs. This ceramic vessel, whose lip, neck, and belly are elaborately dressed with a series of brass bosses and fan- and canoe-shaped fittings, is similar in appearance to the most prestigious hammered-brass vessels formerly produced by Bida brass smiths—the gourd-shaped vessels known as *mange*. Brass *mange* water jars were formerly purchased by the Fulani king of Bida, the Etsu Nupe, for his daughters' dowry and as gifts to members of the Fulani political élite. *JP*

# Northern Africa

Artistic expression—preserved in rock engravings and paintings, and stone utensils and sculpture—developed in northwestern Africa during the Neolithic period, which lasted from the seventh to the first millennium B.C. By the eighth century B.C., Phoenician traders from what is now Lebanon had founded colonies at harbor sites along the coast. The most important of these was Carthage, whose style was an amalgam of Egyptian, Greek, and Phoenician influences. After the defeat of Carthage in the second century B.C., northern Africa became a prosperous part of the Roman Empire, making its own distinctive artistic contribution in the fields of relief sculpture and polychromed floor mosaics.

In the seventh century A.D., Muslim armies from Arabia dislodged the forces of the Romans' successors, the Byzantines, from northwestern Africa. The region became linked culturally to the Islamic lands to the east, as well as to Muslim Spain. Yet the indigenous population, though converted to Islam, did not abandon its own language and culture. Trade with western sub-Saharan Africa and with western Sudan brought wealth to the Islamic dynasties of northern Africa and introduced Islam and its art and architecture to these areas. Much of the trade was conducted by Saharan nomads—the Arabic-speaking "Moors" of the western Sahara and the Tuareg of the central and southern Sahara—using camels, which had become a means of transport at the end of the Roman period. While early objects have been preserved in urban centers, the rural arts of the nomads living in mountain and desert regions were documented by ethnographers only in the late-nineteenth and twentieth centuries.

Egypt flourished again during the Islamic period, especially under the independent Fatimid (969–1171) and Mamluk (1250–1517) dynasties. The Fatimids, whose power base had been in what is today Libya, annexed Egypt and founded their new capital at Cairo (from the Arabic for "victorious"), where the luxury of their court became legendary. During the Mamluk period, Cairo became the spiritual and political center of the Islamic world, and the center of a commercial empire that monopolized not only the spice trade but also the trade in luxury goods between China and the West. After the Mamluks' defeat by the Ottoman Turks, Egypt became part of the Ottoman Empire, and remained so until the nineteenth century.

**91. Rock Engraving**
Lemcaiteb (Saquia el-Hamra),
Western Sahara/Morocco, Neolithic.
Stone, ca. 84 cm high. Museum für
Völkerkunde, Basle, III.21.319.

**92. Rock Engraving**
Lemcaiteb (Saquia el-Hamra),
Western Sahara/Morocco, Neolithic.
Stone, 84 cm high. Museum für
Völkerkunde, Basle, III.11.976.

These two rock engravings are examples of the wider Neolithic engraving tradition found in both the Sahara and the Atlas Mountains. Such engravings are executed in a remarkably naturalistic style, depicting both men and animals on small stone plaques and ostrich eggshells, and, on a much larger scale, on rock faces. The technique used in most of them is the smooth U- or V-shaped incision. The second example shown here depicts, on the left-hand side, a striding ostrich in outline and, on the right-hand side, six four-legged animals, four with horns. Scholars have interpreted the species represented as oryx, other antelope, sheep, goat, and hyena. It has also been suggested that certain of the geometric designs on the plaque—including the V-shaped marks between the legs of the ostrich and the rectangular pattern in the center of the plaque—are later additions, since they do not display the same degree of patination.

The realism of these images has made them useful in the study of wild fauna in the Sahara and the mountainous regions to the north during the Neolithic period, and as a source of information on domestication of animals. The Sahara was not, at the beginning of the Neolithic period, the desert that it is today.

Concentrations of wildlife occurred at the large lakes then in the region, and included animals now found only well to the south of the Sahara. An extensive flora, including willow, hazel, and ash, supported animal and human populations. These animal species, which are abundantly represented in the rock and ostrich eggshell engravings, were to disappear from the Sahara in the first millennium B.C.
*TAI, MRM*

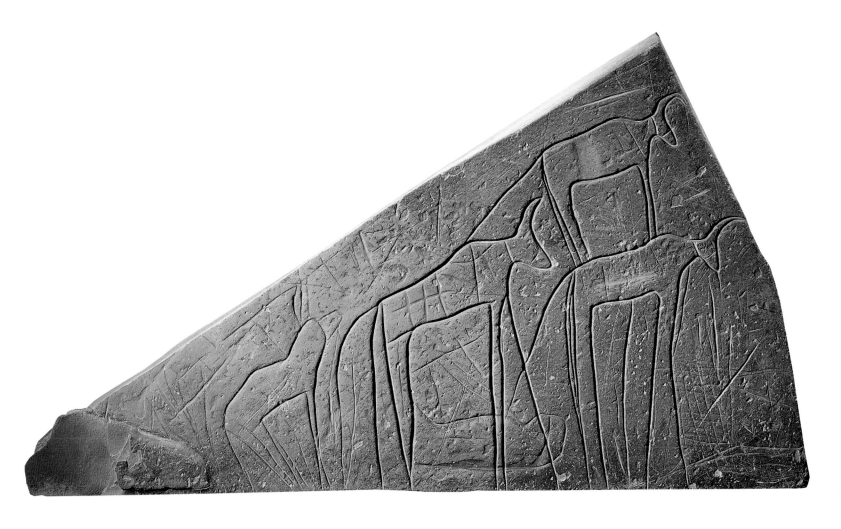

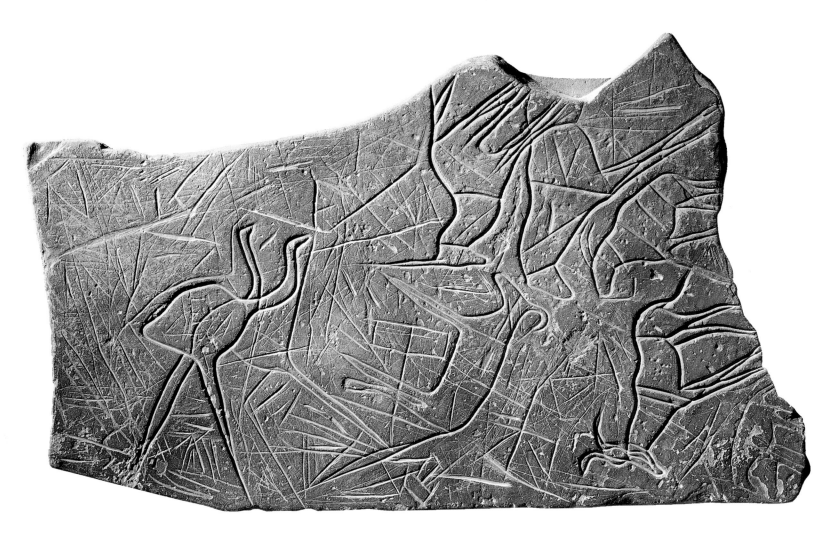

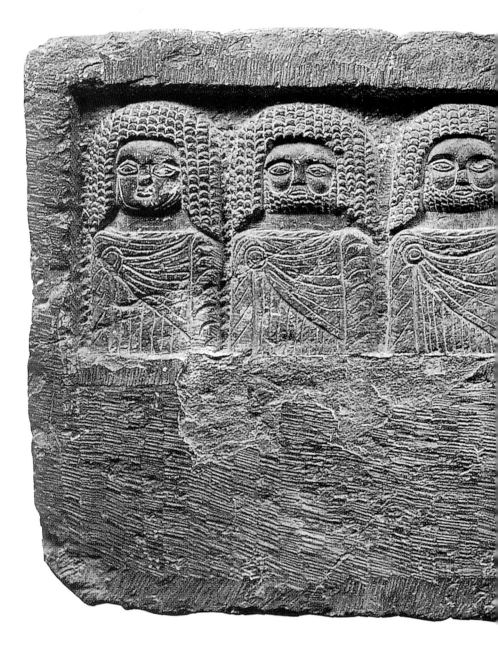

### 93. Relief of Eight Divinities

Tunisia, 2nd–1st century B.C. (?)
Limestone, 65 x 159 x 28 cm. Musée
National du Bardo, Le Bardo, Tunisia.

This unusual stone has a recessed
rectangular panel in which are depicted
seven men and one woman in flat
relief. The male figures are identical,
with stylized wiglike hair; they are
bearded and wear long-sleeved
garments pinned by a circular brooch
on one shoulder. The female figure,
fourth from the right, has similar
wiglike hair, but she also wears drop
earings and armlets as well as a band or
diadem in her hair. The relief almost
certainly depicts the indigenous deities
of the Numidian peoples of the interior
of northern Africa. In the absence of
the slightest trace of Roman influence
in the relief's iconography or style, it
probably predates Roman control of
northern Africa, belonging to the
period when the Numidian kingdoms
were at their height in the second and
first centuries B.C. Chemtou
(Simitthu), near which this relief was
found, was an important Numidian
settlement, and its famous quarries of
yellow marble (*giallo antico*) were then
being exploited for the first time. That
the worship of these multiple divinities
in the Chemtou region continued into
the Roman period is shown by a rough
cut relief, also depicting eight
divinities, still visible in the Roman
quarries at Chemtou. Neither the relief
shown here nor the quarry carving is
inscribed, but Latin inscriptions
elsewhere in northern Africa normally
refer to these indigenous deities as the
*dii Mauri* ("the Moorish gods"). The
inscription on a third-century A.D.
relief from Béja in northern Tunisia,
about seventy kilometers from
Chemtou, names the seven deities it
depicts as Macurtam, Macurgum,
Vihina, Bonchor, Varsissima, Matilam,
and Lunam, names that are native
Libyan in origin (only Bonchor may
owe something to the Carthaginian
world). Since these names are
unknown elsewhere, it is impossible to
say if any of these gods are represented
on this relief; indeed, another
pantheon of five, known collectively as
the *dii Magifae* and carrying the quite
different names of Masiden, Thiliva,
Suggan, Lesdan, and Masiddica, is
documented near Tébessa in eastern
Algeria; while another clutch of
godlings, also in Algeria, bears the
names of the *dii Ingitozoglezim*. Little
is known about indigenous cults in pre-
Roman and Roman northern Africa;
the Chemtou panel provides a rare
glimpse of one such pantheon. *RJAW*

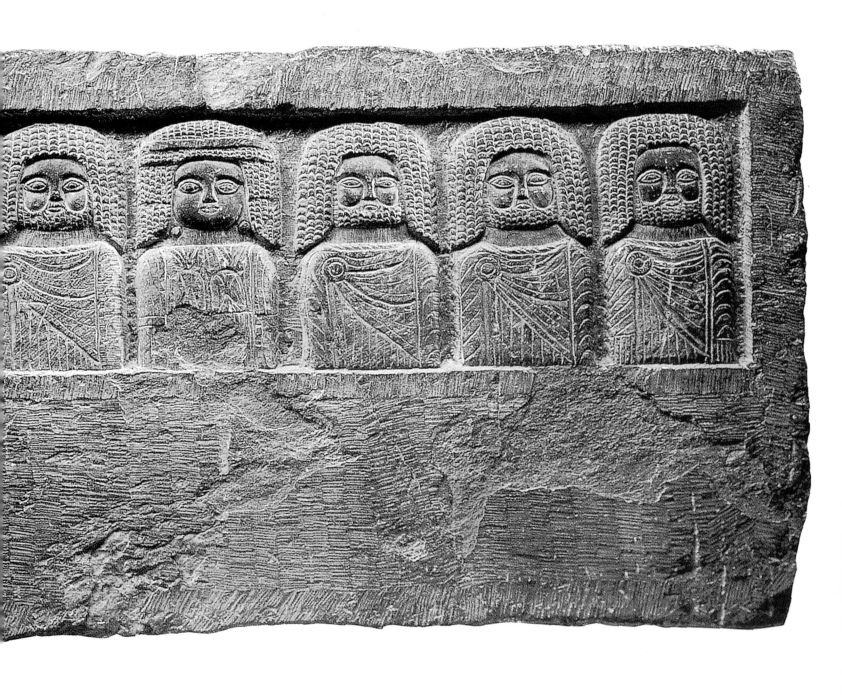

**94. Two Segments of a Necklace**
Moknine, Tunisia, 17th century (?).
Gold, filigree, and cloisonné, each
4 x 2 cm. Musée National des Arts
d'Afrique et d'Océanie, Paris, MNAM
1968.5.27.1/4.

Tunisian jewelers were working with
precious metals well before the
Christian era. The quality of their
techniques (filigree, chasing, cloisonné,
engraving, etching, and repoussé) was
famous all over the Mediterranean.
The arrival of Jews and Muslims
expelled by the Spanish from
Andalusia between the fourteenth and
seventeenth centuries meant that the
arts of the court of Granada (especially
jewelry) would survive in northern
Africa.

The two bobbinlike segments of a
necklace (*qannuta*), resembling small
tubular containers, are intended to hold
texts from the Hebrew Torah; this
would have given them a religious
significance, in fact would have made
them into talismans. They are
reminiscent of fourteenth- and
fifteenth-century jewelry from
Granada, particularly the elements
found in necklaces of the Nasrid
dynasty, which were also called
*qannuta*. Some scholars think that
these are derived from ancient forms
(Greek, Roman, or Byzantine) handed
down from generation to generation
from the Caliphate of Cordoba to the
Maghreb. *MFV*

**95. Fibulae with Connecting Chain and Central Ovoid Bead**
Berber groups of Anti-Atlas Mountains, Ait Ouaouzguite, 20th century. Silver, cloisonné, and glass, 147 cm high. Musée Barbier-Mueller, Geneva, 1000-35.

"Berber" is the general name given to the indigenous peoples of northern Africa, whose cultures have survived in remote mountain and desert regions, despite the Arabization of the plains following the Islamic conquest. The Berber languages are completely different from those of the Semitic family, although many Berbers today speak both Berber and Arabic. Most Berbers are Muslims, but there is a small Jewish minority. Their traditional material culture is easily distinguished from the Arab and Andalusian culture of the towns. In Morocco, this Berber culture is particularly rich and varied, and the inability of the central government based in Fez, Meknes, Marrakesh, or Rabat to control the mountain peoples ensured that it flourished in relative isolation until the French and Spanish colonial domination of the twentieth century.

While jewelry in the cities was often made of gold inset with precious stones, Berber jewelry is characteristically made of silver decorated with niello and cloisonné, and set with glass or semiprecious stones. Both in cities and in Berber regions, the jewelers were often Jews. The jewelry was worn exclusively by women (Islamic strictures about the wearing of precious metals seem not to have curtailed its use), usually given as part of their bride-price.

Two fibulae (*bzayim*) with a connecting chain and a central ovoid bead (*taghmut*) are used by Berber

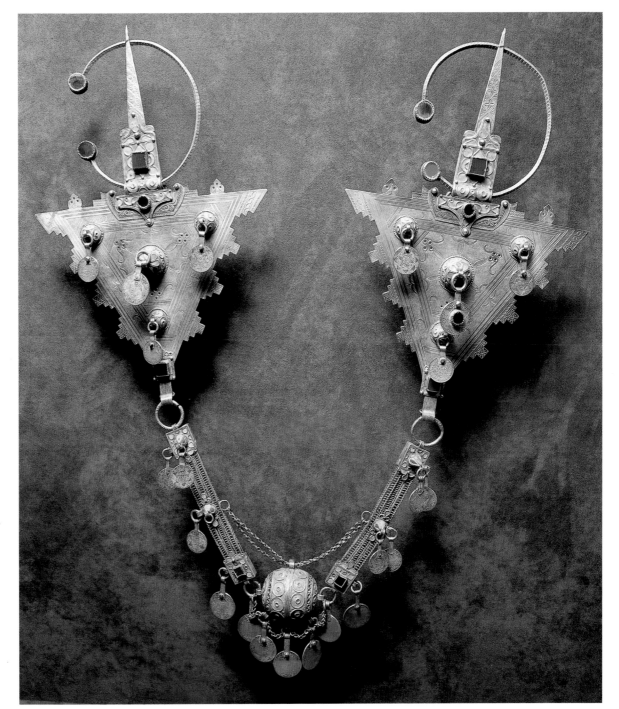

women to hold a cloak or loose garment at the shoulder. The fibulae shown here have ancient classical and early medieval prototypes, but their striking triangular shape is characteristic of Berber jewelry of the Anti-Atlas Mountains. Both the triangular form and the ovoid shape of the bead are understood as symbols of female fertility. The elaboration of the silver engraving and the enamel make this a particularly fine example. *NE*

**96. Bag**
Tuareg, Sahara, mid-20th century.
Leather, 115 x 100 cm. Collection of
Bert Flint.

The modern populations of the Sahara can be divided into two geographic groups, the Berber-speaking Tuareg who inhabit the central and southern Sahara (modern Algeria, Libya, Chad, Mali, Niger, Burkina Faso, and Nigeria), and the Arabic-speaking "Moors" who inhabit the western Sahara, Mauritania, Mali, and western Algeria. They lead a nomadic life, herding camel, goat, and sheep and conducting trade between northern and sub-Saharan Africa, although during the twentieth century there has been increasing settlement. In Mauritania, a number of ancient medieval oasis towns such as Oulata, Chengiti, and Tindouf have been settled by the Moors. In Algeria, Libya, and Chad, there are oases populated by agriculturalists and artisans, mostly from the black minority among the Tuareg. In the Tibesti region of southern Libya and northern Chad, there are whole populations of black settlers, known as the Tedda, who probably originated in the western Sudan. A system of slavery or vassalage of black peoples is still practiced by the Tuareg and Moors.

Apart from a small minority population of metalworkers, the Tuareg are self-sufficient, and produce their own utensils, predominantly of leather. They do not weave cloth, but import cotton cloth and wool from sub-Saharan or northern Africa. Goat hair is used for making rope. Leather is obtained primarily from goats and sheep, and sometimes camels, and is worked by women of the ruling Tuareg and artisan class. Leather is essential for the walls of their tents, some articles of clothing, harnesses, and all types of containers.

Many different containers are made to hold clothes and provisions. The shapes of leather bags vary, but the most common are very long, with the top part folding over to make a closing flap, a type used by men in northern Africa as far north as the Mediterranean. The shape of the bag shown here, in which the body is wider than the neck and opening, can be identified with Tuareg women's traveling bags.

Blue is the favorite color for leather, as well as for the robes and veils of the Tuareg, known as the "blue men" for the indigo that rubs off on their skin. The blue-dyed leather is often applied in openwork cut-out designs on a background of brown or black leather, and is painted or embroidered with white, red, and black thread or leather thongs. There is a taste for long flaps and fringes. The leather can have a mat or polished surface. The decorative motifs, as in this example, are all geometric: checkerboard, lozenge net, equilateral triangle, circle, six-point star, zigzag, spiral, and the so-called "Tuareg cross." The decoration of this bag resembles that of Moroccan Berber and sub-Saharan Hausa textiles, and contrasts with the more complex repertoire of the towns of northern Africa. *NE*

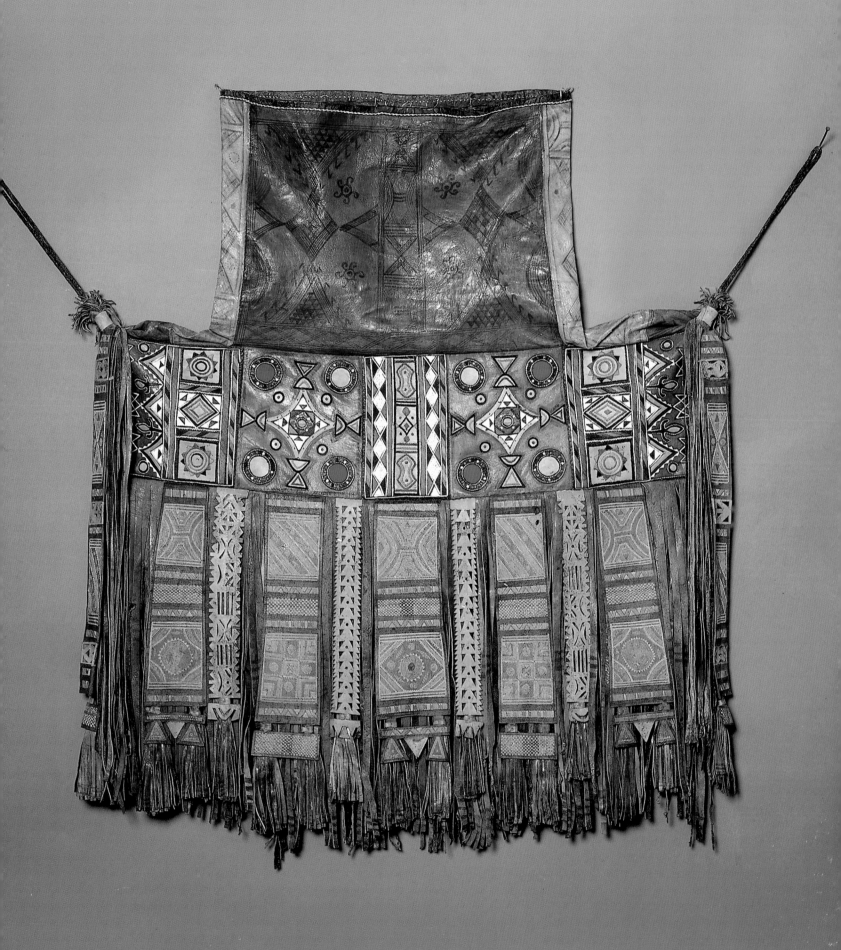

## 97. Ewer

Egypt, Fatimid, last quarter of 10th century. Rock crystal; 18 cm high, ca. 12.5 cm in diameter (at base); crystal: ca. 2.5 mm thick, with relief ca. 0.5 mm. Tesoro della Basilica di San Marco, Venice, 80.

Rock crystal occurs in crystals of hexagonal form, some only tiny specks, others as long as a meter. Because of its purity, beauty, and permanence, it has been fashioned into objects of particular rarity from quite early times. The art of carving rock crystal reached a peak in the central lands of the Islamic world between the eighth and eleventh centuries. This ewer is a fine example of a group of six precious rock-crystal ewers with a relief-cut decoration made in Egypt in the tenth and early eleventh centuries. The object has been carved from one piece of rock crystal and decorated by means of a bow drill by artisans who specialized in the carving of precious stones. The decoration, a pair of lions in heraldic posture, one on either side of the jug and separated by scrolls of interlaced branches and palmettes, is extremely fine. The thumb rest is in the form of a ram. The object is of particular importance because it bears a Kufic inscription around the shoulder with the name of the Fatimid caliph al-ʿAziz of the Fatimid dynasty, who reigned between 975 and 996. It is therefore securely dated to the last quarter of the tenth century and can be used as a point of reference for dating other rock crystal objects. The inscription reads *baraka min Allah lil-Imam al-ʿAziz bi-llah* ("May the blessing of God be on the Imam al-ʿAziz bi-llah"). The piece is mounted with a gold and enamel European mount that is later in date.

About 180 such Islamic rock crystals survive. Many of these are now in royal and church treasuries of western Europe, some having arrived as early as the tenth century; others were found in archaeological excavations, notably those at Fustat. *AC*

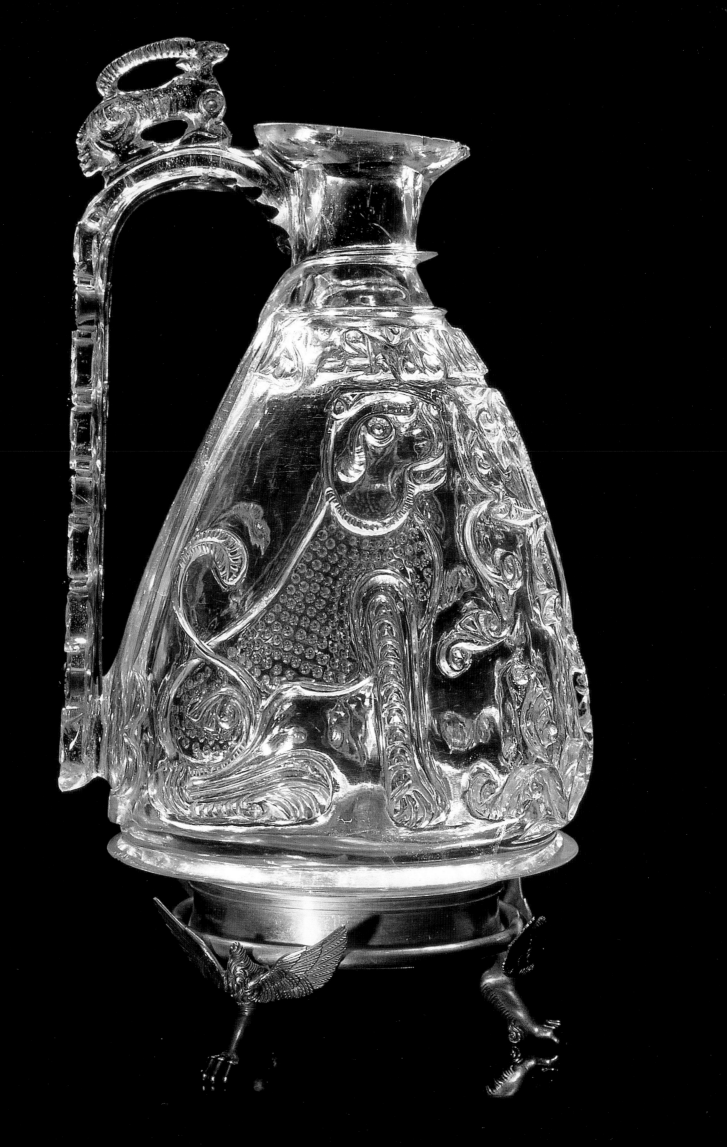

**98. Volume of a Seven-Part Qur'an**
Cairo, Egypt, A.D. 1305 (705 A.H.).
47 x 32 cm. The British Library,
London, Add. 22408.

This is volume three of a large Qur'an
in *asba'* (seven divisions), written in
*thuluth-ash'ar* script, with a double-
page frontispiece and fine illumination
throughout. It was copied by Shaykh
Sharaf al-Din Muhammad ibn
al-Wahid and illuminated by Abu Bakr,
known as Sandal, for the Mamluk
amir Rukn al-Din Baybars al-Jashnaqir
(later Sultan al-Muzaffar Baybars
[1309–10]).

This is the earliest dated Mamluk
Qur'an; it stands at the beginning of an
exceptionally rich period of Qur'an
production and is one of the finest of
them all. The writing of this Qur'an is
recorded by several Mamluk historians.
The fullest description is given by Ibn
Iyas in D. James's translation:

*In that year [A.D. 1305–6 (705 A.H.)] the*
atabak *[tutor to the crown prince] Baybars*
*al-Jashnaqir began to build his* khanqah
*[Dervish convent] which is in the square*
*of Bab al-'Id opposite Darb al-Asfar. It is*
*said that when the building was*
*completed, Shaykh Sharaf al-Din ibn*
*al-Wahid wrote a copy of the Qur'an in*
*seven parts for the* atabak *Baybars. It was*
*written on paper of Baghdadi size, in*
ash'ar *script. It is said that Baybars spent*
*1,600 dinars on these volumes so that they*
*could be written in gold. It was placed*
*in the* khanqah *and is one of the beauties*
*of the age.*

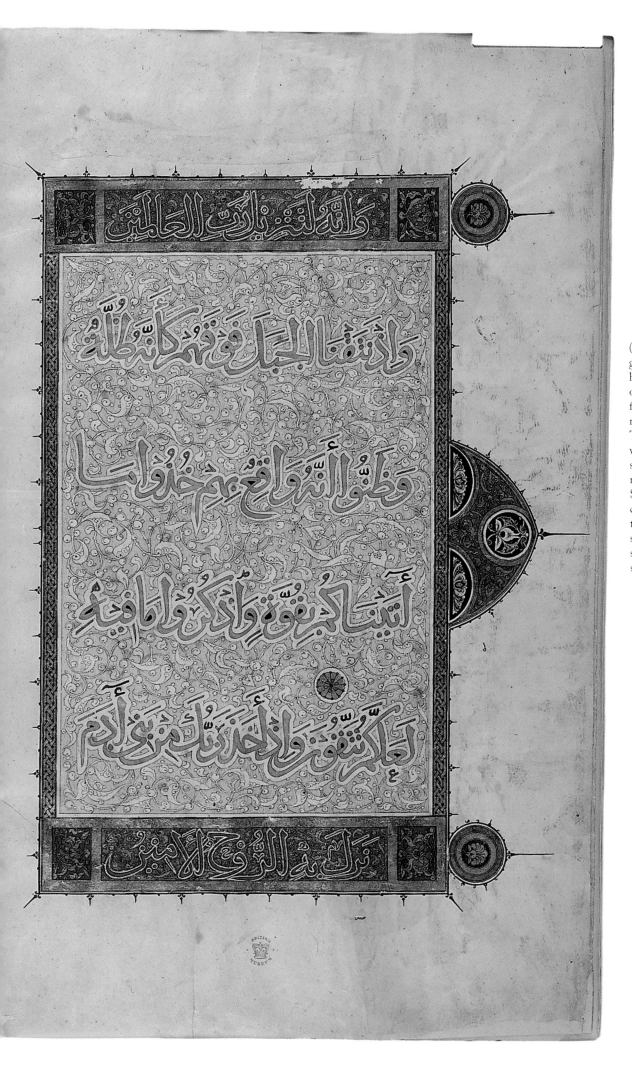

The calligrapher Ibn al-Wahid (d. 1311) was one of the best calligraphers of the fourteenth century, and his Qur'ans attained high prices. This one is written in gold outlined with a fine black line, a technique usually reserved for *sura* (chapter) headings. The illumination of this and two other volumes was the work of Sandal, who signs this volume in the marginal medallion of the final colophon page. Sandal was also highly regarded by his contemporaries. The frontispiece in this volume has a central, star polygon surrounded by interlocking geometric shapes, which is characteristic of his style. *RW*

## 99. Tray

Cairo, Egypt, Mamluk, 14th century.
Brass with silver and bitumen inlay,
71.1 cm in diameter. The Metropolitan
Museum of Art, New York, Edward C.
Moore Collection, Bequest of
Edward C. Moore, 1891, 91.1.605.

This tray, used to carry food, is one of a
group of about forty existing works of
art made by Mamluk craftsmen in
Cairo specifically for the Rasulid
sultans of Yemen. When the Mamluks
gained power in Egypt in 1250, Yemen
was ruled by the Rasulid dynasty
(1288–1454). Although fully
independent, the Rasulids
acknowledged that the Mamluks were
their potential overlords, and they
regularly sent embassies to Cairo
bearing gifts. The Mamluks sent envoys
in return with presents, and it is under
these favorable circumstances that
Mamluk metalworkers and glassmakers
received commissions for works
intended for the Rasulid sultans. These
artists did not adhere to a specific
decorative program to distinguish
objects made for local demand and
those made for export to Yemen. The
sole features that differentiate the two
productions are the Rasulid titles in the
inscriptions and the presence of the
emblem of the Yemenite dynasty, the
five-petaled rosette. According to its
prominent *thuluth* inscription, the tray
shown here was made for the Rasulid
sultan al-Mu'ayyad Hizabr al-Din
Dawud ibn Yusuf (ruled 1296–1321), a
contemporary of the Mamluk sultan al-
Nasir Muhammad ibn Qalawun (ruled
1294–95, 1299–1309, 1310–41). In
addition, five-petaled rosettes are
present inside circles that interrupt the
inscriptions inside the smaller bands.
The composition in concentric bands of

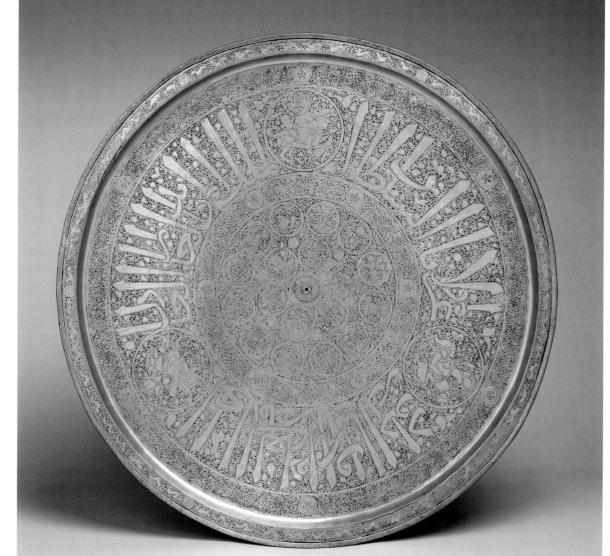

this tray is one of the most elaborate on
this type of object. Animal and human
figures were very popular in Mamluk
iconography. The central roundel
contains representations of the seven
planets and the twelve signs of the
zodiac. The sun is in the center; Mars,
Jupiter, the moon, Mercury, Saturn, and
Venus are shown clockwise. The twelve
signs are in their traditional sequence,
clockwise. Three large roundels
interrupt the main inscription. Two of
them seem to show a horseman
extracting an arrow from his quiver,
then shooting it at a gazelle; in the
third, a horseman attacks a lion with his
spear. The small quadrupeds running in

profile around the rim provide a
complete Mamluk bestiary: rhinoceros,
lion, antelope, cheeta, saluki, wolf, hare,
unicorn, bear, elephant, horse, onager,
gazelle, deer, and sphinx. The border of
the rim is completed by a band of tiny
stylized quails. The two smaller bands
immediately next to the main band
include eulogies in an elaborate, barely
readable "knotted Kufic" style. The
silver inlay is very shallow, and the tray
evidently was frequently used and
polished. As a consequence, the inlay
has almost disappeared and only the
black bitumen is still partially visible.
*SC*

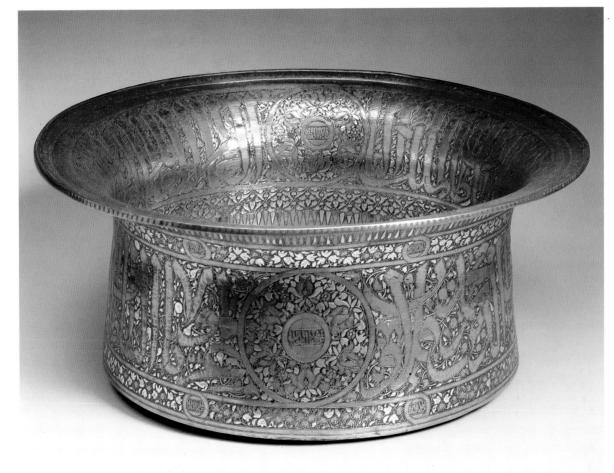

**100. Basin**
Made for Sultan al-Nasir Muhammad ibn Qala'un, Cairo or Damascus, ca. 1320–41. Brass, gold, and silver; 22.7 cm high, 54 cm in diameter. The Trustees of the British Museum, London, OA.1851.1-4, 1.

Majestic inscriptions in Mamluk *thuluth* script, originally inlaid with gold, decorate the interior and exterior of this large basin. They give the name and titles of the Mamluk Sultan al-Nasir Muhammad ibn Qala'un, who ruled between 1293 and 1341: "Glory to our master the Sultan al-Malik al-Nasir the wise, the efficient, the warrior, the champion of the faith, the defender Nasir al-Dunya wal-Din Muhammad ibn Qala'un, may his victory be glorious."

Small medallions containing the epigraphic blazon of the sultan ("glory to our master the Sultan") are at the center of the floral roundels that punctuate the inscriptions and are repeated in the narrow leafy borders on the exterior of the basin. The interior of the base is decorated with a large roundel filled with swimming fish.

Large basins like these were among the most prestigious of Mamluk metalworkers' productions. The fish inside the base confirm that they functioned primarily as ablution vessels, but their size and shape made them appropriate for a number of other uses also. The historian al-Jazari (1260–1338) described a circumcision ceremony organized by Sultan Khalil for his brother Muhammad (before he became sultan) at which each amir had to throw as many gold dinars as he had mamluks into a basin. The fourteenth-century Italian pilgrim Sigoli described wedding festivities in Cairo during

which women guests put gifts into a large basin placed by the side of the bride.

The long reign of Sultan al-Nasir Muhammad coincided with a period of prosperity and relative stability in the Mamluk empire. The sultan was responsible for making peace with his Mongol neighbors in Iran, after nearly a century of war between the two empires; this encouraged trade between Iran and Egypt and introduced a range of Chinese and Persian luxuries to the Mamluk court. The effect of these imports can be seen here in the lively lotus flower design in the main roundels, probably inspired by roundels on Chinese textiles. The sultan was an active patron of art and architecture. He and his officers were responsible for commissioning many other inlaid brass vessels and were probably largely responsible for the blossoming of the Mamluk fine metalworking industry during the fourteenth century. *RW*

# Selected Bibliography

Abiodun, R. "The Kingdom of Owo." In *Yoruba: Nine Centuries of African Art and Thought*. New York, 1989.

Adams, B. *Ancient Hierakonpolis*. Warminster, England, 1974.

Adams, M. "Eighteenth Century Kuba King Figures." *African Arts* 21, no. 3 (1988), pp. 32–38, 88.

Aldred, Cyril. *Egyptian Art*. New York, 1980.

Al-Jazari. *La chronique de Damas d'al-Jazari*. Translated by J. Sauvaget. Paris, 1949.

Allison, P. "A Yoruba Carver." *Nigeria Magazine* 22 (1944), pp. 49–50.

Almagro, M. *La necrópolis meroitica de Nelluah*. Madrid, 1965.

———. *La necrópolis meroitica de Nag Gamus*. Madrid, 1965.

Almagro, M., et al. "Excavations by the Spanish Archaeological Mission in the Sudan, 1962–3 and 1963–4." *Kush* 13 (1965), pp. 78–95.

Argan, C. "Art." In *Encyclopedia of World Art*. Vol. 1. New York, 1959.

Arnoldi, M. *Playing with Time: Youth Society Masquerades in Central Mali*. Bloomington, Indiana, 1995.

Aslanapa, O. *Yüzyıllar Boyunca Türk Sanatı*. Ankara, 1977.

Astuti, R. "Invisible Objects: Mortuary Rituals among the Vezo of Western Madagascar." *RES* 25 (1994), pp. 111–22.

Atil, E. *Renaissance of Islam: Art of the Mamluks*. Washington, D.C., 1981.

Barrett, D. *Islamic Metalwork in the British Museum*. London, 1949.

Bassani, E. "Ogetti africani in antiche collezione italiane." *Critica d'arte* 42, no. 151 (1977), pp. 151–82.

———. "Additional Notes on the Afro-Portuguese Ivories." *African Arts* 27, no. 3 (1994), pp. 34–45, 100.

Bassani, E. and W. Fagg. *Africa and the Renaissance: Art in Ivory*. New York, 1988.

Bastin, M.-L. *Art décoratif tshokwe*. Lisbon, 1961.

———. *Statuettes tshokwe du héros civilisateur "Tshibinda Ilunga."* Arnouville, France, 1978.

———. *La sculpture tshokwe*. Meudon, France, 1982.

Beier, U. "Festival of the Images." *Nigeria* 45 (1954), pp. 14–20.

———. *The Story of One Small Yoruba Town*. Lagos, 1957.

Ben Amos, P. *The Art of Benin*. London, 1980.

Bénabou, M. *La résistance africaine à la romanisation*. Paris, 1976.

Bent, J. *The Ruined Cities of Mashonaland*. London, 1896.

Berlyn, P. "Some Aspects of the Material Culture of the Shona People." *Native Affairs Department Annual* 9, no. 5 (1968), pp. 68–73.

Besancenot, J. *Bijoux arabes et berbères du Maroc*. Casablanca, 1953.

Beumers, E. and H. Koloss, eds. *Kings of Africa: Art and Authority in Central Africa*. Maastricht, 1992.

Biebuyck, D., ed. *Tradition and Creativity in Tribal Art*. Berkeley, 1969.

Bird, C., et al. *The Songs of Seydou Camara*. Vol. 1. *Kambili*. Bloomington, Indiana, 1974.

Blier, S. "Art Systems and Semiotics: The Question of Art, Craft, and Colonial Taxonomies in Africa." *American Journal of Semiotics* 6, no. 1 (1988–1989), pp. 7–18.

———. "African Art at the Crossroads: An American Perspective." In *African Art Studies: The State of the Discipline*. Washington, D.C., 1990.

Bothmer, B. "On Realism in Egyptian Funerary Sculpture of the Old Kingdom." *Expedition* 24, no. 1 (1982), pp. 27–39.

Bourgeois, J.-L. *Spectacular Vernacular, The Adobe Tradition*. New York, 1989.

Bravmann, R. *Islam and Tribal Art in West Africa*. Cambridge, England, 1974.

———. *Open Frontiers: The Mobility of African Art in Black Africa*. Seattle, 1973.

———. *African Islam*. Washington, D.C., 1983.

Brovarski, E., et al. *Egypt's Golden Age: The Art of Living in the New Kingdom 1558–1085 B.C.* Boston, 1982.

Bryant, P. *The Zulu People, as They Were Before the White Man Came*. Pietermaritzburg, 1949.

Camps, G. "Beginnings of Pastoralism and Cultivation in North-West Africa and the Sahara: Origins of the Berbers." In *The Cambridge History of Africa*. Vol. 1. Edited by J. Clark. Cambridge, England, 1982.

Capart, J. *Primitive Art in Egypt*. Translated by A. Griffith. London, 1905.

Center for African Art. *Art/Artifact: African Art in Anthropology Collections*. New York, 1988.

Clark, J. "African Beginnings." In *History of Africa*. New York, 1971.

Cole, H. *Icons: Ideals and Power in the Art of Africa*. Washington, D.C. and London, 1990.

Cole, H. and D. Ross. *The Arts of Ghana*. Los Angeles, 1977.

Collingwood, G. *The Principles of Art*. Oxford, England, 1938.

Coote, J. "A Table-Cloth of Grasse Very Curiously Waved." *Pitt-Rivers Museum News* 5 (1995).

Cornet, J. *Art royal kuba*. Milan, 1982.

Cruickshank, B. *Eighteen Years on the Gold Coast of Africa*. London, 1853.

Curnow, K. "The Afro-Portuguese Ivories: Classification and Stylistic Analysis of a Hybrid Art Form." Ph.D. diss., Indiana University, 1983.

———. "Oberlin's Sierra Leonean Saltcellar: Documenting Bicultural Dialogue." *Allen Memorial Art Museum Bulletin* 44, no. 2 (1991), pp. 12–23.

Dampierre, E. de. *Harpes zande*. Paris, 1992.

Daniel, Glyn. *The First Civilizations: the Archaeology of their Origins*. London, 1968.

Danto, Arthur. "The Artworld." *Journal of Philosophy* (1964), pp. 571–84.

Dark, P. "Benin Bronze Heads: Styles and Chronology." In *African Images: Essays in African Iconology*. Edited by D. McCall and E. Bay. New York and London, 1975.

Davidson, Basil. *Africa: History of a Continent.* Reprint, London, New York, Sydney and Toronto, 1978.

Davison, P. "Some Nguni Crafts: The Use of Horn, Bone and Ivory." *Annals of the South African Museum* 70, no. 2 (1976), pp. 79–155.

Davison, P., ed. *Art and Ambiguity: Perspectives on the Brenthurst Collection of Southern African Art.* Johannesburg, 1991.

d'Azevedo, W., ed. *The Traditional Artist in African Societies.* Bloomington, Indiana, 1973.

Devisse, J., ed. *Vallées du Niger.* Paris, 1993.

Dewey, J. *Art as Experience.* New York, 1934.

Dewey, W., ed. *Sleeping Beauties. The Jerome L. Joss Collection of African Headrests at UCLA.* Los Angeles, 1993.

Dias, A. and M. Dias. *Os Macondes de Moçambique.* 3 vols. Lisbon, 1964–1970.

Drewal, H., J. Pemberton and R. Abiodun. *Yoruba: Nine Centuries of African Art and Thought.* New York, 1989.

Drewal, H., and M. Thompson Drewal, *Gelede: Art and Female Power among the Yoruba.* Bloomington, Indiana, 1983.

Emery, W. and L. Kirwan. *The Royal Tombs of Ballana and Oustul.* Cairo, 1938.

Evans-Pritchard, E. "The Bongo." *Sudan Notes and Records* 12, no. 1 (1929), pp. 1–61.

Evers, T. "Excavations at the Lydenburg Head Site, Eastern Transvaal, South Africa." *South African Archaeological Bulletin* 37 (1982), pp. 16–30.

Eyo, E. *Two Thousand Years of Nigerian Art.* Lagos, 1977.

Eyo, E. and F. Willett. *Treasures of Ancient Nigeria.* Detroit, 1980–1983.

Ezra, K. "Figure Sculptures of the Bamana of Mali." Ph.D. diss., Northwestern University, 1983.

———. *A Human Ideal in African Art: Bamana Figurative Sculpture.* Washington, D.C., 1986.

———. *Royal Art of Benin: The Perls Collection.* New York, 1991.

Fagg, W. *Afro-Portuguese Ivories.* London, 1959.

———. *Nigerian Tribal Art*, 1960.

———. *Nigerian Images: The Splendor of African Sculpture.* London and New York, 1963.

———. *Nok Terracottas.* Lagos, 1977.

———. *African Majesty from Grassland and Forest.* Toronto, 1981.

Fagg, W. and J. Pemberton. *Yoruba Sculpture of West Africa.* New York, 1982.

Fantar, M., ed. *30 ans au service du patrimoine.* Tunis, 1986.

Felix, M., M. Kecskési, et al. *Tanzania: Meisterwerke Afrikanischer Skulptur.* Edited by J. Jahn. Munich, 1994.

Fentress, E. "Dii Mauri and Dii Patrii." *Latomus* 37 (1978), pp. 507–16.

Fernandes, V. *Description de la côte occidentale d'Afrique (Sénégal au Cap de Monte).* Edited by T. Monod. Bissau, 1951.

Fischer, H. *Ancient Egyptian Representations of Turtles.* New York, 1968.

Fraser, D. *Primitive Art.* Garden City, New York, 1962.

Gargouri-Sethom, S. *Le bijou traditionnel en Tunisie.* Aix-en-Provence, 1986.

Garlake, P. *The Early Islamic Architecture of the East African Coast.* Oxford, England, 1966.

———. *Great Zimbabwe.* London, 1973.

Garstang, J. "Excavations at Hierakonpolis, at Esna, and in Nubia." *Annales du Service des Antiquités de l'Egypte* 8 (1907), pp. 132–48.

Gerster, G. *Churches in Rock; Early Christian Art in Ethiopia.* New York, 1970.

Gilbert, M. "The Leopard who Sleeps in a Basket: Akuapem Secrecy in Everyday Life and in Royal Metaphor." In *Secrecy: African Art that Conceals and Reveals.* Edited by M. Nooter. New York and Munich, 1993.

Gillon, W. *A Short History of African Art.* London and New York, 1984.

Goldwater, R. *Bambara Sculpture from the Western Sudan.* New York, 1974.

González, V. *Emaux d'Al Andalus et du Maghreb.* Aix-en-Provence, 1994.

Haas, S. *Als die Sahara grün . . . Würfelsbilder aus der Saguia el-Hamra.* Basel, 1977.

Hahnloser, H., ed. *Il tesoro di San Marco: il tesoro e il museo.* Vol. 2. Florence, 1971.

Hall, M. *Great Zimbabwe.* London, 1905.

Harter, P. *Arts anciens du Cameroun.* Arnouville, France, 1986.

Hegel, G. *Aesthetics: Lectures on Fine Art.* Translated by T. Knox. Oxford, England, 1975.

Helck, W. and W. Westendorf, eds. *Lexikon des Ägyptologie.* Wiesbaden, 1977.

Hersak, D. *Songye Masks and Figure Sculpture.* London, 1986.

Holy, L. *The Art of Africa: Masks and Figures from Eastern and Southern Africa.* London, 1967.

Horn, H. and C. Rüger, eds. *Die Numider. Reiter und Könige nördlich der Sahara.* Bonn, 1979.

Houlberg, M. "Social Hair: Tradition and Change in Yoruba Hairstyles in Southwestern Nigeria." In *Fabrics of Culture: The Anthropology of Clothing and Adornment.* Edited by J. Cordwell and R. Schwarz. New York and Paris, 1979.

Houlihan, P. and S. Goodman. *The Birds of Ancient Egypt.* Cairo, 1986.

Huffman, T. "The Soapstone Birds from Great Zimbabwe." *African Arts* 18, no. 3 (1985), pp. 68–73.

Hugot, H. "The Prehistory of the Sahara." In *General History of Africa.* Vol. 1. *Methodology and African Prehistory.* Edited by J. Kizerbo. London and Berkeley, 1981.

Huntingdon, W. and P. Metcalf. *Celebration of Death: The Anthropology of Mortuary Ritual.* Cambridge, England, 1979.

Imperato, P. *The Cultural Heritage of Africa.* Chanute, Kansas, 1974.

———. *Buffoons, Queens and Wooden Horsemen: The Dyo and Gouan Societies of the Bambara of Mali.* New York, 1983.

Inskeep, R. "Terracotta Heads." *South African Journal of Science* 67 (1971), pp. 492–93.

Jacques-Meunié, D. "Bijoux et bijouteries du Sud marocain." *Cahiers des arts et techniques d'Afrique du Nord* 6 (1960–1961), pp. 57–72.

———. *Architecture et habitats du Dadès.* Paris, 1962.

James, T. *Egyptian Painting.* London, 1984.

James, D. *Qur'ans of the Mamluks.* London, 1988.

Jolles, F. Messages in Fixed Colour Sequences? Another Look at Msinga Beadwork." In *Oral Tradition and its Transmission, The Many Forms of Message.* Edited by E. Sienaert, M. Cowper-Lewis, and N. Bell. Durban, 1994.

Kant, I. *Critique of Judgment.* Translated by J. Bernard. New York, 1951.

Kasfir, S. "One Tribe, One Style? Paradigms in the Historiography of African Art." *History in Africa* 11 (1984), pp. 163–93.

Kendall, T. *Kush: Lost Kingdom of the Nile.* Brockton, Massachusetts, 1982.

Kenmogne, M. "Histoire d'une chefferie: aujourd'hui Baham." *Revue Binam* (1991–1992), pp. 48–50.

Kerchache, J., J.-L. Paudrat and L. Stéphan. *The Art of Africa.* Translated by M. de Jager. New York, 1993.

Killian, C. "L'art des Touareg." *La Renaissance* 1, nos. 7–9 (1934), pp. 147–55.

Kinahan, J. *Pastoral Nomads of the Central Namib Desert: The People History Forgot.* Windhoek, 1991.

Kingdon, Z. "A Host of Devils: The History and Context of the Modern Makonde Carving Movement." Ph.D. diss., University of East Anglia, 1994.

Kozloff, A. and B. Bryan. *Egypt's Dazzling Sun: Amenhotep III and His World.* Cleveland, Ohio, 1992.

Kroenberg, A. and W. Kroenberg. *Die Bongo Bauern und Jäger in Südsudan.* Wiesbaden, 1981.

Lamm, C. *Mittelalterliche Gläser und Steinschnittarbeiten aus dem Nahen Osten.* 2 vols. Berlin, 1929–30.

Lanci, M. *Trattato delle simboliche rappresentanze arabiche e della varia generazione de' musulmani caratteri sopra differenti materie operati.* 2 vols. Paris: 1845–46.

Lane-Poole, S. *The Art of the Saracens in Egypt.* London, 1886.

Langer, S. *Feeling and Form: The Theory of Art.* New York, 1935.

Lansing, A. "The Burial of Hepy." *Bulletin of the Metropolitan Museum of Art* 29 (1934), pp. 27–41.

Laurenty, J. *Les cordophones du Congo belge et du Ruanda-Urundi.* Annuaire du Musée Royal du Congo Belge. Tervueren, Belgium, 1960.

Law, R. *The Horse in West Africa.* London, 1980.

Lawal, B. "Yoruba Shango Ram Symbolism: From Ancient Sahara or Dynastic Egypt?" In *African Images: Essays in African Iconology.* Edited by D. McCall and E. Bay. New York, 1975.

———. *The Gelede Spectacle: Art, Gender, and Social Harmony in an African Culture.* Seattle, in press.

Leclant, J. "Kushites and Meroites: Iconography of the African Rulers on the Ancient Upper Nile." In *The Image of the Black in Western Art.* Vol. 1. New York, 1976.

Lecoq, R. *Les Bamiléké.* Paris, 1953.

Lehuard, R. *Art bakongo, les centres de style.* 2 vols. Arnouville, France, 1989.

Leiris, M. and J. Delange. *Afrique noire. La création plastique.* Paris, 1967.

Lewis-Williams, J. and T. Dowson, eds. *Contested Images: Diversity in Southern African Rock Art Research.* Johannesburg, 1994.

Lings, M. and Y. Safadi, eds. *The Qur'an: A British Library Exhibition.* London, 1976.

Loir, H. *Le tissage du raphia au Congo belge.* Brussels, 1935.

MacGaffey, W. *Religion and Society in Central Africa: The Ba-Kongo of Lower Zaire.* Chicago and London, 1986.

MacGaffey, W. and M. Harris. *Astonishment and Power.* Washington, D.C., 1993.

Mack, J. *Madagascar: Island of the Ancestors.* London, 1986.

Maggs, T. and P. Davison. "The Lydenburg Heads and the Earliest African Sculpture South of the Equator." *African Arts* 14, no. 2 (1981), pp. 28–33.

Marees, P. de. *Description and Historical Account of the Gold Kingdom of Guinea, 1602.* Translated by A. Van Danzig and A. Jones. Oxford, England, 1987.

Mark, P. "Constructing Identity: Sixteenth and Seventeenth Century Architecture in the Gambia-Geba Region and the Articulation of Luso-African Ethnicity." *History in Africa* 22 (1995), pp. 307–27.

McEvedy, Colin. *Penguin Atlas of African History.* Reprint, London and New York, 1995.

McNaughton, P. *Secret Sculptures of Komo: Art and Power in Bamana (Bambara) Initiation Associations.* Philadelphia, 1979.

———. *The Mande Blacksmiths: Knowledge, Power, and Art in West Africa.* Bloomington, Indiana, 1988.

Mercier, J. *Ethiopian Magic Scrolls.* New York, 1979.

Meyer, P. *Kunst und Religion der Lobi.* Zurich, 1981.

Middleton, J. *The World of the Swahili.* New Haven, 1993.

Migeon, G. *Manuel d'art musulman.* Paris, 1907.

Neaher, N. "Bronzes of Southern Nigeria and Igbo Metalsmithing Traditions." Ph.D. diss., Stanford University, 1976.

Nettleton, A. "The Figurative Woodcarving of the Shona and Venda." Ph.D. diss., University of the Witwatersrand, 1985.

———. "Venda Art." In *Ten Years of Collecting: The Standard Bank Foundation Collection of African Art.* Johannesburg, 1989.

Neyt, F. *Luba: The Sources of the Zaire.* Paris, 1994.

Nicklin, K. "An Anthropomorphic Bronze from the Cross River Region." *Tribal Art Bulletin: Musée Barbier-Mueller* 16 (1982).

Nicolaisen, J. *Ecology and Culture of the Pastoral Tuareg with Particular Reference to the Tuareg of Ahaggar and Ayr.* Copenhagen, 1963.

Nkwi, P. *Traditional Government and Social Change. A Study of the Political Institutions among the Kom of the Cameroon Grassfields.* Studia Ethnographica Friburgensia 5. Fribourg, 1976.

Nooter, M. and A. Roberts. *Memory: Luba Art and the Making of History.* New York, 1996.

Northern, Tamara. *Royal Art of Cameroon. The Art of the Bamenda-Tikar.* Hannover, 1973.

———. *The Art of Cameroon.* Washington, D.C., 1984.

O'Connor, David. *Ancient Nubia: Egypt's Rival in Africa.* Philadelphia, 1993.

Olbrechts, F. *Plastiek van Kongo.* Antwerp, 1974.

Page, A. *Egyptian Sculpture in the Petrie Collection.* Warminster, England, 1976.

Petrie, W. *Ceremonial Slate Palettes.* London, 1953.

Porada, E. "A Lapis Lazuli Figurine from Hierakonpolis in Egypt." *Iranica Antiqua* 15 (1980), pp. 175–81.

Poyner, R. "The Ancestral Arts of Owo Nigeria." Ph.D. diss., University of Indiana, 1978.

Pradelles de Latour, C.-H. *Ethnopsychanalyse en pays bamiléké.* Paris, 1990.

Prussin, Labelle. *Hatumere. Islamic Design in West Africa.* Berkeley and London, 1986.

Quibell, J. *Hierakonpolis.* Vol. 1. *Plates of Discoveries in 1898.* London, 1900.

Quibell, J. and F. Green. *Hierakonpolis.* Vol. 2. London, 1902.

Quirke, S. and J. Spencer, eds. *The British Museum Book of Ancient Egypt.* London, 1992.

Ravenhill, P. *The Self and the Other: Personhood and Images among the Baule, Côte d'Ivoire.* Fowler Museum of Cultural History Monograph Series no. 28. Los Angeles, 1994.

Ross, D., ed. *Elephant: The Animal and its Ivory in African Culture.* Los Angeles, 1994.

Roy, C. *Art of the Upper Volta Rivers.* Meudon, France, 1987.

Reeves, C. *Valley of the Kings.* London, 1990.

Reisner, G. *Mycerinus: The Temple of the Third Pyramid at Giza.* Cambridge, Massachusetts, 1931.

Rosenwald, J. "Kuba King Figures." *African Arts* 7, no. 3 (1974), p. 26–31, 92.

Ross, D. "The Verbal Art of Akan Linguist Staffs." *African Arts* 16, no. 1, pp. 56–67.

Ross, E. *The Art of Egypt through the Ages.* London, 1931.

Rouach, D. *Bijoux berbères au Maroc dans la tradition judéo-arabe.* Paris, 1989.

Rubin, W., ed. *"Primitivism" in Twentieth Century Art.* New York, 1984.

Schildkrout, E. and C. Keim. *African Reflections: Art from Northeastern Zaire.* New York, 1990.

Schutt, O. *Reisen im Sudwestlichen Becken des Congo.* Berlin, 1881.

Schweinfurth, G. *The Heart of Africa: Three Years' Travels and Adventures in the Unexplored Regions of Central Africa from 1868 to 1871.* 2 vols. Translated by E. Frewer. New York, 1874.

———. *Artes Africanae: Illustrations and Descriptions of Productions of the Industrial Arts of Central African Tribes.* Leipzig, 1875.

Seipel, W. *Bilder für die Ewigkeit: 3000 Jahre ägyptischer Kunst.* Heidelberg, 1983.

Seligman, C. "An Ausumgwa Drum." *Man* 11 (1911), p. 7.

Shanklin, E. "The Odyssey of the Afo-a-Kom." *African Arts* 23, no. 4 (1990), pp. 62–69, 95.

Shaw, T. *Igbo-Ukwu: An Account of Archaeological Discoveries in Eastern Nigeria*. London, 1970.

Sheppard, W. *Presbyterian Pioneers in Congo*. Richmond, Virginia, 1917.

Sieber, Roy. *African Textiles and Decorative Arts*." New York, 1972.

Sigoli, S. "Pilgrimage of Simone Sigoli to the Holy Land." Translated by T. Bellorini and E. Hoade. *Publication of the Studium Biblicum Franciscanum* 6 (1948), pp. 157–201.

Sijelmassi, M. *Les arts traditionnels au Maroc*. Paris, 1986.

Smith, W. *A History of Egyptian Sculpture and Painting in the Old Kingdom*. Boston, 1949.

Spencer, A. *Catalogue of Egyptian Antiquities in the British Museum*. Vol. 5. *Early Dynastic Objects*. London, 1980.

———. *Early Egypt: The Rise of Civilization in the Nile Valley*. London, 1993.

Summers, R. "The Zimbabwe Bird." *Rhodesian Countryman* 1, no, 13 (1961), pp. 2–4.

Sydow, E. von. *Afrikanische Plastik*. Berlin, 1954.

Tessman, G. *Die Pangwe*. 2 vols. Berlin, 1913.

Thiel, J. and H. Helf. *Christiche Kunst in Afrika*. Berlin, 1984.

Thompson. R. "The Sign of the Divine King: An Essay on Yoruba Bead Embroidered Crowns with Veil and Bird Decoration." *African Arts* 3, no. 3 (1970), pp. 8–17, 74–80.

———. *Black Gods and Kings: Yoruba Art at UCLA*. Los Angeles, 1971.

———. *Rediscovered Masterpieces of African Art*. Paris, n.d.

Thornton, John. *Africa and Africans in the Making of the Atlantic World, 1400–1680*. Cambridge and Melbourne, 1992.

Torday, E and T. Joyce. "Notes ethnographiques sur les peuples communément appelés Bakuba, ainsi que sur les peuplades apparentées, les Bushongo." *Annales du Musée Royal de l'Afrique Centrale* series 4, no. 2 (1910).

Török, L. *Late Antique Nubia*. Budapest, 1988.

Trowell, M. *African Design*. London, 1960.

Yankah, Kwesi. *Speaking for the Chief: Okyeame and the Politics of Akan Royal Oratory*. Bloomington and Indianapolis, 1995.

Van Beek, W. "Functions of Sculpture in Dogon religion." *African Arts* 21, no. 4 (1988), pp. 58–65, 91.

Vandier, J. *Manuel d'archéologie égyptienne*. Vol. 1. *Les époques de formation: les trois premières dynasties*. Paris, 1952.

Vansina, Jan. "Ndop: Royal Statues among the Kuba." In *African Art and Leadership*. Edited by D. Fraser and H. Cole. Madison, 1972.

Vansina, Jan. *The Children of Woot*. Madison, 1978.

Vogel, S. "The Buli Master and Other Hands." *Art in America* 68, no. 5 (1980), pp. 133–42.

———. "African Aesthetics and the Art of Ancient Mali." In *The Menil Collection*. New York, 1987.

———. "People of Wood: Baule Figure Sculpture." *Art Journal* 33, no. 1, pp. 23–26.

Walker, R. "Anonymous Has a Name: Olowe of Ise." In *The Yoruba Artist*. Edited by R. Abiodun, H. Drewal, and J. Pemberton. Washington, D.C. and London, 1994.

Ward, R. *Islamic Metalwork*. London, 1993.

Wembah-Rashid, J. "Isinyago and Midimu: Masked Dancers of Tanzania and Mozambique." *African Arts* 4, no. 2 (1971), pp. 38–44.

Wenig, S. *Africa in Antiquity: The Arts of Ancient Nubia and the Sudan*. Brooklyn, New York, 1978.

Wiet, G. *Catalogue général du Musée Arabe du Caire: objets en cuivre*. Cairo, 1932.

Willett, F. *Ife in the History of West African Sculpture*. London, 1967.

Williamson, L. "Ethnological Specimens in the Pitt Rivers Museum Attributed to the Tradescant Collection." In *Tradescant's Rarities: Essays on the Foundation of the Ashmolean Museum 1683, with a Catalogue of the Surviving Early Collection*. Edited by A. MacGregor. Oxford, England, 1983.

Woods, W. "A Reconstruction of the Triads of King Mycerinus." *Journal of Egyptian Achaeology* 60 (1974), pp. 82–93.

Zahan, D. *Sociétés d'initiation bambara: Le Ndomo, le Korè*. Paris, 1960.

———. *The Bambara*. Leiden, 1974.

Zaki, M. *Atlas al-funun al-zukhrufiya wa'l tasawir al-islamiya*. Cairo, 1956.

© 1996 The Solomon R. Guggenheim
Foundation, New York.
All rights reserved.

ISBN 0-8109-6894-0 (hardcover)
ISBN 0-89207-171-0 (softcover)

Guggenheim Museum Publications
1071 Fifth Avenue
New York, New York 10128

Hardcover edition distributed by
Harry N. Abrams, Inc.
100 Fifth Avenue
New York, New York 10011

Design by Tsang Seymour Design Studio

Printed in Germany by Cantz

*front cover:*
**Head of a Queen**, Yoruba, Nigeria,
Ita Yemoo, Ife, 12th–13th century (cat.
no. 59). Terra-cotta, 25 x 17 x 13 cm. The
National Commission for Museums and
Monuments, Ife, Nigeria, 79.R.7.

*back cover:*
**Dance Shield**, Kikuyu, Kenya,
early 20th century (cat. no. 18). Wood,
60 x 42 x 8 cm. Collection of Marc and
Denyse Ginzberg.